Blake as an artist

David Bindman

BLAKE
as an artist

PHAIDON E. P. DUTTON
OXFORD NEW YORK

To Frances

Phaidon Press Limited, Littlegate House, St Ebbe's Street, Oxford
Published in the United States of America by E. P. Dutton, New York
First published 1977
© 1977 by David Bindman
All rights reserved
Designed by Crispin Fisher
ISBN 0 7148 1637 X
Library of Congress Catalog Card Number: 77–71183
Printed in Great Britain by Western Printing Services Ltd, Bristol
Plates printed by Burgess & Son Ltd, Abingdon

The author and publishers would like to thank all those who have given permission
for works in their possession to be reproduced. Plate 20 is reproduced by gracious per-
mission of Her Majesty the Queen. Plates 9 and 25 are reproduced by courtesy of the
Royal Academy of Arts; plates 36, 94, 95, 108, 115, 141, 143 are from the collection
of Mr and Mrs Paul Mellon; plate 88 is by courtesy of the Trustees of Sir John Soane's
Museum; plates 15, 38, 39, 40, 42, 83, 99, 109, 125, 128, 166 are Crown Copyright,
Victoria and Albert Museum; plates 104, 127 are by courtesy of the Glasgow Museums
and Art Galleries, Stirling Maxwell Collection, Pollok House; plates 114, 146, 150,
151, 152, 155 are by courtesy of the Museum of Fine Arts, Boston (*Comus and his
Revellers* was a gift from Mrs John L. Gardner and Mr George N. Black); plate 174 is
copyright the Frick Collection, New York; plate 175 is reproduced by permission of
the Birmingham Museum and Art Gallery. We would also like to thank the Ham-
burger Kunsthalle and Prestel Verlag, Munich, for their kind help, and Gordon
Roberton of A. C. Cooper Ltd for taking a number of the photographs.

Dates are given in the captions only where these are certain. Pictures are by
William Blake unless otherwise stated.

Contents

Preface

The germ of this book was a doctoral dissertation on *The Artistic Ideas of William Blake* presented to the Courtauld Institute in 1971, but the present work goes beyond it in scale and coverage. My principal debt is to the supervisors of the thesis, Professor Sir Anthony Blunt and Mr Martin Butlin, who were always critical but never discouraging. I have tried to be mindful of the former's insistence upon the especial need for clarity when writing about Blake, and of the latter's creative scepticism about so many common assumptions. Martin Butlin has been inordinately patient in dealing with my enquiries, and he has made freely available his work towards the great *catalogue raisonné*, which at the time of writing is still unpublished. I have also benefited enormously from long conversations with my friend Professor Morton Paley. To my profound sorrow one of my greatest debts must be a posthumous one, for my father, Dr Gerald Bindman, died on 23 January 1974. As a lover of Blake he had not only encouraged my interest by giving me, in my school years, a copy of Gilchrist's *Life of Blake*, but he also took a close and critical interest in my work on this book and read part of the first draft shortly before his death. It is hoped that, however inadequately, this book will be a memorial to him. My indebtedness to Sir Geoffrey Keynes, Professor David Erdman and Professor G. E. Bentley, Jnr., is such that it is hard to separate my gratitude for their personal kindness from their invaluable publications, which have been beside me at all times during the writing of this book.

In the years I have been working on Blake, scores of people have talked freely to me about him and have helped in all sorts of ways. Professor L. D. Ettlinger, Mr Michael Kitson and Mr William Vaughan were particularly encouraging, and my experience of working on the Fitzwilliam Museum Blake collection with Mr Malcolm Cormack was a turning point. I cannot list all the contributions made by my students and colleagues at Westfield College, but especial thanks should go to Miss Dorothy Moore, the former College Librarian, Professors Nicolai Rubinstein and Christopher Brooke, Mr Neil Stratford and Dr David Freedberg. Others who have been particularly helpful include the late Professor T. S. R. Boase, Professor Julian Brown, Mr E.

Croft-Murray, the late Earl of Crawford and Balcarres, David Davies, William Drummond, Bob Essick, Arnold Fawcus, Dr John Gage, Professor J. E. Grant, Professor Robert Rosenblum, John Sunderland, Ruthven Todd, Deirdre Toomey and Andrew Wilton.

It is also impossible to list the endless kindnesses received from officials in museums and Print Rooms in England and the United States, but I cannot forbear to single out Robert Wark of the Huntington Library. The book would have been greatly delayed if it had not been for the heroic efforts of Joyce Jayes and Jackie Hoogendyk in typing the manuscript, and I am deeply grateful also to Keith Roberts of the Phaidon Press, who accepted my excuses for many delays with greater patience than they deserved, and to Dr I. Grafe, whose incisive attention to the manuscript prevented many errors and infelicities.

Frances Carey has perpetually tried to convince me that it was all worthwhile, and it is to her that the book is dedicated.

D.B.

Introduction

The starting points for my work on Blake were two books: Anthony Blunt's *Art of William Blake*, 1959, and Robert Rosenblum's *Transformations in Late Eighteenth-century Art*, 1967. The former, although brief, if taken in conjunction with a series of articles in the *Journal of the Warburg and Courtauld Institutes* in the late 1930s and '40s, offered a methodical approach to the special problem of the relationship between Blake's personal theology and his designs, in the context of the history of art. Rosenblum's book, on the other hand, only mentions Blake infrequently, subsuming him within an international context. This book aims to follow their work by taking an analytical view of Blake's art with particular emphasis upon its relationship to English art of his own time.

I have attempted to approach the Illuminated Books from an art-historical point of view, a task which would have been impossible if a general consensus upon their meaning had not been established in the last few years, primarily by literary scholars. I am now convinced that Blake's mythology can be made sufficiently comprehensible to allow one to discuss his subject-matter in a way comparable to that of any other artist of the past, but I am also aware that many scholars regard the Illuminated Books as more complex in thought than I do. It is clear to me that the Illuminated Books are not a self-contained aspect of Blake's work, but contribute directly to the understanding of the seemingly more conventional designs for the Bible, for Milton and for other writers. A central assumption of this book is that there is a fundamental unity between Blake's art and his writing, but my focus has still been predominantly upon the art, and I have made literary judgements only when they affect the argument.

Perhaps it is premature for me to give an assessment of Blake's stature as an artist, but I find myself haunted by Sir Joshua Reynolds' characterization of the 'original or characteristical style'. Reynolds, of course, could not have had Blake in mind, but none the less it might well be applied to him:

But there is another style, which, though inferior to the (great style), has still

great merit, because it shews that those who cultivated it were men of lively and vigorous imagination. This, which may be called the original or characteristical style, being less referred to any true archetype existing either in general or particular nature, must be supported by the painter's consistency in the principles which he has assumed, and in the union and harmony of his whole design. The excellency of every style, but of the subordinate styles more especially, will very much depend on preserving that union and harmony between all the component parts, that they may appear to hang well together, as if the whole proceeded from one mind. It is in the works of art, as in the characters of men. The faults or defects of some men seem to become them, when they appear to be the natural growth, and of a piece with the rest of their character. A faithful picture of a mind, though it be not of the most elevated kind, though it be irregular, wild, and incorrect, yet if it be marked with that spirit and firmness which characterises works of genius, will claim attention, and be more striking than a combination of excellencies that do not seem to unite well together ; or we may say, than a work that possesses even all excellencies, but those in a moderate degree.[1]

The Emergence of the Prophet

The Visionary Apprentice

William Blake was born on 28 November 1757, the son of a hosier of Broad Street in Soho, London. His father was probably a member of the Church of England,[1] in which he may have brought up his older sons including William, but there is some evidence that he was converted to Baptism in later life.[2] Blake's social background was undoubtedly formative, for the small shopkeepers and craftsmen of London were as a class susceptible to religious enthusiasm of an apocalyptic kind,[3] and his early education is likely to have been based upon a close study of the Bible as Holy Writ. In a letter written many years later he claimed to have been visited in earliest youth by Milton and the prophets Ezra and Isaiah, who in his 'riper years' were joined by such visionary writers as Paracelsus and Böhme, as well as Shakespeare.[4] He also used to recall in later years the visions he saw as a boy; the first, at the age of eight or ten, being of 'a tree filled with angels, bright angelic wings bespangling every bough like stars'.[5] He regarded them not as childish reveries but as a summons into the world of the spirit; and this early vision was remembered as the moment when he first became aware of that calling.

These youthful visions may be associated with his discovery of Jacob Böhme or Behmen, the early seventeenth-century mystic who was to become a tutelary spirit of the Romantic movement. Böhme's arcane works had been translated into English in the seventeenth century, but Blake was most familiar with them in the famous four-volume edition edited by William Law and his admirers, which appeared during Blake's childhood and youth.[6] Blake's mature ideas were also indebted to Böhme, but in early years the most important influence was probably Böhme's insistence upon the centrality of the Imagination in the process of Redemption, for he believed that through the exercise of the Imagination man could aspire to choose between the Fire and the Light, and the Hell and Heaven within himself.[7] Thus, apart from encouraging the young Blake's sense of inner spirituality, Böhme could have sown the seed in his mind of a belief in the redemptive nature of artistic creation. We know nothing of Blake's immediate environment, so we are unlikely ever to know whether he was,

as a boy, on the fringes of a group of Böhme followers, or whether his devotion to the spirit was the lone endeavour of an introverted and bookish youth.

Fortunately we can trace with greater precision his acquisition of an artistic training and his entry into the engraving profession. His father encouraged his artistic ambitions, sending him at the age of ten to Henry Pars' drawing school and buying him prints and plasters of 'the Gladiator, the Hercules, the Venus of Medicis, and various heads, hands, and feet'.[8] The Henry Pars drawing school, through its founder William Shipley, was closely related to the Society for the Encouragement of the Arts, Manufactures and Commerce, of which Shipley had been a founder-member in 1754. The emphasis of the training was, therefore, not just on the 'Polite Arts' but also upon 'such manufactures as require Fancy and Ornament'.[9] Henry Pars took over from Shipley about 1761 and ran it upon the same principles.[10] Many well-known painters, sculptors and architects received instruction there and in some cases returned as teachers, including Blake's friends Ozias Humphry and Richard Cosway. Although some art schools in England had already introduced the life model,[11] the Pars school seems to have relied entirely upon copying prints in drawing books and casts from the antique. After the student had achieved proficiency he was allowed to work in the Duke of Richmond's famous gallery of casts.[12] Blake may have met there the painter John Hamilton Mortimer, who assisted at the gallery about this time,[13] but he did not distinguish himself by winning any of the premiums offered to the school by the Society of Arts.[14]

Given that he had shown no unusual gifts as a copyist of the antique and did not possess an income, it was inevitable that he should progress not directly to the 'Polite Arts' but to one of the subsidiary branches, where a living would be assured. Alexander Gilchrist, Blake's Victorian biographer, tells us that William Wynne Ryland, one of the best-known engravers of the day, was approached to take Blake on as an apprentice.[15] In the end James Basire, an antiquarian engraver, was settled upon because his fee was only £52 10s.,[16] while Ryland would probably have charged about £100.[17] Blake began his apprenticeship on 4 August 1772 and he completed his seven-year term before going on to the Royal Academy school. The drudgery of an apprentice engraver's life did not dampen his spirit, and he seems to have been determined to learn as much as possible from artists of 'the historic class' in order to transcend his humble status and become a painter of History himself. He took every opportunity of seeing paintings in private houses and royal palaces; he haunted the auction rooms, buying prints after Renaissance masters of the Northern as well as Italian schools.[18] His desire for improvement was boundless and he must also have been seriously involved in writing poetry, for some of the *Poetical Sketches* were apparently written as early as his twelfth year.[19] Not surprisingly he appeared as an odd specimen to his fellow apprentices, who found his choice of prints strange, and 'were accustomed to laugh at what they called his mechanical taste'.[20]

Despite his lofty ambitions Blake remained appreciative of the lessons he learnt in the Basire workshop, and he remembered with pride the engraving technique he acquired there, even though it was already becoming old-fashioned. Basire, when

younger, had been one of the most eminent engravers of his day, working for Ho-
garth and Benjamin West, but now the best commissions were going to those who
practised a more fashionable style, like Strange, Bartolozzi and Woolett.[21] These rep-
resentatives of the new 'English Style of Engraving' were immensely successful and
broke the French domination of the profession, but Blake in later years claimed,
rather unfairly, that they had sacrificed the traditional independence of the engraver
for the sake of flashy reproductive effects, preferring, as Blake put it, 'Fine Tints'
to 'Fine Forms'.[22] Basire, who had, according to Blake, remained loyal to the style of
'the old English Portraits', was therefore reduced to antiquarian engraving, while the
new engravers became rich and fashionable. Even so, all the engravers were joined in
a common cause (except Bartolozzi), in the face of the Royal Academy's refusal to allow
engravers to become full members, despite a furious campaign led by Strange.[23] Blake's
sense of alienation from the established forces in the art world must therefore have
been twofold; on the one hand from the successful engravers and on the other from
the dominant patrons of the Royal Academy, and he cannot have been unaware of the
fact that Strange was a Jacobite while Bartolozzi, the one engraver for whom an
exception was made by the Royal Academy, was a protégé of Lord Bute.

The Basire workshop was a small one, and for most of the time that Blake was there
only two apprentices were employed.[24] He must, therefore, have had a hand in most
of the shop's work, a large part of which was of an antiquarian nature. The most
significant part of the experience, and the one which he remembered with enthusiasm,
was his employment in copying Gothic monuments and buildings for two large com-
pilations for the Society of Antiquaries: James Gough's *Sepulchral Monuments in
Great Britain* and *Vetusta Monumenta*.[25] The interest of the Society in medieval
remains was entirely historical, and their scholarly approach drew the scorn of
Horace Walpole, who deplored their lack of taste.[26] Blake was particularly enthralled
by the tombs in Westminster Abbey, which 'he drew in every point he could catch,
frequently standing on the monument, and viewing the figures from the top'.[27] His
admiration for the tombs did not, as Gilchrist thought,[28] simply follow from an in-
tuitive fellow-feeling for the piety of their medieval sculptors, but was based on an
appreciation of their aesthetic qualities: 'He saw the simple and plain road to the
style of art at which he aimed, unentangled in the intricate windings of modern
practice.'[29] This appreciation was in harmony with the dissatisfaction of other young
artists with the prevailing emphasis upon manual dexterity and decorative qualities
at the Royal Academy and elsewhere.[30] Blake seems also to have been respon-
sible for engraving some of the drawings he made from the tombs. A number of
engravings in Gough's *Sepulchral Monuments* and the *Vetusta Monumenta* and
finished drawings for them in the Bodleian Library and the Society of Antiquaries
can be confidently ascribed to Blake even though they are signed by Basire.[31] On the
other hand these engravings show little individuality, for they are essentially the
products of a co-operative venture directed by the master of the workshop.

Apart from his work for Basire, which must have been arduous and time-consuming,
Blake was busily engaged in copying the prints which he had collected, and a

number of surviving copies may date from this period or soon after. Only one trial engraving survives (plate 1) but this is of greater importance than the drawn copies, for it was later dated by Blake to 1773,[32] and is significantly different from its proto-type. It exists in a unique impression (private collection) and derives, through an engraving by Beatrizet, from a brooding figure in Michelangelo's *Crucifixion of St Peter* in the Pauline Chapel, which has sometimes been identified as a portrait of Michelangelo himself,[33] to which Blake has added a crude background of rocks and sea not to be found in either the fresco or the Beatrizet engraving. The engraving is no more competent than one would expect of an apprentice of a year's standing, and Blake at a much later date re-engraved it and retitled it *Joseph of Arimathea among the Rocks of Albion* (plate 2). In a long inscription on the later state he identified the man as Joseph of Arimathea, who was 'One of the Gothic Artists who Built the Cathedrals in what we call the Dark Ages, Wandering about in sheep skins & goat skins, of whom the world was not worthy; such were the Christians in all Ages.'[34] The engraving, then, is only partially an exercise, for the image of this lone figure on the rocky shore, even in the first state, is full of personal feeling. The sea and rocks increase the sense of the man's patriarchal isolation, as he seeks for strength within himself. There can be little doubt that this figure even in its earlier form is in some sense a representation of Blake's state of mind, and expresses his feeling of isolation amongst people who had no understanding of his stern mission to excel in the highest reaches of art. A comparable self-consciousness also emerges from some of the *Poetical Sketches*, many of which could have been written as early as 1773. In the prose fragment *Samson*, for example, Samson is revealed as a melancholic figure, conscious of his role as a 'Nazarite', one set apart by God for a special purpose, but bearing his mission as a terrible burden: 'He sat, and inward griev'd . . . for care was I brought forth, and labour is my lot: nor matchless might, nor wisdom, nor every gift enjoy'd, can from the heart of men hide sorrow.'[35] By an intense effort of will Samson is able to overcome his sensual desires and take up his spiritual destiny to destroy the Philistines, the enemies of the spirit and therefore of art. Implicit in Blake's conception of *Samson* is an analogy between the captivity of Israel by the Philistines and the enslavement of the English nation by its materialistic rulers, but at another level it is also the story of a man's conquest of his own material self by his Divine spirit. At yet another level Samson is the artist who must struggle against the neglect of art by the contemporary arbiters of taste, who are Philistines in a more modern sense, and Blake must have had in mind the traditional identification of *Samson Agonistes* with the blind Milton himself. *Samson* is, therefore, despite its early date in Blake's career, a complex allegory in which the Biblical story becomes a vehicle for meditation upon man's and the artist's internal struggle for redemption, his country's struggle for liberty, and the struggle of the spirit against materialism.[36] The English nation, as Blake would have learned from Milton, had itself become the Chosen People,[37] and as its priests and rulers have given themselves over to idolatry the artist and poet must be the voice of the spirit in time of trouble.

If the brooding figure in the 1773 engraving is intended to represent Joseph of

Arimathea then we can suggest that Blake had in mind a similar kind of allegory to *Samson*. Joseph of Arimathea according to legend was sent by Paul to preach the gospel in England, where he became the founder of the first church at Glastonbury. He 'found the Inhabitants of this Island very barbarous and superstitious',[38] but through his piety and persuasive powers he was able to convert many souls. He was, therefore, the messenger of Christ's Incarnation to England but he had much difficulty in persuading the disdainful inhabitants of the truth of the Revelation he brought and its importance to them. Just as the artist could see himself as a Samson whose mission was to destroy the Philistines, so he could identify himself with Joseph of Arimathea, a witness of Christ finding the shores of Britain inhospitable to the news of man's Redemption. At the same time Joseph of Arimathea is a link, though a legendary one, between the Bible story and the history of England, and the two were to be irrevocably intertwined in Blake's work. Furthermore, Blake's interest in Joseph was another sign of what in the eighteenth century was an unusual preference for legend over historical fact. Milton had dismissed the Joseph of Arimathea legend as worthless historically[39] as did the rational historians who followed him, but Blake defiantly upheld the value of poetic over historical truth.

The *Joseph of Arimathea* engraving is ineffably Ossianic in the brooding melancholy of its hero and the northern bleakness of its setting. Blake's Joseph can be related to the aged blind Ossian, who sang to his harp 'a tale of the time of old', and to Gray's *Bard*, who hurled defiance from the mountains of Wales at the forces of the warrior king who sought to destroy Bardic poetry. Some of the *Poetical Sketches* fit into the poetic climate created by Gray, Macpherson, Percy and the 'Gothick', and a certain inwardness can be found in some of the History painting of the 1770s. The *Bard* from Gray was a subject treated by most painters of History,[40] and the painters of the time whom Blake is known to have admired were notable for a consciousness of their separateness as artists.

John Hamilton Mortimer, for example, evoked the 'savage' manner of Salvator Rosa in his paintings, and cultivated an air of bravura which alternated with fits of torment and melancholy.[41] Blake remembered this some forty years later, for next to Reynolds's condemnation in his Discourse of December 1769 of an excessive reliance upon 'Genius': '[he] who would have you believe that he is waiting for the inspiration of Genius, is in reality at a loss how to begin, and is at last delivered of his monsters with difficulty and pain,' Blake has written 'A stroke at Mortimer!'.[42] In Mortimer's two etchings of *Salvator Rosa* and *Gerard de Lairesse*, 1776, the former is shown as a youthful and vigorous bandit on a rocky outcrop, while de Lairesse, famous for a book of academic instruction, is shown as a crippled old man hobbling painfully away from his easel.[43] Two recently discovered self-portrait drawings formerly attributed to Mortimer but now known to be by James Jeffries also reveal a sense of artistic alienation; one is inscribed 'rara avis in terra' and in prophetic vein: 'Who can paint this character as it ought/Tho' Wisdom cryeth out in the Streets yet [rest indecipherable]'.[44]

James Barry, another artist whom Blake later saw as martyr to the cause of High

Art in England, also exhibited conspicuous signs of uncomfortable idealism, 'having few friends and unfortunately of peculiar and stern habits of thinking and acting, not likely in a superficial age, to create many more'.[45] Barry had come back from Italy with a desire to create works on the scale of Raphael's *Stanze* and the Sistine Chapel, but in the end he could not receive adequate financial support for his endeavours; according to Blake he lived on 'bread and apples'[46] while completing his enormous series of wall-paintings for the Society of Arts, which he had begun in 1777. His pictures frequently show stoic heroes, whose sufferings may again reflect those of their author; his painting of *Philoctetes on Lemnos*, 1770,[47] conveys a similar feeling of lonely agony to Blake's *Joseph of Arimathea* print, and the *Job comforted by his friends*[48] engraving of 1778 seems to make a sardonic comment on the attempts to discourage him from his great task for the Society of Arts. The first of the wall-paintings, the general theme of which was the development of civilization from its beginnings to the present day, shows Orpheus 'surrounded by people as uncultivated as the land they inhabit . . . whilst he, as a messenger from the gods, to whose mansions he seems to be pointing, is pouring forth songs of instruction'.[49]

The *Joseph of Arimathea* engraving suggests that Blake had not only an awareness of earlier masters, but an affinity, whether conscious or not at this stage, with some of the more adventurous artists practising in London. Even so, the engraving itself must also be regarded as, if not a copy, at least an imitation of an earlier artist. A comparison might be made with the *Imitation of Spenser* in his *Poetical Sketches*, in which, in a more sophisticated way, Blake expresses his dissatisfaction with the poetic tradition.[50] There are also a number of drawings by Blake, almost certainly of this early period, which are copies, but on occasions they contain intimations of personal feeling. A series of seven pen and wash drawings after a feeble set of engravings by Adamo Ghisi (see plate 4),[51] which themselves are derived at second hand from figures in Michelangelo's Sistine Chapel (British Museum), are of little interest except for one, copied from a seated figure beneath the Prophet Jeremiah on the Sistine ceiling, in which Blake has transformed the indeterminate expression of the Ghisi engraving into an intense and penetrating stare. It is captioned underneath in a tremulous hand 'The Reposing Traveller' (plate 5); suddenly one gets a glimpse of Blake's extraordinary mind desperately trying to cope with the mundaneness of copying.

The drawings after Ghisi show an almost complete lack of natural dexterity; despite his lofty ambitions as an artist, Blake in no way approaches in his drawing the verbal fluency he had already achieved in the *Poetical Sketches*, if some of them were written as early as claimed. Michelangelo at second and even third hand is the dominant influence and was to remain so. An oil painting, the only one ever to be convincingly ascribed to him, dated 1776 (Huntington Library),[52] after a figure from Michelangelo's *Last Judgement*, shares with the *Joseph of Arimathea* engraving the distorted calf muscles and hesitant outline of the feet, which together with the box-like and static torso suggest too little practice at life-drawing. On the other hand we can see in embryonic form many characteristics of his later art; the tendency to

isolate figures within their own space; the difficulty in achieving largeness of form and the lack of easy movement from one part of the body to another.

Two line drawings (British Museum) copied from engravings in the celebrated d'Hancarville edition of Sir William Hamilton's collection, first published 1766–7,[53] confirm Blake's interest in the latest artistic trends (see plate 6), for the illustrations of Hamilton's vases were decisive in the development of the severe linear style, which culminated in the line engravings of John Flaxman in the 1790s.[54] The vases were thought by connoisseurs to represent a more primitive phase of Greek art than had hitherto been fashionable and an interest in them, combined with a taste for Gothic art, completes the picture of the youthful Blake as especially receptive to Neoclassical taste.[55] He is also known to have had in his possession as an apprentice, Henry Fuseli's translation of Winckelmann's *Reflections on the Painting and Sculpture of the Greeks*, 1765,[56] the primary Neoclassical text. The small number of original designs which can be attributed to his apprentice period are, by contrast with the exercises, full of bravura and ambition. The dichotomy between the two can be seen most clearly in a sheet with a pen drawing of *The Second Vision of Ezekiel* (plate 7)[57] on the recto and a careful drawing of antique casts on the verso (Rosenwald Collection). The apocalyptic image of mankind's awakening to the Divine Light under the auspices of the Prophet looks forward to his later work, but the drawing is distressingly crude and flaccid. A watercolour and drawing, on the same sheet, of *The Sacrifice of Manoah* (Lady Melchett Collection) are hardly more impressive in technique but the subject again is an apocalyptic one depicting Samson's parents' recognition of the angelic messenger, who brings the news of the impending birth of their son, the Deliverer of Israel. The story of Manoah is told by Samson in the *Samson* meditation in the *Poetical Sketches*, and it is possible that the watercolour is connected with the text: in any case, it shows that Blake was already working towards common themes in both his art and his writing. In *Samson* Manoah meditates upon the oppression suffered by his people and prays fervently for deliverance, in terms which Blake implicitly compares with the sufferings of the English nation:

> *The sword was bright, while the ploughshare rusted, till hope grew feeble, and was ready to give place to doubting: then prayed Manoa—'O Lord thy flock is scattered on the hills! The wolf teareth them. Oppression stretches his rod over our land, our country is plowed with swords, and reaped in blood! . . . O when shall our Deliverer come?[58]*

In the *Poetical Sketches* many of the pictorial and poetic themes of his future career are already foreshadowed, although as yet in relatively conventional form. The personification of Winter in the poem *To Winter* is already the bleak vengeful northern god Blake was later to call Urizen:

> *I dare not lift mine eyes;*
> *For he hath rear'd his sceptre o'er the world.*
> *Lo! now the direful monster, whose skin clings*
> *To his strong bones, strides o'er the groaning rocks.[59]*

Gwin King of Norway tells of an ancient tyrant whose depredations cause his people

B

to rise up in bloody revolt against him under the leadership of Gordred, like Orc in the Prophetic Books of the 1790s, a symbol of revolutionary energy. It is the tyrants who are responsible for the bloodshed of revolution, not the oppressed:

O what have Kings to answer for,
Before that awful throne!
When thousand deaths for vengeance cry,
And ghosts accusing groan![60]

The redemptive vision of Blake's later work can also be clearly discerned; the personification of Spring in the poem *To Spring* is a Christ-like Redeemer:

issue forth,
And let thy holy feet visit our clime.
Come o'er the eastern hills, and let our winds
Kiss thy perfumed garments; let us taste
Thy morn and evening breath; scatter thy pearls
Upon our love-sick land that mourns for thee.[61]

In the *Couch of Death* death is seen as a release from the material world; the youth who feared death after hearing the voice of wisdom 'breathes out his soul with joy into eternity'. In the *Prologue to King John* a denunciation of the times is a prelude to a vision of national regeneration:

Beware, O Proud! thou shalt be humbled; thy cruel brow, thine iron heart is
smitten, though lingering Fate is slow. O yet may Albion smile again, and stretch
her peaceful arms, and raise her golden head, exultingly! Her citizens shall throng
about her gates, her mariners shall sing upon the sea, and myriads shall to her
temples crowd! Her sons shall joy as in the morning! Her daughters sing as to the
rising year![62]

On the evidence of the surviving works of the apprentice period, we can conclude that Blake had to an astonishing degree established the lines of his future development. The intense individuality of his mature work was not the consequence of a sudden revelation, but was the ripening of a seed planted in his earliest days. A profound anti-materialism pervaded his youthful productions, and he had already decided that his spiritual ambitions were to be fulfilled through the arts. The often conventional forms of his expression do not detract from this, for Blake had his eye more firmly set upon the ends than the means, and he had established that the form of his revelation should be both poetic and visual. Thus, even in his apprentice days, the Illuminated Books, uniting poetry and design, may be said to have had a notional existence.

Student and Independent Engraver

It is difficult to penetrate the obscurity of Blake's apprentice days, but with his entry into the Royal Academy in 1779 he emerges more clearly; he now became acquainted with more readily identifiable artistic figures and we begin to discern something like a Blake circle. Blake had won a place at the Academy, probably after submitting a drawing from casts and undergoing a probationary period before he was formally admitted on 8 October 1779, under the signature of the President, Sir Joshua Reynolds.[1] He was enrolled as an engraver,[2] but as engraving was apparently not taught at the school, this may have been an indication that he was not expected to serve his full term as a student. As a student he would normally have been entitled to use the drawing facilities for six years, but within one year he began executing engravings professionally after other artists, so he must either have dropped out of the Academy after a few months or perhaps retained only a casual connection for a few years. His career as an art student was, however, not unsuccessful, for he attracted the attention of some established artists, and formed long-standing friendships with John Flaxman and Thomas Stothard, who were amongst the ablest and most serious students at that notoriously rowdy establishment.[3] Yet he can hardly have been happy there; he claimed later to have formed a dislike both for Reynolds and for the Keeper G. M. Moser, and he resented drawing from the human figure, preferring to draw from the Antique, as Malkin relates:

> [he] *began a course of study at the Royal Academy, under the eye of Moser. Here he drew with great care, perhaps all, or certainly nearly all of the noble antique figures in various views. But now his peculiar notions began to intercept him in his career. He professes drawing from life always to have been hateful to him; and speaks of it as looking more like death, of smelling of mortality. Yet he still drew a good deal from life, both at the Academy and at home.*[4]

Some odd drawings by Blake from the antique may belong to this period,[5] and the only two life drawings which have survived (British Museum)[6] must date from his time at the Academy. In one, a male figure with arms raised seen from the back, the

drawing is careful and accurate, but without much sense of structure, and the use of parallel hatching betrays the practical engraver. The other, of a male figure looking towards the spectator, is more precisely characterized, and is usually thought to be of his brother Robert (plate 8),[7] but it is more likely to be of Blake himself posing before a mirror; once again the intensity of the gaze elevates the drawing above a mere exercise.

Two watercolour drawings by E. F. Burney (Royal Academy)[8] made in the year of Blake's entry into the Academy show the students at work in the Antique School amongst casts of approved antique sculptures and a small number of modern works (see plate 9). The atmosphere was informal, and students were evidently left on their own except for an occasional word of advice from the visitors, amongst whom in 1780 were James Barry and Richard Cosway, or the Keeper Moser, an intimate friend of Reynolds's. Moser was not an artist but a goldsmith by training, and when Blake entered the Academy he was seventy-four years of age. He seems to have been amiable and approachable, but his ideas belonged to a much earlier generation: 'His early society was composed of men whose names are well known in the world; such as Hogarth, Rysbrach, Roubiliac, Wills, Ellis, Vanderbank &c.'[9] Blake later reported a confrontation with Moser:

> *I was once looking over the Prints from Rafael & Michel Angelo in the Library of the Royal Academy Moser came to me & said You should not Study these old Hard, Stiff & Dry Unfinished Works of Art. Stay a little & I will shew you what you should Study He then went & took down Le Bruns & Rubens's Galleries How I did secretly rage. I also spoke my Mind. . . . I said to Moser, These things that you call Finished are not Even Begun how can they then be Finishd? The Man who does not know The Beginning never can know the End of Art.*[10]

This dialogue expresses neatly the gulf between the academicism of the founders of the Royal Academy and the Neoclassical tendencies of the younger artists who had been aware of the new currents of taste to emerge in Rome in the 1760s and 1770s. Artists like George Romney, whom Blake may have known through Flaxman, had found special qualities in Trecento and Quattrocento Italian frescoes as early as the 1770s, although such works were still generally regarded as barbaric and lacking in 'science' by academic writers.[11] The beginning of this shift in taste can be attributed largely to the influence of Winckelmann, and such ideas were particularly current in Rome.[12] Winckelmann had laid strong emphasis on the superior qualities of the earlier Greek sculptures, implicitly equating the virtuosity of the later classical period with artistic decadence.[13] The history of art adopted by Reynolds looked forward, roughly speaking, to unending progress and improvement; young artists were in the favourable position of being able to learn not only from Antiquity but from the great masters of the Renaissance. He advocated to his students at the Royal Academy an essentially eclectic approach, in which the most useful ideal was not Michelangelo but Lodovico Carracci, who had learned and assimilated the best styles of the past.[14] While Reynolds deplored the 'excesses' of Bernini, it was to the restrained Baroque favoured by the seventeenth-century academies that he looked, and it is on their

principles that he shaped the Royal Academy. But for artists brought up on Winckel-mann, and those writers like Seroux d'Agincourt[15] who applied his principles to the 'Moderns', the balance had shifted decisively away from the seventeenth century, which seemed comparable in its decadence to late Greek sculpture, towards the fore-runners of the High Renaissance, like Cimabue and Masaccio. Raphael and Michel-angelo still remained the touchstone for both sides of the argument, but it was their supposed simplicity and sincerity which appealed to the younger generation, while their monumental grandeur and representational accomplishment remained para-mount to the Academicians. The argument between Moser and Blake was not, however, just a matter of taste; their differences were more profound. Blake was advocating an art of single-minded intensity, Moser one of compromise and the recon-ciliation of styles. Furthermore there were strong moral, even political, considerations in Blake's denunciation of Moser's academicism; just as the sculptures of Periclean Athens were for Winckelmann a reflection of an uncorrupt and harmonious society, so the 'old Hard Stiff & Dry Unfinished Works of Art' represented for Blake a simpler, less corrupt age. The models advocated by Moser—Le Brun and Rubens—on the contrary, were blatantly exhibitionist and autocratic in tone; for Blake Le Brun and Rubens were the willing servants of tyranny, and Reynolds was their true heir.

Despite the difference in emphasis and attitude, Blake was undoubtedly inspired by the call to the Great Style in the *Discourses* which Reynolds delivered biennially to the students of the Royal Academy; but these lofty exhortations had not prevented the Academy exhibitions from being dominated by portrait, landscape and flower paintings. In the first half of the 1780s very few 'serious' subjects were offered to compete with the mass of landscapes and portraits on view. Benjamin West exhibited Biblical subjects every year from his enormous Royal commission to decorate the interior of St George's Chapel at Windsor,[16] but in 1785, for example, apart from William Beechey's *Witch of Endor*, and T. F. Rigaud's *Piety of Shem and Japheth*, West and Blake were alone in exhibiting Biblical subjects, and serious literary and poetical subjects were hardly more prominent. The Royal Academy was also seething with political intrigue, and the struggle for office and even the subjects of paintings often veiled ideological differences. Reynolds was well known as a government supporter and 'Patriot',[17] while Blake was fiercely pro-American from his earliest youth.[18] The foundation of the Royal Academy in 1768 had been resisted by many artists, and its early existence had been threatened by the not unjustified suspicion of Royal influence. John Hamilton Mortimer was President of the rival Society of Artists and held out against joining the Royal Academy until just before his death in 1779.[19] It is perhaps no coincidence that many of his subjects, although drawn from English and Roman history, could carry veiled references to the much-debated con-stitutional question of the limitations on Divine Right and the need of kings to govern with the consent of their subjects.[20] James Barry had produced in 1776 a satirical print applauding the new American republic,[21] and was a fierce radical; George Romney was to be an enthusiastic supporter of the French Revolution,[22] and Benjamin West, although he was employed by the King throughout the period, was

covertly sympathetic to his countrymen.[23] There was undoubtedly, therefore, in England in the 1770s and 1780s a certain connection among artists between Neo-classical idealism and political radicalism.[24]

Blake's first attempt to gain a reputation as a public artist was through designs from English history which he began before his apprenticeship was finished; according to Malkin he made two engravings 'as soon as he was out of his time' with Basire, 'after drawings which he had made in the holiday hours of his apprenticeship'.[25] One of these may well have been an early state of the large plate of *Edward and Elenor* (plate 10), published as late as 1793, but obviously designed at a much earlier date.[26] As an exercise in the sentimental-historical genre it may be compared to Angelica Kauffmann's version of the same subject, exhibited in the Royal Academy in 1776 and engraved by Ryland in 1780,[27] but it lacks Kauffmann's rococo fluidity and variation of light and texture, replacing them with a certain primitive severity. The main action is centralized, the background is shallow and the strong verticals created by the standing figures impart an air of gravity to the scene. The curious throne frames Eleanor's heroic action in sucking poison from her husband's wound and casts the attendant figures into the role of spectators who exhibit a gamut of reactions to the event. A close precedent for Blake's design is to be found in Mortimer's painting of *Vortigern and Rowena* (plate 11)[28] exhibited at the Royal Academy in 1779. Blake has clearly borrowed figures and groups from Mortimer's painting, and in both pictures there is a backcloth parallel to the picture plane and shallow space, while Rowena's selfless act is also observed by gesturing spectators. Blake's range of gesture is more limited and his grouping of figures less confident than Mortimer's, but this imparts to the engraving a greater primitivism, particularly in the way the heads in the left-hand group overlap like playing cards, which may be intentional. The spectators in Blake's composition are more obviously universal, encompassing different generations and physical types, and the boy with the sword observing the action recalls 'William' in the play-fragment *Edward III* in the *Poetical Sketches*.

Although the subject is taken from English history, the formal framework of the composition is redolent of the neo-Poussinism introduced to England by Gavin Hamilton and Benjamin West.[29] This type of composition was described by Flaxman in referring to a relief sculpture by Thomas Banks of exactly the same period and type: 'The basso-relievo of Caractacus before Claudius, is composed on the principle of those on the adjacent sarcophagi, of which many are to be seen in Rome and other parts of Europe; the subject is historical, but the characters are heroic, and a drama-tized gradation of passion is expressed in a few figures.'[30] Benjamin West also painted subjects from English history in this manner, and it is probable that Blake studied at the Royal Academy exhibitions his paintings of *Alfred the Third of Mercia with the daughters of William d'Albanac*, exhibited in 1778 but now known only from an engraving, and *King Alfred sharing his last loaf with a pilgrim*, exhibited in 1779.[31] The space in both paintings is shallow, and the disposition of the figures is friezelike, but the primitivism of Blake's design again points to a slightly later generation, which had absorbed the influence of Greek vase paintings and 'Gothic' art.

The *Edward and Elenor* engraving is one of the most finished of a large group of designs from the History of England, most of which probably date in original conception from about 1779–80, but with which Blake continued to tinker until possibly as late as 1793. In 1780 the Royal Academy exhibition accepted his watercolour of *The Death of Earl Godwin* (plate 13), which survives in the form of a small water-colour sketch (British Museum); this is either the version exhibited or a study for it. The composition is bold and quite unclassical as befits such a dramatic scene. The asymmetry of the motif and the mannerist figure of the boy looking backward over his shoulder at the corpse of Godwin suggest the influence of the extravagant designs of Henry Fuseli, which were then beginning to attract attention in England; the horrific motif of Godwin suddenly choking to death after swearing a false oath calls to mind Fuseli's grisly deathbed scenes such as *The Death of Cardinal Beaufort* of 1776.[32] The watercolour of *The Death of Earl Godwin* was commended in a review of the Royal Academy exhibition written by Blake's friend George Cumberland under the name of 'Candid' in *The Morning Chronicle and London Advertiser* for 27 May 1780: 'No. 315, the death of Earl Goodwin, by Mr. Blake; in which, though there is nothing to be said of the colouring, may be discovered a good design, and much character.'[33] Ironically, considering the poor quality of the work, this was virtually the only published criticism he was to receive for any of his Royal Academy exhibits.

The existing *Death of Earl Godwin* is one of a series of watercolours of English historical subjects, ten of which have now been identified. Blake may have intended to produce a series covering the history of England from its mythological beginnings with the landing of Brutus of Troy, and there must have been many more either contemplated or lost. The subjects for the most part are familiar among the work of contemporary painters and from Royal Academy exhibitions, but one can detect in some cases a sharp polemical edge.[34] *The Death of Earl Godwin*, *The Making of Magna Carta* (R. Essick Collection) and *The Penance of Jane Shore* (Sir Harry Verney Collection) could be taken to point to the cruelty of kings and the limitations of worldly power;[35] Godwin is struck down while challenging the divine power by taking a false oath; Magna Carta binds kings to a contract which can be enforced by their subjects, and Jane Shore is an innocent victim of the arbitrary cruelty of a royal tyrant. The subjects of *The Death of Earl Godwin* and *The Landing of Brutus* (Robert H. Taylor Collection) are, however, apparently unique to Blake, and their choice is illuminating. The sensational story of the death of Earl Godwin is in one sense typical of the kind of anecdote artists illustrated from such popular history books as Rapin's *History of England* and Leland's *Itineraria*, which told of astonishing events or examples of human nobility or sentiment. But the story of Earl Godwin differs in two important respects: it tells of the miraculous intervention of the Divine in human affairs; furthermore, doubt had been cast upon the authenticity of the story by eighteenth-century historians. Under the powerful influence of rational historians like Hume and Rapin (the principal source for the story) artists tended to choose incidents which at least had some documentary authority or the sanction of a historian; supernatural events were thus implicitly discredited. The story not only

was miraculous, but Rapin had pointed out that it was 'probably invented to blacken the memory of the Earl and his family'.[36] Blake, then, was making a deliberate gesture of defiance against the 'reasoning historians' and affirming his belief in miracles.

The Landing of Brutus is also, in a rational sense, a fictitious event; the story was first told by Geoffrey of Monmouth in the twelfth century[37] to explain the discovery and foundation of Britain in the mists of antiquity; it was, therefore, a 'monkish fabrication'. Brutus, the great-grandson of Aeneas of Troy, was said to have given his name to the island of Britain, defeating the giants who were the original inhabitants. The legend had been thoroughly discredited as history long before the eighteenth century, and relegated to a remote 'British Antiquity' or the mythical era before the landing of Caesar.[38] Milton, however, had recognized the value of British Antiquity to poets, and Blake's choice of such a subject shows not only a concern for poetic and mythological truth rather than historical fact, but also an affinity with poets, like Spenser and Milton, who had made use of British Antiquity and Arthurian legend.[39] There is also, perhaps, an element of defiance since the Society of Antiquaries, for which Blake had worked as an apprentice, assumed special responsibility for eradicating the errors perpetrated by the early chroniclers.[40]

Despite the small scale the handling of the History of England series is vigorous and bold, but Blake as yet does not have a complete grasp of pictorial structure; his shorthand is uneasy, and the extremities of the figures are hesitant. With exceptions Blake still clings to an essentially Neoclassical mode of composition. The two watercolours of *The Landing of Brutus* and *The Landing of Caesar* appear to be two halves of a single composition and they are processional in form, reflecting the influence of the reliefs on Trajan's column.[41] In *The Penance of Jane Shore* the heroine and the other main actors occupy the same foreground plane, but the soldiers behind her are reduced to a crowded group of heads. The scene is set in St Paul's Church, but there is no indication of medievalism other than vaguely Shakespearean costumes of the type favoured by Angelica Kauffmann. The colour in the series is rarely more than an afterthought, applied as a form of tinting to completed wash drawings.

If the small History of England series was an inauspicious start to Blake's career as a History painter, then a group of larger and more highly finished watercolours from English history show much greater promise. While their initial conception may date from the same period as the small series, they were probably executed a few years later. Unfortunately there is no evidence for dating them precisely and it would be hazardous to use them to chart Blake's development in the 1780s.[42] The large History of England watercolours were not apparently conceived as a series, but as independent paintings of episodes in which temporal power is arraigned against spiritual virtue, usually embodied in a suffering or sacrificial female.

The Penance of Jane Shore (Tate Gallery), the one theme repeated from the small series, illustrates the popular story of the innocent Jane Shore,[43] whose dignity in the face of humiliation at the instigation of Richard III won her universal respect. Blunt has suggested that Blake intended a protest against sexual hypocrisy, a theme which may equally be found in *The Ordeal of Queen Emma* (W. Brandt, Esq.); an accusa-

tion of adultery was levelled at the Queen by her son Edward the Confessor, but refuted through trial by ordeal (plate 14).[44] Although sexual hypocrisy was undoubtedly, in Blake's eyes, an instrument of tyranny, the unifying factor seems to be the power of true innocence to unmask its tormentors. Jane Shore's bearing proclaims her innocence, while the falsely accused Queen Emma is able, with divine aid, to endure her ordeal. *The Ordeal of Queen Emma* above all reveals the duplicity of Edward the Confessor, whose case was a critical one for eighteenth-century historians; he was pre-eminently the monarch who tried to sway the verdict of posterity by employing chroniclers to fabricate the myth of his unblemished reputation and thus conceal his true, bloodthirsty character. Mortimer had already painted a picture (now lost) of *Edward the Confessor despoiling his Mother* in a context which would suggest a reference to the contemporary British king, for such subjects could bear directly on constitutional issues at a time when George III was reasserting the principle of Divine Right.[45] Equally in the *Edward and Elenor* engraving Eleanor represents mercy and self-sacrifice, as opposed to the ruthlessness of her warrior-king husband: humanity is miraculously able to prevail against ruthless ambition.

The Ordeal of Queen Emma stands out amongst Blake's early work for the conscious Gothicizing of the setting and the figures. The ordeal had taken place in Westminster Abbey, of which Edward the Confessor built the first church, and Blake has provided a background of Gothic tracery, in itself not unusual in historical paintings of the period. He has also given the figures something of the rigidity of tomb effigies of the type to be found in the Abbey;[46] thus he has made a serious attempt to fit the style to the subject at the expense of naturalism. No such medievalism can be found in the large watercolour of *Edward III and the Black Prince* (Harold Macmillan Collection) except for the armour and some of the costumes. The strikingly elaborate helmet of a figure in the foreground could be Roman, while the background shows traces of classical pilasters, perhaps intended to suggest an association between military aggression and Roman ideals. The gestures, like those in *The Ordeal of Queen Emma*, are notable for their primitivistic angularity, which may here find its origin not so much in Gothic prototypes, but in the Greek vases which Blake had studied in d'Hancarville's edition of Sir William Hamilton's collection.

To judge from the surviving watercolours, Blake seems to have failed to impose a clear structure upon the different episodes from English history he depicted in the early 1780s, and it was not until 1793 that he made a last attempt to put them in order. In the Prospectus of 1793 he announced 'The History of England, a small book of Engravings. Price 3s.'; but no trace of such a work has been found. It is probable that a list in the *Notebook*, f. 116,[47] is connected with that attempt but it is heavily corrected, and Blake probably abandoned the task. The History of England designs are nevertheless important for the understanding of Blake's later work, for the history of England as the history of the latter-day Chosen People was to be subsumed in the Prophetic Books within the larger myth of man's redemption.

Blake's view of the history of England was a singular one, but its springs were in an antinomianism and political radicalism not unknown amongst his friends and

colleagues. Flaxman showed an early interest in religious dissent,[48] and in 1786 he joined the Theosophical Society,[49] from which grew the Swedenborgian Church, with Philip de Loutherbourg, the scene and landscape painter, and William Sharp the engraver. In this respect William Sharp was perhaps the most significant of Blake's acquaintances, for he drew together most clearly the threads of political radicalism and religious enthusiasm.[50] His involvement with the world was to be more direct than Blake's and his fanaticism more intense, for he progressed from active political radicalism to become a devoted follower of Richard Brothers and Joanna Southcott,[51] but the pattern of an engraver progressing from radicalism to apocalyptic religion is germane to an understanding of Blake. Other members of the group were Thomas Stothard[52] and George Cumberland, a contemporary of Flax-man's at the Royal Academy, who was to be a lifelong friend of Blake, but seems not to have aspired to be more than an amateur artist.[53]

The only direct glimpse remaining of the circle at work comes from an anonymous obituary of Flaxman of 1828, written perhaps by George Cumberland:

In early life he [Flaxman] was in the habit of frequently passing his evenings in drawing and designing in the company of that excellent painter Mr. Stothard, Mr. Blake the engraver (lately deceased), so remarkable for the eccentricity of his opinions and designs, Mr. George Cumberland and Mr. Sharp. The works of the two first-mentioned artists together with Mr. Flaxman's own, partake, although in different degrees, of the same character; which appears to be founded on the style of the very eminent English sculptor, Banks, whose basso-relievos, of 'Thetis and Achilles', and 'Caractacus' will furnish, to those who examine them, sufficient proofs of the validity of this supposition.[54]

The formal influence of Banks upon Blake has already been indicated, but the admiration of Blake's circle was evidently based on his unbending commitment to the Great Style combined with an open radicalism, which, at the time of the French Revolution, was to bring him close to imprisonment.[55] Banks's *Caractacus before Claudius* (Stowe School) had been finished in Italy in 1777, but was first exhibited in England at the Royal Academy in 1780 (plate 12). Caractacus extracted a pardon from the Emperor Claudius by making a speech of great nobility; he epitomizes, therefore, the power of eloquence and of righteousness to melt a tyrant's heart. The Romans are here depicted as conquerors, but the true heroes are ancient Britons, whose naked simplicity is allied with their moral purity while the Romans are concealed within a swathe of draperies. Blake's early watercolour of *Gregory the Great and the British Captives* (plate 15) (Victoria and Albert Museum) can be seen as a kind of homage to Banks's relief; the angelic simplicity and beauty of the British captives arouses the pity of the Papal tyrant, whose shapeless garb contrasts with the near-nakedness of the Britons. Whether or not because of his radicalism, Banks had suffered neglect by the established powers, and Cumberland in 1783, while disclaiming a personal acquaintanceship, claimed to have long felt 'pain for his obscurity'.[56]

An engraved broadsheet (plate 16) designed by Stothard and engraved by Sharp in 1782, dedicated to the Society for Constitutional Information,[57] confirms the radical-

ism of Blake's circle of friends, and is prophetic of his own use of Biblical imagery. The declaration of the rights of free citizens, which is the chief matter of the text, is supported by Biblical illustrations, which contrast the state as it exists with a state enjoying liberty; a scene of contented labour and rest illustrating *Micah*, iv, 4, is set against a scene of labourers under bondage from the Book of Joshua (ix, 23). A serpent is depicted symbolically and variously described: as a symbol of eternity; of wise government, because the serpent changes its skin every year; and as the body politic which is divided unequally between rich and poor.

Such, then, is the nearest we can get to a picture of Blake's artistic and intellectual life at the beginning of the 1780s, and it remains a very incomplete one, but a little more can be said of his work as engraver, which impinged upon his higher ambitions. Blake's evenings may have been spent in artistic improvement and discussion of serious matters, but his commercial engraving tied him to daily drudgery. As early as 1780 he was beginning to earn a living as a reproductive engraver, and in that year alone he may have produced five plates, two of them after Stothard.[58] He seems to have worked in partnership as Stothard's engraver of book illustrations, and up to 1785 he produced as many as thirty-three engravings from Stothard's designs. In the years 1782–3 he executed four plates in mezzotint for Thomas Macklin,[59] like Alderman Boydell a vigorous entrepreneur; but sadly he did not call enough attention to himself to gain regular work from these two publishers, so that, when they and Bowyer were offering lucrative engraving commissions in the next two decades for the various Galleries of engravings, Blake received virtually none.[60] He did make one plate for Boydell in 1788 after Hogarth's *Beggar's Opera* and another, which was apparently not published, for the Shakespeare Gallery, but essentially he failed to reach the forefront of his profession as William Sharp had done.[61] Flaxman said in 1784 that Blake's 'encouragement as an engraver was not extraordinary',[62] but he did at least have a steady stream of work throughout the 1780s. Qualitative judgements are difficult in such matters, but it is perhaps fair to say that he was amongst neither the best nor the worst of the reproductive engravers of the time. He could not aspire to the delicacy of tone of Sharp's best work, but he was certainly as competent as most of the engravers who worked on the Boydell Gallery. The reasons for his relative lack of success may lie within his personality, for he seems to have been habitually suspicious of his friends, who were slowly establishing themselves in the world as serious artists while he was forced to struggle with hack work. The ambivalence of his position as both imaginative artist and reproductive engraver is bitterly summed up by a later reminiscence of this early period: 'Flaxman cannot deny that one of the very first monuments he did, I gratuitously designed for him; at the same time he was blasting my character as an Artist to Macklin my employer, as Macklin told me at the time.'[63] Furthermore his reputation as an inventor would have hindered rather than helped him as a reproductive engraver, as he again realized: 'the lavish praise I have received from all Quarters for Invention and drawing has Generally been accompanied by this: "he can conceive but he cannot execute;" this Absurd assertion has done me & may still do me, the greatest mischief.'[64]

CHAPTER THREE

Painting and Prophecy

In the years 1783–4 Blake began to emerge as a man of accomplishment; he had achieved a reputation as a poet amongst a small circle of enthusiasts and in 1784 he exhibited again at the Royal Academy. John Flaxman was an active supporter at this time; he was probably partly responsible for the printing of the *Poetical Sketches* in 1783,[1] and also pushed Blake's reputation as an artist amongst his own influential friends. In June 1783 Flaxman wrote to his wife that he had persuaded a Mr Hawkins to commission Blake 'to make him a capital drawing for whose advantage in consideration of his great talents he seems desirous to employ his utmost interest'.[2] The 'capital drawing' is not identifiable if it survives, but in April 1784 Hawkins was apparently 'so convinced of his [Blake's] uncommon talents that he is now endeavouring to raise a subscription to send him to finish his studies in Rome'.[3] In the event Hawkins, being a younger son, was unable to raise the money, and Blake was never to set foot outside England, so we can only speculate on the effect a trip to Italy would have had upon his career. There are signs that Flaxman's art at this time was influenced by Blake, and there is further evidence that his friends thought he showed great promise both as poet and as artist. According to J. T. Smith, who knew Blake at this time, 'He was considered by Stothard and Flaxman with the highest admiration. These artists allowed him their utmost unqualified praise, and were ever anxious to recommend him and his productions to the patrons of the arts.'[4] In the previously cited letter to William Hayley, Blake's future patron, Flaxman commended Blake's *Poetical Sketches*, and noted that 'Mr Romney thinks his historical drawings rank with those of Ml.Angelo'. Romney's extravagant comparison should not be taken as more than conventional hyperbole, but it does lend credibility to Blake's repeated claims that he had enjoyed a great reputation as an artist in his youth. But the admiration of his contemporaries was already balanced by an element of condescension, which in the long run for Blake was to outweigh all their practical help. In the same letter Flaxman also pointed out Blake's lack of education: 'his education will plead sufficient excuse to your Liberal mind for the defects of his work & there are few so

able to distinguish & set a right value on the beauties as yourself', and he also revealed that 'he is at present employed as an engraver, in which his encouragement is not extraordinary.'

Blake, even by his friends, was fatally typecast, not as a gifted artist in the elevated manner, but as an engraver with unusual gifts. His uncertain social standing was compounded by his 'unbending deportment, or what his adherents are pleased to call his manly firmness of opinion, which certainly was not at all times considered pleasing by everyone'.[5] Smith describes Blake's appearance at the rather self-conscious 'conversaziones' given by the Rev. A. S. Mathew and his wife, who were also involved in the printing of the *Poetical Sketches*: 'There I have often heard him read and sing several of his poems. He was listened to by the company with profound silence, and allowed by most of the visitors to possess original and extraordinary merit.' But Blake's lack of social grace soon led to the curtailment of his visits. His conduct may be contrasted with the greater ease of Flaxman who, in return for the favours he had received from the Mathew family, 'decorated the back parlour of their home, which was their library, with models of figures in niches, in the Gothic manner'.[6]

The history of England was the major, although by no means the exclusive, source of both poetic and visual themes in Blake's work in the early 1780s, but by the middle of the decade Old Testament subjects began to predominate. The initial impulse seems to have been his work on illustrations after other artists for *The Protestants Family Bible*, 1781(?) and the *Royal Universal Family Bible*, 1780–82;[7] for the former he engraved three plates from the paintings in the Vatican Loggia by the Raphael studio, the so-called 'Raphael Bible', which were known in England through a set of weak engravings. The Loggia frescoes are no longer especially highly regarded but they were taken by English artists of the late eighteenth century, along with the Raphael Cartoons, to be the canonical depictions of Biblical subjects. The qualities admired in the Raphael Bible were defined by Stothard, who recommended copying the engravings despite their low quality:

> He (*the student*) *would see how simply Raphael told the story of his piece; yet what admirable judgement was displayed in bringing into order and harmony, into soberness, and, as it were, into perfect nature, even the supernatural conceptions of his own great mind. How much he showed the dependence of one figure upon another, in the incident, or, as it might be called, the argument of his picture. The graceful union that pervades the whole, whilst every part is varied according to the character, or circumstances that marks every individual scene.*[8]

Blake's finished watercolour (plate 17) of *Saul and the Witch of Endor* (New York Public Library), dated 1783, reflects a painstaking absorption of elements from his own engraving for *The Protestants Family Bible* after the rendering in the Loggia of *Abraham and the Three Angels*. The outstretched arms of the figures at the left of the watercolour reflect the gestures of the two foremost angels confronting Abraham, and Saul's attitude is based upon the kneeling figure of Abraham, but it is in the relationship of the figures that Blake's Raphaelism can be discerned. Instead of the

predominantly frieze-like composition of the English History watercolours, the figures overlap each other in a clear recession; the dominant figure of Saul is isolated from the other participants, who form a gracefully interrelated group. If one looks at contemporary renderings of similar subjects by Mortimer and Benjamin West (see plate 18),[9] then the sober restraint of Blake's version is all the more obvious. Raphaelesque sobriety also marks the watercolour of *Abraham and Isaac* (Boston Museum of Fine Arts), which bears a date of Feb. 1783 on the back in another hand; Abraham and Isaac form a static, pyramidal group in their embrace, and the dramatic form of the Angel of the Lord, which is well defined in the preliminary drawing (Philadelphia Museum of Art),[10] becomes an intangible mist in the watercolour.

Ironically, perhaps, the Raphaelism of these watercolours is most closely comparable, in everything but scale and medium, with Benjamin West's Biblical pictures for Windsor Castle, which were an annual feature of Royal Academy exhibitions from the late 1770s throughout the 1780s. The *Peter preaching at Pentecost* (Greenville, S.C., Bob Jones University), for example, exhibited in 1785 (plate 19), reflects the gravity and elevation of the Raphael Cartoons, which as King's Painter he would have had a special opportunity to study. There is no record of Blake's feelings about West at this time but one may conjecture that Blake felt equivocal towards him; West's seriousness as a History painter was not in doubt, but many of his paintings could have been regarded as tendentiously monarchical in sentiment. Blake could hardly have mistaken the political implications of West's massive series of wall-paintings commissioned by George III to vindicate his predecessor Edward III, whose aggressive ambitions were exposed by Blake in the *Poetical Sketches*.[11] Nor were West's Biblical paintings for St George's Chapel in Windsor devoid of political implications for someone of Blake's cast of mind; while they cannot be strictly described as monarchist, the bishops of the Established Church who approved the scheme[12] understandably excluded from illustration the texts from the Prophets and the Book of Revelation which had been traditionally cited by radicals to emphasize the limitation of kingly power. West's monumental painting of *Isaiah* (Greenville, S.C., Bob Jones University), for example, exhibited at the Royal Academy in 1784, depicts the prophet's reception of Divine prophecy from the seraph and not his curse upon the errant Kings of Israel. A drawing by Blake (plate 20), on the other hand, *The King of Babylon in Hell* (Windsor Castle), of *c.* 1783, depends upon a passage from Isaiah which is as hostile to kingship as any in the Bible; the King of Babylon is depicted being greeted in Hell by his royal predecessors, and the drawing is inscribed: 'Hell is moved for thee at thy coming—Isaiah.' The lines which follow in Isaiah could readily be taken to have a universal application: 'it stirreth up the dead for thee, even all the chief ones of the earth; it hath raised up from their thrones all the kings of the nations' (Isaiah, xiv, 9).

The King of Babylon in Hell is one of several drawings by Blake in pen and grey wash over a pencil underdrawing which can be dated to the first half of the 1780s. This technique is also used by Flaxman at the same period, but in a more consciously

classical and linear manner, while Blake's drawing is looser and less finished.[13] The subjects of Blake's wash drawings are predominantly Biblical or devotional, but they do not seem to constitute a single series. A number of Old Testament drawings may be loosely grouped together, but they are not consistent in degree of finish or in subject-matter and may have been made over a period of years. A number of studies exist for a work known as '*The Good Farmer*',[14] which could illustrate any of several Old Testament prophecies of the Messiah or references to such prophecies in the New Testament. In each version a Christ-like figure points to a flourishing wheat field, while another in the background is struck by Divine wrath, an image which Blake could have applied to his own time: his countrymen will reap the harvest they sow. A drawing known as *A Pastoral* (British Museum) appears to depict the pastoral peace which would follow the descent of the Messiah, and it is notable for the first appearance of the leitmotiv of the little boy lying down with the lamb. A drawing of a similar type (John J. Warrington Collection),[15] showing Job surrounded by his family, is also prophetic of a later Blake design for the *Book of Job*, and another, which may also be of Job (Miss Caroline Newton),[16] is close to it in style.

A further group of grey wash drawings, which may represent the beginnings of a series on the subject of death and the afterlife, have close spiritual affinities with eighteenth-century 'Churchyard' poems such as Robert Blair's *The Grave* and Edward Young's *Night Thoughts*, although they do not appear to illustrate directly passages from known works. *The Counsellor, King, Warrior, Mother and Child* (private collection, Scotland) (plate 21) has usually been taken as a study for the version engraved for the Cromek edition of *The Grave* published 1808 (see plates 115–19),[17] but in fact the corpses appear to be lying on a battlefield—and the black cloud contains the barely distinguishable figure of Death hurling darts. A drawing inscribed 'the spirit of a just man newly departed' (Windsor Castle) also looks forward to *The Death of the Good Old Man* (plate 119) in *The Grave* engravings, and a drawing of a *Young Woman reclining on a couch* (private collection) is redolent of the melancholy of imminent death, which may afflict even the young, pure and beautiful, as it did Young's 'daughter' Narcissa in the *Night Thoughts*. Slightly apart from this sorrowful group, though perhaps with a similar source, is a large early watercolour (plate 23) formerly known as 'The Pilgrimage of Christiana' from Bunyan (Tate Gallery).[18] A kind of school is represented in which children are working from books under angelic instruction, and a child is led in by her mother and greeted by an angelic figure. At the back a boy leans against the parapet, contemplating an enormous book bathed in heavenly radiance, while the instructor turns around in wonderment. The boy apparently sees beyond the confines of this world, closed in by the parapet, to the real book of life beyond; perhaps the watercolour is an allegory of the letter and the spirit.

All these designs are for unknown projects, possibly for engravings, or ideas for pictures to submit to the Royal Academy. In 1784 Blake exhibited there, according to the catalogue, two lost watercolours of '*A breach in a city, the morning after a battle*' and '*War unchained by an angel, Fire, Pestilence, and Famine following*'. The

general design of '*A breach in a city*' is known through later watercolours,[19] and a recently discovered drawing (dated June 1783 by another hand) may well be a preparatory study for '*War unchained*'[20] (Steigal Fine Art, Edinburgh) (plate 22). To the exhibited watercolours may be added another of *Pestilence* (R. Essick Collection, Los Angeles) (plate 24),[21] probably of this period, and the three may have formed part of a series of apocalyptic subjects projected at this time. The *Pestilence* design goes back to a small watercolour of the *Great Plague of London* (Steigal Fine Art, Edinburgh) from the English History series of *c.* 1779–80,[22] and the London context is still retained in the dress of the nightwatchman and the classical church in the background. The theme of 'A breach in a city' may also have originated in English History, for similar scenes are mentioned in a list of historical subjects, probably compiled in 1793, in the *Notebook.*[23] 'War unchained' is the most explicitly apocalyptic—the title comes from Revelation—and it may express Blake's sense of the impending wrath of God, as portended in the Plague of London in the seventeenth century and the cruel and materialistic strife of his contemporaries. In all three designs Divine wrath is visited upon an apparently prosperous city, and the classical buildings in *Pestilence* and the probable study for 'War unchained' carry implications of material pride, idol-worship and abstract reason.

The apocalyptic spirit of these works is a central theme in Blake's art; it finds open expression at certain points in his career, whereas at other times it is beneath the surface. A sense of impending doom is the other side of the prophetic vision, for the prophet's role is not only to tell of the Messiah but also of God's retribution for the sins of mankind, represented in Blake's time by the English Nation. This shadowy group of watercolours of *c.* 1784 can be seen, therefore, as a kind of intermediate stage between the imprecations against temporal power in some of the *Poetical Sketches* and the apocalyptic energy of the Prophecies of 1793 onwards. Many of the motifs evolved in his early years were used again by him in the 1790s, but liberated from the conventional artistic language, which diminishes much of the dramatic intensity in the early versions. This apocalyptic note is by no means unique to Blake in the public art of the period; indeed, to the casual observer at the Royal Academy of 1784, Blake's two watercolours of 'A breach in the city' and 'War unchained' must have seemed not dissimilar in spirit to another work on exhibition: Benjamin West's large drawing of *Death on a Pale Horse* (plate 25), from Revelation (dated 1783 and retouched in 1802; Royal Academy).[24] In a work which Blake must also have known, the *Elysium, or the State of final Retribution* panel in James Barry's great scheme at the Society of Arts, completed in 1783, are depicted the 'great and good men of all ages and nations', but in the right-hand corner, in the realm of Tartarus, personified figures of War, Tyranny and other evils are dragged down into the bottomless pit.[25] Also in the background to Blake's paintings was the large painting of *The Deluge* by Mauritius Lowe, exhibited at the Royal Academy in 1783 after the well-publicized intervention of Dr Johnson.[26] The painting was a huge composition of many figures in violent action, a forerunner of the kind of apocalyptic landscape in which John Martin specialized in the early nineteenth century. Un-

fortunately virtually all that is known of Mauritius Lowe is that he was another History painter of presumed genius to die in poverty and neglect.[27]

In 1784 Blake set himself up as a print-seller and publisher with his friend from the Basire workshop, James Parker, probably on the strength of money left to him by his father, who had died in July of that year.[28] His career as an entrepreneur began with the production, by Parker and himself, of two mezzotints after Stothard of *Zephyrus and Flora* (plate 26) and *Callisto*.[29] They were engraved by Blake, and are so close to the pair of prints he had made for Macklin in the previous year,[30] in their format and fey eroticism, that it can be assumed that he was trying to break into the same market. Despite their finely judged public appeal they had no success, and they remain the only concrete evidence of the activities of Parker and Blake; nevertheless, the partnership marked Blake's entry into the commercial world, from which he later claimed he was not to escape for another twenty years. In October 1804 he avowed that he 'was again enlightened with the light I enjoyed in my youth, which has for exactly twenty years been closed from me as by a door and by window-shutters'.[31] By becoming 'annoyed' in 1784 by 'that spectrous Fiend' of Commerce, he had no longer felt free to practise his art in his own way. His entry into 'Commerce' was intended to free him from drudgery, but in practice it had the opposite effect. From 1784 to 1787 he made no engravings for other publishers, presumably because he no longer sought such menial work. In the event he was soon forced back to reproductive engraving, but he never lost his taste for independence or his desire to act as his own publisher. Behind this ambition lay also a desire to reach a wider public than that which existed for History painting in the context of the Royal Academy. The decision stemmed not from a realization that he lacked monumental gifts as a painter, but from an incurable belief in his ability to make a fortune, if only he could, like Hogarth, eliminate the intermediaries between his work and the public; a belief which survived every demonstration to the contrary. In 1785 he made his last showing at the Royal Academy for fourteen years with a total of four water-colours, and from then until 1795 almost his whole output was in the form of prints and book illustrations.

An insight into Blake's mind in the years 1784–5 can be gleaned from the fragmentary manuscript known as *The Island in the Moon* (Cambridge, Fitzwilliam Museum),[32] in which he attempts a satire on contemporary attitudes. The manuscript has been exhaustively analysed by Erdman,[33] but it is possible to add to his account some perceptions which pertain to Blake's role as an artist at that time. Blake himself is heard in the voice of the ironically named Quid the Cynic, the central figure, whose lofty ambitions outrage the other participants: 'I think that Homer is bombast, & Shakespeare is too wild, & Milton has no feelings; they might be easily outdone';[34] when someone sings an Italian song he proclaims 'English genius', and in a revealing passage, which Blake deleted with his pen, we can see the alienated genius ill at ease in polite company perhaps of the kind which met in the Mathew's house: 'This Quid (cries out Miss Gittipin) always spoils good company in this manner & it's a shame.'[35] Suction the Epicurean is tentatively identified by Erdman

C

as Blake's younger brother Robert,[36] but he seems in fact to be the type of conventional painter whose ambition is confined to success in the annual Royal Academy exhibition. He takes to heart with unthinking literalness Reynolds' precepts about the value of hard work, and he reflects the philistine attitude of the Royal Academy towards 'philosophic' and serious art: 'If I don't knock them all up next year in the Exhibition, I'll be hanged', said Suction. 'Hang Philosophy! I would not give a farthing for it! Do all by your feelings, and never think at all about it. I'm hang'd if I don't get up tomorrow morning by four o'clock & work Sir Joshua.'[37]

The protagonists of *An Island in the Moon* should perhaps be seen as types of humanity rather than individuals, and the melancholy of Steelyard the Lawgiver may represent the consequence of too much immersion in such works as Hervey's *Meditations among the Tombs* and Young's *Night Thoughts*; excessive contemplation of mortality can lead to the sense of death as an end rather than a beginning: 'says Jerome, "Happiness is not for us, poor crawling reptiles of the earth. Talk of happiness & happiness! It's no such thing." '[38] The source of such a satire has been found in the dramatic farces of Isaac Foote,[39] but another type is represented by the satire on the Royal Academy, *The Royal Academy: Icarus, A Farce*, 1786, by Anthony Pasquin, in which the most famous artists of the day are lampooned under comical but easily recognizable names.[40]

In 1785 Blake made the last and most impressive showing of his early period at the Royal Academy exhibition, with as many as four watercolours (see plates 27, 28) of which three have survived: *The Story of Joseph* series (Cambridge, Fitzwilliam Museum),[41] but 'The Bard, from Gray' is lost, although it is commemorated in Blake's later versions of the subject.[42] *The Story of Joseph* watercolours are large and monumental, still within the Neoclassical mode of Benjamin West and James Barry. A comparison with West's large painting of *The Last Supper* (Windsor Castle), also in the 1785 exhibition, reveals how close Blake remained to West despite the differences in size and technique. In each case the Biblical drama is enacted by a small number of participants while spectators are shown reacting to the event in various ways, in the manner of the Raphael Cartoons. Blake's composition is more frieze-like than West's, and the large empty forms and the self-conscious reference to classical prototypes may owe more to the influence of James Barry. It is easy to see why Blake's watercolours made no obvious impact upon the public at the time, although they may have been sold.[43]

From the point of view of subject-matter their surface conventionality is deceptive, for the story of Joseph in Egypt is as full of implications for a prophetic artist as Samson in Gaza and Joseph of Arimathea in Glastonbury. In *Joseph's brethren bowing down before him* (plate 27), Joseph is seated amidst the trappings of power, receiving the homage of his brothers, who are as yet unaware of his identity; Joseph's distress is signified by the Niobe-like gesture with which he veils his face and by his upward-turning gaze. In the second, *Joseph ordering Simeon to be bound*, Joseph undergoes a severe mental struggle and takes Simeon as a hostage for Benjamin, his favourite brother, who had not accompanied the others; the latter show consternation at this

apparent cruelty, which they cannot comprehend. In the final design, *Joseph making himself known to his brethren* (plate 28), Joseph discloses his identity as Benjamin reaches forward to embrace him; the other brothers, however, appear more puzzled and apprehensive than joyous at the revelation. There can be no doubt that the story of Joseph is here intended as a spiritual allegory in which Egypt is the historical locus defined in the Bible, but also a paradigm of the state of materialism.[44] Joseph can be identified as a prophetic archetype, fulfilling the same role vis-à-vis the Egyptians as Samson in relation to the Philistines in the early prose-poem *Samson*. According to the Book of Genesis, Joseph's gift of prophecy was responsible for his sale into slavery, through the jealousy it aroused among his brethren. Once in captivity, the same gift is instrumental in Joseph's advancement, thereby creating a further moral dilemma, because the power vested in him by Pharaoh can only be enjoyed at the expense of concealing the true nature of his purpose. The prophet may thus be honoured by the forces of materialism so long as he denies his Divine mission.

Joseph may, therefore, exemplify both the spiritual projection of every artist's dilemma in a materialistic society and act as an expression of Blake's own problems as an artist at the time the watercolours were executed.[45] By 1785 he had achieved worldly success in the form of his contemporaries' esteem and a certain prosperity, but it was his artistic fancy that was admired, not his prophetic voice; in other words, his works were praised for the means employed in their execution and not for the redemptive end to which they were subservient. Similarly, Pharaoh had respected Joseph's predictive and interpretative skills without comprehending the larger power of which they were the instruments. The story of Joseph thus illuminates Blake's private feelings of artistic crisis at a critical point in his career, when he first became annoyed by the 'spectrous fiend' of commerce, which seemed to draw him away from the springs of his prophetic mission. Yet the uneasy incomprehension with which Joseph's brothers greet his revelation was,[46] for Blake, a reflection of the difficulties he himself would encounter when declaring his true intent. Significantly, only Benjamin can accept Joseph's pregnant disclosure; on one level he may refer to Blake's beloved younger brother, Robert,[47] but in the allegorical sense he represents uncorrupt youth, or the 'Young Men of the New Age'[48] who will understand Blake's prophetic mission.

The Story of Joseph watercolours represent the highpoint of Blake's Raphael-esque-classical style, in which the underlying emotional content is veiled by measured compositional rhythms and rhetorical gestures. The grouping of the bystanders still betrays a certain primitivism, which becomes even more marked in the *Job* and *Ezekiel* engravings (see plates 29, 30). The first state of the former dates from *c.* 1786 and the first realization of the latter is a finished drawing of about the same date (Philadelphia Museum of Art).[49] In the first state of the *Job* engraving the figures are still monumental, but the space is restricted, and a powerful effect is achieved by the huddled grouping, the gloom of the setting, and the accusatory grimaces of the comforters, as Job sits nobly apart in spirit, like a primitive patriarch. The emotion of the comforters is drawn entirely towards the suffering face of Job, who

inhabits a different order of pain and hope. The transition from the classicism of the *Joseph* watercolours becomes apparent when it is compared with its principal source: James Barry's engraving of *Job reproved by his friends* of 1777 (plate 3), in which separate groups are dispersed in a clearly defined recession but unified by strong compositional lines, creating a framework of balance and order. From a preliminary drawing by Blake (*Tate cat.* no. 5), in which Job sits in the middle between his wife and the comforters, it is clear that Blake had begun with a more measured composition, which evolved towards the concentrated effect of the engraving.

Job's isolation from the rest of humanity is mirrored by that of Ezekiel; they share a lonely faith in God, which is incomprehensible to their friends. Job looks only towards God for comfort, but Ezekiel, forbidden by God to mourn his wife, refuses to surrender to his grief: 'And the people said unto me, Wilt thou not tell us what these things are to us, that thou doest so?' (Ezekiel, xxiv, 19). The true prophet, because he is directed by a higher purpose, is forced into unconventional behaviour which calls down upon him the incomprehension and scorn of his countrymen. Ezekiel's separateness is emphasized by his strong verticality, which contrasts with the rigid horizontal of his dead wife and the compacted forms of the mourners.

The intensity of feeling in both designs conveys the sense of the civilization of the Old Testament, summed up in James Barry's description of the Jews as a 'metaphysical, abstracted, gloomy people',[50] and the effect is essentially Sublime in the Burkian sense. Edmund Burke in *A Philosophical Enquiry into the Origin of our Ideas of the Sublime and Beautiful*, 1757, had polarized the definitions of the Sublime and the Beautiful around two mutually exclusive concepts. The Sublime had qualities inimical to the clarity, rationality and elegance which made the Beautiful soothing to the senses; it could be ugly, frightening and disturbing, but nonetheless could excite pleasurable feelings of awe, terror and mystery. Burke's recognition of such emotions and effects helped to confirm the appreciation in the later eighteenth century of works of a predominantly non-classical kind. The horrific passages in *Paradise Lost* could be appreciated for their sublimity, and the Old Testament came into its own as an artistic model as well as a source of Divine truth. Burke had picked out the *Story of Job* as the prime example of the Sublime in all literature,[51] but he says almost nothing about the visual arts except to express his appreciation of Stonehenge. His notion of the Sublime, however, could easily be taken by painters as an encouragement towards painterly suggestion rather than clarity of form,[52] and he cites the passage in the *Book of Job* in which Eliphaz recounts his dream, to illustrate the proposition that 'A clear idea is therefore another name for a little idea.'[53]

Blake claimed to have read Burke on the Sublime in his earliest youth and to have disliked it intensely.[54] Whatever moral grounds Blake may have had for his disapproval of indefinite form, his training had been essentially classical, and his belief in clarity of expression and dislike of 'mystery' in all its guises was the central premise of his later artistic theory. Even so, the appeal of the idea of the Sublime was

irresistible not only to Blake but to many other artists of classical training. James Barry, for example, was both a direct protégé of Burke and a confirmed classicist, and something of a conflict can often be seen in his paintings.[55] In the large painting of *Lear and Cordelia* (plate 31) of 1784–7 (Tate Gallery), for example, the measured classicism of the composition is broken by the distracted, wild head of Lear, whose hair streams out as if blown by a gale as he strives to stave off madness. In the first states of the *Job* and *Ezekiel* prints Blake has striven to express concentrated emotion, but the figures are still conceived as solid volumes and are bounded by clear contours. This emotion is, however, restrained in moral as well as formal terms; Job and Ezekiel bear calamity with fortitude, for their feelings are also kept in check by their stoicism. One is reminded of Winckelmann's interpretation of the Hellenistic *Laocoön* group as an example of the greatness of the Greek soul facing horrific calamity with 'eine edle Einfalt und eine stille Grösse'.[56]

It is surprising, in view of Blake's later admiration for him, that so little of Fuseli's influence is discernible in Blake's first tentative adumbration of the Sublime in the mid-1780s. He could hardly have been unaware of the paintings Fuseli exhibited during this period at the Royal Academy, and he may have known him personally. Blake was apparently not yet ready for Fuseli's extremism, and there is little in Fuseli's paintings before the *Milton Gallery* of the early 1790s that might have persuaded Blake that he was a fellow-spirit; Blake's paintings of the 1780s are still moved by a gravity which he could find more readily in Barry and even in Benjamin West than in Fuseli.

Not all of Blake's few surviving works of 1785–6, however, are of 'elevated' subjects, and the large 'poetical' watercolour (plate 32) of *Oberon, Titania and Puck with fairies* (*Tate cat.* no. 4) might have some connection with Alderman Boydell's scheme to commission Shakespearean subjects from the 'best masters' for his *Shakespeare Gallery*, first mooted in 1786.[57] Blake had previously made a small series of roundels on Shakespearean subjects[58] (Boston Museum of Fine Arts), but these were little more than character heads heavily indebted to Mortimer's engravings of Shakespearean characters. Blake's *Midsummer Night's Dream* watercolour is fully realized and makes an interesting contrast to Fuseli's approximately contemporary paintings[59] from the same play for the Boydell *Shakespeare Gallery*. Blake's rendering is altogether more staid; Oberon and Titania are not differentiated in scale from the fairies, and the dance of the fairies seems measured and classical[60] compared with the crowded disorder and dramatic variations of Fuseli's compositions. If it can be assumed that the artists were responsible for the choice of subject then the contrast becomes even more revealing, for Fuseli has selected incidents which allow for a profusion of erotic and nightmarish suggestions, while Blake has chosen to place Puck in the centre of the stage in the final scene where he points out ironically the insubstantiality of vision:

If we shadows have offended,
Think but this, and all is mended,
That you have but slumbered here

while these visions did appear.
And this weak and idle theme,
No more yielding but a dream,
Gentles, do not reprehend;
if you pardon, we will mend.[61]

The watercolour is the first appearance in Blake's oeuvre of fairies,[62] who were to play an important role in the Illuminated Books. They appear later as spirits who rule over nature,[63] and the vegetative and butterfly-winged garlands worn by the dancing fairies in the present watercolour suggest that the idea already existed in Blake's mind.

Blake's early years are poorly documented; there are no early letters, no substantial contemporary accounts, and no way of knowing how much of his early work has been lost. The intentions behind much of the early work can only be conjectured, but of the seven watercolours exhibited at the Royal Academy up to 1785 three can be identified with certainty, and there are other versions of all the lost compositions. This fact confirms the continuity of Blake's vision. The hesitancy of execution and the stylistic conventionality of the early compositions often disguise an imaginative originality, which revealed itself when the motif was reworked in a more forceful manner. Blake was in the habit of returning to his early designs in later life, and it was their inventiveness rather than their execution which seems to have impressed his contemporaries. The evocative design *My Son! My Son!* in *The Gates of Paradise*, 1793, for example, in which a boy turns round to throw a spear at his aged and defeated father, is a reworking of a previous design possibly of *David and Absalom* (British Museum). The superiority of the later version is obvious, even though the original motif is retained. It is probable that most characteristic Blakean motifs were conceived during his early period, and there are enough early prototypes for his later designs to indicate that many others have been lost. This suggestion is supported by a sheet of studies by Flaxman after Blake, inscribed by him: 'J. Flaxman from memory of three drawings of Blake June 1792' (London, private collection).[64] Flaxman had left England for Italy in 1787, so they must be reminiscences, however vague, of earlier Blake compositions. The composition in the right-hand corner might be a garbled memory of *Joseph making himself known* (plate 28) from the *Story of Joseph* series, but the other two bear a greater resemblance to Blake's designs of his later period than anything known from before 1787. The motif in the left-hand corner seems to foreshadow *The Chaining of Orc* colour print of 1795, and the upper scene, an angelic group intervening in a scene of death, looks forward to designs in the Prophetic Book *America*. If Flaxman's memory is at all reliable there must have been early drawings by Blake which anticipated the imaginative freedom of the 1790s. Up to the year 1787, Blake sought to veil the prophetic meaning of his work behind a public style, but it was becoming clear that the personal intensity of his belief was beginning to force his art beyond the confines of the Royal Academy exhibition picture.

The Infernal Method

Illuminated Printing and Private Mythology

Robert Blake's death in February 1787 precipitated Blake into an emotional crisis, and Robert was to remain in his brother's thoughts for the rest of his life, making unexpected appearances in his letters and Prophetic Books. Gilchrist reports that Blake watched by Robert's bedside continually for the last fortnight until 'At the last solemn moment the visionary eyes beheld the released spirit ascend heavenward through the matter-of-fact ceiling, clapping its hands for joy'.[1] According to J. T. Smith, Robert appeared to his brother in spirit after his death and solved for him the problem of combining text and design:

Blake, after deeply perplexing himself as to the mode of accomplishing the publication of his illustrated songs, without their being subject to the expense of letter-press, his brother Robert stood before him in one of his visionary imaginations, and so decidedly directed him in the way in which he ought to proceed, that he immediately followed his advice. . . .'[2]

This confirms that Blake's experiments with illuminated printing were successful after February 1787, but there is some evidence of the more direct intervention of Robert's spirit.

Despite his very early death, probably at the age of nineteen, Robert had shown signs of an artistic personality quite distinct from that of his elder brother.[3] A number of Robert's drawings can be identified, and while they look superficially like naive versions of Blake's early style, they are decidedly untutored (see plate 34). Figures are often huddled together quite uninhibitedly, and the use of gradations of tone enables Robert to give expression to a sense of inchoate horror and a dreamy poeticism, uncharacteristic of his brother's early work. Even so, some motifs almost certainly of Robert's invention were to prove seminal to Blake. The huddling figures watching a nameless terror in *The Approach of Doom* drawing (British Museum) (plate 35), for example, anticipate the group of fiends in the engraving known as *War* or *Our end is come*;[4] William's beautiful watercolour design of *Oberon and Titania* (private collection, U.S.A.) and plate 5 of *The Song of Los* derive from a wash

drawing of two figures reclining in a flower, certainly by Robert himself, in the *Notebook*, but which in turn appears to go back to a design by Stothard (plate 33) published in 1781.[5]

The Approach of Doom drawing, for example, is full of foreboding as a group of elders look fearfully at an amorphous form in the distance. It is barely passable as a piece of drawing but William was deeply stirred by it: an engraving which he made from this design, almost certainly in 1787–8, exists in a unique, crudely printed impression (British Museum).[6] William has clarified the design and eliminated the intangible form but his main interest seems to have been in essaying different methods of engraving on the plate. If we read from the right-hand edge, we find that the first figures and the background are printed in white line, i.e. the outlines and hatching are printed as white, but the three central figures on the edge of the cliff are printed positively with the contours outlined in black. These three main figures, who stand tremulously on the shore, have clearly been printed in a stereotype process, in which the dark lines on the paper have been printed from the upstanding surface of the copper under light pressure, while the design on the rest of the plate has been printed from the surface of the copper rather than squeezed from the incised lines upon it. The experimental nature of the print is self-evident, and it would be difficult to explain why he should have kept such a messy piece of paper if it did not have some importance for him. It is almost certainly, therefore, a record of a stage in his discovery of relief printing, which he claimed later to have taken place in 1788,[7] and one can see why he should have connected this with the spirit of Robert, which survived in the drawings he left behind.

Before considering the use to which he put the stereotype process, it is worth looking at this step in a wider context. While the intervention of Robert's spirit may have later satisfied Blake as an explanation of his desire to experiment with the printing process, there were practical consequences which he hoped would follow from any success. By 1787 it must have been clear to him that he was not going to receive a share of the hoped-for bounty accruing to painters and engravers from the Boydell *Shakespeare Gallery* and other schemes proposed at the time.[8] His own attempts to set up a publishing business, Parker and Blake, had failed. Something drastic was needed, for if he were to be excluded from the patronage of Boydell, Bowyer and others, then his economic future as an engraver was bleak. Nor was he alone in his predicament. Another artist of genius, James Gillray, also working as a reproductive engraver, was placed in jeopardy by his failure to obtain work from Boydell. Gillray decided to abandon all alternatives to caricature, and this decision was signalled by the devastating satire of the *Shakespeare Gallery* of 20 June 1789 entitled *Shakespeare-Sacrificed-or-The Offering to Avarice*.[9] This issue was expressed with the utmost candour by the more successful Henry Fuseli in a letter to William Roscoe of 17 August 1790:

> *Not withstanding the success of my election at the Academy, and of the pictures which I have painted for the Shakespeare Gallery, my situation continues to be extremely precarious. I have been and am contributing to make the public drop*

their gold into purses not my own; and though I am, and probably shall be, fully employed for some time to come, the scheme is hastening with rapidity towards its conclusion. 'There are', says Mr West, 'but two ways of working successfully, that is, lastingly, in this country, for an artist,—the one is, to paint for the King; the other, to meditate a scheme of your own.' The first he has monopolised; in the second he is not idle: witness the prints from English history, and the late advertisement of allegorical prints to be published from his designs by Bartolozzi. In imitation of so great a man, I am determined to lay, hatch, and crack an egg for myself too, if I can. What it shall be, I am not yet ready to tell with certainty; but the sum of it is, a series of pictures for exhibition, *such as Boydell's and Macklin's.*[10]

Artists who had been favoured by Boydell were thus forced into conceiving 'schemes of their own', so all the more reason why one outside the circle should feel a special urgency.

In a way Blake showed an even greater shrewdness than Fuseli in conceiving a scheme involving a printing process; it was very well known at the time that any method capable of genuinely simplifying the manufacture of books and newspapers could ensure for its inventor not only wealth, but also unlimited access to a public platform. Blake was not alone in his search for a new method of stereotype printing,[11] for it had long been felt that the system of printing by movable type was both expensive and cumbersome and had the inevitable effect of putting the author at the mercy of the publisher or middleman, who as a man of commerce either might not wish to print his work or, if he did so, would deprive him of all profit. It was widely thought that, if a method could be found of writing directly on to a plate and running off thousands of copies of a text from it, then this would supersede letterpress altogether and secure the inventor's fortune; it would avoid the laborious business of setting up type, and the problem of dismantling it after the printing of each edition. The problem of retaining a page of type on a permanent plate did not present a great technical obstacle; as early as 1725 William Ged had printed experimentally from plates;[12] but the printing trade had resisted it, and it was only with the work of Alexander Tilloch that there was general acceptance of the stereotype printing process. Tilloch perfected his achievement in Glasgow in 1781–2, and in 1784 he took out a patent for 'printing books from plates instead of movable types'.[13] He moved to London in 1787 and became well known as a journalist. Blake certainly made his acquaintance at some time, for in 1797 he, James Basire and William Sharp were among the signatories of a testimonial on behalf of Tilloch, who wanted to apply his method to the printing of banknotes.[14]

The stereotype process for which Tilloch took out a patent in 1784 may have used plates, but it still depended upon ordinary typesetting in the production of the plate, although the testimonial which Blake signed for Tilloch suggests that he had also considered the problem of an engraved plate in producing specimen banknotes. Blake's stereotype process was based not on type but upon the written word and design upon the plate, but even here a current process was readily available to him.

One of the most common recipe books of the time, *Valuable Secrets Concerning Arts and Trades*, first translated from the French in 1758, and subsequently reprinted many times, gives a clear account of a stereotype process, so that the artist 'may thus engrave all sorts of works'. The method is simply to draw on the copper plate with a compound impervious to acid; upon immersion, the acid would eat away the rest of the copper 'so that the work may appear like a basso relievo'.[15] This is not completely straightforward because of the problem of underbiting, but there is a more fundamental disadvantage if it is used for writing as well as design; if one wrote directly on to the plate the lettering would come out in reverse, so the artist would either have to write in reverse or insert an intermediate stage in the process. As it happens, at approximately the same time, and conceivably with the help of Blake, George Cumberland was working on this problem in the pursuit of a method of engraving written text upon copper, with the half-serious expectation of making his fortune out of it.[16] He published an account of his method in Henry Maty's *New Review* in 1784, but he says nothing about the problem of reversal.[17] In the Cumberland correspondence, however, there is a letter of 3 January 1784 to his brother Richard,[18] in which Cumberland enclosed a specimen of his new printing. It is of a poem, 'To the Nightingale', and is both perfectly legible and printed the right way round. In the letter he discussed his solution, which differs from the method published in the *New Review*, for he seems to have taken impressions from the printed sheets while they were still wet from the press:

> the occasion of my writing to day is to send you the enclosed specimen of my new mode of printing—it is the amusement of an evening and is capable of printing 2000 if I wanted them. . . . All this would [paper torn] much if there were not one difficulty—a work thus printed can only be read with the help of a looking glass as the letters are reversed—I know that would be none to you or any one who reflects, and knows that Glasses are always at hand . . . however we have a remedy for this defect also for in printing 20 we can have 20 more right by only taking the impressions while wet—in fact this is only etching words instead of landscapes.[19]

Cumberland's brother was puzzled and wrote back asking for further details:

> I am impatient to know the method, which I perceive is upon the principles of etching, but cannot conceive how the ink is applied. . . . The poem is I find printed on the back of the page as one may say, but from your account I suppose duplicates may be taken off on any kind of paper if wet—so that one impression will be inverted and the other right but not so clear . . . could not a Man learn to right [sic] backwards as Compositors read?[20]

Unfortunately George's reply to this pertinent letter is not in the correspondence.

Blake is not mentioned in Cumberland's correspondence at this time, but that he knew of these experiments is virtually certain from what appears to be a satirical reference to Cumberland's experiments in the *Island in the Moon*, of late 1784–5, which captures something of Cumberland's bubbling enthusiasm for the new method:

[missing leaf] thus Illuminating the Manuscript'. 'Ay', said she, 'that would be excellent.' 'Then', said he, 'I would have all the writing Engraved instead of printed, & at every other leaf a high finished print—all in three volumes folio— & sell them a hundred pounds apiece. They would print off two thousand' 'Then' said she, 'whoever will not have them will be ignorant fools & will not deserve to live.'[21]

Blake in fact describes a format which is closer to the conventional separation of text and design than to his later Illuminated Books. Cumberland was also interested in the process of reproduction of drawings, and in November 1784 he was playing with aquatint with a view to adding illustrations to a collection of his poems.[22] Whether the extract from the *Island in the Moon* is aimed at Cumberland or is self-parody, it reveals beyond doubt that Blake was aware of the current experimentation in printing processes, and of its economic possibilities.

Blake, however, went beyond the processes described, and eventually solved the problem of reversal of lettering by producing a stereotype plate in which the design and lettering were integrated with the text in reverse on the plate. He probably did not normally do this by writing in reverse, although this has been thought to be the case.[23] We have no account of Blake at work upon his stereotype plates, but modern reconstructions of the process make it reasonably clear that he was able to transfer the image and lettering in reverse on to the plate by applying them initially to paper in gum arabic which would resist acid when applied from the paper to the surface of the copper plate.[24] Although this process is theoretically sound it is not easy, for it is hard to prevent the acid from underbiting the copper from the upraised forms, and it seems to have been difficult to transfer the text evenly from the paper to the copper plate. Above all, the process required care and devotion; it had grown out of a lone experiment by a single individual, and was only suitable for a person committed to both literature and design. Almost all surviving copies of his Illuminated Books show the direct intervention of his hand, either in strengthening and altering the drawing, or in adding colour, to the extent that the stereotype process must have had virtually no labour-saving merit at all. In many cases, particularly in the late printings, the printed surface has been colour-printed or so heavily gone over in pen and water-colour that it appears to have acted only as a guide to his hand, for hardly any of it remains visible. Although the impulse behind Blake's experimentation with printing processes was in keeping with the technological spirit of many late eighteenth century artists, his use of the discovery was more like that of a medieval manuscript illuminator.[25]

A preliminary attempt at a work combining text and design on separate pages is represented by the *Tiriel* manuscript (British Library), with which can be connected twelve finished sepia drawings now widely scattered.[26] As Bentley has pointed out, the horizontal format of these drawings makes them fit uncomfortably with the text,[27] but they would in this respect have conformed with many illustrated books of the period including Boydell's *Shakespeare Gallery*. The style of the drawings, many

of which are somewhat stiff in execution, would point to a date nearer the middle of the 1780s than the end, although they have been traditionally dated about 1790.[28] An earlier dating would fit in better with their structure, which would be hard to explain if they followed the *Songs of Innocence*. The *Tiriel* project, therefore, may be seen as transitional between the Biblical illustrations of 1785–6 and the invention of illuminated printing in 1788.

Tiriel is the murkiest and most Ossianic of Blake's works of prophecy. The central figure, the blind and deranged Tiriel, journeys through a bleak landscape in search of redemption. After his expulsion from his royal palace by vengeful sons, his wanderings are marked by stages which represent spiritual alternatives; the 'vales of Har', which he enters briefly but from which he recoils, stand for the state of Innocence which shuns the necessity of Experience; his confrontation with Ijim the giant, who carries Tiriel back to the palace, where he curses the sons who have expelled him, may represent a life based upon vengeance, and his final return to the 'vales of Har', where he dies at the feet of his parents, Har and Heva, probably signifies his redemption in death.[29] Such a bald account, however, does scant justice to the complexity of the work, with its confusing kinship patterns—the participants are all interrelated— and the variety of themes, many of which are tentatively adumbrated. This may well be partly due to the unfinished nature of the surviving manuscript, which is at a less developed stage than the drawings.

Although the twelve drawings are uniform in finish they are not uniform in style, a variation probably attributable to a difference in function rather than date, although some could have been executed later than the main group. The drawings fall readily into two groups; nine are strongly rectilinear in structure and angular in form, but three are different in character: the figures are more monumental and sensual, and depict Har and Heva (the parents of Tiriel) and Mnetha (the grandmother and muse) from the 'vales of Har' episode; they also share a less literal relationship with the text than the majority of the drawings. This group presages the early Illuminated Books, *Songs of Innocence* and the *Book of Thel*, both of which are meditations upon the theme of Innocence, while the literal renderings of the other nine are more closely allied with the conventions of History painting. The 'vales of Har' represent a lyrical antithesis to the horrors of Tiriel's existence. They are populated by Har, Heva and Mnetha, who inhabit an earthly paradise, where their refusal to face the world of Experience has petrified them in a state of puerile senility, and their withdrawal from reality has been responsible in some undefined way for Tiriel's ghastly fate. There can be no doubt that they represent allegorically the arts of painting, poetry and music, dissipated in trivial pursuits, and the account of the 'vales of Har' is full of images of both sensuality and mental captivity. The trio are depicted as idle and languid, and Heva's rich garment, which strikes an unexpectedly vivid note in the designs, must be a reference to the futility of art reduced to mere ornament. Tiriel's eventual decision to leave the 'vales of Har' is a recognition that man's and the artist's journey to redemption is a painful one and does not end in delectation: 'My journey is o'er rocks and mountains, not in pleasant vales.'[30]

Tiriel is able to see that the 'vales of Har' have now become a spiritual prison for their inhabitants, one which 'breeds pestilence'; Har sings 'in the great cage', and their days are spent not in mental struggle, but in catching birds and gathering ripe cherries.

The drawing (plate 37) of *Har and Heva bathing, Mnetha looking on* (Cambridge, Fitzwilliam Museum) does not correspond to any passage in the text, but depicts most completely the sensual delight of life in the 'vales of Har'. Har and Heva embrace, their faces pressed together, while the attenuated form of Mnetha looks on.[31] Despite their age, the females are imprisoned in eternal youth, and they abandon themselves to 'soft sexual delusions'. The 'vales of Har' are, in a sense, a prefiguration of what Blake later calls the state of Beulah, where man can seek a respite from the rigours of spiritual strife but at the same time is a prey to complacency. *Har and Heva asleep, watched over by Mnetha* (private collection) also depicts life in the vales, with the arts shown in a state of peaceful slumber, in a manner curiously reminiscent of sixteenth-century Franco-Flemish paintings of the arts sleeping in time of war.[32] The third drawing of this group has been lost since the early 1860s but its character is apparent from W. M. Rossetti's description: 'An ancient man blessing or advising a damsel, an elderly woman by his side: all three kneeling on a bed. . . . The damsel, whose back is turned, is robed in a richly-patterned dress, unusual with Blake.'[33]

The illustrations depicting Tiriel's wanderings have, by contrast, a rigidity and spareness which contrasts with the declamatory speech and often violent overflow of feeling in the text. In illustration I, for example, of *Tiriel supporting Myratana* (Mellon Collection) (plate 36), Tiriel is depicted in the act of cursing his sons, at the same time supporting his dead wife, whose death he blames upon their usurpation; but the blood-curdling oath of the text is not reflected in the pictorial language. The design is related to the text by conflating the actions attendant upon the curse, including the contemptuous reply by his eldest son, who wears his crown. In the drawing for chapter 5, *Tiriel denouncing his four sons and five daughters* (private collection), Blake avoids the most dramatic incident in the chapter, the slaughter of the sons and daughters, in favour of a moment of relative calm. The terror of Tiriel's children at the curse is contained by the formality of their group, but the text evokes their fate with all the apocalyptic horror of the later Prophetic Books:

> *In haste they fled, while all the sons and daughters of Tiriel,*
> *Chain'd in thick darkness, utter'd cries of mourning all the night;*
> *And in the morning, Lo! an hundred men in ghastly death!*
> *The four daughters stretch'd on the marble pavement, silent all,*
> *fall'n by the pestilence![34]*

In the drawing we see only the human reactions of the children to the prospect of their destruction, and not the physical effect of the destruction upon them.

The relative restraint of the *Tiriel* illustrations is a function not only of pictorial structure and expression, but also of an exclusive concentration upon the human figure as a means of expression. Landscape or setting is purely subordinate, and does no

more than reflect the atmosphere or lend symbolic support to the theme, as, for example, in illustration I, where the plain behind conveys a sense of barrenness, and the pyramids suggest an 'Egyptian' tyranny. In the period following the *Tiriel* drawings Blake was to extend the range and expression of the subordinate elements. If one compares the first state of the *Job* engraving of *c.* 1786 with the final state of 1793 (plate 29),[35] in the latter the use of light and the more fervent depiction of emotion reflect the torment within Job's mind. In the first state the emphasis is upon Job's restraint; he directs a stoic gaze towards heaven, but in the second state tears roll down his face. The neutral background of trees has now been enlivened by lightning flashes, which nervously accent the forms; the ponderous forms of Job and his comforters now become jagged and animated. Job has been transformed from a Laocoön bearing his terrible fate with antique fortitude into a Lear to whom the very heavens respond in anguish. A comparison between the drawing of *Tiriel denouncing his four sons and five daughters* and an untitled drawing of a different subject using the same design (Manchester, Whitworth Art Gallery)[36] of *c.* 1790–3 also reveals to what extent Blake had, by that date, abandoned the compromising style of the later 1780s. In every respect the later drawing has a greater tautness and intensity, epitomized by the contrast between the timidly crouching daughter in the *Tiriel* drawing and her anguished Rodinesque counterpart in the later drawing.

While the *Tiriel* drawings lack the intensity of Blake's later work, they are by no means artless; he is still capable of using Neoclassical conventions for expressive effect. In *Tiriel supporting Myratana* (plate 36) Blake contrasts the rigidity of the immense columns of Tiriel's palace of Reason with his physical frailty, to underline the reality of his waning power in the face of his virile usurping sons. In *Tiriel leaving Har and Heva* (Robert Essick Collection), the rigidity and isolation of Tiriel is contrasted with the sensual, protective warmth of Har and Heva. Tiriel's stiff-necked isolation pervades the drawings as a whole, by way of contrast with his father Har, whose rounded form reflects his sensual existence. The *Tiriel* drawings can be seen in terms of insistent polarities: the stiffness of Tiriel compared to the softness of Har; the isolation of Tiriel with Har's need to cling to his female counterpart, and the contrast between curvilinear and rectilinear forms associated with the male and female principles. The two 'contrary states of the Human soul' are already foreshadowed in the contrast between the grim landscape of Tiriel's journey and the beguiling 'vales of Har'.

The final two drawings show the journey of Tiriel with his daughter Hela, culminating in his death at her feet. Hela may represent true art which confronts reality, and she seems to contribute to his apparent redemption in death in the final illustration, *Tiriel dead before Hela* (collection unknown).[37] He lies outstretched at her feet, but the wood behind is filled with fruitful vines which almost sprout from his prostrate form. The vine may be here a reference to the prophecy of the Messiah in the Old Testament and to Christ, who described Himself as the vine and the faithful as the fruit.[38] Tiriel has already declared, in his dying monologue, the error of his life and asks 'Why is one law given to the lion & the patient Ox?'[39] His realiza-

tion that his 'paradise is fallen' enables him, in a paradox subsequently used by Blake, to proceed to his eternal salvation; through death he enters into universal life.

This redemption may be implied in Tiriel's closing speech, and Blake's use of the vine as a symbol contains intimations of a style in which natural forms play a subtly allusive role in relation to the text. But in *Tiriel* text and design still essentially inhabit their own worlds, and the character of the illustrations serves to reinforce the narrative aspect of the poem without drawing the reader to deeper meanings beneath the surface. Blake's predicament can be illustrated by a sketchy pencil drawing which Keynes has convincingly suggested might be associated with Tiriel's final speech of self-realization (C. Ryskamp Collection),[40] where his new awareness is expressed in aphoristic images. Blake's drawing appears to illustrate the rhetorical question: 'Why is one law given to the lion & the patient Ox?', an ox and a lion are shown co-existing peaceably under the domination of a figure resembling either Tiriel or Har;[41] a male youth reading a book reclines upon the lion, while the ox is attended by a young female holding a lyre. The direct allegory distinguishes it in kind from the finished *Tiriel* illustrations, although there are other precedents among Blake's work; the large drawing of a *Pastoral Scene*, c. 1780–5 (British Museum), in which the pastoral idyll is symbolized by a little boy lying upon a sleeping lamb while a cow and a dog exchange a kiss; and the sheet of doodles on the back of the *Island in the Moon* manuscript of c. 1784–5 in which a lamb nestles into the side of a resting lion.[42] The origin of such imagery is in Old Testament prophecy, and it receives its definitive expression in Blake's work in the form of the two children playing with the sleeping ram in plate 7 of *America*. The domination of the two animals by either Tiriel or Har in the Ryskamp drawing carries, however, the suggestion of a false paradise: a docile peace which allows the tyrant to thrive; and a similar suggestion may also be found in the *America* plate. What is significant at this point, however, is that Blake was apparently experimenting in this symbolic mode while still working upon *Tiriel*, and out of his dissatisfaction with his artistic vocabulary were to come dramatic changes in the use of imagery.

It is possible to piece together the remains of an abortive series showing man's early life on earth, almost certainly begun at this time. The purpose for which they were conceived is totally unknown, but the fact that some are in watercolour tends to suggest they were not done for engraving. A clue to their relationship is given in two recently discovered drawings (British Museum), which if they are joined together form an incomplete series of roughly-drawn scenes,[43] two of which seem to correspond with drawings of *God appearing to Adam and Eve* and a *Couple warming themselves by a fire* (both British Museum). The rough verso drawings show that Blake had in mind a series showing the Fall of Man and its aftermath; the Tree of the Knowledge of Good and Evil can be identified, as well as Adam and Eve sleeping in a position which is again adopted for the famous *Paradise Lost* illustration of 1808. The bleakness of the early Fallen world is revealed in a scene of murder, and the couple warming themselves follows a drawing of the discovery of fire presumably by Prometheus. On this basis some other drawings may be added to this series. A

charming watercolour in the Fogg Museum of a priestly figure receiving obeisance from a youth and a girl undoubtedly shows the submission of mankind to priesthood; thus it foreshadows a common motif in Blake, seen in its clearest form in the *Garden of Love* (see plate 74) in *Songs of Experience*, and in *The Angel of the Divine Presence clothing Adam and Eve in coats of skins* (Cambridge, Fitzwilliam Museum).[44] In the Fogg watercolour priestly authority is emphasized by the symmetry of the composition and the sense of enclosure created by the primitive architecture, which literally emerges from nature. The same children are apparently depicted in *Age teaching youth* (Tate Gallery),[45] and here again a contrast is posed between the academic knowledge imposed by the old man and the girl's desire for the Eternal world expressed in her upward-pointing finger; the shading trees and fence behind suggest a learning which restricts rather than reveals.

If these drawings and watercolours are to be dated about the period of *Tiriel* or more probably a little later, then they suggest that before the end of the 1780s Blake was advancing towards some kind of syncretic myth. The hesitancy of their realization confirms that, as in *Tiriel*, he had not found the form for his growing sense of vision; but latent in these series is the energy which was to marry his cosmic vision with a proper means for its expression.

Swedenborg and Swedenborgianism

Blake was consistently hostile to institutional religion, but around the years 1788–9 he became closely associated with the Swedenborgian New Church. He is not re-corded as a member but he and his wife can reasonably be identified as the 'W. and C. Blake' who attended the first general conference on 17 April 1789,[1] designed to bring together sympathizers from all over England, Sweden and America, and who signed the articles of belief. In fact, on the basis of very slender evidence he seems to have been a late convert to Swedenborgianism in his circle; both Flaxman and William Sharp had joined the New Jerusalem Church's forerunner, the Theo-sophical Society, in 1784,[2] and it is, therefore, reasonably certain that Blake was well aware of its problems. Blake's relationship with the Swedenborgians was complex, for he seems to have become rapidly disillusioned with the Church itself, but, despite the satirical assault upon Swedenborg in the *Marriage of Heaven and Hell*, he never quite detached himself in spirit from it. According to Henry Crabb Robinson, he was converted by the evangelizing minister of the New Church, the Rev. Joseph Proud,[3] and he remained a lifelong friend of the son of a founder member, John Augustus Tulk.[4]

Before considering the effect of Swedenborgianism upon Blake it is necessary to make a distinction between the writings of Swedenborg himself and the doctrine derived from them by his English followers after his death in 1772. His own writings were essentially visionary and it was through his conversations with 'angels', so admirably parodied by Blake in *The Marriage of Heaven and Hell*, that he asserted the primacy of the spiritual world; but he applied to his visions the systematizing logic of a Natural Philosopher and produced, in an immense number of volumes, a morphology of the spiritual truths concealed within the words of the Bible.[5] From this exegetical corpus the English Swedenborgians extracted their doctrine, which they promulgated in a simplified form.

Robert Hindmarsh, one of the founders of the New Jerusalem Church in London, claimed to have been led to Swedenborg's writings by his puzzlement over the

D

conventional account of the nature of the Trinity. He concluded that there was only one Divine Person and 'that the Lord Jesus Christ is that God'.[6] Christ was identified by Hindmarsh as 'One God in One Divine Humanity', a belief that was to become central to Blake's thought, expressed in his idea of Christ as man's true humanity or 'Eternal Humanity Divine'.[7] Hindmarsh claimed this conception of the Godhead to be one of only two fundamentals of the Swedenborgian doctrine, the other being that faith was to be conjoined with the good life. In this sense, then, Blake remained a Swedenborgian all his life despite his strong reservations about Swedenborg himself and his writings.

Many of Swedenborg's own writings came into Blake's hands during his period of spiritual ferment after the death of Robert.[8] Swedenborg's doctrine of Correspondences was of particular interest for the formulation of his artistic ideas, but in practice it is difficult to separate the direct influence of Swedenborg from the other idealist notions which Blake had absorbed from his earliest youth. Indeed the theory of Correspondences was in a certain sense compatible with the idealism of academic theory, which proclaimed, in Reynolds's words, an art of 'ideal beauty, superior to what is to be found in individual nature'.[9] Thus both Swedenborg and Reynolds posit an ideal world of forms to which all terrestrial matter corresponds, however imperfectly, and just as for Reynolds this ideal world is the true realm of the artist, so for Swedenborg it is where the truly spiritual man finds his mental abode. They differ, however, in their conception of the nature of the forms of this ideal world. For Reynolds the oak as it appears in the forest finds its ideal existence in the 'Central Form' of the oak, which is its perfect form in the ideal world.[10] For Swedenborg, on the other hand, the ideal form of the oak is its allegorical existence, which resides in the attribute of strength or fortitude; thus the abstract qualities attached to mundane objects are not secondary characteristics but form part of their essential nature. For Swedenborg the purpose of art as apprehended by the ancients, who possessed knowledge of these correspondences, was not to glorify the visible manifestations but 'to call to mind the heavenly things which they signified.'[11] Thus the Egyptians made images of calves and oxen to represent the affections and powers of the natural man; of serpents to represent 'the prudence and subtlety of sensual man'; of children to represent 'innocence and charity'; of old men, 'wisdom', etc. Natural objects are, therefore, a kind of veil, behind which true spiritual meaning is concealed, and works of art, in their purest form, were plastic dispositions of eternal concepts.

Swedenborg's main concern, however, was not with art, but with the Bible as the repository of spiritual truth, in which historical events acted as spiritual allegories. Thus he drew a distinction between the literal sense of the Bible and its internal sense, which could be reached, not by exegesis and deduction, but only by direct revelation to men who were inspired.[12] The literal sense of the Bible was open to the 'natural man', even if he could not understand it, but the spiritual sense was correspondingly concealed. Swedenborg's commentaries on the Bible, therefore, had the purpose of revealing the internal sense, to which as a divinely inspired man he had access, to the 'natural man'. According to Swedenborg, the Bible's ostensible

opacity of meaning was deliberate and gave Divine protection, for the spiritual truths were concealed in order that those 'who from their religion are in falsities' could not pervert the Bible, for they would not know how to alter or destroy the spirit behind the letter.[13]

In a sense all artistic and literary allegory stems from the idea that images in this world can represent eternal truths, which by definition are concealed from mundane perceptions.[14] Thus the effect of Swedenborg upon Blake's art is not to be measured in terms of direct influence, but must be seen as part of the clarification in Blake's mind of the spiritual role of art itself. Many of the notions isolated in Swedenborg's doctrine of Correspondences either were, or were to become, central to Blake's mature work. It is evident, for example, that Blake's later illustrations to the Bible contain implicit allegories even if it is not easy to discern them in every case.

Blake had been familiar from his earliest years with the underground current of Platonic idealism through his acquaintance with the writings of Jacob Böhme,[15] but Swedenborg provided a more systematic account of the way in which images can actually reflect the forms of the Divine. The 'doctrine of the two worlds' was inherited by Christianity from Plato, but it is a Neo-Platonic idea that man can reach the Eternal world through imagery as well as through the scriptures. Egyptian hieroglyphics, based on natural forms, were also a medium of expression for the Divine will. Swedenborg believed that the Egyptians, like other ancient peoples, had access to the sacred wisdom of the Correspondences through hieroglyphics,[16] which remained a mystery to all but the divinely inspired. Swedenborg and Blake agreed that the Egyptians misused the ancient wisdom; the former saw this misuse as ending in a belief in magic and the latter in the worship of the material world, but also agreeing that their images became idols instead of intermediaries between this world and the next. This process of transformation is described by Swedenborg: 'Their posterity, when the knowledge of correspondences was forgotten, began to worship as holy, and at length as deities, the images and emblems set up by the ancients, because they found them in and about their temples.'[17] According to Swedenborg the source of this ancient wisdom was the antediluvian sage Enoch, who had gathered correspondences from the lips of angels, and transmitted them through the Asian kingdoms, whence they arrived finally in Greece.[18] The form of Biblical exegesis practised by Swedenborg is in fact as old as the Church Fathers,[19] and his notion of the two levels of interpretation places him within the same tradition, which is itself Neo-Platonic, although three or four levels were more common. Equally the problem of God's communication with man in the Bible had exercised the Christian Neo-Platonists, and Pseudo-Dionysius the Areopagite had argued that the difficulties and even grotesqueries of the Bible were designed to prevent the identification of the heavenly beings as 'real', and thus lead man further up the ladder to the Divine, and beyond the idolatry of abstract concepts or, even worse, of images.[20]

The effect of such ideas will be explored in the consideration of Blake's art, but it is perhaps worth reiterating the difficulties of isolating Swedenborg's influence, particularly in view of his oft-repeated doubts about Swedenborg's sincerity. On the

other hand, they were arguing from, as it were, the same side of the Neo-Platonic fence, and there can be no doubt that Blake continued to be aware of him.[21] If Böhme had given Imagination the central role in the apprehension of the Divine, then a careful reading of Swedenborg could yield as great an emphasis upon the Imagination. Whatever Blake's reservations about the authenticity of Swedenborg's spirituality, his categories coloured Blake's own for the rest of his life, and Swedenborg's writings, particularly at the end of the 1780s, were the most accessible repository of Christian Platonic ideas.

Blake evidently did not long retain a formal attachment to the New Church, and *The Marriage of Heaven and Hell*, begun in 1790, marks his final disaffection from it. This may have been due less to a disillusionment with Swedenborg's ideas than to the growing institutionalization of the New Church itself. About 1788 Blake had written that 'The Whole of the New Church is in the Active Life & not in Ceremonies at all',[22] but on the 27 January 1788 the first chapel was opened, and the meeting which Blake and his wife may have attended on 17 April 1789 was a conference to gather together the faithful from the old and new worlds; the New Church was becoming like the Old Church, and at that point Blake apparently took his leave.

The Three Tracts
There is no Natural Religion, series *a* and *b*, and *All Religions are One*

The first application of Blake's method of stereotype printing was disarmingly modest and tentative, taking the form of three tiny philosophical tracts, which he did not publish nor even bind together. It has been necessary to reconstruct 'ideal' copies, because all the originals are either incomplete or bound in the wrong sequence.[1] There is some evidence also that the surviving leaves of the tracts were printed later by Blake,[2] and the only other sign of his subsequent interest seems to be that he apparently gave to Linnell the one near-complete copy of *All Religions are One*.[3] There are two *There is no Natural Religion* series, both incomplete; series *a* lacks a title-page—the title usually given to it is almost certainly incorrect[4]—and ends inconclusively on the sixth proposition; series *b* lacks plate 5 (Proposition III)[5] and perhaps an 'Argument' page. Without Blake's additions in pen and wash many of the figures would be hard to read because of the irregular biting of the acid, and it is at this point that Blake's commercial ambitions may have foundered; he proved to be more interested in enhancing the artistic effect of the designs than in simplifying his technique. They are all printed lightly in either green or brown, so that they could take the addition of wash or watercolour.

The three tracts are Blake's first surviving direct attack upon 'the philosophy of the five senses' or Deism, and they are phrased not in the language of allegory but as a series of logical propositions which 'prove' the necessity of Christ. *There is no Natural Religion*, series *a* (see plates 38, 40), refutes the Deistic idea that moral ideas can be derived from sense perception; series *b* (see plate 39), demonstrates the existence of an infinite world beyond the five senses. *All Religions are One* (see plates 41, 42) argues that the Poetic Genius is universal, and is to be found in Christ. In this final tract Blake adumbrates in its most concise form his theory of the divine mission of art. The Poetic Genius, 'which is every where call'd the Spirit of Prophecy', reaches out beyond 'the confined nature of bodily sensation'.[6] The Poetic Genius is universal, and is the source of all religions and philosophies, but the Bible has a special place as an 'original derivation' from the Poetic Genius. Even false

religions, therefore, have a common source in divine truth, but are perversions of it; a distinction which Blake was later to formulate in terms of the contrast between 'Vision' and 'Allegory'.[7] From out of the Poetic Genius comes the 'faculty of knowing', the speaking of truth; Christ himself, the source of the Poetic Genius, dwells within every man, for 'true Man is the source, he being the Poetic Genius'. Blake, then, conflates the Swedenborgian idea of the centrality of Christ with his own notion of the Poetic Genius, asserting the essential unity of imaginative perception, prophetic truth, and faith in Christ. The artist is not only a prophet but he is part of the body of Christ; his art is the Christ within him.

The tracts are intensely serious, but they resemble children's books of the most ephemeral kind; perhaps Blake intended their delicacy and charm to act as a lure into the world of ideas. *There is no Natural Religion*, series *a*, may be the earliest of the three tracts,[8] because the relationship between text and design seems to be relatively primitive; in each case text and design share the page in approximately equal proportions and a tree or vine arches up from the design to enfold the text. The propositions are couched in a language of pure abstraction, and Blake has responded with visual images which confirm or enlarge the meaning of the propositions; these images take the place of metaphors, and serve to put flesh upon the bones of the argument. Proposition I reads, 'Man cannot naturally Percieve but through his natural or bodily organs' and is illustrated by a vignette of a bowed old man supported by a stick while a dog looks on (plate 40). The dog and the setting discreetly invoke the pastoral context, but the image is a kind of enlargement of the meaning of the text. The old man suggests the decay of 'natural or bodily organs', which have only a limited or finite life compared to man's divine perceptions. At the same time the world of a man bounded by 'natural' perceptions is invoked; he can see things only in terms of decay, for he has no vision beyond the mortal body.

The images, therefore, carry some of the resonances muted by the aphoristic austerity of the text; but the meaning of the imagery is deliberately not made obvious. For example, Proposition II of the same series, 'Man by his reasoning power can only compare & judge of what he has already percieved', is accompanied by the image of a child held by its mother as it reaches out for a bird beyond its grasp (plate 38). The child's gesture could stand for man's desire to reach out beyond sense perception to the infinite symbolized by the bird, or the bird could be seen as a physical object which the child is puzzling to comprehend, suggesting the inadequacy of an empirical process in comprehending the nature of things. The ambiguity is, however, haunting, for in Blakean terms it can 'rouze the faculties to act'[9] in order that they may be led to meditate upon the Divine. A similar ambiguity can be found in Proposition V of the same work, 'Man's desires are limited by his perceptions, none can desire what he has not perciev'd.' A little boy reaches delightedly towards a swan on a river, desiring to grasp its material form, but is he not also reaching out beyond it?

The visual content of the three tracts is predominantly pastoral, but Gothic and classical elements accentuate the revelatory implications of Blake's vision. In series *a*, Proposition IV, 'None could have other than natural or organic thoughts if he had

none but organic perceptions', is illustrated by a piping shepherd, a paradigm of the artist, who has thoughts which soar beyond the 'organic and natural' just like the birds in the sky above the tree, under which he sits. But Proposition III shows an Old Testament prophet seated beneath a tree, writing to the dictation of an angel, illustrating the proposition that 'From a perception of only 3 senses or 3 elements none could deduce a fourth or fifth'; inspiration and true knowledge are of heavenly origin. In series *b* a Christian-Gothic coloration predominates, as the theme shifts from the limitations of sense perception represented by the pastoral world to the role of Christ, associated here with Gothic decoration. In the frontispiece Christ raises Lazarus against a background of Gothic tracery, while the words of the title-page, 'There is no natural religion' are set into an ornate Gothic frame (plate 39). The frontispiece epitomizes the theme, which is the awakening of the human body, here exemplified by Lazarus, to the spirit through the agency of Christ. The Gothic frame on the title-page is a curious synthesis of a medieval tomb canopy of a kind to be found in Westminster Abbey with a cathedral entrance arch set with a tiny pair of angels adoring a Virgin and Child. It may represent the entrance to a tomb, foreshadowing the motif used in the Blair's *Grave* illustrations[10] and the frontispiece to *Jerusalem* (plate 153), of a Gothic door serving as the entrance into the Grave, whose secrets are known only to those who pass beyond material existence.

In series *b* the relationship between text and design on each plate is more varied. In the first four propositions the design is summary and clearly subordinate to the text, but this relationship changes dramatically with the powerful image of despair in Proposition VI, where a chained figure is depicted grasping his brows in pain: 'If any could desire what he is incapable of possessing, despair must be his eternal lot.' Despair is turned into exultation on the next plate, where a joyful figure with his arms outstretched accompanies the proposition: 'The desire of Man being Infinite, the possession is Infinite & himself Infinite.' A similar sudden contrast of images is to be found in the final two pages; the 'Application' shows a man of Reason kneeling to draw a diagram, while the final page concludes the book with a radiant image of the dead Christ in glory: 'Therefore God becomes as we are, that we may be as he is.'

The complex and purposeful interrelationship between text and design in series *b* looks forward to the Prophetic Books of the 1790s, and one can also see in the same book a use of symbolic images which foreshadows the work of his maturity. In the Application plate a 'scientist' is crouched over what is apparently a diagram with a pair of dividers, accompanying the thought that 'He who sees the Ratio only sees himself only.' The object of his scrutiny may be the reflection of his dividers in the pool, and so, like Narcissus, he sees a reflection of himself. The crouching posture and the downward gaze are intentionally parallel to the figure of Despair in Proposition VI, for those who try to apprehend the world through the exercise of Reason must also fall into despair.

In all three tracts the ornamental vegetative borders subtly augment the meaning of the propositions. Overhanging trees often suggest the limitations of the world of

the senses, and where redemptive thoughts are implied in the text the sky is usually open, with birds—'winged thoughts'—soaring aloft, as in Proposition IV of series *a*. In series *b*, Proposition IV, clusters of ivy symbolize 'the unpleasant qualities of material existence',[11] while on the following plate two tiny angels floating aloft with hands in supplication accompany the idea of another universe beyond the substantial one. Thus natural and spiritual imagery act as hieroglyphs leading those who can interpret them beyond the material existence of natural life.

All Religions are One continues the argument of the previous tracts to reveal the necessity of prophecy. The theme is announced in the frontispiece (plate 41), where John the Baptist points with both hands to the left, and the plate is inscribed: 'The voice of one crying in the wilderness.' St John is pointing both to the coming of Christ and to the words of the title-page (plate 42). The idea that 'all religions are one' is synonymous with Christ, for He is the sum and the source of all true religious inspiration. On the title-page the title is inscribed for the benefit of a prophet by an angelic muse, for the divinity of Christ is made manifest to prophets through the Poetic Genius. The designs in *All Religions are One* mark the first appearance of a number of motifs which recur in the 1790s Prophetic Books, and the type of imagery looks forward to them, just as the pastoral imagery of the other two tracts antici-pates *The Songs of Innocence* and *The Book of Thel*. In Principle I the proposition 'Like wise that the forms of things are derived from their Genius, which by the Ancients was call'd an Angel and Spirit and Demon' is accompanied by a bearded man in the clouds, who is a striking prefiguration of Urizen in plate 8 of *America*. In Principle IV the figure later dubbed 'The Traveller who hasteth in the Evening' in the *Gates of Paradise* makes his first appearance. 'As none by travelling over known lands can find out the unknown, So from already acquired knowledge Man could not acquire more.' Biblical parallels are also indicated through the designs: Principle II 'As all men are alike in outward form, So (and with the same infinite variety) all are alike in the Poetic Genius' is illuminated by tiny figures of Adam and Eve, the com-mon parents of humanity.

All Religions are One has a greater density of visual imagery than the other two tracts: in some cases two images separated by the text appear on a single page. Principle V, for instance, 'The Religions of all Nations are derived from each Nation's different reception of the Poetic Genius, which is every where call'd the Spirit of Prophecy' is illuminated by two images which refer to the two parts of the sentence. The transformation of the Poetic Genius into religion is epitomized by a scene of children being taught by an adult, while under the text the Spirit of Pro-phecy is represented by a Bard with a harp. The first part of Principle VI, 'The Jewish & Christian Testaments are an original derivation from the Poetic Genius', is illustrated by the tablets of the Law in a cloud, while the second part, 'this is necessary from the confined nature of bodily sensation', is epitomized by the figure of a man groping in darkness; for bodily sensation cannot reach the illumination of the Poetic Genius. The concluding proposition, Principle VII, 'As all men are alike (tho' infinitely various), So all Religions, &, as all similars, have one source', is illus-

trated by the Ascension of Christ, in which Christ appears in a blinding flash of light, for the revelation of Christ is the only true source of religion. But that revelation is to be found within man himself. The second part, 'the true Man is the source, he being the Poetic Genius', is illustrated by the evocative image of the Holy Spirit as a dove with wings outstretched, hovering above the waters.

Whether *All Religions are One* is to be dated after the other two or not, it is reasonably certain that Blake completed all three tracts in their present form within a year or so of mastering the stereotype process. We are faced, then, with a quite remarkable achievement, for he has already realized some of the expressive possibilities of his new method. The visual images go beyond simple illustration to the point of having a life of their own; there are cross references between them, sometimes commenting on the text as a whole rather than on the individual page; they enlarge the argument by referring to Biblical parallels, yet they retain a quasi-decorative function by subtly creating the atmosphere in which the propositions are to be read. They contain within themselves, even without the text, an implicit suggestion of the eternal dialectic between matter and spirit, sometimes through symbols, like the scientist's dividers, but more often through contrast of gestures and the repetition of physical types, which act as hieroglyphics for eternal states of being.

The Landscape of Innocence

The three tracts signal a decisive shift away from the monumental, both in size and in stylistic convention. By adopting the pastoral mode Blake was turning towards a different audience, for it was at the time generally associated with popular magazine and book illustration. But his use of the pastoral was fundamentally serious, and this is no less true of the *Songs of Innocence* than of the three tracts. Blake's achievement was to endow the pastoral genre with some of the Neo-Platonic elevation it had enjoyed in the Renaissance, but of which little survived by the end of the eighteenth century. His pastoralism was a profoundly Christian one; his shepherds are poets by virtue of their prophetic vision, and their habitat is not only an Arcadian twilight world, but a pre-lapsarian Eden or the era of the Second Coming.

Songs of Innocence was first printed in 1789 as a separate work—*Songs of Experience* was not added until 1794—but it is essentially a compilation of songs of which many existed in draft as early as 1784–5, and which Blake may have sung to his own music at the time.[1] The varying order in the early copies of the book makes it fairly certain that Blake did not at first impose a fixed sequence,[2] and the differing tone of the poems gives them the varied character of compilations of folk songs of the period, in particular Ritson's *Songs*, which Blake knew well. All the early copies are printed lightly, usually in brown, and Blake has added watercolour by hand,[3] creating a delicate effect hardly compatible with any kind of commercial production. The colour is washed in lightly over the printing, which comes through strongly, but in copies which Blake printed in later life, this relationship is often reversed and the pigment becomes the dominant element, particularly in copies of the 1820s.

The copy of *Songs of Innocence* in the Berg Collection, New York Public Library,[4] may be taken as representative of the early style. To an eye accustomed to later copies it seems positively austere; the wash is economical and largely unmodulated, and is applied almost exclusively to the picture area and not to the text. In the later books by contrast the whole page is often made part of a fictive space in which the text itself can be seen as a concrete form. In the *Introduction* page of the Berg copy,

for example, the intertwined leaves which enclose the design can be seen as purely ornamental, and do not form a kind of arbour open to the sky. The beauty of the Berg copy is greatly enhanced by the gentle repetition of colour throughout the book; a bluey-green wash in the background acts as a leitmotiv throughout the whole book, and the colours Blake sets against it are almost invariably contrasting primaries. In the title-page (see plate 43) a subtly modulated blue-green wash covers the background area, leaving the figures barely touched by colour except for the Nurse, who is picked out in yellow. *The Ecchoing Green* (see plate 44), first plate, is joyously coloured and the figures are distinguished from the greeny-blue background by strong reds, blues and yellows, while on the following plate the melancholy of the fading day is suggested by a darkening purple sky. In the *Little Black Boy*, first plate, there is a suggestion of sunlight in the sky, and the following plate has an emphatic and richly coloured red sunset behind the figures, but they cannot compare with the iridescent effect in most late copies, where the rays of the sun intermingle with Christ's radiance. Other colour effects are worth noting in the Berg copy: in *The Shepherd* Blake has painted the wings of the largest bird a striking blue, and in the following plate, *Infant Joy* (see plate 45), the strong red flower contrasts with the pallid drooping one; in *The Little Boy Found* (see plate 46) the background is washed in brown, emphasizing the ethereal whiteness of the Christ figure; and in the *Cradle Song*, second plate, the contrast between the red background and the blue garment of the mother suggests an early Renaissance prototype. Such subtle colour discriminations may be found in most of the early copies.

From 1794 onwards *Songs of Innocence* was normally conjoined with *Songs of Experience* and given a general title-page, but Blake did occasionally issue the former on its own. The incomplete copy in the Tinker Collection, Yale University,[5] for example, can be dated with some precision because it bears on some pages the watermark 1802 and was given by Blake's friend B. H. Malkin to Thomas Johnes of Hafod in 1805. The book completely lacks the naivety of the early copies. It is printed in orange, and the outlines are firmly outlined in pen in a way compatible with the linearity of his post-1800 watercolours. The predominant colour note is a cerulean blue, which acts illusionistically, usually over the whole page, giving the suggestion that the text is floating in the sky. The effects of luminosity are correspondingly more subtle; Christ is invariably shown gently bathed in radiance, as, for example, in *The Little Boy Found*, where a lambent light emerges from his vestigial halo.

Songs of Innocence resembles in general appearance not only the children's books of the period, but such compilations as Joseph Ritson's *English Songs* of 1783, for which Blake had executed engravings after Stothard,[6] and the *Lady's Poetical Magazine*, 1787,[7] for which Stothard had composed the designs. In these cases, of course, the engraved plates had been applied to a page with the text printed in letterpress, and as such they represent the penultimate phase of the combination of poetic text and design before Blake's innovations. In *Songs of Innocence* there are numerous echoes of the designs in Ritson's *Songs* in particular, but also of other designs by Stothard; the *Laughing Song* plainly derives from Stothard's illustration

to a *Drinking Song* in Ritson, while *The Ecchoing Green*, first plate, reflects a Stothard illustration of children dancing round a maypole. The piping shepherd in the frontispiece, the ostensible author of the *Songs of Innocence*, bears an affinity to the vignette of the author of the pastoral songs in the *Lady's Poetical Magazine*, 1787, while Stothard's large engraving of *The Children in the Wood* (plate 47),[8] 1788, is echoed in both *The Little Boy Lost* and *The Little Boy Found*. The striking image of the flower containing the mother and child in *Infant Joy* may have had its genesis also in the frontispiece by Stothard for the poem *Kensington Gardens* by Tickell (see plate 33).[9]

Blake's use of motifs familiar from the genre of book illustration popularized by Stothard undoubtedly led many of his contemporaries to assume that he had been a pupil first of Stothard and then of Fuseli.[10] But despite these undeniable borrowings the influence of Stothard is essentially superficial; formally and spiritually the *Songs of Innocence* far transcend Stothard's illustrations. Although the *Songs* are explicitly directed towards children, as the title-page makes clear, they are full of intimations of the Divine. As, according to Blake, Christ is ever present in childhood, so He is present in the text and design of the *Songs*. Sometimes He is referred to directly in both poem and design; in *The Little Black Boy* He appears as Shepherd of his flock, acting, in the Swedenborgian sense, as God and Father to the children, and He is to be identified with the tiny figure raising a Spiritual Body in *The Divine Image*. He appears in covert form; He is both child and lamb in the poem *The Lamb*, and the design recalls the Renaissance motif of the Christ Child with St John the Baptist;[11] in *Spring* the child reaching out on his mother's knee towards the sheep evokes the pastoral Madonnas of Titian,[12] while the joyful note associates the awakening of spring with the childhood of the Redeemer. Similarly in *Infant Joy* the nature spirits enact an Adoration scene in the flower. In *The Little Boy Lost* and *The Little Boy Found*, the psycho-drama is enacted of the soul lost in darkness, like the man confined by bodily sensation depicted in Principle VI of *All Religions are One*; the soul is then rescued by the light of Christ, the boy's 'father in white',[13] who guides him back to his mother. In *A Cradle Song* the resemblance of the design to a Renaissance painting of the type of Raphael's *Madonna di Loreto* parallels the association made in the poem with the Virgin Mary and the Christ Child:

Sweet babe in thy face
Holy image I can trace
Sweet babe once like thee
Thy maker lay and wept for me.[14]

These divine intimations are carried beyond the pictorial parts to the decorative borders, which in themselves supersede the format of Ritson's *Songs*. Here the symbolism of the vine is predominant, for it carries the implicit presence of Christ within the world of Innocence. In the title-page a vine enfolds protectively the trunk of the tree which shades the nurse and the children; in *The Ecchoing Green*, first plate, the children play around the text among vines laden with grapes, while in the second plate the passing of Innocence is associated with the ending of the day,

when the children are led away from the vine by an adult. The vine curls around the text, and one boy stands on a branch reaching towards a bunch of grapes, while another languidly hands down a cluster to the last child in the procession. In *On Another's Sorrow* the fruitful vine is associated with Christ's watchfulness, and in *The Lamb*, a vine entwines the two trees forming a protective shade over the child and the lambs. Blake's use of such symbolism allies him with a long tradition of devotional illumination, going back to medieval Psalters. But an acquaintance more with inheritors of this medieval tradition then medieval manuscripts themselves can be assumed; in particular with the well-known prayer-books and devotional works of John Sturt, which were printed in the early eighteenth century from silver plates.[15] The text is engraved from handwriting and the borders are made from separate plates, which are repeated throughout the book. Sturt's borders usually employ formalized vegetation, sometimes the fruitful vine with putti, angels or tiny figures disporting amongst it, like Renaissance grotesque borders. In one design used in *The Orthodox Communicant* (plate 48), 1721, flowering leaves intersect in a repeating pattern, into which are incorporated praying figures, angels, saints and winged putto heads; in many cases the page is adorned in addition by a small engraving at the top, and occasionally an elaborate initial enlivens the lower part.[16]

The use of marginal decoration as an oblique commentary upon the main text was a device often employed in medieval manuscripts. According to Howard Helsinger,[17] the naturalistic scenes and drolleries adorning *Beatus* pages of a number of thirteenth- and fourteenth-century psalters do not fulfil a purely decorative function, but illustrate allegorically the struggle between good and evil implied in the First Psalm. The danger faced by the Christian soul upon earth may be represented as a deer hunt in which the soul is the quarry pursued by the forces of evil; or a fowler threatening birds may stand for Satan lying in wait for unsuspecting souls. These motifs are often woven into a decorative framework, and portray commonplace scenes, but their presence in such a context recollects the whole tradition of Biblical exegesis, in which typological significance is noted as well as verbal imagery; Blake's use of visual commentary is, however, less concerned with drawing an analogy between spiritual truth and everyday life than with leading the reader to a higher level of understanding. The hints of medievalism in the *Songs of Innocence* are, for the most part therefore, the consequence less of direct influence of medieval manuscripts—Blake is unlikely to have had more than a passing acquaintance with them—than of his experience of Swedenborgianism. The element common to medieval illumination and Blake's imagery in the *Songs of Innocence* is the acceptance of two levels of Biblical interpretation, derived ultimately from the commentaries of the Church Fathers.[18]

The preciousness and devotional quality of Sturt's books provide a partial context in which to place the *Songs of Innocence*; however, the latter's ostensible role as children's lyrics should not be ignored. Children's poetry books in the later eighteenth century were invariably illustrated, but usually just with a single woodcut or engraving to go with each poem on the same page, as, for example, in Christopher Smart's *Hymns for the Amusement of Children*, 1770, and in emblem books like

Quarles' *Emblemes*, where the engravings accompany the letterpress. However, a decorative connection between text and design was to be found in music books, which were normally engraved throughout and sometimes contained decorative borders of a vegetative design reflecting the mood or rhythm of the song. *Songs of Innocence* as a book is notably more elaborate than ordinary song and music books of the eighteenth century, but it compares in richness with the masterpiece of British rococo book illustration, George Bickham's *Musical Entertainer*, 1737–9 (plate 49). The pictorial design, except for a single instance, is separated from the musical text, but the decorative borders on each plate are elaborate and individually tailored for each song, and the pictorial designs also vary considerably in shape. The plate containing the song 'The Constant Lover' has, uniquely, a border with putti at play amongst the formalized vegetation, which enfolds both the text and the music as well as the picture at the top. The pastoral is here all-pervasive, and indeed in almost all secular song-books. The songs Bickham has chosen are usually shepherds' laments, with the designs mainly borrowed from French artists of the period, including Watteau.

The thematic connection between the border design and the text in *Songs of Innocence* is often oblique, but pertains essentially to the idea of man's salvation. We have already seen the use of the traditional symbol of the vine to denote Christ's presence, but the borders frequently go beyond evocative symbolism to take on a narrative order of their own. In *On Another's Sorrow* there is no pictorial illustration but only a leaf- and branch-filled border in which tiny figures and birds are seen disporting themselves. The birds flying off the flowering tree suggest heavenly thoughts, while the vine encircling the trunk points to the presence of Christ upon earth as described in the poem. On the left of the plate, however, the natural forms can be interpreted as hieroglyphics, each standing for an idea. Sinuous branches form a kind of tunnel going up the side of the page and amongst them more tiny figures can be discerned. If we read upwards from the piper at the bottom we can see that the figures evidently express the idea of the soul, or the poet himself, progressing upwards through the entangled branches to the vinous part at the top, where he appears to stand in exultant freedom. The journey of the soul to redemption parallels the idea of Christ's sacrifice, expressing the eternal verity that man must pass through Experience to find salvation. The connection between the meaning of the border and the central text is not an obvious one, but the border relates Christ's incarnation to man's quest for salvation through the entanglements of Experience. In *A Cradle Song* the soothing words of the mother's lullaby are counterpointed by the rather agitated vegetative forms of the border, which contain small human figures trapped as though in a maze, perhaps expressing the dangers of Experience, from which the child is as yet protected. They should be seen as spirits in nature, who along with the angels, insect forms, plants, and man himself, enact the life of the spirit on all levels of existence, just as in the illustration to *Infant Joy* the flower enacts within itself the drama of Christ's birth as a human child.

The *Songs of Innocence*, then, draw together a remarkable number of threads within the tradition of book illustration. They can be seen as developing directly out

of the illustrated books of his own time, yet their Platonism draws them inevitably towards devotional illumination. But once again this higher purpose is veiled visually, just as the complexity of the text is masked by the rhythms of the language.

The *Book of Thel*,[19] also dated 1789, is, on the other hand, overtly mythological and extends the vision of *Tiriel*, now refined through Blake's Christian pastoralism (see plates 50, 51, 52). The setting is the same vales of Har in which Tiriel's parents live in perpetual Innocence, and the dilemma of Thel is essentially theirs: whether to face Experience or to remain perpetually in her present state of Innocence. The maiden Thel reaches her confrontation with Experience through encounters with natural phenomena: a Lily-of-the-Valley, a Cloud, a Worm, and a Clod of Clay, all endowed with human voice and form. In the end she fails to perceive her own essential unity with a divinely informed nature, and in fear condemns herself to a life of perpetual Innocence. In the state of Innocence she sees all the orders of creation in their human form, and they urge her into the cycle of death and renewal, but she finally rejects Experience, shown to her by the Clod of Clay, and rushes back to the safety of the vales of Har. The designs show Thel conversing with or observing the forms of nature. The title-page makes it clear that her concern with Experience is primarily sexual, for the confrontation of an innocent soul with Experience is revealed to Thel by the rape of a personified female tulip by a male, the tulip being traditionally associated with sexuality. Blake may also have intended a comment on the Linnaean sexual theory of plant reproduction, popularized in the same year by Erasmus Darwin.[20]

The placing of the pictorial design in relation to the text in *The Book of Thel*, apart from the decorative borders, is based on a simple system. The text, though extremely short, is broken up into four chapters, and with the exception of chapter II, which occupies a single unadorned page, they are each inaugurated by a head-piece and closed by a tail-piece. Thus chapter I is introduced by personified forms of nature cavorting around the word THEL, and is closed by the Lily-of-the-Valley bowing down before Thel; chapter III is introduced by a depiction of the Cloud, who had conversed with Thel in the unadorned chapter II, flying away while Thel contemplates the worm in the form of a new-born child seated upon a leafy bed; and it is closed by an image of Thel kneeling sorrowfully over 'mother Clay', who has invited her into her earthly dwelling, and her child the Worm. The final chapter, IV, lacks a head-piece, but this may not have been Blake's original intention, for a unique composition sketch (plate 52) for chapter III (formerly Graham Robertson Collection)[21] shows a different arrangement: the scene of Thel with the Clod of Clay and the Worm is set at the top of either chapter III or IV, a more effective placing for it, while the chapter is closed by an otherwise unknown motif of Clay calling Thel into her house, drawn as a bulky primitive-classical hut, with 'moans' flying above,[22] in illustration of the lines:

Queen of the vales, the matron Clay answered: I heard thy sighs
And all thy moans flew o'er my roof but I have call'd them down:
Wilt thou O Queen enter my house tis given thee to enter.

This drawing provides a remarkable insight into Blake's formal concerns in making the books, and the subtlety of his means; the image of Thel's house was presumably rejected because its bulk would have broken the delicate rhythm established by the continuity of the appearance of Thel, and the image of the departing Cloud in the head-piece of chapter III gives a central place to the idea of transience. This chance survival serves as a warning that the final result in Blake's Illuminated Books is often the culmination of a long process of trial and error, in which formal compromises are made, and vestiges of earlier conceptions are found in the final work.

The arrangement of the pictorial elements according to chapters in *The Book of Thel* develops consistently from *Tiriel* and the two-page poems in the *Songs of Innocence*, but the book lacks elaborate decorative borders, although the vignettes on the first page of the text and the concluding design, of children riding a serpent, are of a different order from the essentially narrative character of the other illustrations. On the first page of the text the nature spirits around the word THEL are related to those in the tree on the title-page to the *Songs of Innocence* (see plate 43), and although humanized, they seem to retain their insect-like character, which in turn reflects human activity: the naked figure is perhaps a caterpillar, who 'reminds thee of thy mother's grief';[23] the mother reaching out for a child perhaps stands for birth; the floating figure pointing at the eagle[24] for man's aspiration to a more elevated world, while the tiny figure with sword and shield may be a wasp or a bee, a symbol of man's aggressive instincts. In the vignette which closes the poem a group of children are seen playing in a carefree fashion on the back of a tame serpent, a motif which recurs in Blake's later work.[25] The serpent may be intended as an emblem of Experience, and the point seems to be in this context that childhood is an essentially unstable state, for the serpent will not remain a plaything for ever. Thus is may provide a gloss upon Thel's decision to return to the vales of Har, the innocence of which is as precarious as that of the children who ride upon the serpent's back.

The Book of Thel is considerably rarer than *Songs of Innocence and Experience* combined, for it was obviously less comprehensible to the casual reader, but the surviving copies still exhibit a comparable range of different colouring.[26] The spectrum is perhaps best defined by the three copies in the Rosenwald Collection: the earliest, copy H, like most early copies is printed in green and lightly washed with watercolour; copy F, the Isaac d'Israeli copy,[27] and therefore probably printed and coloured *c.* 1794; and copy O, a characteristic late copy, almost certainly produced in the 1820s. On the title-page of copy O (plate 51) Thel appears in a white dress against a reddish background and airy blue sky, and throughout the book she remains dressed in white. Copy F is printed in light brown, and on the title-page Thel is seen in a bright yellow dress, the bluey background now enriched with touches of yellow and red in the distance. The colouring in copy O is, however, of a richness that defies division into areas of colour. An overall silvery tonality and density almost mask the printed surface, and the forms are defined and rounded by precise pen outlines. The colours are modulated throughout the page into alternate and subtly merging strands of blue, pink and brown washes, and this richness is carried through the whole copy.

As in many late copies of *Songs of Innocence and Experience*,[28] Blake has clearly been carried away by a desire to produce a book of medieval splendour. It is also indicative of his late concern with decorative values that Thel should no longer be depicted in a single colour, but should vary from page to page. Each page is treated as an illusion-istic whole and is not, as in the early copies, divided by colour into text and design areas. In copy O, Blake has also demonstrated a great zeal in defining the relationship between ground and sky with an illusionism he would have probably condemned in earlier years. Thus page 4, which is virtually empty in the early copies except for a tiny printed flourish at the top, is here given a full landscape setting, with a clear ground plane, framing tree and background washed in, while on plate 5, where the design is at the top of the page, Blake has made the text section form part of the underworld, in which roots are continued down from the tree in the design to the earthy bottom of the page. The decorative qualities of copy O would tend to militate against the assumption that Blake intended to use colour symbolically, but the early copies might suggest this was in fact the case. To leave Thel's dress white as in copy H would tend to underline her virginal qualities and her innocence when faced with animate nature, and Blake might have intended more than a decorative effect in the early copy E,[29] on the title-page of which he has shown Thel in red contemplating the rape of the flower, which is also red, thus subtly pointing to her identification with the victim.

It is perhaps premature to raise the question of the reception of *Songs of Innocence* and *The Book of Thel*, when no original owners of the former are known before it was combined with *Songs of Experience* about 1794.[30] On the other hand there are enough early copies of *Songs of Innocence* to make it evident that a certain number of people did buy them, and it is more than probable that these were members of Blake's immediate circle. One of the surviving copies must surely have belonged to George Cumberland, although it has not been specifically identified, and it is pro-bable that Thomas Stothard was an early purchaser. More is known about original purchasers of *The Book of Thel*, for George Cumberland's copy is identifiable[31] as is Thomas Stothard's.[32] Stothard's copy (Beinecke Library, Yale University) stands out from all other copies not so much because of its poor condition, although that is rare in itself, but because it has evidently been used as a working copy. While few are as pristine as the Marquis of Bute's copy of *Songs of Innocence*,[33] Blake's Illuminated Books were normally subjected to little handling. This evidence of Stothard's handling neatly confirms what is clear from an observation of his own designs of the 1790s; that of all Blake's books, he was closest in feeling to *Thel*, which could well have influenced his own subsequent imagery.[34]

The Book of Thel and *Songs of Innocence* are the last Illuminated Books in which the state of Innocence and its associated pastoral mode are dominant. They signify the end of the pre-revolutionary phase in Blake's oeuvre. The date 1789 on their title-pages is not without significance, for the French Revolution and its consequences were to be of overriding concern to him from now on, and their lyricism was to be consumed in fire and flame.

E

Revolutionary Intimations

The next illuminated book, *The Marriage of Heaven and Hell*, was almost certainly begun in 1790, and it is consequently Blake's first book of the French Revolutionary era (see plates 53–5). It is in part an ironical assault upon Swedenborg, imbued with an apocalyptic spirit embodied in the concept of revolutionary Energy[1] which is destructive of the Old Order. Blake now believes the Old Order to be represented in spirit by Swedenborg, whose own 'new heaven' is ironically proclaimed on the third plate. The title refers directly to Swedenborg's *Heaven and Hell*,[2] and the structure is to some degree based upon it; 'Memorable Fancies' take the place of 'Memorable Relations', and it is an exploration of Hell in the same way that *Heaven and Hell* is an exploration of Heaven, in the form of direct argument, proverb and parable. The seriousness of Blake's adumbration of the concept of Energy is veiled this time by satiric irony, which revolves around Blake's reversal of Swedenborg's moral priorities; thus Blake announces his desire to give the Devil his say, for his target is the conventional piety he attributes to the Swedenborgian 'Angels', who represent Passive Good[3] as opposed to the purgative force of Active Evil.

At another level *The Marriage* is a personal record of Blake's own spiritual struggle at the time and cannot be separated from his conception of art. The structure of *The Marriage* is built upon the implicit metaphor of the enquiring soul passing through a moral universe where truth is progressively revealed by precept or symbolic experience. In the first 'Memorable Fancy' Blake collects from a Devil the Proverbs of Hell, which invert Swedenborg's conventional notions of religion; in the second he receives from Isaiah and Ezekiel the truth about the role of prophecy; in the third he learns how knowledge is transmitted through the generations. In the light of this knowledge he is able to confront the errors of the 'Angel' representing Deism in the seductive guise of Swedenborgianism; and finally assuming the role of a Devil himself, he is able to overcome his former self, and proclaim the necessity of his own mission to speak the eternal truth.

The 'conversations' Blake reports with 'Angels' and Prophets are in one sense a parody of Swedenborg's reported conversations in his own visions, but they are also

a metaphor for the process of artistic inspiration. Blake's imaginative journey in *The Marriage* is also seen in ironic terms:

As I was walking among the fires of hell, delighted with the enjoyments of Genius;

which to Angels look like torment and insanity, I collected some of their Proverbs.[4]

The Proverbs are presented as self-evident truths but their 'Devilish' provenance leads Blake to explore the nature of conventional belief. Thence he is led to a reconsideration of the role of prophecy, and in this section he confronts the Prophets with an 'enlightened' objection:

The Prophets Isaiah and Ezekiel dined with me, and I asked them how they dared

so roundly to assert that God spake to them; and whether they did not think at the

time, that they would be misunderstood, & so be the cause of imposition.[5]

The prophets assure Blake that their God is the sense of 'the infinite in every thing', and that to write under 'a firm persuasion' in a 'voice of honest indignation' is to write in the voice of God. So the voice of prophetic wrath in which Blake writes is, therefore, written from the same impulse that moved Isaiah and Ezekiel, and this 'Poetic Genius' has reduced all other religions to submission, 'for all nations believe the jews code and worship the jews god and what greater subjection can be[?]'.[6]

After confirming the necessity of prophecy by invoking Old Testament prophets Blake now considers the method of revealing the prophetic truth. His new stereotype method becomes a metaphor in itself of the process of clearing his own mind, and that of man in general, of error, for in a sense it is, like carving, an essentially subtractive process: the image is latent within the plate, awaiting discovery:[7]

But first the notion that man has a body distinct from his soul is to be expunged;

this I shall do, by printing in the infernal method by corrosives, which in Hell are

salutary and medicinal, melting apparent surfaces away, and displaying the

infinite which was hid.[8]

Blake sees his art, then, as a means of purging images of error and revealing the hidden truth behind the delusive surface; so in eternity the soul is purged of material existence. The Memorable Fancy which follows describes the process of the creation of books in 'A printing house in Hell', which may be identified as a spiritual projection of his own workroom. The account seems to relate to the necessity of inspiration, in the form of an eagle, in the transmutation of Divine truth into poetry and design, for the eagle causes 'the inside of the cave to be infinite'; but the eagle grasps a viper within its talons, which may imply the necessity of technique in the process, since 'Execution is the Chariot of Genius'.[9] At the end of the process men receive the metals cast by 'Unnamed forms'; which are then transformed into books.

Armed with the knowledge of prophecy and the weapon of illuminated printing, Blake is now able in the next Memorable Fancy to answer the Angel's warning of damnation by pointing out, in the course of an allegorical journey, that the true object of the Angel's worship was no less than the monster Leviathan, and that the origin of 'Angelic' religion was not Divine inspiration but merely 'Aristotle's Analytics'.[10] In the final stage Blake is able to purge the Angel within him, and to still the voice of reason, by demonstrating the Angel's misunderstanding of the role

of Christ. The Angel submits to the eternal truth '& he was consumed and arose as Elijah'. The work ends with Blake's resolution to release upon the world 'The Bible of Hell', which is necessitated by the continued existence of 'Angelic' notions, and in particular the failure to understand that 'One Law for the Lion & Ox is Oppression'. *The Marriage of Heaven and Hell* therefore, tells of the conquest of error within himself, and Blake's own realization of the Prophetic truth; it now remains for the world to hear of his discovery, in a forthcoming 'Bible of Hell'.

The title-page acts as an epitome of the book:[11] it depicts a cross-section through the earth and reveals the underworld beneath, while figures walking upon the surface are unaware of the seething drama below their feet.[12] By giving predominance to Hell, Blake offers as his main subject the life of Devils instead of a pious vision of 'Angels'. He represents Hell, perversely, as a place of reconciliation where two figures are locked in embrace. The two figures are associated with flame and cloud; their union, therefore, is an unstable one and the flames are clearly in the process of putting the clouds to flight,[13] for a static union between the bursting energy of Hell and the passivity of Heaven is impossible. By showing visually the essential instability of the union of opposites, Blake demonstrates the ultimate victory of Energy, which must cast out passive Good as surely as flames evaporate water. The title-page is thus prophetic of the impending outburst of Energy, and the Argument page which follows gives a sense of expectancy. Rintrah,[14] or wrath, is about to break out: 'Hungry clouds swag on the deep', for the Old Order is on the brink of conflagration, as good men are forced into hiding: 'Now the sneaking serpent walks / In mild humility. / And the just man rages in the wilds / Where lions roam.'[15]

The marginal design is apparently unrelated to the text: a girl hands down what appears to be fruit to another below, and two naked female spirits recline voluptuously at the bottom. The scene depicts a Har-like paradise, but the significance of the handing down is unclear, except perhaps as a contrast with the voluptuous figures. An air of expectancy informs the design as well as the text, but the imagery seems to belong to a different order.

In plate 3 (plate 53), the first page of the book proper, the text announces, ironically, the revival of Hell, following Swedenborg's announcement in *Heaven and Hell* of the birth of a new Heaven in 1757, and the necessity of the contraries of Good and Evil, for 'Without Contraries is no progression'. The two designs, of conception and birth, can be associated with the text discussed on the same page; the fiery copulation represented at the top and its consequence below wittily parallel the dialectic proclaimed in the text, and the two Contraries of Good and Evil seem to be running off after the birth. But these images also pertain to a wider context; the Leda-like female, who submits exultingly to the flames, appears to be related to the cloud form who is reconciled uneasily with flame on the title-page, and the child to whom she gives birth is evidently the struggling child she holds in the next page.

The illuminations, then, follow each other in succession, for in a sense they tell the story of the child who will become Blake's mythological figure Orc in later Illuminated Books. The story of the child Energy told in the designs represents,

therefore, a stage half-way between Energy as an abstraction and its full-blooded characterization as Orc in the Prophetic Book *America*. Thus we can see Energy as the product of fiery copulation, leaping from his mother's womb, apparently fighting against her restraints, and finally in plate 5 possibly emulating Phaethon by harness- ing the chariot of the sun. Other explanations of the illustrations are possible,[16] but it is clear that the relationship between text and design is no longer a straightforward one. Furthermore, Blake gives few clues to the identification of the figures, and his intentions are obscure in some cases, perhaps indicative of an incompletely realized myth. In plate 4 the figure chained by his foot, apparently blind, reaching out to- wards the child is not explicable by reference to the text, but the motif is one re- peatedly used by Blake at different periods. The origin seems to lie in a drawing by Flaxman of an unknown subject about 1783;[17] it reappears vaguely in Flaxman's drawings from memory of Blake,[18] in a watercolour of the early 1790s, in which the chained figure reaches out more obviously to grasp the child (Cecil Higgins Museum, Bedford), and in its canonical form in the large Colour Print of 1795, titled by Blake the 'Good and Evil Angel[s]'.[19] In the context of *The Marriage* the chained figures would make sense as an embodiment of sightless reason reaching out to restrain the active force of Energy; but such images exist 'eternally' in Blake's mind; they stand for the perpetual spiritual conflicts between energy and blind reason.

In plate 5 (plate 54) the airborne chariot, the earth engulfed in flames and the falling sun refer unmistakably to the story of the fall of Phaethon in Ovid, but they must also refer to the Satan of *Paradise Lost* who, Blake argues on the same page, is really the Messiah who 'formed a heaven of what he stole from the Abyss'.[20] In Renaissance interpretations the story of Phaethon is treated as a paradigm of the sin of Pride, as in Michelangelo's finished drawing for Tommaso Cavalieri (Royal Collection),[21] which Blake could have known from an engraving; Phaethon is destroyed because he overestimates his skill in handling Apollo's chariot. However, in another interpretation current in the seventeenth century, he is a Promethean figure, propelled by a desire so strong that he courts destruction rather than com- promise.[22] Blake has clearly drawn a similar inference from the myth equating Phaethon with an unrestrained energy which cannot be diverted until it destroys itself. Perhaps the ambiguity is deliberate, for as Erdman suggests, it may be a 'picture . . . adaptable to both parties' histories of the fall'.[23] In terms of the struc- ture of the book, the images of birth on plate 3 may be said to act as head-piece to the introductory section, to which the image at the bottom of plate 4 acts as tail- piece. The so-called *Fall of Phaethon* becomes, therefore, the head-piece for the long section including the first Memorable Fancy and the celebrated 'Proverbs of Hell', up to the tail-piece on plate 10. In the Memorable Fancy Blake relates how he received inspiration 'among the fires of Hell' just as Swedenborg claimed to have done in Heaven. The tail-piece on plate 10 also parodies the Swedenborgian idea of Heavenly inspiration, for Blake is shown receiving 'Infernal wisdom' from a devil, who holds out a scroll like a Recording Angel. The other 'Angel' is presumably the friend mentioned who ultimately becomes a 'Devil'. The images on plate 14 of a

figure with arms outstretched over a corpse, on plate 20 of a coiled serpent, on plate 21 (plate 55) of a youthful seated figure, and on plate 24 of Nebuchadnezzar all reappear in Blake's later work, but not necessarily with the same meaning. The two figures on plate 14 apparently depict a regenerate form arising from the flames surrounding a corpse; the form is the soul released from corporeal matter, but this soul is not distinct from the body, it is the body in its eternal form.[24] This is one of the designs reprinted without text in the *Small Book of Designs*[25] and it is further developed in the famous illustration to Blair's *Grave*, published in 1808, of the *Soul hovering over the body reluctantly parting with life*. The sea serpent at the bottom of plate 20 can be identified as Leviathan, Isaiah's 'crooked serpent', whom Blake saw as a presence behind the structure of Swedenborg's religion, but a coiled serpent appears on the title-page of *Europe*, 1794 (plate 65), as apparently destructive of Leviathan.[26]

The regenerate figure of a youth on plate 21 appears again in *America* as the prisoner freed from mortal evil, but in the context of *The Marriage* he evidently signifies the resolution in Blake's mind of the problem presented by 'Swedenborg's Angel' in the previous Memorable Fancy, and his realization that 'Aristotle's Analytics' was at the core of the Angel's religion. The youth stands for the expulsion of doubt; in later coloured copies the sun appears behind him to dispel the doubting clouds,[27] and in a uniquely coloured copy (Rosenwald Collection)[28] his awakening from materialism is signified by Egyptian pyramids in the background. *The Marriage* proper ends on plate 24 with an image of Nebuchadnezzar, who is not mentioned in the text but is captioned 'One Law for the Lion & Ox is Oppression', almost the words spoken by Tiriel when he realized his error.[29] The reference to Nebuchadnezzar acts as a gloss upon the text, perhaps to remind the reader that the Old Order still survives despite the individual man's embracing of the spirit. As a tail-piece it seems to refer back to and contrast with the regenerate figure of plate 21.

The illuminations already discussed are only one aspect of the total visual effect of *The Marriage of Heaven and Hell*, which Gilchrist described so evocatively: 'The ever-fluctuating colour, the spectral pigmies rolling, flying, leaping among the letters; the ripe bloom of quiet corners, the living light and bursts of flame, the spires and tongues of flame vibrating with the full prism, make the page seem to move and quiver within its boundaries.'[30] Gilchrist was certainly describing a later and elaborately coloured copy of the book, none the less he captures Blake's concern to animate the book, and fill any empty space with writhing figures and flourishes. The eternal duality of matter and spirit is thus enacted in the minutest particulars. On plate 3, for example, aside from the main illustrations, above the words 'new heaven' a tiny figure floats upwards; next to the words 'Love and Hate are necessary to Human existence' two tiny figures on a serpentine leaf grasp hands in reconciliation. Many of the Proverbs of Hell (plates 7–10) are illuminated by tiny figures, and headings throughout the book are adorned by visual contraries. Plate 11 shows as well as any the range of different types of illumination throughout the book. The page is a prologue to the Memorable Fancy concerned with Prophecy, where Blake argues, following Swedenborg and St Paul, that false religion emerged at the point at which

men began to deify the personifications they had given to natural forms, forgetting that the true origin of these deities resided in their own minds. This idea is expressed in the head-piece, in which vegetative spirits are seen on land surrounded by water or, in later coloured copies, inside a cave.[31] At the bottom of the page there appears a white-bearded figure with arms extended, resting on a cloud, a form later to be associated with the repressive Urizen in *America*, while a mysterious human form floats away from him as if escaping. This clearly refers to the terminal idea on the page: 'Thus men forgot that All deities reside in the human breast,' for it shows a Jehovah-like god now worshipped in his own right, divorced from his origin as a 'Genius' of a 'sensible object'. Thus we travel on the page from an image of nature in harmony to the domination of a thundering vengeful god.

The text itself is also adorned with a tiny scene of worship, which is inserted into the space left by the end of the penultimate sentence: 'And at length they pronounced that the Gods had order'd such things.' The barely distinct group of worshippers bow down before the lower half of a statue with a sword, for the consequence of their error is to submit to warlike gods. Human and natural forms also act as a kind of punctuation, giving emphasis to individual words and phrases. Birds fly in between the lines of text, and the flock is usually accompanied by a larger bird flying upwards, symbolizing man's thoughts of the heavenly spirit. They pertain to the eternal world, and often emphasize words and phrases denoting transcendence; a bird hovers over the word 'Geniuses'; three birds hover over 'enlarged & numerous (senses)', and the large bird is next to the word 'Percieve'. A tiny but indistinguishable figure, perhaps of an ancient poet, marks the first word of the text, and it is even possible to discern a tiny figure in the loop of the A of 'And' at the beginning of the second sentence. In some cases the decorative elements simply animate empty spaces, as in the case of the large ribbon-like leaf, after 'thus began Priesthood'. Such configurations can be seen on virtually every page, and in later copies of *The Marriage*, such as the two copies in the Fitzwilliam Museum, dating from the 1820s, Blake has augmented the effect of profusion by adding rich colour and gold leaf to the main designs and the text.[32]

All copies of *The Marriage* end with *A Song of Liberty*, which is so close in theme to the Prophetic Book *America* of 1793 that it is usually thought to have been added about that date to the main text.[33] The evidence of the early coloured copies, however, tends to suggest a date nearer 1790. In what may be the earliest known copy (Pierpont Morgan Library),[34] the green printing and sparsity of colouring seem close to the earlier printings of *Songs of Innocence*,[35] presumably of about 1789–90.

In *A Song of Liberty* 'the new born terror' of revolution confronts the Old Order in the form of a tyrant king who 'promulgates his ten commands', but is destroyed as the new dawn arises in the East. This unequivocal desire for Revolution is the dominant note of the Illuminated Books which follow, and *The Marriage* passes beyond Swedenborgianism to a direct concern with contemporary events, for the French Revolution signified for Blake the actual fulfilment of the prophecy of Revelation— the first stage in the process which would culminate in the Last Judgement.

The Prophecies

The Continental Myth

A. AMERICA

The period from 1793 to 1795 was the most intensely productive of Blake's career, unsurpassed in both the spate and the urgency of the work produced. If the French Revolution was the catalyst for the release of Energy upon the world, it also had a similar effect upon his own work. The Great Day of His Wrath predicted in *Revelation* was thought by Blake to have arrived, and he, along with such contemporaries as Richard Brothers and William Sharp, welcomed the overthrow of the French monarchy as a necessary prelude to the total destruction of the Old Order and the advent of the New.[1] In 1793 he began to release upon the world 'The Bible of Hell' promised towards the end of *The Marriage of Heaven and Hell,* and this may be taken to include the whole of the Prophetic Books up to 1795.[2]

Blake's conception of the Bible is, therefore, central to his intentions in the Prophetic Books, and he had already shown an awareness of the Patristic and Swedenborgian distinction between the literal and the spiritual sense of the Bible. He was, moreover, especially aware that the prophecies of the Old Testament were works of social criticism directed against worldly powers, and it is perhaps not fortuitous that the two books most directly concerned with contemporary events, *America* and *Europe,* are subtitled Prophecies. In addition, the Prophetic Books, from *America* onwards, unfold a psychological drama, or psychomachia, in which the principal characters, representing mutually warring attributes of a universal mind, proceed through antithesis to ultimate reconciliation. The mythological history of the world is, therefore, enacted within the mind of man in his own struggle for Redemption in the Fallen world. This sublime struggle is, furthermore, embodied in the heroic efforts of the true artist to give form to his visionary conceptions. Blake's titanic characters have the responsibility, as it were, of providing an explanation for the particular historical circumstances of his own time; hence the essentially syncretic nature of the Prophetic Books, which draw upon the universality of all myth as the expression of the 'Poetic Genius'.

During the first years of the French Revolution Blake associated himself with the group of revolutionary sympathizers gathered round the publisher Joseph Johnson. Despite the legends attached to this episode in Blake's life he was probably not a prominent member of the circle, which included Mary Wollstonecraft, Tom Paine and Fuseli, but he found an appreciative audience amongst them. Johnson embarked on the publication of Blake's apocalyptic poem *The French Revolution*, 1791, in ordinary letterpress but proceeded no further than the proof stage; it exists only in a single copy (Huntington Library).[3] Although the book as printed was unillustrated, the text is partly conceived as a series of tableaux prophetic of his later imagery. The prisoners in the Bastille are held in seven towers or dens, named Horror, Darkness, Bloody, Religion, Order, Destiny and Tower of God, where they are tortured for resisting tyranny:

And the den nam'd Horror held a man
Chain'd hand and foot, round his neck an iron band, bound to the impregnable wall.
In his soul was the serpent coil'd round in his heart, hid from the light, as in a cleft
rock;
And the man was confin'd for a writing prophetic.

The nobles of France who were responsible for these atrocities are described in terms which recall not only the Biblical Book of Revelation, but in their sublimity and attenuation the paintings of Fuseli:

Then the ancientest Peer, Duke of Burgundy, rose from the Monarch's right hand,
red as wines
From his mountains; an odor of war, like a ripe vineyard, rose from his garments,
And the chamber became as a clouded sky; o'er the council he stretched his red limbs,
Cloth'd in flames of crimson.

If *The Marriage of Heaven and Hell* acts as a transition between the philosophical and ironical works of Blake's early period and the revolutiony arconsciousness of the later books, then *Visions of the Daughters of Albion*[4] can be seen as drawing the problem of sex and experience into the Revolutionary era. It is dated 1793, but in spirit it partly reverts to the *Book of Thel*. The heroine Oothoon enters Experience where her sexual desires are expressive of the Energy which will eventually destroy the Old Order of England; but Oothoon as representative of the daughters of Albion, the women of England, is trapped within a frustrating union: she loves Theotormon but is raped by Bromion, and is rejected by Theotormon because of her adultery. The three are tied together in eternal frustration created by 'rational' morality, though Oothoon looks towards America, the land of liberty, where the hegemony of the Old Order has been broken. The book ends with the unhappy three still chained together, and the plate depicting their plight is placed in some copies as the frontispiece (plate 56) and in others at the back of the book.[5] They are seen in the mouth of a cave on the rocky coast of Albion: Bromion is manacled around his ankles, while his arms imprison Oothoon's; Theotormon sits higher up, his head enfolded in his arms in a posture of abject despair. Bromion howls in agony, his hair standing on end, for

his manacles are mind-forged, just as Theotormon's despair is self-inflicted. They are chained not only to each other but to the inhospitable rocks of Albion; Oothoon is trapped in a materialistic cave when her spirit aspires to fly across the sea to America. In the title-page she is seen running exultantly across the waves away from the cloudy realm of the vengeful god of the Old Order, now identified for the first time as Urizen. Oothoon's rape brings her back to the rocky shore, and in the tail-piece the Daughters of Albion watch her spirit floating over the shore, aspiring to America but still restrained, her arms outstretched in a parody of Urizen's outstretched wings on the title-page.

Visions of the Daughters of Albion is realized in a sparer and more unadorned manner than the previous books. There are few decorative flourishes and natural forms, emphasizing the barrenness of the Rocks of Albion and the misery of the protagonists. On the title-page imprisoned or disturbed spirits can be seen amongst the clouds, while to the left of Urizen three shadowy figures appear to enact, in the form of a dance, the threefold drama. The spirits who cavort around the word VISIONS at the top of the first page of the text are decidedly sinister: one scatters pestilence while others release arrows towards the land below, where Bromion and Oothoon are stretched upon the rocks in post-coital abandon. On plate 2 the only adornment, apart from leafy flourishes, is an interlinear vignette of a slave crawling along the ground.[6] The pictorial illuminations emphasize the alternation of sexual delight and frustration. On the Argument page Oothoon is shown in Thel-like innocence before her brutal rape; in plate 3 she lies on a cloud in a Leda-like posture of sexual abandon, but she is attacked by a Promethean eagle, and in plate 4 she soars upwards but is held down by a chain, like Hope with an anchor, while Theotormon crouches in despair.

The idea of America as representing both political and spiritual liberty to the inhabitants of Britain becomes the central image of the more important book of the same year, *America*. This is the first book which Blake calls 'A Prophecy', and in sublimity and visual power it far surpasses *Visions of the Daughters of Albion* and all previous work. It is also the first Illuminated Book in which Blake's historical myth is adumbrated, and it should be seen not as complete in itself but as the first of a cycle of books telling of the history of man from his creation to his hoped-for Redemption. *America* covers historically the period from the outbreak of the American Revolution to the first stirrings of revolution in Europe in terms of the emergence of Orc, the embodiment of Energy, from the captivity in which he is held by his parents Los and Enitharmon. It is more densely illustrated than the previous narrative Illuminated Books; no pages are without some design, but only the frontispiece lacks text altogether. As a gallery of images *America* conveys a similar impression as Fuseli's paintings for the *Milton Gallery*: a sense of primeval drama enacted in a dissolving inchoate world. The designs do not simply illustrate the text, and Blake has clearly aimed at a partnership between text and design in which neither is completely subordinate to the other (see plates 57–63). In the Prophetic Books in general this

relationship is not consistent, but certain kinds of relationship may predominate more in one book than another. Equally the ease and certainty with which we can identify the figures in the designs may also vary. In some cases it is obvious that a figure is, say, Orc or Los, but in others it is not, and Blake often makes a special point by revealing through the designs the true spiritual nature of a participant whose identity is not otherwise clear. Thus, in *America* Albion's Angel is identifiable in the text as the spiritual existence of George III, but he is also revealed through the design on plate 10 (plate 60) as identical in mien to Urizen, the promulgator of the Ten Commandments; for the artist's task is to melt 'apparent surfaces away, and displaying the infinite which was hid.'[7]

In the frontispiece (plate 57) a helpless woman clutches her children, with emblems of battle, displaced cannon and a broken sword at her feet, while beside her a giant winged figure stops the breach in the wall. The winged giant is most frequently identified as Orc; however, he is possibly not a living figure at all but a huge idol embodying the despair of hapless mortals under the Old Order, now reduced to a merely physical presence as a piece of masonry. Blake could have been aware of the existence of such ancient winged deities from Jacob Bryant, who illustrated in his *New System* an ancient Persian Mithraic temple in which a winged idol is the focal point of the worship.[8] Blake's winged giant, therefore, if it is indeed meant to be a sculpture, would suggest that the idols of the Old Order were the first casualties of Revolution and were no more protection for their worshippers than the stone of which they were made.

Even if the identity of the winged giant has never been satisfactorily explained,[9] the general meaning becomes clear if it is taken in conjunction with the title-page (plate 58), which has, above, a representation of the putative audience[10] and at the bottom a stormy scene of a woman embracing her dead husband on a battlefield. Motifs from both the title-page and the frontispiece are to be found in versions of the composition '*A breach in a city—the morning after the battle*' (plate 59), after a lost work exhibited at the Royal Academy in 1784. The title-page draws on the motif of the mourning woman on the battlefield, while the motif of the breached city goes back to the same watercolour, although a different context is suggested by the strange decoration of the wall in the frontispiece.[11] We are clearly back in the world of apocalyptic war, and the scenes are suggestive of the degradation of the spirit under the Old Order, which presages its final nemesis.

The two-page 'Preludium', which follows the title-page, offers hope of liberation in the form of Orc, whose break from his chains and subsequent rape of 'the shadowy Daughter of Urthona' are related in the text of these pages. The events leading to this point are told obliquely in the designs, in a continuous sequence beginning at the bottom right-hand corner of the first page. Orc enters existence as a coiled worm,[12] passes through primeval existence in humanoid form and through the mandrake-like roots of a tree, until he lies, chained hand and foot, under the same tree, watched by a man and a woman. The motif of the couple watching a chained figure recurs in Blake's later work,[13] and there can be little doubt that they are Orc's parents Los and

Enitharmon gazing in despair upon their Promethean offspring,[14] an event which is referred to in the text of the *Book of Urizen*, 1794,[15] but is not clearly described until the unfinished *Vala or The Four Zoas* manuscript, probably begun in 1797.[16] The differing reactions of the parents to their progeny suggest a parallel between their characters and those of Adam and Eve, as seen by Milton in *Paradise Lost*. Enitharmon gives way to emotional despair, while Los betrays horror but also looks clearly at the figure of Orc.[17] The sequence is continued on the next page of the Preludium, as Orc pushes himself out of the ground to prepare for his fiery ascent on the first page of the Prophecy which follows. Thus, as in *The Marriage of Heaven and Hell*, the Orc sequence moves from one design to another without referring precisely to the text.

The Prophecy opens (page 3) with an account of the gathering of the Americans to resist the tyranny of George III, 'The Guardian Prince of Albion'. The words of the title A PROPHECY are elaborately calligraphic and the A flowers into forms of wheat, while birds or divine thoughts rise up amongst it. Orc in his broken chains can be seen above the word 'PROPHECY'. Between the first paragraphs an angel blows flames from a trumpet, while at the bottom a family flees from the flames, looking back at them in horror. The page contains signs both of terror and hope; the flames of revolution cause physical destruction on the earth below, but they also effect the release of imagination as the birds fly upwards. Orc's ascent towards Urizen lies behind Washington's confrontation with George III, who appears on the next page (page 4), a 'dragon-form' metamorphosing into a vengeful tyrant descending to earth with a sceptre and a book of iron laws. Thus the dragon-form who stands on the cliffs of Albion in Blake's vision appears to the Americans in the human-form of 'Albion's wrathful Prince'. The scene of despairing humanity below, and the clouds which fill the space between, reflect the apocalyptic images of fire, cloud and blood which accompany the wrath of Albion's prince, while an innocent family—perhaps the same which fled from the conflagration on the previous page—huddles in terror. Orc's advent is announced fearfully in the text of this and the following page but he does not yet reappear in visual form. The image which dominates the page (page 5) and surrounds the text is one of retributive justice, in which angels carrying scales and a flaming sword accompany a grisly scene of an executioner hurling victims into a flaming pit (plate 62). This is presumably a bizarre representation of Albion's justice, explained in the reference on the same page to 'the Stone of Night', an analogy of the 'Druidic doctrine of revenge', which in the land of 'Albion's wrathful Prince' passes for justice, and to which Albion's prince clings in the face of revolution.

This horrific sequence of images of impending conflict is suddenly broken by two pages of haunting beauty. On page 6 (plate 63) Orc now speaks of the future when 'Empire is no more',[18] and this beautiful vision is paralleled by the naked figure of a young man awakening to immortal life. Here the stormy turbulence of the previous pages gives way to an emblematic image whose singular nature offsets the fragmentary forms of the Old Order. This simple image of spiritual awakening is full of

subtle reverberations of meaning. Orc tells Albion's Prince (or 'Albion's Angel', an ironical reference to his pretensions to righteousness) of the new dawn of humanity which is imminent as 'the night decays', and the soul of man is freed:

Let the slave grinding at the mill run out into the field,

Let him look up into the heavens & laugh in the bright air,

Let the inchained soul shut up in darkness and in sighing . . .

Rise and look out, his chains are loose, his dungeon doors are open.[19]

In the illustration, however, the captive does not leap in the air in abandon, but sits up wonderingly. He is a Lazarus awakening to life, rather than the Christ of the Ascension suggested in the text: 'The grave is burst, the spices shed, the linen wrapped up.' But in the interplay between text and design several metaphors are implied: a man awakening from slumber; the release of a prisoner from a dungeon; the dead awakening on Judgement Day; Christ's return to Heaven after his Incarnation; a man seeing daylight after being incarcerated in a grave; and the release of the soul from mortality, expressed in the lowly forms of life at the bottom of the page: the lizard and the fly, the forlorn thistle, and the mortal skull on the ground beside the man. The awakening man is another Blakean leitmotiv; he has already appeared as the man awakening to mortal life in plate 21 of *The Marriage of Heaven and Hell*, but in *America* he bears the marks of Experience endured and surmounted. He is to be seen, again above the grave into which an old man passes, in the engraving of 'Death's Door' for Blair's *Grave* (plate 116), 1808, as 'the renovated man' or spiritual form of the old man who enters the grave.

On the next page (page 7), which lies opposite the previous page in early printings of the book, is a halcyon scene of the Golden Age, where children sleep against a large recumbent ram, while exotic birds sit amongst the sparse branches of the shading tree (plate 61). This idyll, however, might suggest an equivocal Paradise like the 'vales of Har' in *Tiriel* and *The Book of Thel*. It contrasts with the previous image of the regenerate man; the children are at the bottom of the page instead of the top, and their slumber contrasts with his awakening from the earthly realm; the children are essentially passive, and the exotic birds on the branches are suggestive of a conventional Eden in which all is sensual delight. The text of this page seems completely at variance with this pacific vision, for it consists of the reply of Albion's Angel to Orc's vision of Redemption, in which Orc is denounced as a 'Blasphemous Demon, Antichrist, hater of Dignities: Lover of wild rebellion and transgressor of God's Law'; but the vision of passive delight could also be intended as a reply to Orc's picture of the soul rejoicing in liberty. When Orc appears in the distance as a physical threat, Albion's Angel resorts to tyrannical repression and so, when faced with Orc's vision of a new world, he may resort to his 'Angelic' vision of the afterlife. This vision may also be the vision of Enitharmon, which Albion's Angel accuses Orc of wishing to destroy, for the Old Order is dependent upon art which seeks to gratify the senses not to encourage revolutionary thoughts. Albion's Angel, therefore, in terms of injured innocence, stigmatizes Orc as the destroyer of the idyllic peace in which England rests under his rule:

Art thou not Orc, who serpent form'd

Stands at the gate of Enitharmon to devour her children[?].[20]

Orc replies on the next page (8) that his purpose is not just with Albion but with the God who stands behind him: the Jehovah who 'The fiery joy . . . perverted to ten commands'. Orc reveals himself, therefore, as the herald of universal redemption, for the American Revolution is but a portent of universal conflagration. Albion's Angel is merely a temporal tyrant; Orc's purpose is to destroy Urizen himself, the creator and ruler of the Fallen world, who is now depicted on this page in his most Jehovah-like apparition. As befits his reasoning nature, he is seen seated upon clouds, which suggest his endeavour to delimit man's perceptions of eternity; he is water to the fiery flame of Energy, the eternal dialectic first adumbrated in *The Marriage of Heaven and Hell*. This powerful image of Urizen is balanced by an opposing one of Orc on the next page but one (10). Orc there occupies the lower half of the page, whence he ascends in flames to evaporate Urizen's clouds. In the intervening page (9), Albion's Angel calls up his armies in apocalyptic terror, and the page is adorned with a border of curiously non-descriptive cross-hatching, in which a child or female figure is caught apparently within the eye of a horrendous storm. This marginal design is printed negatively; Blake has engraved it straight onto the plate, but printed it as relief-etching (plate 60).[21]

On plate 10 Albion's Angel summons the American colonies, 'the thirteen Angels', to come to his aid in the impending struggle against Orc, but on the next page they refuse, led by 'Boston's Angel', who may be the figure flying through the air on the back of a swan.[22] Boston's Angel speaks of the perversion of the Fallen world, and at the bottom of the page there is another version of the final image in *The Book of Thel*: children riding on the back of the serpent, while night falls in the background, perhaps implying the descent of darkness upon the Old Order.

The following plate (12) has the thirteen Angels renouncing their allegiance to George III, accompanied by a design of an old man entering the grave. The imminent victory of the revolution is, therefore, paralleled by another image of redemption, for he enters the grave to emerge regenerate. The imprecise yet infinitely suggestive relationship between this visual image and the text is also to be found in the remaining plates of the book, with the exception, perhaps, of the final one. In the next plate (13) the horrific images, a female corpse on the shore attacked by an eagle and a male one at the bottom of the sea about to be devoured by fishes, could refer to the transatlantic defeats of the British troops described in the text,[23] but the female figure seems also to refer back to the illustration of Oothoon attacked by Theotormon's eagle in *Visions of the Daughters of Albion*. The sinister oracle on the next page has an even less tangible relationship to the text, which tells how the plagues released by Albion's Angel upon America rebound upon him. The oracle is seated beneath a large overhanging oak, whose roots stretch down beneath the text and end with a curious fire-breathing fish; a young man in an attitude of prayer, his elbows resting on a book, looks towards her. The oracle is, of course, representative of false religion, to which the young man is submitting, so the scene is but another

manifestation of the Old Order. The marginal design on the next page (15) refers directly to the text, for the naked figures writhing in the flames are evidently 'the female spirits of the dead pining in bonds of religion' who are released by the sexual fires of Orc; but their forms are shown in a progression from the bottom right-hand corner, beginning with a womb-like figure, through three embracing figures, to a figure who floats upwards, transmogrifying, like Orc in the Preludium plate, through the roots of a tree, into despair on earth, until her spirit flies off to heaven in the form of a bird. The design tells in cryptic terms, therefore, of the redemption of the female soul through sexuality, a theme adumbrated in the story of Oothoon in the *Visions of the Daughters of Albion*.

After this series of mysterious images, the last page reverts to the text with striking literalness. The news of Orc's advent finally reaches Urizen in his frozen Northern outpost in heaven. There he pours out his tears of snow and ice until Orc is hidden 'with clouds & cold mists from the earth'. Urizen is depicted according to the lines in the text:

and Urizen who sat
Above all heavens in thunders wrap'd, emerged his leprous head,
From out his holy shrine, his tears in deluge piteous
Falling into the deep sublime;

as a Brobdingnagian giant with tiny figures crawling over him. He is crouched in despair while a cataract, suggestive of both water and beard, pours out from his hidden visage upon the earth beneath, which is represented as thorny and thistly plants enclosing the word *finis*. Urizen's icy cataract has the effect of damping down the revolutionary fire for twelve years until 'France reciev'd the Demons light' and revolution could break out in Europe.

B. EUROPE, AFRICA AND ASIA

The theological crux of *Europe* is the problem of Christ's Incarnation, and why it was not followed by universal peace and Redemption.[24] Just as Orc is the dominant figure of *America*, so Enitharmon presides over the subversion of the true meaning of the Incarnation, until Orc bursts out to proclaim the end of the Old Order. The Prophecy begins with the descent of a 'secret child' in explicit imitation of the opening of Milton's *Ode on the Morning of Christ's Nativity*;[25] the child is Christ, but in another sense he is Orc, representing the revolutionary aspect of Christ, the destroyer of the legalism of the Synagogue. Enitharmon as representative of the ornamental arts provides the ritual and imagery to subvert the revolutionary nature of the New Dispensation. She rejoices in Christ's birth because to her it is a harbinger of the restoration of an Eden in which the senses may be indulged. Accordingly she hides the 'red light' of Orc, and proclaims a false interpretation of Christianity through her messengers Rintrah and Palamabron, who 'tell the human race that Woman's love is sin' and promise not true redemption but 'an Eternal life . . . in an

allegorical abode where existence hath never come'; thus Rintrah and Palamabron, representing King and Priest, can reimpose their rule upon the Fallen world. Enitharmon now enters an eighteen-hundred-years' sleep, the period between the first descent of Orc and his awakening to Revolution, and between the birth of Christ and the outbreak of the American and French Revolutions. The action of *Europe* returns to the point of Albion's Angel's reply to the advent of Orc first described in *America*. Albion's Angel under this threat, as recounted in *America*, returns to the source of his authority in his Druid serpent-temple. As revolution comes nearer to Albion, so Albion's Angel becomes more oppressive, but Newton blows the Last Trump and the Angels fall.[26] Enitharmon awakes and calls her children to her, but Orc by now has reached 'the vineyards of red France', while Los 'called all his sons to the strife of blood'.

The main Prophecy of *Europe* is preceded, as in *America*, by a frontispiece (plate 64), title-page (plate 65) and two-page Preludium (see plate 66). The frontispiece is the famous 'Ancient of Days' with a pair of dividers, which may be read as Urizen creating the world, following Milton's description of the Creation.[27] Urizen appears here as the presiding genius of the Fallen world,[28] and Blake subtly undermines the traditional benevolence of the act of Creation, by an ironic use of pictorial language. Urizen's head is lowered beneath his shoulders, a posture associated in Blake's art with despair; he is confined within the circumference of the sun and he holds a pair of dividers, a symbol of science, in order 'to circumscribe this universe, and all created things'. Much of the force of the image comes from the way in which Blake reverses expectations. The white-bearded figure is unmistakably God the Father in the tradition of the universally familiar images of Raphael and Michelangelo, but his 'true' nature can only be discerned by paying attention to the 'minute particulars' of Blake's design. The rampant serpent which dominates the title-page serves to announce the advent of Orc upon Europe, and implicitly to contrast with the tamed serpent on plate 13 of *America*. The precarious co-existence of Urizen and Orc is made clear in two reworkings by Blake of proofs of the *Europe* title-page. In one (Pierpont Morgan Library) the figure of Urizen rests precariously on the serpent's principal coil writing in his 'Book of Brass', implying his imminent downfall as the serpent rises in majesty, and in another altered proof (private collection, Scotland) a youthful figure (Los?) appears to be trying to hold the serpent down as it rises up. The motif as printed, with the rampant snake alone, is perhaps more dramatic, for it opens the book with a confrontation between the opposing forces of Urizen and Orc; the Old Order is threatened by the New, as the pagan gods were by the coming of the Christ Child.

The text of the Preludium returns to the 'nameless shadowy female', raped by Orc in the Preludium of *America*, who laments the corruption of her children by Enitharmon, but the illuminations to the two Preludium pages are totally different in theme. In the first, a pilgrim[29] with a walking stick and a sack on his back is about to pass a rock, within which can be seen a fiendish assassin waiting to attack him with a knife; beneath are a shrouded figure with bat wings, and a man apparently dragged

down by a heavy weight attached to his wrists.[30] The journeying pilgrim is the en-
quiring man or 'Mental Traveller', and the fiend in the rock is an image of Male-
volence, as in Blake's later watercolour entitled *Malevolence* (plate 96) (Philadelphia
Museum of Art). On the following page the fiend is seen again, throttling two naked
men one with each hand, while another man, apparently wreathed, floats off to
heaven on a cloud. The two designs appear to express the dangers which beset the
man or poet who seeks the truth in the Fallen world; he is surrounded by fiends on
all sides and only a few of his company escape their fatal grasp.[31]

In the first two pages of the Prophecy, text and design relate more clearly to each
other. In the design on the first page a winged female shakes from her locks a flaming
infant, the 'secret child' who crouches inside a globe, while emblems of unity and
fecundity dance around the words 'A Prophecy'. In the British Museum copy of
Europe the early hand has identified the female figure as a comet, with supporting
quotations from Milton, Homer and Shakespeare, but comets were thought of as
breaking away from stars and a child-comet here would combine the idea of birth
with a portent of the dramatic and astonishing events which will follow the descent
of the child.[32] On the next page the naked female holding a cloth-veil over the sleep-
ing child must be Enitharmon, while the disporting figures on the clouds are evi-
dently Enitharmon's children delighting in voluptuous sports, because Enitharmon
had reassured them that Christ-Orc was the inheritor of classical paganism:

Arise O Orc from thy deep den
First born of Enitharmon rise!
And we will crown thy head with garlands of the ruddy vine.

It has been much disputed whether Enitharmon is unveiling or covering up the
form of the sleeping Orc,[33] but it would surely be more fitting for her to cover Orc,
for her purpose is to *veil* his 'red light' although she calls upon him to arise. The
motif, on the other hand, is evidently based upon renderings of Psyche lifting up
Cupid's bedclothes to shine a lamp on him.[34]

The imagery of the first six plates has been organized according to a system of
pairs: frontispiece/title-page, the two Preludium pages and the first two pages of the
Prophecy. Plate 5 is also paired—not with the following plate but with plate 11. In
the text of plate 5 Enitharmon sends Rintrah and Palamabron to pervert humanity;
Rintrah is depicted on that page as a young god of war and Empire, while Palama-
bron is seen on plate 11 as a bat-winged pope representing Religion; what Rintrah
achieves by force of arms Palamabron achieves by guile. At the bidding of Enithar-
mon they impose a false conception of Christianity by the sword and the book. They
are both accompanied by Flaxmanesque angels, who, in the case of Rintrah, express
by their pious gestures the spiritual guise assumed by warlike power, and, in the
case of Palamabron, by their crossed sceptres the worldly power which lies behind the
assumed spirituality of institutionalized religion. The 'Gothicism' and unusual sym-
metry of both images suggest that Blake may have intended to 'unveil' medieval art,
contrasting the dominion of King and Priest with the pious façade represented by the
angels in attendance upon them.

F

In most copies of *Europe* plate 5 is followed by the full-plate illustration entitled by the early hand in the British Museum copy *Famine*, which may be paired with the other full-page plate, *Plague* (plate 67). As has been mentioned above, both these return ultimately to youthful designs in which the prophecy of Revelation is associated with the visitations of Plague, Famine and War upon the English nation.[35] The *Famine* and *Plague* plates thus invoke the prophecy of Revelation, the history of England and the suffering of Blake's own contemporaries;[36] but in the context of *Europe* they refer also to the consequences of the mental sleep imposed upon man by Enitharmon through the agency of Rintrah and Palamabron. Behind the vision of delight conjured up by Enitharmon there exist all the known horrors of the Fallen world; strife, hunger, disease, fear and cruelty. Enitharmon sleeps for 1800 years, and during this time Europe falls deeper and deeper into the mire created by Rintrah and Palamabron. The two plates thus form part of a sequence of images of the horrors which beset Europe during the 1800 years in which the true meaning of Christ's incarnation is perverted. In plate 8 the area of text is dominated by the image of an old man warding off some unseen terror while his daughter kneels and grasps his legs fearfully. This motif is rather retardataire in style, returning to the 'Approach of Doom' print of *c.* 1788, engraved by Blake after his brother Robert.[37] The old man is beset by terrors he can neither comprehend nor control, perhaps marauders attacking his lands, and his fate makes an ironical counterpoint with the text, for Enitharmon at this point calls up Rintrah and Palamabron in ecstatic language drawn from the *Song of Solomon* and the Psalms. In plate 9 two male and female figures, or 'Mildews', blight corn by scattering mildew from extravagantly curved trumpets. The scene of blight continues the sequence of horrors, but also refers to the plagues which at this point in the text are thrown back upon Albion's Angel (plate 69). The sequence of large-scale images ends on plate 13, in which a despairing man is seen manacled in a cell while his scaly-skinned jailor, carrying a large key, departs up the steps. The imagery reflects the description of the allegorical prisoners kept in the Bastille described in *The French Revolution*, but some hope is suggested in some copies in a chink of light in the direction of his gaze.[38] The text on that page announces Newton's blowing of the last Trump, which heralds the prisoners' release from the captivity of tyranny and the five senses, and the final image of *Europe*, plate 15, is of a family escaping the flames of the revolution, a design which relates back to the first page of the Prophecy in *America*.

The continuity of the two books is thus emphasized as the revolution spreads from continent to continent. Plates 10, 12 and 14 are the only ones in which the design is reduced to marginal or textual decoration. In plate 10 a serpent coils round the text, enfolding it. At the point that Orc makes his first appearance in Europe, he appears to Albion's Angels not as a redemptive figure but in serpentine form, for in their minds 'Thought chang'd the infinite to a serpent'. Plate 12 describes in apocalyptic terms the consequences for the inhabitants of England as the Old Order reacts in terror to the impending revolution, imposing upon the citizens even greater repression:

Enitharmon laugh'd in her sleep to see (O womans triumph)
Every house a den, every man bound; the shadows are fill'd
With spectres and the windows wove over with curses of iron;
Over the doors Thou shalt not: & over the chimneys Fear is written:
With bands of iron round their necks fasten'd into the walls
The citizens in leaden gyves the inhabitants of suburbs
Walk heavy: soft and bent are the bones of villagers.

The text is surrounded by a decorative design of a spider's web trapping myriads of flies, while at the bottom a female figure trapped in the web looks up to heaven, symbolizing the soul of man caught within the nets of Religion woven by Albion's Angels. Plate 14, the penultimate page, is decorated with lower forms of creation, invoked by Enitharmon as she wakes from her 1800 years sleep. Her shallow vision of nature at peace has been superseded by the reality of the dissolution of the Old Order, and this page provides an ironic breathing-space between the image of the man in prison and the conflagration in France. Above the flames of Revolution in the last plate there are joyful birds amongst leaves dancing between the lines of the text, and the Prophecy of Europe ends with the rise of Los calling 'all his sons to the strife of blood': in 1794 Blake still had hopes that the flames of Orc would destroy Albion's Angel now cringing in terror at the events on the continent.

Thematically the continental myth begun in *America* and *Europe* is completed by *The Song of Los*, dated 1795, which contains the *Africa* and *Asia* sections. *The Song of Los* was never systematically printed and sold.[39] Despite its brevity it contains some of Blake's most powerful visual images, and the effect is greatly heightened by the use of colour printing in each bound copy. Both *Africa* and *Asia* are tersely covered in two pages each, through the song sung by Los 'to four harps at the tables of Eternity' in his role as Bard to the Eternals. The visual images dominate the text in their brooding power and the matter of the book is contained within two monumental contrasting images; the Frontispiece (plate 70), of a Urizenic priest kneeling at an altar in homage before a murky sun which gives off a thin, uncertain light; and the full-page plate at the end of the book, of Los resting from his labours above the form of the radiant sun. Thus the conflict between Los and Urizen is embodied within a series of visual contrasts: the opposition of false and real suns; submissive worship and creative labour; age and youth; darkness and light; and clothed and naked. *Africa* tells of Urizen's reign over the Fallen world from the beginning of the Garden of Eden until the creation in the eighteenth century by Locke and Newton of a 'philosophy of the Five senses', ending with the first line of *America* and the advent of Orc. The title-page of *The Song of Los* shows a gloomy figure who could be identified as Urizen or Noah reclining as if fading into death, his hand resting upon a skull. The bleakness of the image is reinforced by the barren hills behind, into which the figure is about to merge. On the first page of the text Los begins his song with Adam in Paradise and Noah on Mount Ararat watching Urizen giving 'his Laws to the Nations'. Dividing the introduction and the beginning of Los's song is a

small scene of a boy lying down with a sleeping sheep beside him. This must be a
reference to the Garden of Eden, which is here synonymous with the delusive para-
dise offered by Enitharmon in *Europe*; it exists at the same time that 'the sons of Los'
or false prophets were disseminating the laws of Urizen as the only true religion.
Within a few lines Blake compresses the story of the Old Testament and the origins
of all other religions, including the 'abstract law' of the Greeks. On the second page
of *Africa* 'Eternity was obliterated & erased' until 'Har and Heva fled because their
brethren & sisters lived in War & Lust'. Har and Heva here seem to be not the
parents of Tiriel but the last representatives of uncorrupt humanity, hounded by
Urizen until 'as they fled they shrunk into two narrow doleful forms'. They are
depicted, at the bottom of the page, running in terror across an arid landscape, now,
presumably, metamorphosed into the 'narrow doleful forms' of Fallen man.

The frontispiece to *Asia* (plate 71) establishes a more lyrical note than the previ-
ous frontispiece; it is in Asia that Orc finally achieves his triumph over the whole
world, and the Last Judgement can begin. The king and queen who recline in the
flowers may represent the kings of Asia who 'heard The howl rise up from Europe'
at the beginning of *Asia*, for the image contains an intimation of a dark night which
is about to be banished by the dawn; but the genesis of the design is complex. The
original inventor of the motif was evidently Robert Blake, who drew a king and queen
lying in a poppy-like flower in the *Notebook*.[40] Blake himself adopted the motif as
his own in two watercolours of *Oberon and Titania* (see plate 32), probably of the
early 1790s, with the king and queen resting upon a lily (private collection, U.S.A.,
and Folger Library, Washington). Blake's fairy king and queen in *Asia* may also
contain the suggestion of the impending renewal of nature; the tyrants of Asia who
preside over nature's night will soon be swallowed up in the Last Judgement, and
Blake's final image in the text is of a world of animated nature in which nature
itself returns to its true sexuality. The first page of *Asia* establishes the horror of
Asian tyranny in words and visual images. Figures appear to be performing strange
rites amongst the letters A S I A; just above the text a man appears to be holding an
expiring female inside a cave, while at the bottom of the page there is a sinister
headless figure. On the following page the final denouement of the Old Order is
scarcely illustrated except by decorative vegetation and a long figure falling headlong
into the abyss. Los with his hammer is left to preside over the Redemption, for the
continental myth ends with Los triumphant. It is clear, however, that the myth is
not complete with *Asia*, for the process of Redemption is scarcely adumbrated, but
Blake in this phase of his career did not carry it any further.

The Process of Creation:
from the *Notebook* to *Songs of Experience*

The final appearance of *America* represents the culmination of a process of evolution in which the conflicting aims of acting as 'secretary [to] the Authors in Eternity'[1] and ordering the visions into an artistic framework were reconciled. No original manuscripts of Prophetic Books are known except the abortive *Vala, or the Four Zoas*, but that in itself suggests that earlier drafts of all the Illuminated Books were made. There are identifiable preparatory drawings for some of the images in the Books; thus the title-page of *America* (plate 58) was originally conceived with trumpet-blowing angels in the upper part,[2] and a rejected proof shows the difficulty with which the first page of the Preludium was achieved.[3] The best evidence of Blake's way of realizing his conceptions comes from the *Notebook* (British Museum),[4] which he used on and off for over twenty years after the death in 1787 of his brother Robert, to whom it originally belonged.[5] Blake worked through the *Notebook* several times over the years, filling in every empty space, often going over previous entries and writing across drawings. The main sequence of drawings consists of some 64 emblems, mostly captioned with quotations from other writers, which Blake originally seems to have titled 'Ideas of Good and Evil', perhaps as early as 1787.[6] From these drawings he extracted the sixteen designs which he engraved as *The Gates of Paradise* and a number were used in the *Songs of Experience*. Another sequence in the *Notebook* forms almost a complete set of designs for *Visions of the Daughters of Albion*,[7] and there are a few roughly drawn designs in illustration of *Paradise Lost*,[8] which evidently were not carried further at the time. The 64 drawings of the 'Ideas of Good and Evil' cannot be plainly deciphered in all cases, but they confirm Blake's tendency to use motifs in different contexts without changing them substantially. Thus amongst the motifs used again in *Songs of Experience*, emblem 23[9] shows in embryo the design for the title-page; emblem 36, a figure reclining on a scroll, is used for the Introduction page, and emblem 42, a child rejected by a reclining woman, is adapted for *The Angel*. The *Nebuchadnezzar* motif in *Marriage of Heaven and Hell*, plate 24, appears as emblem 27 of 'Ideas of Good and Evil', and emblem 9 unites in a single image motifs used later in both the *Famine* and *Pestilence* plates in *Europe*, but is itself adapted from the early *Great Plague of London* designs.[10]

Many other emblem designs can in varying degrees be connected with other Blake compositions, but some relate also to poetic imagery. Thus two delightful drawings of a child trapped in a cage (emblem 7) and escaping from it (emblem 50) reflect the idea of the soul trapped within the cage of the body which can be found in the Song 'How sweet I roam'd from field to field' in *Poetical Sketches*,[11] while the drawing of the figure chained to a rock (emblem 55), apparently of Fate,[12] recalls the imagery of Fallen man as a prisoner in the Bastille in Blake's *The French Revolution*. Many 'Ideas of Good and Evil' are of deathbed scenes, or concerned with death and transience; two emblems (6 and 29) are concerned with suicide, and one with murder, and two most touchingly are of mothers refusing to believe in the death of their children (emblems 48, 53). The order of the complete series is impossible to establish,[13] and Blake has changed his mind several times before reducing the number drastically for *The Gates of Paradise*, to refocus the theme on the life of man.

The Gates of Paradise was first published in 1793 in the form of a tiny book in ordinary engraving, with brief captions to each plate; a format which, it has often been observed, is like that of an emblem book.[14] The sudden reversion in 1793 to conventional engraving may reflect Blake's concern, as a Prospectus of that year reveals,[15] to put in order his designs even from early years and publish them. The theme of *The Gates of Paradise* can be read as the progress of an individual soul through the Fallen world, or his vegetative existence, to Eternal life. The frontispiece, 'What is Man?', shows the child as a chrysalis watched over by a caterpillar, signifying the unity between man's life on earth and the other processes of nature. The first five emblems are concerned with the Fall and its consequences for Man's 'Serpent Reasonings'. The motif of the woman finding a child in the form of a mandrake root in the ground may express the idea that man's physical body was the consequence of the division of sexes created by the Fall. The four elements Water, Earth, Air and Fire, engraved on the following pages, can be seen from the *Notebook* to have begun as the doubts and melancholy which afflict the mind of Fallen man.[16] In the remaining emblems man progresses through earthly life to death, when his soul goes to Redemption and his body returns to the worm from which it started. The stages of life are marked by appropriate emblems: the child breaks out of the shell (emblem 6); in growing up he learns the pain of his actions by killing a butterfly or insect he seeks to capture (emblem 7); he revolts against his tyrannical father (emblem 8), seeks for the moon (emblem 9), and falls into despair (emblem 10) and old age (emblem 11). The turning point is emblem 13, where the deathbed of an old man reveals the spiritual existence of man which transcends that of the body; 'The traveller hasteth in the evening' in pursuit of the Eternal life (emblem 14) (plate 72), and passes through Death's Door to the Eternal Life (emblem 15).

Songs of Experience was first announced in the 1793 Prospectus as a separate publication of 25 designs, but all the known copies are dated 1794 on the title-page (see plate 73), and are bound with *Songs of Innocence*.[17] The first known complete copy of both books together, the McGeorge copy in the British Museum, contains 50

plates: 28 in *Innocence* and 22 in *Experience*.[18] Blake had already included in this copy a frontispiece to *Innocence*, *The Piper*, and in subsequent copies there are a general title-page, which explains that the *Songs* show 'the Two Contrary States of the Human Soul', and additional plates, which make a total of 54, a number which remained constant despite changes of order in subsequent reprintings.

Most poems of *Songs of Experience* exist in various stages of completion in manuscript in the *Notebook*, but there they are not physically connected with their designs; many of the designs still form part of 'Ideas of Good and Evil'. Thus in the *London* plate in *Experience* the Babylonian vision of the city expressed in the poem is illustrated by an old man on crutches being led by a small child through the city streets. This motif appears in sketchy form as emblem 33 of 'Ideas of Good and Evil', but in conjunction with the poem it carries the imagery beyond the Fallen world of urban life; the old man is hobbling towards death, in which he will be reborn like the child, who leads him towards the entrance to the tomb through the door in the wall behind. The motif of the figure reclining on a scroll-like cloud at the bottom of the *Introduction* page to *Experience* depends upon emblem 36 of 'Ideas of Good and Evil', but it is now naked and female instead of male and clothed; transformed into the Earth of the text. In 'Ideas of Good and Evil' the emblems 41 and 42 are apparently paired, but the former, captioned 'I found him beneath a tree in the garden', appears again in *Gates of Paradise*, while the latter accompanies the poem *The Angel* in *Songs of Experience*. In the latter case, however, there is a subtle change of meaning; emblem 42 can be read as a mother rejecting her beseeching child, while the winged angel in *The Angel* looks upon the maiden benignly.

The contrast between the Contrary States of Innocence and Experience is expressed in the structure and visual imagery of the whole book. The frontispiece of *Innocence*, *The Piper*, has a counterpart in the frontispiece to *Experience*; in *Innocence* a cherub in a cloud hovers exultingly over the shepherd-piper, urging him to write down his *Songs*; the child is inspiration, which in the state of *Innocence* is untroubled. In the frontispiece to *Experience*, on the other hand, the poet, no longer with his 'happy pipe', holds the cherub captive, and his unhappy expression reveals that in the Fallen world inspiration is a burden to be carried; imagination is now the captive of Experience, and the artist's task is a gloomy one.[19] Instead of looking upwards, the shepherd's glance is fixed directly upon the spectator, who shares the same world, and there is ivy creeping up the tree trunk beside him.

The title-pages are similarly contrasted; the rectilinearity of the *Experience* title-page contrasts with the rounded, exuberant forms of *Innocence*. The two children, at their nurse's knee in the *Innocence* title-page, convey the pathos of Experience as they weep over their dead parents; like Thel they have passed through childhood. The forms of the letters are now regular and impersonal, flowering with ivy. The two souls, male and female, which float above, are separated from each other by the word 'of', perhaps providing an analogy of the divisive sexuality of the Fallen world.

Some of the poems in *Experience*, but not all, are designed as counterparts to those in *Innocence*. *The Garden of Love* (plate 74), for example, returns to *The Ecchoing*

Green (plate 44) in the light of Experience; innocent delight is replaced by symbols of Priesthood: 'A Chapel was built in the midst, Where I used to play on the green.' The joy of *The Ecchoing Green* is conveyed through certain images and words: the sun, happy, merry bells ring, Spring, sky-lark and thrush, sing, laugh etc. In *The Garden of Love* the contrary is evoked: gates, Chapel, shut, Thou shalt not, door, graves, tombstones, Priests in black, summed up in the final line: 'And binding with briars my joys & desires.' Similarly the visual imagery of the two poems is contrasted: the protective tree, the harmonious village and the exuberant play of the children in *The Ecchoing Green* is replaced in *The Garden of Love* by the stark imagery of *Experience*; two children (presumably the same children as on the title-page of *Experience*) at the grave of their parents are led in prayer by a cowled monk, who reads from a book and directs their attention towards the grave or mortality; the church behind occupies the playground, and the children are led into the submission required by conventional piety. The direction of their gaze also underlines the symbolism, and the grouping is cramped and claustrophobic, in contrast to the spaciousness of *The Ecchoing Green*. The *Nurse's Song* of *Innocence* is also inverted by the *Nurse's Song* of *Experience*; the benign nurse who had watched contentedly over the children playing is now filled with regret: she is seen in the illustration preparing an elder child to enter the world of manners and convention. In the designs to the two poems entitled *Holy Thursday* the orderly lines of the processions in *Innocence*, though viewed ironically, are contrasted with the vision of death and deprivation in *Experience*, where a woman contemplates a dead child above tiny scenes of children orphaned or dead. In *Songs of Experience* there is often a hint of parody, in which seeming normality is made sinister. *The Fly* shows a nurse helping a child to walk, while an older girl in the background is hitting a shuttlecock. The images, however, are essentially of transience, which is one of the themes in the poem. The movement of the three figures is continuous and eternal; the child will change into the girl playing carelessly in her youth, who will in turn become the nurse. Similarly the illustration to *Infant Sorrow* contains a hint of dissociation between mother and unwilling child, inverting the relationship between the mother and child in *Spring* in the *Songs of Innocence*.[20]

All Blake's images are thus united by their implicit reference to the dualities of Fall and Redemption; Innocence may seek to avoid the painful road to Redemption, and Experience is redeemed by the promise of Christ's mercy. The nurse can be the protector of Innocence but can also groom the child for Experience; the mother gives joy to the baby but also binds it down; the father may be a merciful Christ or a repressive Jehovah, and nature can be a playground of delight or a thorny path. Blake broke the circle of conventional illustration by drawing from the repertoire of imaginative forms in his own mind. A certain disjunction between text and design was often the result of such an approach, but this contributes to the sense of higher mystery which surrounds the Illuminated Books, causing the reader to seek spiritual meaning behind the surface.

The Myth of Creation: The Completion of the Bible of Hell and the Large Colour Prints

The [First] Book of Urizen,[1] 1794, tells the story of the Creation of the world and the history of man until the giving of the Law. Despite the title, the central actor is not Urizen but Los, whose struggle to give form to chaos is the real subject of the book. *The Book of Urizen* is the most overtly Biblical of all the Prophetic Books, and in one sense it attempts to rewrite Genesis from a radical perspective upon the God of the Old Testament. Blake's treatment of the Creation, however, is strongly visual. A powerful effect is created by the full-page designs, which appear in a different order in all the seven known copies.[2] Most copies have also a differing number of plates, and six of the copies are colour-printed, giving a remarkable sense of the primeval universe in which the 'dark visions of torment' are unfolded. *The Book of Urizen* represents the high point of Blake's Sublime style; his experience of the Sistine Chapel through engravings imbues both the conception and the form of the book, as does Fuseli's *Milton Gallery*. *The Book of Urizen* has also an important explanatory function in the scheme of the Prophetic Books, for it adumbrates the primary myth from which the conflicts in the other Prophetic Books arise. Like the *Rheingold* in Wagner's *Ring* cycle, it introduces the fundamental events and traits of character which give rise to the later episodes.

The fact that all copies of the *Book of Urizen* known to have been made in the 1790s are colour-printed confirms that this was integral to Blake's conception of the book.[3] By the use of colour-printing Blake was able to create a richer and denser texture, at the expense of purity of outline. The result is an epitome of the Burkian Sublime as applied to visual art: the immensity of chaos and the awe-inspiring sense of primeval struggle rendered in a visual and verbal language of indefinite forms and mysterious images. The universe in a state of 'Petrific abominable chaos' is marvellously suggested by titanic figures moving tormentedly through a threatening void, implying also the titanic effort necessary to create form out of that chaos.

Blake's use of colour-printing can be assigned with some certainty to the years 1794–6, and was applied mainly to the Illuminated Books dated 1794 or 1795, although there are in existence colour-printed copies of *The Marriage of Heaven and*

Hell and *Visions of the Daughters of Albion*.[4] There are no colour-printed copies of
Songs of Innocence and *The Book of Thel*, although there are three of *Songs of
Experience*.[5] It is likely, therefore, that Blake intended to associate colour-printing
with the Fallen world as well as primeval chaos, for the lack of definition in colour-
printing would have made it appropriate to what Blake later argued was the indefi-
niteness of the material world.[6] We have no account of his method of colour-printing
on a small scale, but Frederick Tatham reported that in the large Colour Prints of
1795 the colours were applied with a piece of millboard.[7] There are three interesting
proofs for the *Book of Urizen* in existence[8] (Beinecke Library, Yale University), in
which the colour-printing has been applied to the print without any additional work,
but in virtually all cases Blake was obliged to strengthen the printing with pen and
water-colour. Furthermore this colour-printing process was difficult to control,
particularly on a small scale, and in some copies an unpleasant opacity has resulted.
Blake's most successful effects were achieved when the colour-printing was applied
sparingly in partnership with pen and watercolour; and in some copies of the *Book of
Urizen* the colour-printing is barely perceptible.[9]

The events of the Creation and the Fall of Man are inaugurated in *The Book of
Urizen* by Urizen's banishment from the company of the Eternals, because of 'the
primeval Priest's assum'd power' through which he created Religion. Urizen conse-
quently falls into chaos, and the creation both of man in a physical form and of the
material world is performed by Los as a means of giving Urizen coherent form and
thus delimiting his domain to the newly-created universe. By implication, then, the
creation of the world is synonymous with the Fall, but the Fall in Blake's mythology
has a second stage: Los's fall into division, in which the sexes are created and the
artist is divided from man's conscious mind. In his Fallen state Los denies his re-
demptive existence and therefore is party to the suppression of his child Orc, which
allows Urizen to enslave man within the net of Religion he draws over the whole
world. In psychological terms the separation of reason from the other components of
man's mind causes the Fall; reason as an autonomous force misunderstands and seeks
to suppress man's imaginative perceptions. The artist exists as the voice of the ima-
gination, but he must struggle with reason both within himself and as a force which
dominates the Fallen world in which he lives.

The creation of the form of Urizen is a central purpose of Los as the Eternal
Prophet, for Urizen falls from the realm of the Eternals in a 'disorganised' formless
state, and without form Urizen's true nature cannot be discerned by man. By 'or-
ganising' Urizen, Los gives man a tangible image of him, and Blake, by telling the
story of the creation of Urizen, reveals the true nature of the presiding deity of the
world: how he was created by man himself, why he assumes the vengeful form of
Jehovah, and in what way he imposes his will upon Fallen humanity. Urizen's
Biblical form, as Jehovah, is, therefore, the creation of the prophet, who by realizing
Urizen in a literary and visual form, reveals the forces of evil to be part of the cycle
of Fall and Redemption; but Los's view of Jehovah as a vengeful tyrant also reflects
the limitations of the Old Testament prophets' view of God.

Blake's conception of the artist as creator of the outward form of evil may be regarded as complementary to the idea of the artist as keeper of the redemptive imagination. The evils of the Fallen world were the predominant subjects of Blake's art of the 1790s; there is little redemptive imagery in the Prophetic Books, and where Christ the Redeemer makes an appearance it is in his most energetic form, as the child Orc. Fuseli's *Milton Gallery* may also be interpreted as concentrating upon the character of Satan and the most horrific events from *Paradise Lost*. Hence Blake was able to see Fuseli's preoccupation with 'dread imaginings' as an anatomizing of evil potent enough to give offence to Satan's agents upon earth. The reasons for the neglect of the *Milton Gallery* were regarded by Blake as exactly comparable to the neglect of his own Prophetic Books: 'O Society for Encouragement of Art! O King & Nobility of England! Where have you hid Fuseli's Milton? Is Satan troubled at his Exposure?'[10] Behind this is the implicit notion of Satan's beauty and persuasiveness, derived from Milton: Fuseli, therefore, had unveiled the true nature of Lucifer by associating him with horrid deeds. The crux of Blake's theological problem was, however, not Satan, but Jehovah, and *The Book of Urizen* can be seen on one level as an attempt by Blake to expose Jehovah in the same way as he believed Fuseli to have exposed Satan.

There is a constant interplay in *The Book of Urizen* between the image of Urizen as a completed form and his gradual creation. The title-page (plate 75) shows him in his most organized form, in which his façade of paternal benevolence is subtly undermined by Blake's visual language, as in the frontispiece to *Europe*. He is depicted as a symmetrical figure, squatting in front of the tablets of the Law and writing sightlessly with both hands, or, as Erdman claims, writing with one hand and illuminating with the other.[11] There is a book at his feet, and the scene is enclosed by overhanging fronds. The tablets stand for the Ten Commandments, the repressive code of Jehovah, and he is evidently writing in his 'books of brass' laws to enslave humanity:

Laws of peace, of love, of unity:
Of pity, compassion, forgiveness,
Let each chuse one habitation:
His ancient infinite mansion:
One command, one joy, one desire,
One curse, one weight, one measure,
One King, one God, one Law.

Urizen's squatting posture, beneath the Tablets, implies spiritual despair; he is imprisoned by his own creation, a mere parody of the omnipotent creator on the Sistine Chapel ceiling. On plate 5[12] he appears wielding a Book of Brass; although disorganized to mortals, at this point he is fully articulated in the design because he has form to the Eternals, who watch him in despair. The Book of Brass, like the sun Urizen worships in the frontispiece to the *Song of Los* (plate 70), is a murky object propagating darkness not light.

Los's extended creation of the form of Urizen commences on plate 6 after Urizen's fall, rent from Los's side into an 'unorganis'd' form. The account of Urizen's fall is

accompanied on the same page by a puzzling design of three figures entwined by snakes and falling headlong into the void. Blake may have intended to draw a visual analogy between the Fall of Rebel Angels and Urizen's fall, but the group is also akin to the *Laocoön* group but inverted, suggesting a further analogy between the fate of Urizen and that of the Trojan High Priest. Los's pain at the separation from Urizen is graphically depicted on the next page, plate 7, where he is seen howling in agony, his physiognomy distorted like a Fuselian damned soul. On plate 8 the formation of Urizen begins with the creation of the skeleton, a grand image of which dominates the page, the skeleton's embryo-like posture suggesting birth as well as death. At this point in the narrative the nature of Los as a creator emerges; he is depicted as a blacksmith who forges the human form of Urizen at an anvil. His urge to create is awakened by pain and anguish at the sight of the 'unorganis'd' void, and his labour at the anvil, lasting for 'Ages upon ages', to create an entity out of Urizen's chaotic and intangible fragments is an analogy of the struggle of the prophetic artist to order his material. Creation is perpetual sleepless torment, in which the artist is beset by enemies; he has to bear the loneliness of a man who like an ancient prophet sees what others do not see, and because he is human he must overcome his own material desires. This anguish is expressed in visual form in the heading to plate 10 (plate 76), where Los is seen struggling through rocks, which press in on him from all sides. The skeleton of Urizen is formed by Los of chains welded with 'rivets of iron and brass' created in Los's forge, and on plate 11 Los is seen resting from his labours, at the point at which the skeletal Urizen has become sentient enough to agonize in the flames of the forge. At this critical moment Los in his weariness begins to feel pity for his creation; but pity is associated with the failure of inspiration. By feeling pity for Urizen, Los attributes to him a humanity that he does not possess; thus Urizen becomes an idol.

This moment, then, is the Fall of Los, for he loses his will to depict the true face of Urizen, as the material world comes into existence. On plate 18 Los stands unsteadily, apparently releasing his hammer at the moment his inspiration fails. As he falls he divides into male and female; thus the second stage of the Fall is accomplished. At an artistic level Los's Fall is into an art of compromise, in which a benign face is put upon Urizen; Jehovah is depicted not as vengeful and tyrannical but as a stern and protective father, as in the representations of Raphael and Michelangelo. Art, therefore, becomes a veil to the truth, and a servant of the rulers of the Fallen World. Los's female portion or Emanation, Enitharmon, now emerges Eve-like from Los; art is fatally divided from its true source in Divine inspiration, and Divine truth is no longer recognized by man through art, which is now deemed to be a trivial pursuit or merely an adornment to civilized life. Enitharmon is herself Pity, and she emerges as a coquette, refusing 'in perverse and cruel delight' the advances of Los. At this stage of the Fall, the Eternals, whose brooding presence has hung over the titanic events, now divide themselves from the new world of Los and Urizen by a curtain of darkness which is Science. On plate 19 Los, his submission complete, crouches in despair before Enitharmon, who turns away from him; his

God-like stature is now diminished to that of a mortal, for 'No more Los beheld Eternity.'

From the troubled union of Los and Enitharmon is begotten Orc, whom the fallen Los binds to a rock with a Chain of Jealousy, for he feels threatened by the unrestrained energy of the infant. Enitharmon weeps over him in pity, but does not oppose his captivity (plate 77). The jealous action of the fallen Los may also reflect Blake's observation of the artistic conditions of the period following the French Revolution, for Los in the state of creative weariness may be partly a parody of the established artists of Blake's day. The dominant artists at the Royal Academy, as the Secretary Joseph Farington reports, were fearful of those thought to be of Radical sympathies, and took action to keep them out of office.[13] The Royal Academy's hollow display of patriotism would have seemed to Blake a further excuse for the suppression of the few men of genius in their midst, and he wrote frequently of his and other artists' sufferings at the hands of mediocre artists who envied their genius despite their own worldly success.[14]

The binding of Orc is not depicted in *The Book of Urizen*, but he is shown already bound in the first Preludium page of *America*, where the motif as a whole appears to refer to the chaining of Prometheus by Hephaestus, as depicted by Flaxman in his line engravings from Aeschylus of *Prometheus Chained*, 1793.[15] If Orc is Promethean, then a parallel between Los and Hephaestus is equally compelling. Hephaestus was, of course, a blacksmith, and Los riveting and soldering the form of Urizen recalls Hephaestus forging the armour of Achilles; Los's position as artist to the Eternals also recalls Hephaestus's role upon Olympus.[16] Plate 21 (plate 78) shows the fallen Los, bearded and tied by the Chain of Jealousy, resting his hammer upon the forge while he looks jealously upon the embracing Orc and Enitharmon. The motif is instantly recognizable as bearing a relationship to the common Renaissance subject of *Venus, Vulcan and Cupid at the Forge*,[17] and it is sufficiently obvious to make it certain that the analogy between Los and Hephaestus was made consciously. In *All Religions are One*, c. 1788, Blake had advanced the theory that all religions are recipients of the Poetic Genius, but only the religion of the Jews may claim to have Divine authority.[18] Blake included the visual arts within the Poetic Genius, but he argued several years later in the *Descriptive Catalogue* that the Greeks, because their Muses were daughters of Memory rather than of Inspiration, could only imitate divinely inspired works. He postulated a set of 'original' Hebrew sculptures on the Temple of Solomon which provided prototypes for the Greek sculptors; the essential idea is that neither Greek sculpture nor Greek mythology was created by the Greeks but both were a reminiscence or rationalization of an earlier inspired art.[19] Thus the story and imagery of *Venus, Vulcan and Cupid* in their classical form are a kind of imitation of lost 'inspired' works which would represent the deeds not of pagan gods but of their 'originals', Los, Enitharmon and Orc.

The chaining of Orc implies the frustration of man's energy, the release of which can only come with the revolution which breaks out in Blake's own time, beginning with the American Revolution. Orc emerges in flames from Enitharmon's womb on

plate 20, but he has already made an appearance. The design to the very brief
Preludium, a floating female figure drawing along behind her a small child, may
refer to the childhood of Orc before Los's jealousy becomes threatening. Given its
position at the beginning of the text, Blake may also have intended to evoke the un-
fragmented world of delight before Urizen's fall, and it makes a contrast with plate 3,
which follows it, of Orc exulting in the fires of Eternity. With Orc in chains and Los
mentally emasculated, Urizen is now free to impose his will upon the world. He
wanders in misery through the cities of the Fallen world, and in plate 23 he is seen
with a lamp journeying through a dark and terrifying landscape, in which lions
roam. As he walks 'over the cities in sorrow' he pours out behind him a 'web dark
and cold' which is the 'Net of Religion'. The inhabitants of earth begin to take on
human form; they shrink from their infinite into their finite form,

for their eyes
Grew small like the eyes of a man,
And in reptile forms shrinking together
Of seven foot stature they remain'd.

This process of transmogrification is illustrated at the top of plate 25, where two half-
worm half-human figures are seen sinking in a miasma. The text ends with the
closing of man's infinite perceptions so that they mistake Urizen's dispensation for
Divine laws and worship him as God. Humanity has reached, therefore, the spiritual
and historical state of Egypt, and at the end of the book Urizen appears as Jehovah in
the form of an idol enmeshed in the coils of his own Net of Religion. But Blake
leaves hope for man in the Moses-like figure of Fuzon, who identifies the state of
Egypt and leads the children of Israel from it.

As far as the text is concerned there is little difficulty in ordering the seven copies of
the *Book of Urizen*. The one substantial variant is in plate 4, which in four later
copies is omitted.[20] The full-page plates with design only, however, vary in order
from copy to copy, and many of them are included or excluded apparently unsyste-
matically. In themselves they are not problematic, for they all appear to relate
thematically to the text, but their order is frequently at variance with it.[21] Most of
the full-page images can be tied within a logical sequence, but the variation in order
in the copies can be partly attributed to the simultaneity of events at certain points.
Thus the fall of Los has several immediate consequences: his own self-division into
male and female, his union with Enitharmon, and the creation of Orc. Urizen is also
released simultaneously upon the newly created world, and the four senses come into
being. It is not vital, therefore, that all these events should be depicted in any
single order, as long as they are realized in some proximity to each other. Equally in
the process of Urizen's creation, amongst the earlier plates images of the unformed
Urizen are placed in a different order according to the copy; the plates of Los or
Urizen diving down to the sea bed, Urizen swimming in the waters, and Urizen squat-
ting in the cave come in no constant order, but usually in the first half of the
book.

Similarly the domination of Urizen over the world is expressed in a number of key full-page illustrations, the order of which is unimportant although in practice their order is more constant than the images of chaos in the first part of the book. The plate of the four elements (24) expresses the agony of division into the four elements of fire, air, earth and water. In the British Museum copy Blake has painted out most of the plate, leaving only Thiriel (Air) and Utha (Water), and adding a sinister sunset associating the creation of the world with man's imprisonment within the senses. The plate of a boy beseeching heaven while a dog howls in misery (26) is an image of the Fallen world under Urizen: 'The Ox in the slaughter-house moans, The Dog at the wintery door,' and in its sudden glimpse of the contemporary world it draws the remote primeval world of the Creation into conjunction with *Europe* and *Songs of Experience*, implying the essential unity of the Fallen world from the moment of its creation to its hoped-for dissolution in Blake's own day.

The account of the creation of the material world is subsumed amongst the events surrounding the creation of the form of Urizen and the fall of Los. The Creation is referred to explicitly in a Michelangelesque vignette on plate 13, where it is described in the text, and the penultimate plate apparently depicts Urizen moving through the firmament. *The Book of Urizen* encompasses the episodes from Genesis depicted on the Sistine Chapel ceiling; the full-page designs of Urizen, therefore, can be read as a demonic parody of the magisterial actions of Michelangelo's God the Father. Thus Michelangelo's benevolent Father of Mankind disposing the firmament according to a rational plan is revealed by Blake as neurotic and self-divided, his appearance of wisdom and gravity being nothing less than the creation of the artists enslaved by him.

The sequence of Illuminated Books of 1793–5 is completed with *The Book of Ahania* and *The Book of Los*, of 1795,[22] which both conform to the historical scheme of the Bible of Hell. The latter describes the creation of the world from Los's viewpoint, while the former follows on from *The Book of Urizen*, telling of the captivity of Israel and the giving of the Ten Commandments. Unlike the other Prophetic Books they are etched in intaglio and colour-printed. Like *The Song of Los*, also of 1795, they are shorter than the prophecies of 1793–4, consisting of only five and six pages, and they are equally terse in language. They bear the marks of artistic crisis, and the interplay between text and design is relatively simplified. In *The Book of Los* the visual imagery is confined to the frontispiece (plate 79), title-page, decorated heading on the first page of text, and a tiny vignette to end the book, leaving one page completely unadorned. *The Book of Ahania* is even more austere; two full pages of text are completely unadorned and the heading on the first page of text is reduced to non-figural flourishes, but the pictorial images which remain are of stunning power.

In *The Book of Los* the lament by 'Eno, aged Mother' for the Golden Age before Urizen's division is made memorable by the anguished symmetrical image of Eno on the frontispiece: her mouth is opened in a howl, and her densely pigmented form barely emerges from primordial gloom. The frontispiece to *The Book of Ahania* shows Urizen lamenting over Ahania, who represents the principle of pleasure, now

divided from him: 'he groaned anguished & called her Sin. Kissing her and weeping over her.' The ambivalence of Urizen's feelings is admirably conveyed in Blake's image: Urizen is seated in a position of despair, but fondles Ahania's hair longingly. Ahania is an Oothoon-like female, whose redemptive spirit is depicted on the title-page to the *Book of Ahania*; otherwise the atmosphere of the two books is one of unrelieved gloom, in which the title-page of *The Book of Los* and the final vignette of *The Book of Ahania* form complementary images of metaphysical despair: the Eternal Prophet is seen trapped in rocks in the former, and in the latter bleeding fragments of Titans lie crushed amongst the rocks.[23] In the heading to the first page of text in *The Book of Los* the 'o' of the word Los contains a tiny but clearly etched image of Urizen holding the Tablets of the Law while two cherubs beneath recline in attitudes of adoration; a parody of conventional religious painting, with a hint of a Baroque altarpiece.

The Prophetic Books as a whole represent an extraordinary achievement in artistic and technical terms, but they brought very little return to Blake. The few contemporary purchasers tended to be either collectors of 'curious' books, who would also have been inclined to pick up medieval manuscripts, or friends of the artist. The most important of the former was Isaac d'Israeli, author of *Curiosities of Literature* and in the early 1790s a member of the Joseph Johnson circle.[24] He apparently visited Blake as early as 1794,[25] and bought a wide selection of Illuminated Books, including fine copies of *Europe* and *The Book of Urizen*, all of which are now identifiable.[26] Baron Dimsdale seems also to have come into the same category of collector, and he probably bought his copy of *The Book of Urizen* before 1800;[27] and Francis Douce, the great collector of curiosities and benefactor of Oxford University, was an early owner of *The Book of Thel* and *The Marriage of Heaven and Hell*.[28] Of Blake's friends the most avid collector was George Cumberland, who owned, amongst other books, *Europe* and *The Book of Urizen*.[29] Blake gave to C. H. Tatham in 1799 a copy of *America*,[30] and there is a tradition that the Yale University copy was given by Blake to Benjamin West.[31] Unfortunately there is no way of confirming this suggestive possibility, but it is not inherently unlikely that the artist should have presented a sample of his work to the President of the Royal Academy.

Other owners before 1800 are at present not identifiable, but it is known that Blake printed 'a selection from the different Books of such as could be Printed without the Writing'[32] for his old friend, the miniaturist Ozias Humphry.[33] This must refer to sets known as the *Small* and *Large Book of Designs*: a complete copy of each is in the British Museum, while the plates from second copies of both sets are scattered. In fact the second copies are not simply duplicates of the first, but make a slightly different selection from Blake's plates.[34] Both sets are magnificently colour-printed, and their date can be established by the first page of the *Small Book of Designs*, which is the title-page of *The Book of Urizen*; in the British Museum copy the printed date of 1794 is retained, but in the other version (private collection) the date has been altered to 1796. The British Museum copy of 23 pages seems to be nothing

more than a sampler from the Illuminated Books. Blake has simply printed the design part of the page, and they seem to come in no special order. As he himself pointed out, 'they when Printed perfect accompany Poetical Personifications & Acts, without which Poems they never could have been Executed.'[35] In the scattered second set, of which ten examples are known, he has added framing lines and enigmatic captions. The image of Urizen from the cut-down title-page of *The Book of Urizen* is captioned 'Which is the Way The Right or the Left'; the design of vegetative forms from *The Marriage of Heaven and Hell*, plate II, is inscribed 'Death & Hell Teem with Life', and the design from plate 14 of the same book, of the angel hovering over the body, is inscribed 'a Flaming Sword Revolving every way'.[36]

The *Small Book of Designs* is taken predominantly from *The Book of Urizen*, *The Marriage of Heaven and Hell*, and *The Book of Thel*, but the *Large Book of Designs* also contains designs which do not appear in the Illuminated Books. One of these is the famous *Dance of Albion*, and the two colour-printed versions (British Museum and Huntington Library)[37] apparently represent an intermediate stage between the first conception of 1780 (now lost) and the final engraved state (plate 80), inscribed 'Albion rose from where he labour'd at the Mill with Slaves: Giving himself for the Nations he danc'd the dance of Eternal Death.' It is a key image of Regeneration in Blake's work, and the gesture of exultation appears frequently in later designs as a paradigm of true religious ecstasy, a note rarely struck in the Prophetic Books of the 1790s. Blake has also included a colour-printed version of *The Accusers*,[38] colour-printed over an engraving which exists in several states, and a small and exquisite design of *Joseph of Arimathea preaching to the ancient Britons*.[39] This design was probably conceived originally in the context of the *History of England* series, although no early version is known, and its precise references to a 'historical' incident would have been contrary to the more generalized context of the Prophetic Books.

Although it is not part of the *Large Book of Designs*, it is perhaps appropriate to mention at this point the large print of *Lucifer and the Pope in Hell*, which is known only as a unique colour print on top of conventional engraving (Huntington Library) and an uncoloured impression of the engraving, also unique (British Museum).[40] Both the engraving and the colour print almost certainly date from *c.* 1794–6, but the design reverts back to an early drawing from Isaiah, where a king rather than a Pope is represented, in conformity with the Biblical text, and it returns again in a watercolour in the Butts series of *c.* 1805 (Boston Museum of Fine Arts).[41] The precise purpose of the print is unknown, but it is yet another example of Blake's tendency to revive youthful designs.

The *Large Book of Designs* also includes the plate known as 'A Dream of Thiralatha', probably a rejected design for *America*,[42] and full-page plates from *The Book of Urizen* and *Visions of the Daughters of Albion*. The visual effect of the whole is of great splendour, for the impressions have been made with great care. The general feeling is of powerful sublimity despite the small scale of the designs, and, in the Preludium design for *The Book of Urizen*, Blake achieves an extraordinary effect of tender luminosity by exploiting the fluidity and texture of the colour-printing. As a

G

sample of the glories of Blake's art the *Books of Designs* pre-eminently fulfil their purpose.

The tendency of visual design to become dominant in the Prophetic Books of 1795 reached its logical conclusion in the set of twelve large Colour Prints of the same year, which have no accompanying text and no fixed order.[43] Their size and careful finish give them more the character of exhibitable paintings, but they make reference to themes already adumbrated in the Prophetic Books. Blake offered them for sale individually; several were bought by Thomas Butts in 1805–6,[44] and in 1818 Blake described them as '12 Large Prints, Size of Each about 2 feet by 1½. Historical & Poetical, Printed in Colours',[45] and proposed to sell them for five guineas each. They are technically monotypes, but each design exists normally in three impressions, which differ in finish because the colour-printing provided only the foundation and each is finished extensively in pen and watercolour. According to Frederick Tatham:

> *Blake when he wanted to make his prints in oil . . . took a common thick millboard,*
> *and drew in some strong ink or colour his design upon it strong and thick. He then*
> *painted upon that in such oil colours and in such a state of fusion that they would*
> *blur well. He painted roughly and quickly, so that no colour would have time to*
> *dry. He then took a print of that on paper, and this impression he coloured up*
> *in watercolours, re-painting his outline on the millboard when he wanted to take*
> *another print.'*[46]

Doubt has been cast upon Tatham's account, for it seems unlikely that Blake would have used oil colour. But the effect intended was undoubtedly equivalent to the density of oil pigment, at the same time Blake was able to use a firm pen outline upon the surface so created. He evidently had difficulties from an early age with the 'blotting and blurring' properties of oil paint, and sought a way to combine its density with the precision of pen outline. He was not unaware also of the vigorous effect created by the 'accidental' look of his colour-printing technique, and the large area of the prints gave him much greater scope for achieving striking contrasts of colour and texture.

Although the twelve designs make reference to Blake's transcendental myth, ten of them have an immediate source in imagery and episodes from Milton, Shakespeare and the Bible; only *Newton* and *The Good and Evil Angels* refer back directly to Blake's myth. The literary sources are, however, of secondary importance. The subjects can all be related to the matter of the Prophetic Books, and Blake has been able to suggest interconnections between the episodes which would otherwise be unclear. Thus *Nebuchadnezzar* and *Newton* are paired as representatives of Science and the Senses;[47] *Pity* with *Hecate* as expressions of the Female Will, and *Elohim creating Adam* (plate I) and *God judging Adam* express the slavery of Religion. Even without placing the designs in a fixed order it is possible to see them as representing the salient points of Blake's myth as it applies to the history of man on earth, from his physical creation by Jehovah to the rationalism of the eighteenth century represented by *Newton*.

The most probable starting design is *Elohim creating Adam*, which is known in

only one example in the Tate Gallery.[48] In the literal sense it illustrates Genesis, ii, 7: 'And the Lord God formed man of the dust of the ground', for it shows Jehovah creating the form of Adam out of earth. Jehovah is revealed here as an aspect of man's Fall; the half-formed Adam protests violently, his face contorted in anguish, while a worm entwines itself around his leg. The Fallen nature of this action of creation is made more evident by contrast with its ultimate prototype, Michelangelo's *Creation of Adam* on the Sistine Chapel ceiling, where the gift of life is bestowed upon Adam. In Blake's interpretation it is not man who is created, but only his material form, for he exists eternally in the spirit. The design *Elohim creating Adam* seems to be paired with *God judging Adam*,[49] in which the aged Adam offers submission to Jehovah seated upon a flaming chariot led presumably by Horses of Instruction. Jehovah is seated with a book upon his knee, and his gesture of blessing implies the submission of man to Religion in the form of a vengeful God. *Satan exulting over Eve* appears to represent the second stage of the Fall: the division into sexes. Satan here is not a Promethean Orc figure, but the agent of Jehovah in corrupting Eve, who is now in the coital grip of the serpent.

The three designs discussed so far establish two parallel lines of development in the series; one, the domination of Urizen over the Fallen world and the other the division of sexes, from which arises Orc. Thus the colour print *Pity* appears to show the birth of Orc from Enitharmon lying on the ground. Enitharmon's prone position reflects that of Eve in *Satan exulting over Eve*. The *Good and Evil Angels* print shows the next episode in the childhood of Orc, and it might depict Los, perhaps bound down by jealousy, reaching out to restrain the boy as related in *The Book of Urizen*. Orc apparently makes no further appearance in the Colour Prints except insofar as he can be identified with the Risen Christ, and this may reflect Blake's disillusionment by 1795 with the possibility of political revolution in England.[50]

A group of three Colour Prints of relatively unusual subjects from the Old Testament continue the theme of the submission and division of man under the Old Dispensation. *Lamech and his two wives* tells of Lamech, a descendant of Cain and also a murderer: 'And Lamech said unto his wives, Adah and Zillah, Hear my voice; ye wives of Lamech, hearken unto my speech: for I have slain a man to my wounding, and a young man to my hurt. If Cain shall be avenged sevenfold, truly Lamech seventy times sevenfold.'[51] The story of Cain himself would seen to be more appropriate than that of the obscure Lamech to epitomize the cycle of murder and vengeance in the Fallen world, but Lamech was father by each of his wives of two artistic archetypes: by Adah he begat Jubal, 'the father of all such as handle the harp and organ'; and by Zillah he was the father of Tubalcain, 'an instructor of every artificer in brass and iron'. The two wives may represent, therefore, the arts in the Fallen world huddling together, but still the prey of the vengeful. The story of *Naomi, Ruth and Orpah* (plate 85) is also one of division, emphasized in the design by Ruth and Orpah turning away, the former towards the God of Israel, the latter towards many gods. *Nebuchadnezzar* is less problematic, for he had appeared in *The Marriage of Heaven and Hell* associated with the idea 'One law for the lion and the ox is

oppression.' His madness depicted here is associated with materialism, for Nebu-
chadnezzar realized the error of his belief in earthly power after his sojourn amongst
the beasts of the field.

The Old Testament scenes were probably intended to be followed by *Christ appearing
to the Apostles*, a design which has much in common with the watercolour of 1785 of
Joseph making himself known to his Brethren (plate 28).[52] Just as Joseph's revelation
was greeted with misunderstanding by all but Benjamin, so when Christ reveals
Himself only a young apostle looks towards him with adoration; the others prostrate
themselves as if He were an idol; hence the necessity for a Second Coming, and the
continuance of Urizen's tyranny even after the first Incarnation. If Blake had a
coherent order in mind he may have intended to place the enigmatic design of
Hecate here, for the mystery and darkness for which she stands would be an apt
parallel to Enitharmon's '1800 year sleep' in *Europe*. Hecate points to an open book,
the pages of which are blurred and unclear like the 'Book of Brass' carried by Urizen
in *The Book of Urizen*, plate 5. The horrific *Lazar House* (plate 81) is close in feeling
to the full-page plates in *Europe*, suggesting that it is meant to represent the miseries
of the pre-revolutionary era, where Death presides over a scene of disease and self-
destruction.[53] The scroll carried by Death probably represents the law, and the stand-
ing figure of the jailer combines the attributes of spiritual deprivation and mal-
evolence. He is related to the fiend who waits for the poet in *Europe*, Preludium I,
and he achieves his final apotheosis as the bestial warrior Skofeld in *Jerusalem*.[54]
Newton (plate 82) is chronologically the last design in the series of Colour Prints, and
he embodies the modern creation of a philosophy of the five senses. He is seated pre-
sumably in his cave,[55] working on a diagram with a pair of dividers, that often-used
symbol of materialism, his bent form implying the despair attendant upon such
activity. The origin of the motif in Blake's work is in *There is no Natural Religion*
series *a*, plate 10, where a similar figure accompanies the idea that 'He who sees the
ratio only sees himself only'; Newton's activity is, therefore, narcissistic, for the
diagram is but a reflection of the limits of his own perceptions. Newton, however,
has a redemptive role to play, for his overt materialism reveals Natural Religion as
nothing more than scientific materialism; Satan has thrown off the veil of Religion
and appears as his true self.[56]

The Lambeth Books and Blake's Contemporaries

Blake did not work on the Prophecies in complete isolation; he was fully engaged in the art world of London at the time, and many of his contemporaries were aware of his endeavours. The artists who gathered at Farington's house were all familiar with his designs and were divided on their merits. On 19 February 1796 Farington records: 'West, Cosway & Humphry spoke warmly in favour of the designs of Blake the Engraver, as works of extraordinary genius and imagination,—Smirke differed in opinion, from what He had seen, so do I.'[1] Blake's strongest defenders were principally those who had known him from youth, and those who scorned him were apparently equally hostile to Flaxman and Fuseli. Farington later reports a conversation of 12 January 1797:

> We supped together and had laughable conversation. Blakes eccentric designs were mentioned. Stothard supported his claims to Genius, but allowed He had been misled to extravagance in his art, & He knew by whom. —Hoppner ridiculed the absurdity of his designs, and said nothing could be more easy than to produce such. —They were like the conceits of a drunken fellow or a madman. 'Represent a man sitting on the moon, and pissing the Sun out—that would be a whim of as much merit.'

Hoppner then went on to make derisory remarks about Flaxman: 'Hoppners description of Flaxmans figures was equally ridiculous as that of Blakes fancies.'[2]

Blake must have been conscious of a general hostility towards his art in the 1790s, particularly in the years following the French Revolution, but he may have consoled himself with the knowledge that he shared the opprobrium of the multitude with such men of genius as Flaxman and Fuseli. Artists of known Radical sympathies were particularly open to wanton neglect and persecution. Barry's position at the Royal Academy became gradually untenable,[3] and Banks was in danger at one point of being tried for sedition.[4] Fuseli rapidly repented of his Revolutionary ardour and was able to live down his brief flirtation with the Wollstonecraft circle,[5] but Blake's reputation for eccentricity may have prevented his political views from being taken

seriously, and he was probably as oblique in conversation as in his prophetic writings.

Many stylistic elements of the Prophecies follow from Blake's higher aims, but they can also be related to a more general context. Thus the use of outline was a moral question to Blake, insofar as he claimed precision of contour to be necessary for visionary conceptions; on the other hand, in the 1790s artists influenced by Neo-classical ideals saw a firm outline as a way of recapturing the clarity and simplicity of early Greek art. Equally the symmetry of individual figures is usually associated in Blake's art with rigid morality; Urizen's symmetry of posture in the title-page to *The Book of Urizen* (plate 75), for example, is associated with despair and Science rather than Vision. In the wider artistic context, however, deliberate symmetry was a mark of conscious primitivism, and implied a rejection of Baroque illusionism. The distortion of physiognomy and gesture in Blake's Prophetic Books was appropriate to his horrific vision of the Fallen world, but the use of such imagery implied a definable position in relation to the theory of the Sublime and to the question of the theoretical limits of antique sculpture. Blake's contemporaries had little difficulty in placing him somewhere in the orbit of Fuseli, and debated the validity and seriousness of his imaginative gifts as they did in the case of the older artist.

Apart from Fuseli's *Milton Gallery*, the contemporary works of art most important to Blake were Flaxman's outline engravings to Homer and Aeschylus, which became available to his English friends in 1793–6. Flaxman had been in Italy from 1787 to 1794, but he had apparently written several times to Blake,[6] and it is likely that Blake, along with such artists as George Romney, had seen the engravings shortly after Flaxman's return.[7] Flaxman and Fuseli reveal an awareness in their works of the inadequacy of a naturalistic mode for the depiction of a moral universe, and their vocabulary is consequently dreamlike and insubstantial. Figures stand or float in a mysterious empyrean: in Flaxman's case an allegoric void (see plate 84), in Fuseli's a dense, smoke-filled abyss (see plate 85). The forms of nature play virtually no part in Flaxman's engravings, and they are treated with little enjoyment by Fuseli even where he depicts the delights of Paradise. The weight of expression in both works is entirely upon the human form, either naked or with robes revealing the underlying lineaments which are depicted, especially by Flaxman, with a firm contour and bounding outline.

Although Blake insisted in the *Descriptive Catalogue* of 1809 upon absolute purity of outline,[8] in the Lambeth Books his style avoided in practice the extreme linearity of Flaxman, because the exigencies of Illuminated printing made it difficult to achieve a sharp contour. However, he engraved several outlines in the manner of Classical gems for George Cumberland's *Thoughts on Outline*,[9] published in 1796, and his letters to Cumberland, which begin in 1795, are full of enthusiasm for the project. Cumberland argues that outline, as the authentic Greek method of making sculptures and reliefs, is essential to the revival of modern art, which must be based on the study of good examples of classical works. He also attacks the Royal Academy for 'crucifying invention', but the distinctive feature of the argument is the extremism of his commitment to purity of outline. Flaxman's *Homer* and *Aeschylus*

illustrations and the outline engravings after ancient vases in d'Hancarville's compilation of Sir William Hamilton's collection, which Blake had copied in his youth, are found deficient in purity, for even they contain lines 'thick and thin alternately, like the flourishes of a penman'.[10] Outline should represent 'A wire that surrounds the design', and should be at all times 'fine, firm, flowing and faint'. Cumberland admits that Michelangelo and Raphael revived the flame of antiquity, but he does not accept the claim that the Renaissance masters ever rivalled the antique. His position, though not cogently argued, thus places him amongst the most extreme advocates of Neoclassical idealism.

The outlines designed by Cumberland are simply etched 'inventions' in a tepid classical manner, and one would expect Blake to regard his own involvement merely as hack work; but his enthusiasm for Cumberland's classical idealism leaps from his letters of this period: 'If I were to act otherwise it would not fulfill the purpose for which alone I live, which is, in conjunction with such men as my friend Cumberland, to renew the lost Art of the Greeks.'[11] The Illuminated Books of 1793–5 would seem to be an unlikely vehicle with which 'to renew the lost art of the Greeks', but in Fuseli's art and attitudes a seeming contradiction between a theoretical classicism and stylistic sublimity can also be found. In matters of theory Fuseli was conservative enough to refuse even to consider the claims of artists and styles outside the tradition of Antiquity and the High Renaissance;[12] on the other hand, although he had translated Winckelmann in his youth, he dissociated himself from what he called 'the frigid ecstasies of German criticism',[13] by which he meant the insistence of Winckelmann, Mengs and Lessing that the beauty of Greek art was to be found in restraint and the suppression of emotion. Fuseli held that their unwarranted insistence upon the static qualities of Greek art denied the painter a classical precedent for depicting uncontrolled emotions, although a Dionysiac element was undeniably present in Homer. For Fuseli the *Laocoön* group was notable not for noble simplicity and calm grandeur, as it had been for Winckelmann, but for its expression of emotion, which he claimed the Greeks had allowed to fall within the province of artists as well as writers; the *Laocoön*, therefore, 'will always remain a sufficient answer to all that has been retailed in our days on the limits of the art by tame antiquarians from tamer painters'.[14] He claimed that 'Terror, as the chief ingredient of the sublime', had its place in Greek art as well as in Homer, and that classicism in painting was not confined to the insipid Raphaelism of, say, Mengs' *Parnassus*. Fuseli was concerned also to provide a theoretical basis in ancient art for his own passionate admiration for Michelangelo. For Winckelmann, Raphael had been the greatest representative of the 'Moderns',[15] but for Fuseli, Michelangelo was the true heir to antiquity, a view expressed also in Reynolds's last Discourse to the Academy of 10 December 1790: 'I would ask any man qualified to judge of such works, whether he can look with indifference at the personification of the Supreme Being in the centre of the Cappella Sistina, or the figures of the Sibyls which surround that chapel . . .; and whether the same sensations are not excited by those works, as he may remember to have felt from the most sublime passages of Homer?'[16] The

Michelangelesque sublimity of Blake's Prophetic Books, therefore, was not incompat-
ible with reverence for classical antiquity, nor is there any evidence that Blake in
the 1790s doubted the artistic supremacy of the Greeks.

While Blake's contemporaries in the 1790s tended to see him as a follower of
Fuseli, Fuseli himself seems to have been anxious to dissociate himself from Blake,
whom he professed to find eccentric. The relationship was closest from about 1788
until the end of the 1790s, but it was less a friendship of equals than a cordial
acquaintanceship between an eminent painter and man of the world and a bizarre
but entertaining engraver. Blake adopted an attitude of humility; Fuseli alone was
forgiven for 'discarding (Blake's) Graver',[17] an unpardonable offence when com-
mitted by anybody else, but Fuseli's recorded remarks about Blake are as treacherous
as Blake's are generous. He claimed on one occasion that Blake 'has something of
madness abt. him'.[18] Whilst Fuseli may have been intrigued by Blake's imaginative
works, and perhaps occasionally borrowed motifs from them,[19] there can be no
doubt that the predominant influence was from Fuseli to Blake. The idea that Blake
was the dominant force seems to have been created by his Pre-Raphaelite admirers,
at a time when Fuseli's reputation was at a particularly low ebb.[20]

Blake undoubtedly had close experience of the creation of the *Milton Gallery* and
he may have been a frequent visitor to Fuseli's studio at the time. The *Milton
Gallery* was first conceived as a project for an illustrated Milton with thirty engra-
vings after Fuseli's designs, for which Blake was to be one of the engravers.[21] Blake
had in his possession for a time in 1791 a version of *Satan withdrawing from Chaos*,
which preceded the *Milton Gallery* painting dating from 1794–6. This lost early
version was probably close to a drawing of the same subject (Mrs W. Murray Crane
Collection, New York)[22] which contains motifs apparently foreshadowing the *Book of
Urizen*; two Urizenic figures in the drawing, an old man crouching with his head
between his knees and glowering at the spectator and another in extreme foreshorten-
ing, may have influenced *Urizen*, plates 12 and 22, but the drawing as a whole is
more complex and diffuse in focus than any of Blake's compositions. Blake's art is
based more on single figures or small groups than Fuseli's work of the same period;
Fuseli is closer in spirit to the Creation scenes on the Sistine Chapel ceiling, Blake to
the figures of Prophets, Sibyls and Ignudi, which he had copied in his youth from
engravings. In the *Lazar House* colour print of 1795, Blake evidently borrowed the
dominant motif of the centralized figure of Death from Fuseli's painting of the same
subject of 1793 for the *Milton Gallery*.[23] Fuseli's use of symmetry in the 1790s is
often accompanied by extreme gestures and the human figure is treated as infinitely
malleable ectoplasm; such characteristic Blakean motifs as the posture of despair in
which the head falls forward between the knees can be paralleled in the *Milton
Gallery*,[24] as can also the gesture of exultation, but Fuseli's use of such gestures is
essentially unsystematic. Blake's most striking pictorial ideas were usually estab-
lished early in his career, but there can be no doubt that in his work of the 1790s he
absorbed much of the coloration of Fuseli's style in the *Milton Gallery*.

Of the twenty-seven subjects painted by Fuseli from *Paradise Lost* and recorded

in the *Milton Gallery* catalogue, twelve are taken from the first two books, of which
no fewer than eight are from Book II, the most horrific of the books, which tells of
Satan's encounter with the allegorical figures of Sin and Death. Fuseli's bias towards
the story of Satan was noted by Blake, but Fuseli depicts not only the salient epi-
sodes, but striking similes. Thus the painting of *Satan haranguing his Host* is fol-
lowed not by a painting of Pandemonium, but by 'figures from a simile in allusion
to the contracted form of the Spirits assembled in the new-raised Hall of PANDAE-
MONIUM illustrated by a simile from

> . . . *faerie elves,*
> *Whose midnight revels, by a forest side*
> *Or fountain some belated peasant sees,*
> *Or dreams he sees, while over head the moon*
> *Sits arbitress, and nearer to the earth*
> *Wheels her pale course, they on their mirth and dance*
> *Intent, with jocund music charm his ear;*
> *At once with joy and fear his heart rebounds.*[25]

In addition to depicting the *Meeting of Satan with Sin and Death at the Gate of Hell,*
Fuseli depicts a simile for the hounds who grow out of Sin, who are compared to thos
who

> *Follow the night-hag, when call'd*
> *In secret, riding through the air she comes*
> *Lur'd with the smell of infant blood, to dance*
> *With Lapland witches, while the lab'ring moon*
> *Eclipses at their charms.*[26]

Fuseli may have been attracted by the horror of these images, but his attempt to
depict them had important theoretical implications.

According to the traditional theory of *Ut pictura poesis,*[27] painting and poetry were
dedicated to the same end, namely the imitation of reality, and the activities of poet
and painter, though different, were in a sense interchangeable. The terms used to
define literature could be applied to art: an epic painting was just as valid as an epic
poem and so on. As artists turned increasingly to literature for pictorial subjects in
the second half of the eighteenth century, the question of which writers and what
kinds of writing were the most fruitful of visual images was much discussed. The
theory of *Ut pictura poesis* pronounced as the most suitable poets those who created
'poetical pictures' or passages complete enough to evoke the scene described, for the
painter would naturally be drawn to those passages which were most descriptive.
This assumption began to be implicitly attacked in Burke's *Philosophical Enquiry
into the Sublime and Beautiful* of 1757[28] and more specifically in Lessing's *Laokoon,*
first published in 1766.[29] Burke tended to dismiss painting as a means of achieving
the Sublime, because he thought that it was specifically concerned with the creation
of concrete images, while the essence of the true Sublime resided in forms which
were obscure and intangible. Lessing, however, argued that the beauties of poetry
and painting had to be judged by different standards; Homer's 'poetical pictures'

were indeed highly evocative, but it was precisely their quality as description which made it impossible for the painter to aspire to imitate them. It was impossible for the painter to match Homer's description of the shield of Achilles, whereas a brief reference to a banquet of the Gods left the scene on Olympus open to imaginative interpretation by the painter.[30]

Fuseli's essential position was initially anti- or rather pre-Lessing, for he does not seem to have read Lessing until about 1793. Until then he was concerned to emphasize at all costs the equivalence of the poet's and the painter's aim: 'The excellence of pictures or of language consists in raising clear, complete and circumstantial images and turning readers into spectators';[31] however, in a review of 1794 he invoked Lessing to attack 'the old maxim that poetry is painting in speech, and painting dumb poetry'.[32] In practice Fuseli's stance is essentially a traditional one, for by depicting similes he gives visual form to Milton's 'poetical pictures'; but in doing so he implicitly contradicted Winckelmann, who had specifically rejected Milton as a source for pictorial subjects precisely because of the lack of 'poetical pictures' in *Paradise Lost*.[33] It is unlikely that Blake had read or was fully aware of the theoretical implications of the *Laokoon*; it had not been translated from German, and if Fuseli had discussed it with Blake it would have been probably after Blake's practice in the 1790s had been established. Fuseli's treatment of Miltonic similes may, however, have helped to increase the freedom with which Blake treated poetic passages from great authors. Thus in the large Colour Prints of 1795 several designs are based upon similes divorced from their narrative context. *Pity*, for example, follows closely an image from a speech of Macbeth in Shakespeare's play:

And pity, like a naked new-born babe,
Striding the blast, or heaven's cherubin, hors'd
Upon the sightless couriers of the air,
Shall blow the horrid deed in every eye,
That tears shall drown the wind.

Indeed the variety of types of literary source which Blake used as a starting point for his visual imagery in the colour prints may also have been inspired by Fuseli's example.

Blake's relationship with Fuseli was both fruitful and complex, but other artists in varying degrees impinge upon a consideration of Blake's imagery in the 1790s. A glance through books of literary, historical and Biblical illustrations produced in the late 1780s and 1790s reveals numerous analogies between Blake's imagery and that of his contemporaries, but even when they tackle apocalyptic themes, they tend to approach them in a more earthbound and prosaic way. The French artist Philip de Loutherbourg was much attracted by unorthodox religion and had been a member of the Theosophical Society with William Sharp and Flaxman before becoming a Freemason.[34] His designs for the *Macklin Bible*, published in 1800, reveal him as predominantly a landscape artist choosing mainly subjects which involved the sublimity of nature, such as *The Deluge* and *Noah's Sacrifice*. Loutherbourg was also

responsible for the emblematic head- and tail-piece to each chapter, which are quite unlike Blake's imagery in spirit, and which would perhaps have appeared to Blake as unwontedly Catholic. In the head-piece to Galatians, for example, de Loutherbourg depicts a human heart, bleeding lambs, a sacramental cup under heavenly light emanating from Holy words; in the head-piece to Colossians there appears an altar, a papal tiara, cross and cup, and censer; and for Titus a heart impaled upon the Cross.[35] Loutherbourg's design for *The Vision of the White Horse* (plate 86), 1800,[36] reveals in the substantiality of the horse and the rider how far Blake had gone towards emancipating his vocabulary from the constraints of naturalism which still dominated History painting in the 1790s.

If the *Macklin Bible* represented the 'official' approach to the illustration of the Bible, there were other artists in London in the 1790s who would have been closer in sympathy with Blake's imaginative perception of sublime themes. George Romney devoted his last years to an abortive scheme for a series of enormous paintings (see plate 87). He wrote to William Hayley on 15 February 1794:

> *I had formed a plan of painting the Seven Ages, and also the Vision of Adam with the Angel, to bring in the flood, and the opening of the ark, which would make six large pictures. . . . My plan was, if I should live and retain my senses and sight, to paint six other subjects from Milton: three where Satan is the hero, and three of Adam and Eve. Perhaps six of each. I have ideas of them all, and I may say sketches.*[37]

The final paintings are not known but sketches for this project exist in profusion; Romney was in the habit of filling sketch-books with rapid designs, and there are several sketch-books devoted to the *Flood* alone.[38] Other artists in the 1790s also captured something of the visionary note associated with Blake. William Young Ottley, an amateur artist and pioneer of the appreciation of Early Italian painting produced a remarkable set of illustrations to Genesis in 1797 and of the *Life of Christ* in 1796, which combine visionary fervour with a firm, unyielding outline.[39] Ottley and Blake apparently did not become acquainted until much later,[40] but they may have known of each other through their mutual friendship with Flaxman. In Thomas Banks's beautiful model for the *Monument for the Hon. Mary Paken-ham* (plate 88) of 1791 (Soane Museum),[41] the image of the soul of the departed escaping from the prison of the body recalls Blake's visions of Regeneration in the Prophetic Books. Blake was probably aware of these artists at least through mutual friends, but whether he was on closer terms with them is not revealed by any remaining evidence.

An intriguing comparison can also be made between Blake's work in the 1790s and that of his German contemporary Asmus Jacob Carstens.[42] They are very unlikely to have known of each other's work but they shared a sense of the higher purpose of art and were equally at odds with conventional beliefs, from an essentially revolutionary perspective. Carstens' idealism was of a more purely classical kind than Blake's, but it is suffused with a Michelangelesque intensity, bursting from linear conventions. Unlike Blake, he had travelled in Italy and had absorbed the lessons not

only of Michelangelo and Raphael but also of Giulio Romano in the Palazzo del Tè in Mantua.[43] Carstens' subjects were nearly always classical, but his concern with the primeval origins of man brings him close to Blake at his most sublime. Carstens' *Nacht mit ihren Kindern* (plate 89) (Weimar, Nationalmuseum) illustrates Hesiod's account of the Creation, but it bears comparison with some of the plates in the *Book of Urizen*. On the other hand Carstens' inspiration is more sculptural and exhibits the marks of the 'stille Grösse' advocated by both Winckelmann and Lessing.

All the artists with whom Blake shared common attitudes had spent long periods in Rome, but his art in the 1790s begins to look less strange if it is seen in the wider context of the international 'Romantic Classicism', which emerged in Rome in the 1770s, particularly amongst artists from Northern European countries. Artistic self-consciousness, concern with syncretic mythology, admiration for the Primitive and extreme emotionalism are characteristic of many artists who had been in contact with the circle of Fuseli and the Scottish painter Alexander Runciman. Their admiration for the antique was centred more upon Homer than upon antique marbles, and they all sought to unite a 'Homeric' artistic method with Northern myth. Runciman returned to Scotland, and painted scenes from the History of Scotland and from Ossian; Nicolai Abilgaard, the Danish artist, made many designs from Ossian and Nordic mythology. Blake would have been aware of these trends through his friendship with Fuseli and Flaxman, but the 'international' elements of his style are not simply the product of direct influence, but of a common literary background, particularly between England and German-speaking countries. Behind the extremism of Fuseli's style is the influence of the *Sturm und Drang* movement, which began in Zurich under the tutelage of Fuseli's master Bodmer, but derived much of its impetus from a reconsideration of English poetry, particularly that of Milton and Shakespeare. The influence upon Blake of Fuseli and Flaxman in the 1790s had the effect, therefore, not only of providing him with a non-empirical artistic vocabulary, but of bringing him into line with international artistic currents, which in turn fused with earlier impulses in his own career.

Primitive and Original ways of Execution

Young's *Night Thoughts* and Gray's *Poems*

It was probably in 1796–7 that Blake embarked upon the new synthesis which is initially commemorated in the confused and unfinished manuscript of *Vala, or the Four Zoas*.[1] In the years 1796–8 he was also engaged upon two major commissioned projects: illustrations to Edward Young's *Night Thoughts* and, from his friend Flaxman, an illustrated edition of the poems of Thomas Gray. The *Night Thoughts* commission, from Richard Edwards the bookseller, was important and potentially lucrative; Farington noted in his journal for 24 June 1796:

> Blake has undertaken to make designs to encircle the letter press of each page of Young's Night Thoughts. Edwards the Bookseller, of Bond Str employs him, and has had the letter press of each page laid down on a large half sheet of paper. There are abt 900 pages.—Blake asked 100 guineas for the whole. Edwards said he could not afford to give more than 20 guineas for which Blake agreed.— Fuseli understands that Edwards proposes to select abt 200 from the whole and to have that number engraved as decorations for a new edition.[2]

In fact, Blake completed a total of 537 watercolours (British Museum), but publication was discontinued after the appearance of the first volume, which contained only 43 plates illustrating Nights I–IV.[3]

It is not known whether Blake or Edwards was responsible for choosing the *Night Thoughts* as a vehicle for Blake's designs, but Blake had earlier shown a taste for such early eighteenth-century poems[4] and he was capable of seeing the commercial possibilities of a handsome edition of a popular work. His project was one of the many which arose for illustrated volumes of the classics in the wake of the Boydell *Shakespeare Gallery*, and it had the additional advantage that it required investment not in a series of large oil paintings but only in a folio of watercolours. Farington's informant was Fuseli, who might possibly have suggested Blake for the commission as someone who would be grateful for such an opportunity, however meagrely paid.

The problem for an illustrator of the *Night Thoughts* was succinctly stated, pre-

sumably by Edwards, in the introduction to the edition: 'the narrative is short, and the morality arising from it forms the bulk of the poem.' *Night Thoughts* and *The Consolation* are a series of discourses on pious themes, and there is no narrative unity except for brief sections, such as the account of the early death of Young's 'daughter' Narcissa. The structure of the nine Nights follows the pattern of Fall and ultimate redemption through God, whom Blake identifies in his designs as Christ.[5] The dominant presences in Blake's illustrations are the Poet and Christ, and the forces of Darkness are represented by Night and Death. The poet is depicted frequently, and often satirically, in the early books (see plates 90, 92) as a full-size figure whose 'thoughts' are seen as tiny human and vegetable forms. In Night I, page 9 the lines

What, though my soul fantastic measures trod
O'er fairy fields; or mourn'd along the gloom
Of pathless woods; or down the craggy steep
Hurl'd headlong, swam with pain the mantled pool;
Or scaled the cliff; or danced on hollow winds,
With antick shapes wild natives of the brain?

are illuminated by the attenuated figure of Young sleeping, his head resting upon a book, while in the background his 'soul' makes the peregrination described in the passage. The block containing the text is the cliff scaled by the 'soul' and also the 'hollow winds' upon which dance the 'antick shapes'. An equivocal attitude towards Young is perhaps expressed in Night I, page 29, where the poet is seen reading his 'midnight song' to a lark. He is stretched full-length on the ground as female spirits seem to fly from him, but he is bound unknowingly by thorny branches. This design may imply the dangers of poetry which dwells upon nature and death, and it seems to contrast with the following design, which apparently shows the figure of Young soaring upward with his lyre, but still, like Hope, held down by a manacle around his ankle. This design illustrates the lines:

Oft bursts my song beyond the bounds of life;
What now, but immortality, can please?

Thus the poet is seen equivocating between the celebration of Nature and the desire to soar beyond it into the realms of the infinite.

In the designs as a whole Blake has tended to make Young's often discreet allusions to Christ more substantial. Thus both Nights I and VII are preceded by frontispieces of Christ rising, and references to Christ in the text are often given a greater weight in the illustration. The central idea of man's struggle with doubt is expressed in the title-page to the whole book by Thomas pointing at Christ's wound. The line 'Great Vine! on Thee: On Thee the Cluster hangs' in Night IX, page 94, is illustrated by a centralized image of Christ depicted literally as a vine around which cluster figures of adoration and reconciliation. The line 'That Touch, with charm celestial, heals the Soul, Diseas'd,' in Night IV, page 39, is seen by Blake as a reference to Christ's healing powers. Death the enemy and friend of man is depicted as a Urizenic white-bearded figure, usually with darts, but he appears also as a benign

Counsellor holding a scroll (Night III, page 33). Night is a female figure in a dark shroud, and her most striking appearance is in Night IX, page 98, where she is seated like a Burgundian *pleurante*:

> *How like a Widow in her Weeds, the Night,*
> *Amid her glimmering Tapers, silent sits?*

These four personifications, Poet, Christ, Night and Death, may be seen as the chief protagonists in Blake's interpretation of the poem, and a further unity is conferred by the repetition of certain motifs, such as a Gothic door, which stands for the passage beyond the body. An old man urgently turns the key of a Gothic door in order to hasten into death and rebirth (Night IV, page 9) (plate 92), and in the title-page to Night VI, the *Infidel Reclaim'd*, the infidel enters through a Gothic door, beyond which we can see a long cloister and at the far end a light of hope. Gothic motifs are thus at this point in Blake's career usually associated with death; a man muses amongst Gothic tombs in a church (Night IX, page 5); mourners lament beneath a Gothic tomb canopy (Night IX, page 20); but the Gothic age is also represented as one of spiritual tyranny. 'Superstition' is depicted as a raving monk in a Gothic setting denying Narcissa's corpse its rightful grave (Night III, page 14).

Blake's recourse to such constant visual motifs has the effect of reducing Young's meditations to a more orderly spiritual conflict, and the repetition of motifs has a unifying effect over the whole book. Blake also uses the designs to refer Young's thoughts as far as possible to Biblical sources. Thus a discussion of poetic inspiration in the text in Night VII, page 72, is brought back to the idea of Isaiah receiving inspiration upon his lips from a seraph.[6] The notion of shame expressed in the text on Night VII, page 25, is made to refer to Adam and Eve, who are depicted wearing fig leaves, starting up guiltily. The line 'How art thou caught? Sure captive of Belief' (Night IX, page 70) is illustrated by a scene of Christ and the Apostles as Fishers of Men literally gathering up souls in their net. A representation of the Good Samaritan illustrates the line in Night II, page 35, 'Love and Love only, is the Loan for love', but in Night IV, page 10, Blake gives a Biblical reference a distinctively Miltonic coloration by depicting Adam and Eve in illustration of the lines:

> *Sense and Reason show the Door,*
> *Call for my Bier, and point me to the Dust.*

The Fallen world is intimated by the symbol of the thorn,[7] just as the presence of Christ is made manifest by the vine, but the terrible alliance between King and Priest which dominates Blake's vision of the Fallen World is emphasized in the designs in a way that certainly was not intended by Young. Thus the political organization of the Fallen World is visualized by Blake as a mine in which slaves work in darkness, under the cynical jurisdiction of a crowned figure, whose spiritual hegemony is symbolized by the cardinal's and bishop's hats beside him (Night II, page 17); the demons Ambition and Avarice, 'Which goad thro' every Slough our Human Herd', are depicted as a King and Bishop guiding a harrow pulled by two slaves (Night VI, page 12). References in Young's text to the Pope, 'That persecuting Priest, the Turk of Rome', are also taken up with relish and the illustration to Night

III, page 16, shows a bloated bat-winged figure close in form to the figure of Palama-bron in plate 11 of *Europe*.[8]

Blake thus frequently uses his designs to impose his vision upon Young's text, but needless to say it would have been an impossible task to sustain the dialectic through-out 537 illustrations. Furthermore, some of Blake's greatest triumphs in the *Night Thoughts* can be seen simply as inspired solutions to the problems of visualizing the text, and expressing harmoniously and poetically different levels of metaphor within a single design. For example, where Young warns Lorenzo of the dangers of de-bauchery:

> *Should not each Dial strike us as we pass,*
> *Portentous, as the written wall, which struck,*
> *O'er midnight bowls, the proud Assyrian pale*

(Night II, page 27), Lorenzo is depicted as Belshazzar dropping the cup of Debau-chery in terror, while a figure, emitting a terrifying cry points with both hands towards the Writing on the Wall. The line 'Wealth may seek us; but Wisdom must be sought' (Night VIII, page 31) (plate 93) is illustrated by a poetic design of a young female asking the way of two nightwatchmen by moonlight, an image carry-ing an ineffable resonance of the soul seeking the way of truth. The evocative rich-ness of this design is matched by the illustration for the lines beginning 'Queen Lilies! and ye painted Populace!' (Night III, page 12). The idea of idleness is ex-pressed in a luminous vision of Helios led in a chariot by horses, as the personified lilies and sunflower follow his cycle passively. A comparison of the watercolour with the engraving (page 49) makes it clear how much of the brilliance of effect is due to the colouring. Some images achieve their power by startling literalness; thus the lines 'Why not the Dragon's subterranean Den, For Man to howl in?' (Night VII, page 40) are illustrated by a terrifying figure of a man enfolded within the coils of a giant serpent. Young's description of Narcissa's struggle to escape the serpent is represented in the title-page to Book III by a female figure aspiring frantically to reach beyond its enfolding coils, led on by the radiant light of faith. Such literalness, however, can verge upon bathos; the lines in Night V, page 41,

> *the Soul,*
> *which sleeps beneath it, on a Precipice,*
> *Puff'd off by the first Blast, and lost for ever*

are rendered by a comic image of a shepherd squatting asleep, leaning precariously over the side of a mountain. In some cases, however, the humour is intentional, as in Night VII, page 32, where Vanity is represented as a foolish dancing figure about to pirouette into the grave:

> *They see no farther than the Clouds; and dance*
> *On heedless Vanity's phantastic Toe.*

Young's *Night Thoughts* is essentially a solemn poem, and its relentless highminded-ness spreads thinly over the nine Nights it takes the poet to find the Consolation of earthly existence. The demands of the commission which led Blake to provide a design for every page inevitably resulted in a great deal of staleness and repetition.

Nevertheless they seem to have greatly impressed John Flaxman and his wife Nancy, who offered him the more congenial task of illustrating a volume of the collected poems of Thomas Gray, a poet less prolix and more various than Young.

Blake's designs for Gray's *Poems* (see plates 94, 95) are similar in format to the watercolours to Young's *Night Thoughts*, but this time only 116 watercolours were required to fill the volume.[9] A copy of the 1790 edition of Gray was disbound and set into large sheets of paper, which Blake then adorned in watercolour. After the removal of the preliminary matter from the edition, there were 116 spaces left to be illustrated, leaving no gaps in the sequence of illustrations. They were commissioned in 1797[10] and should be seen in the context of the gifts Flaxman was in the habit of giving his wife for her birthday. He often made up presentation volumes, of which some are known; possibly in 1804 he gave her a volume with portraits of most of their friends[11] and in 1812 he made for her a manuscript with illustrations entitled *The Casket*.[12] Such gifts were essentially light-hearted, and usually contained a strong comic or whimsical element. Nancy Flaxman wrote to a friend in 1797 that Blake was 'of strong and singular Imagination he has treated his Poet most Poetically Flaxman has employ'd him to Illuminate the works of Gray for my Library'.[13] Mrs Flaxman then was clearly the *primum mobile* in the project, and it may have been her idea that Gray should be the subject, and that the format should follow the *Night Thoughts*.

One significant difference between the two projects lay in the organization, for while the *Night Thoughts* had a complex structure not easily encompassed by a single idea, the 1790 edition of Gray's *Poems* did appear to be organized so that the themes of the poems corresponded to the development of an individual mind from birth to death. It was, therefore, possible for Blake to regard the sequence of poems as reflecting Gray's own life and career, from the youthful spirit of *Ode on the Spring*, through the perils of adolescence in *Ode on a Distant Prospect of Eton College*, the middle-aged reflectiveness of *The Progress of Poesy* to the concern with death in the *Elegy Written in a Country Churchyard*. Blake is able to impose his own unity on the poems through the illustrations and so to provide a commentary upon Gray and the kind of poet he was. This is not of course the whole story; Blake has also allowed his fancy to wander amongst Gray's imagery, and hidden meaning need not be sought in every illustration. His own poetic preface gives something of the guiding spirit of the work:

Around the Springs of Gray my wild root weaves.

Traveller, repose & Dream among my leaves.

Gray's images are more often comic than tragic, and Blake has tried to respond to the humorous poems in kind.

Gray himself, or rather his spiritual self, makes his first appearance on the title-page 'The Pindaric Genius receiving his lyre' and in a watercolour accompanying a list of designs, which precedes the first poem, *Ode on the Spring* (plate 95); together the two designs represent two stages of poetic creation as 'exulting in immortal thoughts' and the transformation of the thoughts into poetry. The poet writing is

H

seen as young and eager, basking in the sunlight of Inspiration, concentrating in-
tently, if comically, upon his task, an image which also leads on to the design for the
first page of *Ode on the Spring* (page 3), where the poet awakens to the joy of spring.
The governing idea of the first illustrations is youthful Innocence, and the crisis of
Gray's adolescence may be depicted in the *Ode on a Distant Prospect of Eton College*,
where the bookish contemplation of the youthful Gray is suddenly invaded by 'The
Ministers of human fate, And black Misfortune's baleful train!' Blake's illustration
of this episode (page 18) is a *tour de force*, and is a good example of his ability to
create a dramatic effect from the turning of a page (plate 94). Thus the peaceful
scene of adolescent pleasures on page 17, where boys play idly and contentedly, and
reading is a leisurely delight, is destroyed on the following page by a swarm of mon-
strous fiends.

Gray is seen returning to the creative act in the preface illustration (page 42) to
The Progress of Poesy. He has left youth behind and is seated in contemplation of a
folio volume which he studies by the light of a large Gothic window, where can be
seen a prophetic figure apparently writing to the dictation of a muse. The Gothic
window in this context could imply Gray's antiquarianism; on the other hand it is
more likely that Gray is absorbed in his book at the expense of prophetic inspiration
represented by the prophetic image in the Gothic window. In any case it seems fairly
clear that *The Progress of Poesy* is regarded by Blake as a piece of academicism, un-
illumined by the sun of Inspiration, and that Gray, in his middle years, has with-
drawn from a contemplation of the relationship between the Eternal and the Fallen
world. The consequence of this withdrawal is a morbid and fearful material religion
in which death is seen as an end rather than a gateway into Eternity. Thus in the
illustrations to the *Elegy Written in a Country Churchyard* Gray is shown as suc-
cumbing to the inevitable fate of the rationalist: the melancholy contemplation of
death and a forlorn grasping at posterity. Old and bent, he writes on a piece of paper
in what appears to be the portico of a Gothic church (page 105), here signifying the
institutional church; his melancholy is that of a man who has lived life not by a
burning prophetic faith, but by gradual resignation in the face of death.

Much more could be said of the subtleties of Blake's interpretations of Gray's
poems, but the illustrations are principally important for their role in Blake's de-
velopment as a book illustrator. Here we can see illustrative design used as a means of
interpretation, not only illuminating the text but actually running counter to it,
revealing the Divine Analogy even through the work of a poet apparently unaware
of it. These designs, therefore, establish a technique of interpretation which was to
flower in the designs for Milton and Dante, whose poetic personalities were as com-
plex and divided as Blake's own.

The Butts Tempera Series

After the publication of the *Night Thoughts* engravings in 1797 there is little trace of Blake's activities until 1799, when he began work upon a series of Biblical illustrations for his new patron Thomas Butts.[1] Three important Blake letters also survive from that year concerning an unfortunate attempt by George Cumberland to gain for Blake a commission for original designs. It is a delightful irony, and one which does not suggest much prescience on Cumberland's part, that Blake's intended patron should have been the Rev. Dr Trusler, the author of *Hogarth Moralised*, and famous in his day for such works as *The Way to be Rich and Respectable* and *Luxury not Political Evil*. Trusler ordered from Blake two watercolours on the theme of Malevolence and Benevolence, and apparently gave instructions as to the content of the works, but Blake sent a design of his own invention, which he discussed in a letter of 16 August 1799:

> *I attempted every morning for a fortnight together to follow your Dictate, but when I found my attempts were in vain, resolv'd to shew an independence which I know will please an Author better than slavishly following the track of another, however admirable that track may be. At any rate, my Excuse must be: I could not do otherwise; it was out of my power.*[2]

The watercolour of *Malevolence* (plate 96) has fortunately survived and is now in the Philadelphia Museum of Art.[3] Blake describes it as: 'A Father, taking leave of his Wife & Child, Is watch'd by Two Fiends incarnate, with intention that when his back is turned they will murder the mother & her infant.' The innocent beauty of the family group is contrasted with the two fiends, who lie in wait with daggers behind a rock. The foremost fiend resembles the one who waits for the Traveller in the Preludium of *Europe*, and Blake also represents Envy lying in wait to destroy those who are divinely blessed: 'Is not Merit in one a Cause of Envy in another, & Serenity & Happiness & Beauty a Cause of Malevolence?' In the background there is a beautiful but sinister landscape with the moon reflected on the water of a mountainous lake or river.

Trusler, in his reply to this letter, complained specifically that the malevolence of the fiends had no ostensible motive, and his regret that Blake lacked the expressive gifts of a caricaturist enraged the artist and stung him into the first of many apologias for his own art. In his reply to Trusler, on 23 August 1799, Blake asserted for the first time the primacy of what he defines as 'Visions of Eternity', whose authenticity, he claimed, was actually confirmed by Trusler's failure to comprehend them, for 'what is not too Explicit [is] the fittest for Instruction, because it rouzes the faculties to act'.[4] Trusler's call for subject matter taken directly from ordinary life, on the grounds that 'the Visions of Fancy are not to be found in this World', is answered by a ringing defence of Ideal art, 'addressed to the Imagination, which is Spiritual Sensation'. Blake claims that his figures are well-proportioned because 'they are those of Michael Angelo, Rafael & the Antique, & of the best living Models', and contrasts them with the 'Caricature Prints' favoured by Trusler.

Blake's invocation of the classical tradition and an art of ideal forms is particularly interesting at this point, ironically because of its essential orthodoxy. He would have found more agreement for his general position amongst art theorists of previous generations than would Trusler, whose advocacy of simple didacticism would have seemed to them naive. Blake and Sir Joshua Reynolds were agreed that painting should depict the ideal world evoked by the great Antique and Renaissance masters, although Blake rests his Visions upon individual perception, and not, like Reynolds, upon abstraction from the empirical reality of observed nature. Thus Blake denies the existence of a nature existing independently of man, for it can only be experienced through man's perceptions. 'Visions of Fancy' are to be found in the world only in so far as they exist in the mind of the beholder: 'As a man is, So he Sees.' Blake argues, therefore, that Trusler cannot see 'Visions of Fancy' in Nature because of his blinkered perception: 'To the Eyes of a Miser a Guinea is more beautiful than the Sun, & a bag worn with the use of Money has more beautiful proportions than a Vine filled with Grapes.' Trusler regarded nature's supposed 'deformities' as morally illuminating, and Reynolds in his *Discourses* saw them as data from which could be extrapolated an image of the Ideal.[5] For Blake, on the other hand, nature's imperfections are a function of imperfect perception on the part of the beholder. In terms of artistic theory, then, Blake stands with Reynolds against Trusler on the necessity for the artist to represent a world more pure and ideal than our own, but Reynolds and Trusler would have agreed that the world outside their perceptions repaid study and required intervention.

Blake's letter to Cumberland of 26 August 1799, reaffirmed his belief in the Great Style:

> *I have made him a Drawing in my best manner; he has sent it back with a Letter full of Criticisms, in which he says It accords not with his Intentions, which are to Reject all Fancy from his Work. How far he Expects to please, I cannot tell. But as I cannot paint Dirty rags & old shoes where I ought to place Naked Beauty or simple ornament, I despair of Ever pleasing one Class of Men. Unfortunately our authors of books are among this Class; how soon we Shall have a change for*

the better I cannot Prophecy. Dr Trusler says: 'Your Fancy, *from what I have seen of it, & I have seen variety at Mr Cumberland's, seems to be in the other world, or the World of Spirits, which accords not with my Intentions, which, whilst living in This World, Wish to follow* the Nature of it.' *I could not help Smiling at the difference between the doctrines of Dr Trusler & those of Christ.*[6]

In the same letter Blake announces that he is 'Painting small Pictures from the Bible' and he elaborates further: 'My Work pleases my employer, & I have an order for Fifty small Pictures at One Guinea each, which is Something better than mere copying after another artist.' His employer was Thomas Butts and the work which pleased him was the series of fifty tempera paintings of Biblical subjects, many of which are dated 1799 or 1800. The advent of Thomas Butts marks the beginning of a long period in which Blake was able to gain a small but fairly steady income from the sale of his original works. Butts was a clerk in the office of the Muster-Master General, responsible for army supplies, and although apparently not a man of wealth he amassed the most extensive contemporary collection of Blake's work. It is not certain whether Butts or Blake conceived of the idea of a Biblical series, but the original commission was evidently completed to Butts' satisfaction, for he followed it with a further order for watercolour illustrations to the Bible.

Blake later called the techniques he had used for the first Butts series 'Fresco', but in the first letter to Trusler, of 16 August 1799 he claims to be working at the time with some kind of oil painting although he later repudiated its use. This must surely refer to his experiments with tempera, but in the same letter he made reference to his own close study of Rembrandt and Teniers. In 1809, however, when publicizing his discovery of 'Portable Fresco'[7] he associates his tempera technique explicitly with Early Renaissance panel paintings, which in their linear clarity and lack of shadowing his tempera paintings most closely resemble. Blake's method of tempera painting grew essentially out of his earlier experiments with colour-printing, which he had evolved in order to achieve a greater density of texture. But in colour-printing this gain in substantiality had been at the expense of clarity and transparency, for the colour tended to spread when transferred from one surface to another, and required extensive correction in pen and watercolour. The experiments with tempera were concerned with finding a way of preserving the linear clarity of watercolour without losing the density of oil painting.

The technique which Blake evolved is of layers of watercolour applied to a white ground on a firm support of copper, panel or canvas, rather than paper. Density is achieved by the use of a medium which holds several layers of colour separately in suspension, and precision of contour is achieved with penwork. J. T. Smith, an early friend of Blake, has left a vivid description of him at work with tempera: 'Blake's modes of preparing his ground, and laying them over his panels for painting, mixing his colours, and manner of working, were those which he considered to have been practised by the earliest fresco-painters, whose productions still remain, in numerous instances, vivid and permanently fresh. His ground was a mixture of whiting and carpenter's glue, which he passed over several times in thin coatings: his colours he

ground himself, and also united them with the same sort of glue, but in a much weaker state. He would, in the course of painting a picture, pass a very thin transparent wash of glue-water over the whole of the parts he had worked upon, and then proceed with his finishing.'[8] The technique is not fundamentally unsound, but the use of glue made the surface extremely sensitive to the atmosphere. As a consequence some have survived in good condition where atmospheric conditions have been ideal, but others began to flake badly from an early date, especially those on copper. William Michael Rossetti, in the list of Blake's paintings published in Gilchrist's *Life* in 1863,[9] noted the ruinous condition of some of the Butts' Biblical temperas and many can be presumed lost for ever.

Of the fifty paintings commissioned, some forty either survive or can be identified from the full descriptions given by Rossetti or from references in early sale catalogues. Even though a complete reconstruction of the Butts tempera series is impossible, it is clear that the primary theme is the Life of Christ, preceded by historical and typological subjects from the Old Testament. Of the surviving paintings six belong to the Old Testament and twenty-one to the New Testament, and in addition there was a set of the four Evangelists, two of which are now missing. Rossetti also mentions a number of missing paintings of Old Testament subjects,[10] so the series probably consisted of approximately fifteen Old Testament subjects and thirty-five from the Life of Christ.

A general idea of Blake's intentions in the Butts tempera series may be gleaned from two later paintings (plates 97, 98), *The Spiritual Condition of Man*[11] 181(1?) (Fitzwilliam Museum, Cambridge) and *An Epitome of Hervey's Meditations among the Tombs, c.* 1806–15 (Tate Gallery).[12] Both contain small vignettes of Biblical scenes, in some cases ones that had already appeared in the Butts Tempera series, organized according to a sequence illustrating the Creation and Fall of Man and his Redemption through Jesus Christ. *The Spiritual Condition of Man* has, running down the left-hand side, tiny continuous scenes of the history of Israel from the Creation to the Crucifixion of Christ seen from behind, while on the right-hand side the story of the Christian Redemption is depicted, from the *Ascension of Christ* to the *Last Judgement*, with Christ now enthroned on the same level as the Creator on the other side. In the *Epitome of Hervey's Meditations* Christ is depicted, in the centre above the church altar, adored by the figures of Moses and Elijah. Thus Christ is seen both as the Messiah of the Prophets and the inheritor of the law of Moses in its prophetic aspect. The patriarchs of the Old Testament are described by Blake as 'male-females'[13] because they are essentially dualistic; they preserve through the Synagogue the Poetic Genius inherited by Christ. On the other hand their worship of the God of this World leads them into Pharisaism. Christ is, therefore, the inheritor of the Synagogue but also the scourge of its Moral Law.

The subjects of the Butts tempera series are, by and large, different from those in the two synoptic paintings, but as in most Biblical cycles in Western art the subjects mark stages in the process of Fall and Redemption. The most recent precedent was Benjamin West's abortive scheme for the adornment of St George's Chapel, Windsor,

which Blake would have known from the frequent appearance of paintings for it at the Royal Academy.[14] It is not surprising, then, that Blake has chosen Old Testament subjects which in every surviving case have precedents in earlier European art, although some are uncommon. On the other hand, his interpretation of the subjects is guided by his own personal theology, and in one case by his reading of Milton's account of the Fall. In the tempera painting of the *Temptation of Eve* (Victoria and Albert Museum) (plate 99), the striking motif of the serpent coils towering above Eve owes its form more to Milton's description in *Paradise Lost* than to previous iconographic tradition:

> *And toward Eve*
> *Address'd his way, not with indented wave*
> *Prone on the ground, as since, but on his rear,*
> *Circular base of rising foulds, that tour'd*
> *Fould above fould a surging maze, his Head*
> *Crested aloft, and Carbuncle his eyes;*
> *With burnished Neck of verdant Gold, erect*
> *Amidst his circling spires, that on the grass*
> *Floted redundant.*

Eve's position within the coil of the serpent is apparently unprecedented in European art and although her hand reaches upward it is not towards the apple in the mouth of the serpent; she appears to be preening herself at the serpent's flattery, and the sexual overtones are confirmed by her open nakedness and her failure to make the gesture of modesty associating the fatal act with the sense of shame, which often accompanies the grasping of the apple in early German versions.[15] Also apparently unprecedented is the presence of the sleeping Adam with his spade beside him in the background behind Eve and the serpent. German engravings almost always show Adam as an active participant in the Fall if not the prime mover, and his acceptance of the apple is usually conjoined with Eve's. Milton, on the other hand, describes the serpent approaching Eve when Adam has gone to work in the fields: 'Her husband, for I view far round, not nigh.' Blake may have departed from precedent because he wished to conflate several actions attendant upon the Fall; the recumbent Adam may refer to the creation of Eve as well as to his own Fall, and Blake may have intended to show the process of the creation of woman, her Temptation and Fall, and the Fall of Adam, for the serpent's tail seems to curl around his sleeping form. The juxtaposition of the contrasting forms of Adam and Eve suggests birth, but it also points to the Fall as the division of man's primal unity into male and female, a division which is resolved into contrasts between wakefulness and sleep, sexual openness and modesty, innocence and corruption.

Much of the evocative power of the painting comes from the unexpected dissociation of the elements: Eve does not quite reach for the apple, nor does she come directly from Adam's side, she stands in one coil of the snake but is not completely enfolded by it. The background also contributes to the haunting atmosphere: a waterfall under a full moon pours into a river or a lake, also suggestive perhaps of

sexuality. In the picture of *Malevolence*, to which it is very close in date, the motif of the moon reflected on the waters contains the suggestion of the impending descent of darkness, which will allow Malevolence to emerge from hiding, a fitting image of the Fall itself. With the Fall man enters a dark night, which is only illuminated by the advent of Christ.

Lot and his daughters (Huntington Library) is the first surviving painting to depict the Fallen world. The story seems to imply for Blake the unnatural sexual divisions of the Fallen world, which led to the creation of Moabites and Ammonites, the enemies of Israel and inheritors of the vices of Sodom and Gomorrah. Lot is depicted as a slumbering Farnese Hercules, and the composition perhaps makes a satirical reference to the well-known Baroque composition of *Hercules between Vice and Virtue*.[16] Lot is clearly of the type of Strong Man described in *The Descriptive Catalogue* as acting from conscious superiority who 'marches on in fearless dependance on the divine decrees, raging with the inspirations of a prophetic mind'.[17] The role of the *Sacrifice of Isaac* (Mellon Collection) may be explained by reference to the *Descriptive Catalogue* of 1809: 'Abraham was called to succeed the Druidical age, which began to turn allegoric and mental signification into corporeal command, whereby human sacrifice would have depopulated the earth.'[18] The painting must refer to the moment when mankind turned away from human sacrifice; the lamb in the thicket signifies Jehovah's acceptance of an animal sacrifice in its stead. Abraham's obedience to the command of Urizen even if it entails the sacrifice of his son may represent the monotheism of Israel, while Lot, by contrast, would stand for the pagan rejection of all divinity in favour of the senses. Blake would also have been aware of the traditional typological connection between the sacrifice of Isaac and Christ's sacrifice.[19]

The subject of *Bathsheba at the bath* (Tate Gallery) is unexpected in the context of a Biblical cycle but the emphasis on the seductive form of Bathsheba may have been intended to expose the sensuality of the most prophetic of the Hebrew kings, revealing the double nature of Hebraic kingship. Out of David's union with Bathsheba came Solomon, who also plays an important role in Blake's idea of kingship; in the painting of *The Judgement of Solomon* (Fitzwilliam Museum) his act of justice is probably meant to be seen not as an act of superior wisdom, but as a usurpation by a mortal of Divine justice. On other occasions in Blake's visual work, Solomon is depicted with a pair of compasses,[20] a Blakean symbol of materialism, but in the case of Solomon it refers more precisely to Hebrew legalism, or worship of the letter over the spirit.

It is difficult in most cases to be certain of what other subjects might have belonged to the Old Testament cycle of the Butts tempera series, but a *Hiding of Moses* described by Rossetti corresponds to a later watercolour design (Huntington Library) and to an engraving.[21] Moses is the focus of Blake's continued meditation upon the Old Testament. He is a key figure in *The Spiritual Condition of Man* and in the *Epitome of Hervey's Meditations*; in the former in his warlike role, casting the Egyptians into the Red Sea, and in the latter as representative, along with Elijah,

of Hebrew prophecy. Thus he receives the Decalogue from Jehovah, the Moral Law
of repression, but by leading Israel out of Egypt he preserves the spirit of Hebrew
prophecy from those who wish to destroy it, and by praying to Christ in the *Epitome
of Hervey's Meditations* he reveals himself as His prophetic forerunner. In the design
of *The Hiding of Moses* (plate 100) Blake has laid great emphasis on the Egyptian
aspects of the landscape: the two pyramids in the distance, the sphinx, and the palm
trees. But Egypt is a spiritual state, and in a spiritual sense the infant Moses represents
prophecy withstanding determined attack from Pharaoh, who wishes by killing
Hebrew infants to suppress it. The survival of Moses in the bulrushes is, therefore,
vital for the survival of prophecy itself, for had the infant Moses perished, the children
of Israel would have remained perpetually in Egyptian slavery. The fears of Moses'
parents in the watercolour version are for the child Moses, but also for the fate of
prophecy. In the engraved version of 1824 the distant landscape, watched by Moses'
sister Miriam on guard, is illuminated by a dawn-like radiance, suggestive of the
hope of Redemption ensured by Moses' survival.[22] There is also an implicit typo-
logical element in the subject and in Blake's interpretation of it; the story of the
infant Moses was a conventional type of the *Flight into Egypt*, a subject which also
appears in the tempera series, and the way in which Moses' mother falls back upon
her comforting husband foreshadows Mary and Joseph in the *Nativity* tempera of the
present series.

A high proportion of the Old Testament temperas from the Butts series have evi-
dently been lost, but nearly all the paintings of the Life of Christ have either survived
or can be accounted for in sale records. The first subject from the New Testament,
The Angel Gabriel appearing to Zacharias (Metropolitan Museum of Art, New York)
(plate II), acts as a bridge between the Old and New Dispensations, for Zacharias is
a High Priest of the Synagogue and the father of John the Baptist, whose impending
birth Gabriel announces to him.[23] In this extraordinarily beautiful picture it is
light which defines the confrontation between the Old and the New. The light
which Gabriel brings as harbinger of Christ overwhelms in unity the fragmentary
luminosity of the Menorah, the flaming censer, and the sparkling jewels of Aaron's
breastplate, which Zacharias wears. The elaborate trappings of ritual with which the
High Priest surrounds himself are exposed as baubles in the face of Gabriel's revela-
tion of the Inner light. No *Annunciation* is known to have been painted by Blake, and
it is probable that he has substituted this rare subject for the more usual one. The
dramatic advent of the New upon the Old is also seen in the remarkable *Nativity*
(Philadelphia Museum of Art) (plate III).[24] The striking motif of the Christ Child
leaping from the Virgin Mary into the hands of St Elizabeth, and the presence of St
John the Baptist as an infant witness of the birth of Christ, are both apparently
unique in European art, although the infant St John, occasionally accompanied by
his mother Elizabeth, is often depicted paying homage to the infant Christ. The
moment of birth is represented as a heavenly burst of radiance as Mary leans back
chastely against Joseph. The notion of the Christ Child leaping into the world has
intimations in Blake's previous work, if in a less exultant sense than here depicted:

My mother groan'd, my father wept.
Into the dangerous world I leapt:
Helpless, naked, piping loud:
Like a fiend hid in a cloud.[25]

At the beginning of *Europe* the birth of the 'secret child' who is both Orc and Christ is seen as a descent 'thro' the orient gates of the eternal day', but here the revolutionary element of the new-born Christ has been transcended by exultation. The birth of Christ is depicted similarly in the first illustration to the series *On the Morning of Christ's Nativity* (plate 156),[26] and in *Sullen Moloch* in the same series the Christ Child leaps out of Moloch's furnace in a dramatic radiance, putting the spirit of the idol to flight.

The position of Mary sinking back into the lap of the stooping Joseph reflects closely the way in which Moses' mother, overcome with grief, leans back against his father in *The Hiding of Moses*; thus a parallel is made, which would have been clear when the paintings were first assembled, between the fate of Moses unattended in the land of Egypt and the grief of Christ's parents at His fate on Earth. The gestures of Joseph and Mary also recur in the next surviving picture of the series, *The Adoration of the Shepherds* (Brighton City Art Gallery), suggesting a pairing of the two paintings: the former representing the spiritual birth of Christ and the latter the historical birth, in the form of the three Kings offering the child material gifts. The foremost king is a Urizenic type suggesting the formal obeisance of the mighty of the world to Christ—offering material goods but retaining their crowns. The conventionality of the iconography is striking after the extraordinary vision of the *Nativity*, and it emphasizes the physical rather than the spiritual presence of the child Jesus, for the pagan kings submit to him as a greater king and not as a transforming spirit.

The Circumcision (private collection) evidently shows the recognition by the Synagogue of Christ as Redeemer; the mantle of Hebraic priesthood is passed on to the infant by Simeon under heavenly guidance. The next two pictures in the sequence are *The Flight into Egypt* (George Goyder Collection) and *The Repose in Egypt*, now lost but fully described by Rossetti: 'The Holy Family are within a tent; an angel at its entrance; the donkey outside. Very dark by decay of the surface, and otherwise injured.'[27] *The Flight into Egypt* shows the Madonna and child on the back of a donkey led by Joseph, who looks back at them. They are accompanied by three angels and the holy group are surrounded by a radiance of *putti*, who protect them from the material state of Egypt. *The Virgin hushing John the Baptist* (Warren Howell, U.S.A.) (plate 101) is an unusual mixture of motifs deriving mainly from the Renaissance and Post-Renaissance theme of 'Il Silenzio', which Blake could have known from the Bonasone engraving after Michelangelo, and from seventeenth-century masters.[28] The theme combines an intimate domestic scene with intimations of Christ's death in his sleeping posture, which reflects the *Eros Funéraire* of the Psyche legend, explicitly referred to in the butterflies, one of which John brings in to show Christ while another flies off in the air.[29] The butterfly which

often accompanies the *Eros Funéraire* signifies the belief in the return of the soul to the body when the temporary sleep of death has passed. *Jesus riding on a lamb* (Victoria and Albert Museum) shows John the Baptist as the companion of the infant Christ, for he represents for Blake the reconciliation of Old Testament prophecy with Christian Revelation. The infant Jesus points to the Baptist, who holds out straw for the lamb to eat. The lamb is an intimation of Christ's sacrifice, towards which he is led by the prophecy of John the Baptist. There are two versions of the *Christ Child asleep on the cross* (George Goyder Collection and Victoria and Albert Museum), a motif which appears to be exclusively post-Counter-Reformation,[30] and which is another obvious intimation of Christ's sacrifice. The infant lies asleep on a cross-shaped piece of wood, which appears to be part of the house or workshop being built by Joseph in the background. In the Victoria and Albert Museum version the Madonna alone watches over him, but in the Goyder painting Joseph is also present, holding a pair of compasses, which in the Victoria and Albert Museum version rest against the frame of the building behind Christ. In a later watercolour (Walsall Art Gallery),[31] Blake associates the compasses with Joseph's carpenter's shop, where the infant Christ is demonstrating their use to his parents. Blunt suggests that this is intended to show the reconciliation of reason with imagination in Christ's Redemption,[32] but they may also signify in this context that Christ's sacrifice will be at the hands of Reason in the form of the Law of Solomon, which is also in Blake's work symbolized by compasses and often represented by severe rectilinear buildings or constructions.[33] Two lost paintings mentioned by Rossetti, *The Christ Child taught to read*[34] and *Christ with the Doctors in the Temple*,[35] bring to an end the Infancy cycle.

The Baptism of Christ (Rhode Island School of Design) inaugurates the cycle of Christ's Ministry, as he fulfils the prophecy of John the Baptist. The Baptist invokes the Holy Ghost, or prophecy, represented by a dove in an angel-filled radiance in the sky, while bystanders watch in awe. The *Baptism* is followed by four panels of miracles performed by Christ, of which one, *The Pool of Bethesda*,[36] has not been seen since 1863. The emphasis on miracles is deliberate, for Blake wished to emphasize the intervention of the Holy Spirit in human affairs. *Christ giving sight to the Blind Man* (Mellon Collection) expresses the idea of Christ as a cure for spiritual blindness, while *Christ raising Jairus' Daughter* (private collection, U.S.A.), shows his spiritual power transcending physical death; Jairus' daughter awakes not to physical life, but to Eternal life after the death of the body. *The Miracle of the Loaves and Fishes* (private collection), now much damaged, testifies to the power of Christ over physical matter. *Christ blessing little children*[37] (Tate Gallery) also belongs to the Ministry cycle, and the position of Christ as protector of childhood recalls the protective tree which spreads over the scene of childish innocence in the *Eccho- ing Green* in *Songs of Innocence*.

The much-damaged *Christ's entry into Jerusalem* (Pollok House, Glasgow) marks the beginning of the Passion cycle. If the Infancy cycle relates the story of Christ's relations with the Synagogue until his assumption of the mantle of prophecy, and

the Ministry cycle his intervention in human life, then the third cycle meditates upon the significance of Christ's sacrifice. Unfortunately it is not possible to reconstruct with certainty the conclusion of the series; the final painting was apparently a lost panel of the *Ascension*, described as 'The Saviour in the Heavens, with Floating Figures of Children & Angels',[38] and it may be the same as a lost picture described as 'Christ & a heavenly choir'.[39] The surviving panels of the Passion cycle, in addition to *Christ's entry into Jerusalem*, are the following: *The Last Supper* (Rosenwald Collection) (plate 102), *The Agony in the Garden* (Tate Gallery), *The Procession from Calvary* (Tate Gallery) (plate 103), *The Entombment* (Pollok House, Glasgow) (plate 104), and *Christ as Mediator* (George Goyder Collection). In addition there are early references to possible temperas of *'Christ and his disciples'* and *'Christ and the Seven Virgins'*, [40] which are otherwise unknown and might in fact be watercolours wrongly described.

The Entry into Jerusalem is shown as a kind of children's crusade, according to Blake's idea, derived from the words of Christ, that children are able to recognize the prophetic spirit more readily than adults, especially in works of art. As he wrote to Dr Trusler in 1799, when he was working on the present series:

> But I am happy to find a Great Majority of Fellow Mortals who can Elucidate
> my Visions, & Particularly they have been Elucidated by Children, who have
> taken a greater delight in contemplating my pictures than I even hoped. Neither
> Youth nor Childhood is Folly or Incapacity. Some Children are fools & so are
> some Old Men. But there is a vast majority on the side of Imagination or Spiritual
> Sensation.[41]

The Last Supper is one of the best-preserved in the tempera series: the apostles recline as if upon a Roman *triclinium* as in Poussin's painting of the *Eucharist*.[42] Blake seems to have chosen the moment at which Christ announces that one of the twelve will betray him: 'And they began to inquire among themselves, which of them it was that should do this thing.' Judas is seen as a white-bearded Urizenic figure counting his thirty pieces of silver, oblivious to the reactions of the others and to Christ's dramatic announcement.

In *The Agony in the Garden*[43] (Tate Gallery) Christ is shown, unusually, as physically supported by the angel as he falls back, for the intensity of mental struggle has temporarily overcome him. *The Procession from Calvary*[44] (Tate Gallery) and *The Entombment* (Pollok House, Glasgow) are the last paintings in the tempera series to deal with Christ on earth, except for a lost tempera of *Christ & his Disciples*.[45] Joseph of Arimathea is prominent in the *Procession from Calvary* and presides over the *Entombment*, for he is both an archetype of the artist and also played a role in both the life of Christ and the legendary history of England. Apart from a putative lost picture of the *Ascension*, Christ makes his last appearance in the series in the picture known as *Christ as Mediator* (George Goyder Collection). It is not clear to which passage in the New Testament Blake refers, but the female figure is evidently Mary Magdalen representing sinful humanity, for whom Christ intercedes, demanding forgiveness from the Father. The dominant position of Christ in the centre, His

arms spanning both Mary Magdalen and the Father, implies the triumph of His mercy, but the Father retains the sceptre of office to preside over the affairs of man until the Last Judgement. The painting of *Charity* (Carnegie Institute, Pittsburgh) must also belong towards the end of the series, but its role remains problematic. The figure in the centre, holding the two children to her breasts, is undoubtedly Charity, but the other two are not firmly identifiable as Faith and Hope. Each adult is accompanied by children who are receiving instruction; the reference is probably, therefore, to St Paul's image of Charity as the transcendent virtue (I Corinthians, xiii, 8): 'Charity never faileth: but whether there be prophecies, they shall fail; whether there be tongues, they shall cease; whether there be knowledge it shall vanish away.' The children studying with Charity's attendants, could, therefore, be receiving partial knowledge, while Charity would represent perfect knowledge, or the Holy Spirit.

In addition to the horizontal series there were five upright tempera paintings probably painted at the same time. Of the four Evangelists, *St Matthew* (private collection) and *St Luke* (private collection) survive, and in the same format and of a similar size is a remarkable picture thought to be of *Moses indignant at the Golden Calf* (private collection, Great Britain), in which the towering figure apparently of Moses fills almost the whole picture area. There is no obvious reason why such a subject should be in the same format as the Evangelists rather than the main body of the series.

Even in its truncated and uncertain final form it is possible to discern a number of distinctively Blakean themes in the tempera series, both through the choice of subjects and through their individual interpretation. The role of Christ is for the first time fully adumbrated in Blake's work, and emphasis is placed upon him as fulfilment of Old Testament prophecy and inheritor of the monotheism of Israel, as well as scourge of the Synagogue in his insistence upon the spirit of mercy and forgiveness. Blake's choice of subjects was largely dictated by tradition and he was clearly guided here by a desire to emphasize his own position within the mainstream of European art. This becomes even clearer if we consider the series from the point of view of style rather than iconography. Blake's style in the 1790s, despite its extremism and sublimity, can still be defined within the academic-classical tradition, but the tempera series is more explicitly eclectic in its range of influences. We do not know what Butts intended to do with fifty small paintings, but presumably they were to hang together in a room, in the manner of a traditional collector's cabinet. The idea of a 'cabinet' picture was associated in the eighteenth century not with religious painting, but with collections of Dutch and decorative pictures. The vocabulary of Blake's visual work in the 1790s was essentially monumental, deriving principally from such sources as the Sistine Chapel and Fuseli's *Milton Gallery*, but such an energetic style was inappropriate to his conception of the merciful Christ, and the flood of Old Master paintings on the London market from French collections would have offered him alternative sources of inspiration.[46] In a letter to Trusler of 16

August 1799, when he had probably recently begun work on the Butts tempera paintings, he wrote:

> If you approve of my Manner, & it is agreeable to you, I would rather Paint Pictures in oil of the same dimensions than make drawings, & on the same terms; by this means you will have a number of Cabinet pictures, which I flatter myself will not be unworthy of a Scholar of Rembrandt & Teniers, whom I have studied no less than Rafael & Michael angelo.[47]

Such approval of Rembrandt and even Teniers is unexpected in the light of Blake's later strictures, in the *Descriptive Catalogue* and elsewhere, on Northern Post-Renaissance artists, but the influence of the former is fairly evident in some of his tempera paintings, especially the *Nativity* and the *Adoration of the Kings*. The use of a double source of light in his *Nativity* (plate III), for example, recalls Rembrandt's way of contrasting Divine with natural light; the radiance of the exultant Christ shares the illumination of the stable with the light of the Holy Spirit at the window. In Rembrandt's *Adoration of the Shepherds*, 1646 (National Gallery, London) (plate 105)[48] the darkness of the stable is illuminated by the lamp held by the leading shepherd, but this light is outshone by the aura of the Christ Child. In Blake's *Adoration of the Kings* the Christ Child provides the radiance within the stable, while the Star of Bethlehem lights up the retinue outside, casting a few glimmers inside the stable to define the outline of the Kings themselves. Blake's *Nativity* recalls in particular the Rembrandt of the 1630s and 40s in the way in which light picks up contours and cool colours emerge imperceptibly from the warm and dense background. The Divine light gives an incandescent aura to the forms, particularly in *The Angel Gabriel appearing to Zacharias* (plate 11); they are irradiated by light from above, and glow against the dark background of the Temple. Here Rembrandt's *Christ presented to the People*, 1634, also in the National Gallery,[49] is called to mind and similar effects can be discerned in Rembrandt's etchings.

The use of light in the tempera series is, however, not universally Rembrandt-esque. The illumination of *The Temptation of Eve*, for example, is governed by the moon, giving an effect of sinister coolness which recalls the moonlight pictures of Wright of Derby and of Aert van der Neer. The moonlight gives an incandescence to the form of the serpent, bathing Eve in an unearthly glow and dropping glimmers of light upon the Tree of the Knowledge of Good and Evil. In paintings of Christ, especially outdoor scenes, his aura and those of the apostles tend to be localized, but in the *Last Supper* it radiates from him in a blaze of golden light suggesting the illumination the disciples have just received of his impending fate. Such subtleties unfortunately only emerge in those paintings that are in an exceptionally good state of preservation.

The colour values in the tempera paintings have also suffered from the ravages of time, but again there are signs of a wide study of earlier art. While *The Adoration of the Kings* is overtly Rembrandtesque, there is also a strong Venetian influence. The striking red of the foremost king's robe against the less emphatic colour of the older king's garment suggests an experience of Venetian art. *Bathsheba* is even more

strikingly Venetian in spirit; the sensuality of the naked figures recall also Correggio and the luxuriance of the palm trees by the pond is scarcely credible without study of original paintings by Titian and perhaps Veronese. The expansive landscapes in the background of *Christ blessing little children* and *Jesus riding on a lamb* recall the Venetian landscape tradition in their breadth of handling, warm and harmonious distances, with winding fertile rivers fading off into dreamy mountains.

Were it not for Blake's later dogmatic rejection of Venetian and Northern art, there would be nothing unexpected in his eclecticism, particularly at the turn of the century, and a similar broadening of experience can be discerned in other artists of the time, especially Turner.[50] The French Revolution had caused the break-up of many of the finest aristocratic collections in France, and a great part of them were sold or exhibited in London. Throughout the 1790s and early 1800s enormous numbers of works of art, often of the highest quality, were on display in London. Many sources testify to the excitement they caused amongst the artistic fraternity, and it may be taken for granted that Blake along with almost all artists of the time was in the habit of viewing these collections wherever they were to be seen. The Orléans collection, the most notable, was on display in London in 1798–9 for six months,[51] and from it, and from other collections like it, many English artists received for the first time a clear impression of great Venetian and Dutch paintings in profusion. A palpable shift in taste towards the Venetians began to occur in the 1790s,[52] and the rigid division made by academic writers between the intellectualism of the Florentines and the sensuality of the Venetians was modified for many artists by close experience of the Venetians' artful use of colour. Blake's letters of the turn of the century are full of excitement at the prospect of seeing and learning from the great works of the past in the original, not in casts or engravings. On 2 July 1800 he wrote to George Cumberland in respect of the latter's interest in the setting up of a National Gallery:

> *Your honours will be unbounded when your plan shall be carried into Execution as it must be if England continues a Nation. I hear that it is now in the hands of Ministers, That the King shews it great Countenance & Encouragement, that it will soon be before Parliament, & that it must be extended & enlarged to take in Originals both of Painting & Sculpture by considering every valuable original that is brought into England or can be purchased Abroad as its objects of Acquisition. Such is the Plan as I am told & such must be the plan if England wishes to continue at all worth notice; as you have yourself observ'd only now, we must possess Originals as well as France or be Nothing.*[53]

Blake would also have had the opportunity to see major paintings by Poussin, including the *Seven Sacraments*,[54] from which the Eucharist represented by the *Last Supper* must surely have left its mark upon Blake's rendering of the same subject in the tempera series. Equally it can hardly be coincidence that the only important modern renderings before Blake of that rare subject, the *Hiding* or *Exposition of Moses*, were by Poussin, and that the version now in the Ashmolean was on exhibition in London with the Orléans Collection in 1799.[55] Although the composition is

different, the emphasis in both works is upon the emotions of Moses' parents at the moment of casting their child upon the waters. Miriam also stands guard, and the land of Egypt is signified in both cases by a sphinx and pyramidal forms in the background, although Blake has used the pyramids in a more obviously symbolic sense. Blake's acquisition of new impressions in the 1790s did not always, however, mean a complete break with his previous style. Fuseli's art still remained potent, particularly in the more dramatic subjects, and Blake must have been aware of an unusual early engraving after Fuseli of *The Childhood of Christ*,[56] 1772, which seems to be a compendium of motifs used by Blake in the Childhood cycle: the intimations of the Crucifixion, the carpenter's tools, the silencing finger, and the lamb of God.

Even so there are signs also in the Butts tempera series of distinctive compositional modes less easily explained in terms of such outside influences. There is a tendency towards centralization in some of the paintings, which is achieved by placing the central figure firmly on the main vertical axis. In *The Temptation of Eve*, for example, Eve is positioned on the central axis, so that the serpent appears to be offering her an equal choice between the way of Adam, which she apparently spurns by the gesture of her hand, and the tree, towards which she reaches. In *Christ as Mediator* the figure of Christ in its centrality enfolds both plaintiff and judge, while in *Christ blessing little children* he sits foursquare under an oak tree, whose branches extend outwards to shade the whole scene. In some cases Blake goes further and relates figures on opposite sides of the picture to each other. In the *Last Supper* the apostles on one side of the table either reflect or contrast with those on the other side; at the moment of dramatic revelation St John leans towards Christ while the apostle to his right recoils, hands folded in prayer; the solemnly praying apostle on the left-hand side of the table nearest the spectator contrasts with the self-absorption of Judas, while in between two young apostles look into each others' eyes in amazement as if each saw himself in a mirror. Such conscious balancing of the opposite sides of the picture can be seen in other paintings in the tempera series, often to underscore a dramatic contrast, as between, for example, the yielding figure of the Virgin Mary and the eager outstretching gestures of Elizabeth in *The Nativity*. In *The Entombment* symmetry is used with unsurpassed effect: Joseph of Arimathea occupies the central axis; the two mourning women on either side lean slightly away from him against the background of a window symmetrically placed; two mourning figures under the bier crouch in opposite directions on either side of the central axis, while a central arch enfolds the whole scene.

Writing in 1809 about his tempera technique, which he describes as 'Portable Fresco', Blake is explicit about his debt to pre-Renaissance art, and his desire to emulate 'All the little old pictures, called cabinet Pictures (which) are in Fresco and not in Oil'.[57] He does not make a distinction between Early and High Renaissance and so Raphael and Michelangelo are regarded as 'Fresco' painters; the 'Fall' of art, for Blake as for Winckelmann, comes after the High Renaissance, and Blake connects it with the supposed invention of oil painting in the Baroque age:

Whether Rubens or Vandyke, or both, were guilty of this villainy, is to be enquired

in another work on Painting . . . in the meantime let it be observed, that before
Vandyke's time, and in his time all the genuine Pictures are on plaster or Whiting
grounds and none since.

Blake's ambition to recreate 'the genuine little old cabinet pictures' is, therefore, per-
fectly compatible with a desire to emulate Raphael and Michelangelo. It is unlikely
that he had studied Quattrocento panels in as much detail as he claimed to have
studied Rembrandt and Teniers, but he could well have seen Raphael Madonnas, of
the type now in the Sutherland Collection.[58] Blake's *Jesus riding on the lamb* and
The Virgin hushing John the Baptist recall the kind of Raphael Madonna whose
tender domesticity was in the late eighteenth century replacing in artistic esteem the
monumental Raphael of the Cartoons and the Stanze. *The Entombment*, however, is
in its rigid symmetry more Giottesque than Raphaelesque in spirit.

It is by no means impossible that by 1799–1800 Blake had some awareness not just
of Quattrocento but even of Trecento Italian art, and some of his contemporaries like
George Romney had been aware of it since the 1770s.[59] On the whole, however,
paintings and sculptures of the period before the High Renaissance were not plenti-
ful in the French aristocratic collections on view in London in this period. Flaxman
had been particularly drawn in his Italian travels towards both painting and sculp-
ture of the early Renaissance, principally of the Quattrocento, but he had taken a
notable interest in the sculpture of the Pisano family. Flaxman made many drawings
from such works,[60] and it is quite likely that he showed them to Blake some time
after his return from Italy in 1794. Flaxman's experience of Italian Gothic art un-
doubtedly contributed to his sculptural style after his return to England, but this
contribution does not invalidate its essential classicism, for he sought to reconcile in
his sculpture the qualities of Gothic and classical art as he had experienced them. His
tomb sculpture, particularly after 1800, attempts to combine the linear purity of
classical sculpture with the Christian fervour he had observed in Gothic masters; the
result is a 'stripped' classicism, in which Ascension motifs inhabit Greek stelae, and
designs for classical authors and for tomb sculptures inhabit the same remote world of
forms.

Blake's *Procession from Calvary* tempera (plate 103) is based compositionally on
an engraving by Flaxman of *Elektra leading a procession to Agamemnon's Tomb*
from Aeschylus of 1795,[61] but the Gothic rigidity of the figure of Christ carried on
the bier and the atmosphere of piety calls to mind Early Renaissance painting or
medieval tomb reliefs. The relationship between Gothic and Greek elements is not
completely resolved in this painting, however: the bier of Christ sits uneasily both
compositionally and figuratively on the shoulders of the mourners, their rigidity
heightening the sense of a primitive ritual. In the *Entombment*, on the other hand,
the Gothic and classical elements are integrated into a more complete harmony by
the symmetry of the composition. The shrouded Christ is also perfectly rigid, but
the origin of the composition is still to be found in the tradition of heroic deathbed
scenes, which had been revived so influentially by Gavin Hamilton in his *Andro-*
mache bewailing the death of Hector of c. 1761.[62] The impassioned and heartfelt

I

gestures of Blake's mourners are of a quite different order from those of Hamilton, and they reflect, with greater intensity, those employed by Flaxman in, for example, the plate of *Thetis bringing the armour to Achilles*, from the *Iliad* engravings, plate 31 (plate 106). These huddled mourning figures have, however, as much claim to be regarded as distinctively Blakean, for they occur in his own work at least as early as the *Ezekiel*,[63] probably conceived as early as 1786, and they may in fact have influenced Flaxman. The curved arch which contains the composition of the *Entombment* finds also a precedent in Flaxman, and it could derive either from the canopy of Jupiter's throne in the *Odyssey*, plate 1, in which case Joseph of Arimathea would occupy the central position of Jupiter, or from a monumental tomb such as Flaxman's of Mary Blackshaw of 1798–9 in Lewisham Parish Church.[64]

The eclecticism of the Butts tempera series is not a sign of lack of originality, but on the contrary a serious attempt on Blake's part to develop his artistic style beyond the compass of the Fuselian sublime, which still dominated many of the *Night Thoughts* illustrations. His principal concern in the tempera series was to find a language to express the Redemption through Christ, for the Prophetic Books of the 1790s dealt essentially with the morphology of the Fallen world. The depiction of light and the use of symmetry in the tempera series can be associated with the image of Christ and the coming of the New Dispensation. This is foreshadowed already in the *Night Thoughts*, for example in the frontispiece of Night IV, *The Christian Triumph*, where the ascending Christ, a radiant aura streaming from him, parts the clouds; he is flanked at the bottom by two nearly symmetrical angels, one of whom holds a shroud. The tempera series is still, however, a turning point in Blake's career, for the extent and nature of the commission obliged him to depict subjects he had rarely attempted before, and it was a happy chance that made available a wide range of material for him to absorb and refine into a profoundly personal style.

Blake probably completed the tempera series before he moved to Felpham on 18 September 1800, but he had also embarked on a series of watercolours on the theme of the *Crucifixion of Christ*, which were apparently not completed before his departure. He wrote to Butts on 2 October 1800 to say that he was still working on *The Three Marys at the Sepulchre*, probably the watercolour finally delivered on 16 August 1803 (Cambridge, Fitzwilliam Museum).[65] *The Soldiers casting lots for Christ's garments* (Cambridge, Fitzwilliam Museum) (plate 107)[66] is dated 1800, and several others can be associated with it, but there is some stylistic discrepancy between them, which suggests that he might have put them aside and added to the series in later years. The representations of Christ in the tomb are unified formally by a centralized Romanesque-type arch in the background, and emotionally by a profound and moving gravity. Elements of eclecticism still remain, and in *The Soldiers casting lots* Blake borrows the horrific elements explicitly from Fuseli: the grimacing expression, elongated arms, and emphatic gesturing fingers of the soldier on the left of the group. The *Christ crucified between two thieves* (Fogg Museum, Harvard University) also has a strong element of Fuselian grotesquery in the expression of

the thieves. The watercolours from the series which are probably post-1800 develop further the use of tone and light, and in *The Entombment* (Tate Gallery)[67] the shrouded body of Christ is strongly illuminated, but the overall tone modulates by degrees into a complete absence of light, through a deliberate application of neutral grey tints to the paper, while certain heads are picked out by illumination from the overall darkness. In the *Christ and Mary Magdalen in the sepulchre* (Mellon Collection) (plate 108) the Divine light illuminates the darkness with incomparable subtlety, radiating from the figure of Christ to light up the Magdalen's face and the steps behind her, and just gently touching the outline of the trees glimpsed through the door of the sepulchre. The Magdalen turns round in wonder, with a gesture of ineffable astonishment as she perceives the Divine radiance.

The group of *Crucifixion* watercolours is distinguished by the cumulative power of repetition from one picture to another. In *The Soldiers casting lots* the Cross seen from behind, a motif apparently derived from Poussin,[68] is flanked by exactly symmetrical crosses, while the group of the soldiers pivots around the foot of the main Cross. In *The Crucifixion* (Tate Gallery)[69] the Virgin Mary and St John stand on either side of the Cross looking up at Christ, while the apostles hide their faces in mourning, also in a symmetrical grouping. In *The Entombment* St John, Mary Magdalen and the Virgin Mary form a similar symmetrical group to their counterparts in the tempera *Entombment*, but the groups of mourners also arrange themselves symmetrically on either side of the door of the sepulchre. The most striking effect of symmetry in this group of watercolours is to be found in *The Angels hovering over the body of Jesus in the sepulchre* (Victoria and Albert Museum) (plate 109).[70] Here the angels hover over Christ's body, their contours and wings forming, as Blunt has pointed out,[71] the shape of a Gothic ogee arch, of which many are to be found in Westminster Abbey. Blake associates here the New Dispensation with the symmetry of Gothic, so for the first time in Blake's work we receive an intimation of his later belief in Gothic as a sacred style, an idea which was beginning to gain currency in Germany.[72] At the same time this conception was beginning to draw him back towards his youthful experiences of the Gothic in Westminster Abbey, and provide for him a unified understanding of his own artistic development, which would lead him to repudiate, at least in theory, the classical bases of his art.

Felpham

On 18 September 1800, Blake left London with his wife, carrying with him 'Sixteen heavy boxes & portfolios full of prints',[1] for the village of Felpham in Sussex, where he had been invited through the agency of Flaxman by William Hayley, the dilettante and poet. Hayley's incomprehension of Blake, like that of the Rev. Trusler, has not endeared him to posterity, but Hayley had been a devoted and intimate friend of George Romney. Blake's position, however, was equivocal from the start, for by being placed in the role of artistic factotum to Hayley, he was once again labelled implicitly as an engraver rather than a serious painter. Hayley showed an unfailing personal benevolence to Blake, but also a total inability to take seriously the products of his imagination. As Blake put it, Hayley was to him a 'Corporeal friend' but a 'Spiritual Enemy'. The tragi-comedy of Blake's Felpham period has often been told, and many surviving letters reveal his feelings. But the immediate impact of his departure from London was to diminish his artistic activity. He had come to Felpham with the Biblical watercolours for Butts still in hand, but he was to be largely occupied with commissions for Hayley and with work on his manuscript of *Vala or the Four Zoas*.

While few works of art of any importance were produced at Felpham, Blake's mind was never more active, and his spiritual development is amply charted in his letters. He had gone there in a spirit of great optimism, as his first letter to Flaxman, written the day after he arrived at Felpham, reveals:

> *And Now begins a New life, because another covering of Earth is shaken off. I am more famed in Heaven for my works than I could well concieve. In my Brain are studies & Chambers fill'd with books & pictures of old, which I wrote & painted in ages of Eternity before my mortal life; & those works are the delight & Study of Archangels.*[2]

The correspondence of both Blake and Hayley at the beginning of the sojourn at Felpham reveals the euphoria they both felt at their new-found friendship. Blake was a constant companion of Hayley, and the latter writes delightedly to his friends, including Romney and Flaxman, about the 'good enthusiastic Blake'. Blake's

enthusiasm and apparent simplicity endeared him to Hayley and his friends, many of whom were relations of the poet Cowper, upon whose biography Hayley was engaged.[3] Blake threw himself with enthusiasm into all the projects which Hayley had given him; he laboured cheerfully under the anxious eyes of Hayley and the Cowper relations on illustrations for the poet's life, and at Hayley's instigation he began to take up the painting of portrait miniatures, again with great enthusiasm and with some success.[4] On 10 May 1801 he wrote to Butts, apologizing for his failure to send any further work to him:

> Mr Hayley acts like a Prince. I am at complete Ease, but I wish to do my duty, especially to you, who were the precursor of my present Fortune. I never will send you a picture unworthy of my present proficiency. I soon shall send you several; my present engagements are in Miniature Painting. Miniature is become a Goddess in my eyes, & my Friends in Sussex say that I Excel in the pursuit. I have a great many orders, & they Multiply.[5]

In his enjoyment of the company and of village life, Blake had not yet been made aware of the limitations of Hayley's friendship. Hayley was undoubtedly influenced by Flaxman, who applauded Blake's move to Felpham because it would bring him constant employment as an engraver, and, he hoped, would cure him of his ambitions as an imaginative painter. Flaxman wrote to Hayley on 19 August 1800, commending Blake to his future employer in terms that would have been deeply wounding to him: 'I see no reason why he should not make as good a livelihood there (i.e. Felpham) as in London, if he engraves & teaches drawing, by which he may gain considerably as also by making neat drawings of different kinds but if he places any dependence on painting large pictures, for which he is not qualified, either by habit or study, he will be miserably deceived.'[6]

Except for a commission for eighteen decorative paintings for his library, Hayley took Flaxman at his word and treated Blake primarily as an engraver, but entrusting to him in a number of cases the design as well as the execution of engravings. In addition to a constant stream of engraving commissions, Hayley seems to have regarded Blake as a general assistant on his many projects: he took him on visits to his friends and often worked in the same room as Blake, anxiously fussing over the plates for the *Life of Cowper*, teaching him miniature painting, and even urging him to learn Greek. As early as November 1800 Blake had begun the series of paintings for Hayley's library, but by 11 September 1801, he was only able to report that 'Mr. Hayley's Library is still unfinishd but is in a finishing way & looks well'. The paintings were to decorate the library in Turret House, which Hayley had built in 1797. The idea at first was to have decorative paintings of the authors especially admired by Hayley, culminating probably in William Cowper, but Thomas Hayley's death caused the project to be turned into a memorial to him. Tom had been a talented boy with artistic ambitions, and a pupil of Flaxman. Blake had originally been asked to engrave a portrait of the boy and a drawing by Flaxman of *The Death of Demosthenes* for Hayley's *Essay on Sculpture*, but after his death Tom was to become the subject of the final painting in the Library series (plate 110).

There can be no doubt that the choice of poets for the paintings was made by Hayley and not by Blake, and some of the more curious literary references may have been dictated by some remembered preference of Tom Hayley's.

The format chosen for the library paintings was the traditional one of a wreathed head set in an oblong panel, with illustrations from the poet's works in the background. Homer is represented, mysteriously, by the *Batrachomyomachia*, the *Battle of Frogs and Mice*, a piece of Homeric apocrypha, perhaps intended by Hayley as a private joke,[7] while Demosthenes is represented by the scene of his death drawn by Tom Hayley. Of the other poets chosen by Hayley some are famous and some obscure, and several reveal his learning and catholic taste. Some of them obviously appealed to Blake, like Chaucer, Shakespeare and Milton, but many were antipathetic to him. Hayley also admired Klopstock, 'the Milton of Germany', a subject which may have been added to the series on the news of the death in March 1803 of Klopstock, who had been the subject of the bawdy verse in the *Notebook*: 'When Klopstock England defied, Uprose terrible Blake in his pride.'[8] Others in the series must have been even less sympathetic, such as Voltaire and Alexander Pope, and Blake's attitude to Hayley's idol Cowper was disapproving.[9] As Blake worked on the series, he must have been thrust further into dissembling his thoughts to Hayley, and the acid verses and remarks he confided to his notebook are evidence of a growing discomfort. On the other hand the intensely literary atmosphere of the Turret House and the constant discussion of Milton and Cowper must have stimulated him and forced a reconsideration of his attitudes to epic poetry in particular.

In March 1802 Blake was still working closely with Hayley, who remarks that the 'friendly & zealous artist . . . labours every day in my presence, with admirable Industry'[10] on a project for a memorial to Cowper, which Blake later engraved for Hayley's *Life of Cowper*.[11] Hayley remained solicitous of Blake's welfare, writing him atrocious verses to encourage him in his labours, and with kindly insensitivity commissioned him to make designs from Hayley's *Ballads*, as a way of publicizing his ability as a designer:

> To amuse the Artist in his patient labour, and to furnish his fancy with a few slight subjects for an inventive pencil, that might afford some variety to his incessant application, without too far interrupting his more serious business, I chanced to compose, in hours of exercise and leisure, a few Ballads, upon anecdotes relating to animals, that happened to interest my fancy.[12]

The effect of Hayley's uncomprehending kindness was to divert Blake further into channels where he could exhibit his 'fancy' but not his imagination. The illustrations to the *Ballads*, though charming, exhibit a gaucherie which would only have confirmed his reputation as a naive talent unfitted for serious endeavours. The publication of these designs, in 1802, gave Blake's friends a chance to help him, and Flaxman once again disposed of a number to his own friends. The mixed reception they received, particularly the open dislike of the formidable Lady Hesketh, Cowper's cousin, revealed Blake's hypersensitivity to criticism, which even Hayley noted:

> *Whatever the Merits or the Failings of my diligent & grateful artist may be, I*

know I shall interest your Heart & Soul in his Favour, when I tell you, that He resembles our beloved Bard [i.e. Cowper] in the Tenderness of his Heart, & in the perilous powers of an Imagination utterly unfit to take due Care of Himself. —with admirable Faculties, his sensibility is so dangerously acute, *that the common rough Treatment which true genius often receives from* ordinary Minds *in the commerce of the world, might not only wound Him* more than it should do, *but really reduce him to the Incapacity of an Ideot without the consolatory support of a considerate friend.*[13]

Hayley is, of course, making an implicit comparison between Blake's reactions to criticism and Cowper's madness, for Blake also shares the latter's 'little Touches of *nervous Infirmity*, when his mind is darkend with any unpleasant apprehension'.

Blake continued to write to Thomas Butts, apologizing once again for failing to send work, and revealing signs, from his arrival at Felpham, of an extreme spiritual crisis; the letters of 1801 and 1802 are full of impassioned distress. This turmoil, however, although primarily spiritual, also involved artistic questions. On 11 September 1801, he sent a miniature of Butts himself, apologizing to him for the year's delay in sending watercolours, and describing his spiritual state, which drew him away from the mundane reality represented by his drudgery for Hayley:

I labour incessantly & accomplish not one half of what I intend, because my Abstract folly hurries me often away while I am at work, carrying me over Mountains & Valleys, which are not Real, in a Land of abstraction where Spectres of the Dead wander.[14]

In a postscript he comments, apropos of the miniature he has sent of Thomas Butts, on the problem of uniting portraiture and History painting:

Next time I have the happiness to see you, I am determined to paint another Portrait of you from Life in my best manner, for Memory will not do in such minute operations; for I have now discovered that without Nature before the painter's Eye, he can never produce any thing in the walks of Natural Painting. Historical Designing is one thing & Portrait Painting another, & they are as Distinct as any two Arts can be. Happy would that Man be who could unite them!

On 10 January 1802, he wrote to Butts at further length of his mental struggles with 'Spiritual Enemies of such formidable magnitude', but now he reveals that this also involves a renewed struggle with his art, to which he was evidently applying much thought. This letter is a critical one, for it contains the first signs of a major transformation of his attitudes to art:

& if it was fit for me, I doubt not that I should be Employ'd in Greater things; & when it is proper, my Talents shall be properly exercised in Public, as I hope they are now in private; for, till then, I leave no stone unturn'd & no path unexplor'd that tends to improvement in my beloved Arts. One thing of real consequence I have accomplished by coming into the country, which is to me consolation enough: namely, I have recollected all my scatter'd thoughts on Art & resumed my primitive & original ways of Execution in both painting & engraving, which in

the confusion of London I had very much lost & obliterated from my mind.[15]
This renewal was threatened by his need to make money, and the perpetual pressure
he was under from his friends to be practical in his attitudes. But an intense creative
urge would not let him rest, and he feels as conscious as ever of his sublime duty to
depict his visions without thought for his worldly cares:

> *I am not ashamed, afraid, or averse to tell you what Ought to be Told: That I
> am under the direction of Messengers from Heaven, Daily & Nightly ; but the
> nature of such things is not, as some suppose, without trouble or care. Tempta-
> tions are on the right hand & left ; behind, the sea of time & space roars & follows
> swiftly ; he who keeps not right onward is lost, & if our footsteps slide in clay,
> how can we do otherwise than fear & tremble?*

Blake was evidently writing intensively at this point, presumably upon the manu-
script of *Vala, or the Four Zoas*, at the dictate of 'Messengers from Heaven', and it is
likely that the predominantly grotesque illustrations to the manuscript were made
at Felpham.[16] In the first part of *Milton a Poem*, which he probably commenced in
1804, he told the story of his spiritual struggle at Felpham in terms of his subservi-
ence to Hayley, and he felt not only *Milton a Poem* but also his final epic *Jerusalem*
to have grown out of his 'three years slumber on the banks of the Ocean' at Felpham.
In retrospect he saw his struggle with Hayley as initially between Palamabron and
Satan; between the 'mild and piteous' artist and the destroyer of art. In spiritual
terms Blake then realized that to submit to Satan-Hayley was futile, and that he
must denounce all that Hayley stood for by revealing his wrathful voice, or Rintrah.
In *Milton a Poem* the unredeemed Milton is led to descend to Earth by observing
the struggle between Blake and Hayley, for he realizes that his own unresolved con-
flicts make him, in a spiritual sense, the parent of both Blake and Hayley, and that
he must exorcize the latter to achieve true redemption: 'I in my Selfhood am that
Satan . . . / He is my spectre ! in my obedience to loose him from my Hells / to claim
the Hells my Furnaces, I go to Eternal Death.'[17] Milton is the 'cause' of Hayley
because the latter follows him in substituting classical learning for Inspiration; but
Milton is also Blake's prophetic 'Original', a poet of the highest degree of Divine
inspiration. Blake attempts to take on Milton's role as prophetic redeemer of the
English nation, while Hayley applies scholarship to Milton's poems and writes a
biography of Milton's 'mortal part'.

Blake seems to have resolved many of his artistic problems before he decided to
leave Felpham in 1803. In a letter to Butts of 22 November 1802, he enlarges upon
his remark of 10 January 1802, about recollecting 'all my scatter'd thoughts on Art'.
The letter has a rather defensive tone, apparently in response to some critical remarks
made by Butts to Blake's brother James. He begins by defending his works with
vigour, revealing that he has 'now given two years to the intense study of those parts
of the art which relate to light & shade & colour',[18] and arguing that they represent
a distinct improvement upon his paintings made before that study commenced, by
which he presumably means the Butts tempera series and the 1800 watercolours:

> *I have now proved that the parts of the art which I neglected to display in those*

*little pictures & drawings which I had the pleasure & profit to do for you, are in-
compatible with the designs.*

Butts seems to have complained that Blake's latest works were no longer as pictur-
esque, and did not contain what Blake, paraphrasing Reynolds, calls the 'Venetian
finesse' of the tempera series. Blake was unrepentant and announced his intention of
rejecting 'the dawbed black & yellow shadows that are found in most fine, ay, & the
finest pictures.' In justification, Blake fell back on academic theory, quoting Reynolds
on the Picturesque, in which category Reynolds had implicitly included Rubens and
the Venetian painters: (the) 'epithet Picturesque is . . . applicable to the excellencies
of the inferior Schools rather than to the higher',[19] and that the same epithet could
be more appropriately applied to Prior and Pope than to Homer and Milton. If the
Picturesque is, as Reynolds argues, to do with 'variety of Tints & Forms', which Butts
had evidently admired in the tempera series, then Blake is now arguing for a style on
a different theoretical basis. By 'Picturesque', Blake here seems to mean a 'mixed' or
eclectic style based on the reconciliation of two or more different styles, and he refers
with approval in the same letter to Reynolds' rejection in the *Discourses* of attempts
to reconcile 'Venetian finesse' with the Historical style, for it 'can never be united
with the Majesty of Colouring necessary to Historical Beauty'.

Blake, then, is arguing for 'Historical beauty' or Reynolds' 'Great Style', but in a
more uncompromising way than heretofore. He had never lost the ambition to
paint 'History', and his talk of such ambitions had dismayed Flaxman before he went
to Felpham. In rejecting the eclecticism of the tempera paintings he was arguing for
a 'Historical beauty' which transcended variety in colour and naturalistic light. He
further cites Reynolds as arguing that Historical Grandeur is, on the contrary,
achieved through 'uniformity of Colour & a long continuation of lines', and it was
for this that Blake 'had again reconsidered my notions of Art', associating it in his
own mind with his youth, for he 'had put myself back as if I was a learner'.

The results of this reconsideration can be seen in several watercolours sent to Butts
in 1803, and which are now identifiable. On 6 July 1803, he wrote to Butts:

*I have now on the Stocks the following drawings for you: 1. Jephthah sacrificing
his Daughter* [British Museum]; *2. Ruth & her mother in Law & Sister* [South-
ampton Art Gallery]; *3. The three Maries at the Sepulcher* [Fitzwilliam]; *4.
The Death of Joseph* [Mr James Biddle, New York]; *5. The Death of the Virgin
Mary* [Tate Gallery]; *6. St Paul Preaching* [Rhode Island School of Design];
& 7. The Angel of the Divine Presence clothing Adam & Eve with Coats of Skins
[Fitzwilliam Museum].[20]

All these watercolours are in a notably higher key than those of the 1800 series and
Blake has completely eliminated the dark monochromatic shadows. The majority are
filled with an astonishing radiance, which flows outward from the holy figures to
pervade the whole pictorial space. This light is conceived not in terms of Rem-
brandtesque chiaroscuro, picking out highlights and contours, but as a suffusing
ethereal light, transcending modelling, but leaving every form distinct and whole.
This radiance is created in practice not by 'uniformity of colour', but by a minute

and painstaking application of luminous flecks of watercolour, giving a distinctive 'stippling' effect. Even the subordinate areas, such as the raised carpet in *The Death of the Virgin*, are suffused with colour, the effect of which is rich and unworldly.

This supernatural atmosphere is reinforced by the hieratic quality of many of the figures and the diminution of the landscape background. In *St Paul preaching at Athens* (plate 111), St Paul is seen as a rigidly frontal figure occupying the central axis of the composition, his arms extended upwards symmetrically. The Divine light emanates from him, obliterating the background and leaving him isolated on the steps. His audience, six people of various ages, is remote and static, their symbolic existence made plain by the infidel, who faces away from him. The effect is the opposite of dramatic, despite the intensity of Paul's Divine light, suggesting not a historical moment but the timeless operation of the spirit, which is perceived directly only by the young and the old in the audience. This rigidly centralized symmetry is repeated in *The Sacrifice of Jephtha's Daughter*, where the central axis is occupied by Jephtha and his daughter seated on the altar, against which lean lamenting female figures.

In *The Death of the Virgin*, the Virgin Mary is supported at both ends by angels, while a rainbow arches across the picture, bisected by the erect figure of St John. The angels supporting the Virgin as if she were a medieval tomb effigy, and the hieratic praying figure of St John, whose head is surrounded by radiance, are remarkably Gothic in feeling. The rainbow, filled with winged cherub heads, would suggest, as John Gage has noted, in its evanescence and its association with the Newtonian spectrum the material nature of the Virgin and Joseph.[21] The Divine radiance emerges from the Virgin and Joseph at the point where they pass beyond the body. In *The Angel of the Divine Presence Clothing Adam and Eve* (plate 112) Adam and Eve are seen making a gesture of submission to a seemingly benign Jehovah, whose enfolding gesture cuts them off from the Divine light, forcing them into conventional piety; they are enclosed within his body pictorially and symbolically.[22] The sense of enclosure is further emphasized in the palm grove, which arches over the scene and presents another barrier to Adam and Eve's perception of the Eternal world, while symmetrically arranged flaming altars suggest the idea of sacrifice to false Gods. The imagery, then, is again essentially symbolic rather than dramatic.

The Three Marys at the Sepulchre[23] is not symmetrically composed, but also exhibits characteristics of a new style. The unnaturally metallic-blue coloration creates a sense of electric tension, which is reflected in the pallid and tremulous figures of the Marys. Their fear and puzzlement is now suggested not by extravagant gestures, but by a closing in of their forms to create a single unity. The stippling of the colour seems hesitant and overwrought in parts, and it is likely to be a reworked version of a composition begun in 1800, for Blake mentions that he has begun 'the three Marys' as early as 2 October 1800.

By the time Blake sent off the seven watercolours in July or August 1803, disillusionment with Hayley and Felpham had overwhelmed him. He had been labouring on the engravings to Hayley's *Life of Cowper* right up to the end of 1802, but as Hayley reported, 'my Friend the anxious, enthusiastic Engraver says, that all

the Demons, who tormented our dear Cowper when living, are now labouring to impede the publication of his Life'.[24] Hayley continued to pour engraving commissions upon him, but, far from being grateful, he began to feel exploited by Hayley. In a letter of 30 January 1803, Blake announced to his brother James his intention of returning to London: '[Hayley] thinks to turn me into a Portrait Painter as he did Poor Romney, but this he nor all the devils in hell will never do.'[25] Blake rather implausibly accuses Hayley of jealousy, and he returns to the old belief that he could make a fortune by publishing his own works, a pathetic sign that he had not learnt the lessons of his bitter experience. His anger and frustration at Hayley's bland refusal to take him seriously, particularly at a time of intense, spiritual crisis, created in him something of a persecution mania, which intensified his incipient feeling of Christ-like suffering. Blake's own mental turmoil was always interwoven with his desire to create a myth of the Fall and Redemption. Los's struggle, in the *Book of Urizen*, is essentially with himself, against his desire to rest and withdraw from the fierce heat of creativity; now Los's enemies become externalized for Blake, taking on the character of Blake's personal enemies.

This feeling was confirmed in Blake's mind by a harrowing incident, in which an altercation with a drunken soldier led to Blake's appearance in court on a charge of 'assault and seditious words'. By 6 July 1803, Blake had 'determined to be no longer Pester'd with [Hayley's] Genteel Ignorance & Polite Disapprobation',[26] and was preparing his move back to London. On 12 August, a drunken soldier, Scofield, was found by Blake prowling in his garden, apparently investigating reports that a 'Military [sic, for Miniature] painter' lived in the cottage. After a trial Blake was acquitted, but the effect of the incident was to intensify his feelings of persecution, and to provide more material for his personal mythology; 'Skofeld', the representative of brute soldiery, was to reappear as a wayward Son of Albion in *Jerusalem*.

Blake left for London in September 1803, convinced that he 'can alone carry on my visionary studies in London unannoy'd, & that I may converse with my friends in Eternity'. One of the ironical results of the Scofield incident was a reconciliation with Hayley, who had rushed to Blake's defence and provided legal counsel for him, and remunerative work upon his own biography of George Romney in London. The kindly attentions of Hayley had created an intolerable frustration for him at Felpham, and there are very few original designs from those years. That Blake should have been known as a 'Miniature Painter' is indicative of this, but even so, some minor products of the Felpham period are of considerable interest. The surviving miniatures are of great charm and naivety, qualities which shine through the illustrations to Hayley's *Ballads*, and most of the surviving landscape drawings by Blake can be attributed to this period, especially the beautiful watercolour of Felpham in the Tate Gallery.[27] Mention should also be made of a series of watercolours for *Comus*, commissioned by another patron introduced to him by Flaxman, the Rev. Joseph Thomas, but these are better discussed in the context of Blake's Miltonic illustrations.[28] But the central experiences of Felpham proved seminal, and the last great epics owe their germination to the 'three years slumber on the Banks of the Ocean'.

The Return to London

On his return to London in 1803 Blake was in an even poorer financial position than before he left in 1800. He was forced to remain in thrall to Hayley, who was now employing him as a London agent for his work on the *Life of Romney*.[1] Blake's job was to track down paintings by Romney in London, with the promise that he would be able to engrave some of them for the book. This meant that he saw a great many of Romney's History paintings, and his admiration for them was perhaps reflected in some subsequent watercolours made for Butts. Flaxman still obtained engraving commissions for him, but there are no original works dated 1804 except for the title-pages of *Milton a Poem* and *Jerusalem*, both of which were probably only begun that year.

In his letter to Hayley of 23 October 1804, Blake claimed to have overcome the crisis of Felpham and to have emerged with triumphant enthusiasm:

> *For now! O Glory! and O Delight! I have entirely reduced that spectrous Fiend to his station, whose annoyance has been the ruin of my labours for the last passed twenty years of my life.*[2]

This sense of spiritual regeneration was associated, as always, with a change in his attitude towards art. In the same letter he wrote:

> *Suddenly, on the day after visiting the Truchsessian Gallery of Pictures, I was again enlightened with the light I enjoyed in my youth, and which has for exactly twenty years been closed from me as by a door and by window-shutters.*[3]

He dates, therefore, his desperate struggle to earn a living essentially from the formation of the firm of Parker and Blake in 1784, which put him at the mercy of 'the fiends of commerce', and he identifies the 'spectrous fiend' who had tormented him for twenty years as 'the Jupiter of the Greeks, an iron-hearted tyrant, the ruiner of ancient Greece'. In the preface to *Milton a Poem*, possibly written in 1804, he claims that 'Shakespeare & Milton were both curb'd by the general malady & infection from the silly Greek & Latin slaves of the Sword',[4] implying that Greek art and literature is essentially academic: a product if memory rather than original inspiration.

Blake's rejection of the Classics is in the name of the Hebraic sublime, but there are intimations of a renewed theoretical acceptance of the Gothic. The Truchsessian Gallery was one of those speculative collections of Old Master paintings which appeared for sale in London in the wake of the great French collections. It contained altogether about 900 pictures, which included, amongst works by the usual fashionable names, some of the fifteenth century.[5] The role of the Truchsessian Gallery in Blake's mind is not clear, but the sight of so many 'Gothic' pictures may have contributed in retrospect to his feeling of artistic regeneration in the previous years, making him aware of the new life beginning for him again in London. He associated this sense of regeneration not only with the rejection of the Classics, but with 'the light I enjoyed in my youth'. This nostalgia is partly for the time when he was held in high repute by Romney and Flaxman as an imaginative artist, but it is also connected with his unusual experience of medieval art in Westminster Abbey when he was an apprentice with Basire. Virtually all that we know of his youthful love of the Gothic and his delight in English medieval sculpture comes from a biographical account written by Benjamin Heath Malkin, virtually from Blake's dictation, probably in 1805, and published in 1806.[6] The rapture which Blake attributes to his own youth at the sight of the Westminster Tombs, his 'Gothicised imagination', must surely reflect his own feelings at the time he was reminiscing to Malkin. The Gothic was, therefore, a link between Blake's youth and his present regenerate state, for it is evidently now associated in Blake's mind with Divine radiance and visionary clarity.

About 1805 Blake resumed the Biblical watercolours for Butts. These watercolours are quite distinct in style from those of 1800 and 1803 in being more obviously linear and in a generally higher key. The compositions are generally looser and more informal, and the stippling has now been replaced by a more fluid use of watercolour washes. The sheets are variable in finish and quality, but at their best they have a freshness and vibrancy not previously achieved by him. The approximately forty surviving watercolours of c. 1805 do not form a coherent series but were evidently meant to be added to the ones already owned by Butts, in some cases rounding off earlier series with additional subjects. At least ten watercolours were added to the cycle of the Life of Christ; there are a number of additional Genesis subjects, and Blake has added a complete cycle of the Life of Moses, who had previously appeared only in two temperas. The prophets Isaiah and Ezekiel are represented by visions, and there are additions to the Apocalypse and the Acts of the Apostles. Two designs from the Psalms are perhaps the most innovatory: *David delivered out of many waters* (Tate Gallery)[7] and *Mercy and Truth are met together* (Victoria and Albert Museum) illustrate the imagery of the Psalms in a way apparently unprecedented since the Middle Ages. *David delivered out of many waters* (plate 113) conflates a number of images from Psalm 18, in which David fears 'the floods of ungodly men'. The image of the Lord riding 'upon a cherub, and did fly: yea he did fly upon the wings of the wind', as 'he drew me out of many waters' is represented by Christ riding amidst cherubim in a continuous rhythmical row, a motif already used in the

Night Thoughts,[8] while David lies upon the waters, arms outstretched in exultant receptivity. The typological implications of Blake's treatment, in which David is rescued by a vision of Christ's mercy, might suggest the influence of medieval manuscripts, but they are implicit also in the Swedenborgian conception of Christ as the only true God. The watercolour is now too faded to give much idea of the original colouring, but the effect is visionary in the extreme, remote from earthbound forms. *Mercy and Truth are met together*, although taken likewise from a Psalm, is less complex in the illustrative sense, for Blake has presented allegorical personifications of Mercy and Truth.

The great achievement of these watercolours is to establish more firmly a visual language to depict the ineffable imagery of the Bible, without the constraints of a lingering naturalism. Thus in *David delivered out of many waters* Blake places the emphasis of the design not just upon the reactions of David, as previous illustrators of the Psalms had done, but upon the actual vision. Similarly in *The Vision of Ezekiel* (Boston Museum of Fine Arts) (plate 114)[9] he has been able to give Ezekiel's fourfold vision a fully realized form, which is powerful enough to convey a sense of its impact upon Ezekiel. The fourfold man of the vision is depicted as classically naked, but the imagery and the symmetry of the composition suggest something completely unclassical. The outlines of the figures are definite, but the brushwork which creates the vortex swirling around the vision communicates the sense of awe implicit in the difference in scale between the tiny figure of Ezekiel and the visionary man. The fourfold man takes on the Hebraic form of a winged Cherub, and Blake was well aware that the Cherubim of the Temple of Solomon were the only monumental works of art to have a recognized place in the context of Hebrew worship. In the *Descriptive Catalogue* of 1809, Blake argued that 'those wonderful originals called in the Sacred Scriptures the Cherubim' were archetypal works of art from which all the Greek sculptures sprang,[10] and in the *Laocoön* engraving he claimed that the *Laocoön* sculpture represented 'יה & his two Sons Satan & Adam as they were copied from the Cherubim of Solomons Temple by three Rhodians, & applied to Natural Fact or History of Ilium'.[11] In the watercolour of *Satan in his original glory* (Tate Gallery)[12] Satan also assumes the form of a Cherub, for the design illustrates Ezekiel's vision of the Prince of Tyre as 'a covering Cherub', a traditional type of Lucifer, whose beauty and magnificence concealed his Satanic nature.[13] The cherub again has large wings, reflecting the description of the two guardian cherubim on the Temple of Solomon, and he is surrounded by tiny personifications representing luxury. This watercolour too has faded, and lost much of its original splendour. Gothic art also contributed directly to the visual realization of the numinous. In the watercolour of *God blessing the Seventh Day* (private collection) the act of blessing is seen as the effusion of Divine light from God enclosed within a mandorla of six angels, who presumably form together the seven Eyes of God mentioned in *Revelation*. The resemblance to a Gothic boss is evident and the whole work is redolent of the pure realm of the spirit.[14] The circular form and the light emanating from it suggest a personified vision of the sun, beaming for the first time on the Creation.

The Book of Revelation must remain the core of any attempt to depict the ineffable aspects of the Bible. Blake had already attempted a Revelation subject in *Death on a Pale Horse* (Fitzwilliam Museum)[15] probably as early as 1800, and it is painted essentially in the Sublime style of the 1790s: Death is seen as a Urizenic warrior, and the light is modulated tonally, as in other early Butts watercolours. In *The Four and Twenty Elders casting their crowns before the divine throne* (Tate Gallery)[16] and *The River of Life* (Tate Gallery),[17] both of c. 1805, the emphasis is on the milder imagery of Revelation rather than the apocalyptic. The former is a work of great luminosity, in which the light softens the forms to give a sketchy and free effect within a symmetrical composition. *The River of Life*, on the other hand, reverts to the pastoral language of *Songs of Innocence*; the central group, a figure who appears to be Christ and two children, is accompanied by piping shepherds, a young girl reaches for fruit from a tree, and elders saunter on a fecund river bank, under overhanging fruitful trees, the whole scene apparently showing the journey from childhood to the sun of Redemption in the company of Christ. The association between the state of childhood, the arts represented by the pipe, and Redemption through Christ, is maintained throughout by pastoral imagery, as in *Songs of Innocence*.

Pictorially the life of Christ group is the least interesting, and in such works as *The King of the Jews* (private collection, S. Africa) and *Christ accompanied by figures with musical instruments* (private collection, U.S.A.) the gentleness of the depiction of Jesus may be contrasted with the vigorous characterization of Christ in *The Everlasting Gospel*. Even so, there are some striking effects: in *Christ and the Woman taken in Adultery* (Boston, Museum of Fine Arts)[18] the Pharisees' rush for the exit of the colonnade, their backs forming an undifferentiated mass of humanity, is one of Blake's most original ideas, and the fervour of the contrast between their justice and His reveals Blake's consciousness of forgiveness of sin as the supreme distinction of Christ's teaching.

The watercolours of the life of Moses appear to form a cycle; all ten can be dated approximately to the year 1805, and the unifying theme appears to be Moses' opposing roles of prophet and law-giver. In *Moses and the Burning Bush* (Victoria and Albert Museum) he is seen as a shepherd perceiving the vision in the Burning Bush, while in *God writing upon the tablets of the covenant* (National Gallery of Scotland)[19] he is depicted in abject submission to Jehovah in his role of giver of 'the Book of Iron', the Ten Commandments by which he binds mankind within the bonds of the Law. The child Moses leaps with Christ-like exultation from the ark in *The Compassion of Pharaoh's daughter* (Victoria and Albert Museum), for he represents the survival of prophecy and therefore the hope of Redemption amongst alien Egypt, where maidens look upon him with compassion and curiosity but without understanding. In *Moses striking the rock* (formerly Mrs Tonner Collection, Philadelphia), he foreshadows typologically the miraculous power of Christ, yet the consequence of his acceptance of the Ten Commandments can be seen by the exercise of his vengeful laws in *The Blasphemer* (Tate Gallery), if the identification of this unexpected subject

from Leviticus is correct.[20] There are also further hints of typological parallels between Moses and Christ; the composition of the *The Compassion of Pharaoh's daughter*, the maternal gesture of the nurse, and the suggestion of wonder and awe in the procession of attendants, hint at the motifs attendant on the Nativity, and the whole image seems to parallel *The Christ Child saying its prayers* (Doheny Memorial Library), in which Christ's parents and attendant angels adore His heavenly presence. The wrath Moses invokes in the Plagues of Egypt, represented by a watercolour of *Pestilence*, or *The Death of the First Born* (Boston Museum of Fine Arts),[21] may on the other hand contrast with Christ's display of forgiveness in the watercolour of *Christ and the woman taken in adultery*, for Moses as law-giver was the spiritual ancestor of the Pharisees, whose legalism was overthrown by Christ's mercy. The watercolour of *Pestilence* seems to form with *Famine* and *Plague* a self-contained group, all of 1805, to which may also be added *Fire* (Pierpont Morgan Library) and a version also dated 1805 of *Morning after the Battle* (Fogg Museum, Harvard University), a composition first exhibited in 1784, but probably extensively revised.[22] The *Plague* watercolour, with a Gothic church in the background, betrays its origins in an earlier design (Bristol City Art Gallery),[23] in which reference is made both to the Great Day of His Wrath in Revelation and the seventeenth-century Great Plague of London. Despite the 'Egyptian' setting of *Pestilence*, the backgrounds still give a sense of the universality of God's judgement; Egypt was, above all, a mental state rather than a historical place.

Blake continued to make Biblical watercolours for Butts after 1805, and these will be discussed later, but the bulk of them were completed by about that year, and it is safe to regard those executed up to that point as constituting the main Butts series. Even so, they are quite without the overall coherence of the Butts tempera series, and it is probable that Butts did not commission a specific number originally, but expected Blake to send them on to him in return for a stipend. Certain cycles can be isolated, such as the Crucifixion of Christ and the Life of Moses, but it is notable that not all the subjects were completed at the same time or necessarily even in the same format. Butts or members of the family in many cases wrote the passage illustrated in laborious copperplate under the text, and it is probable that they were intended not to be hung on a wall but to be either bound in a volume or interleaved in a large Bible. Their episodic nature reflects, therefore, the circumstances of their production; they were produced at odd intervals at the dictate of Blake's angels, perhaps when he was in need of money or when he was not occupied with engraving or writing.

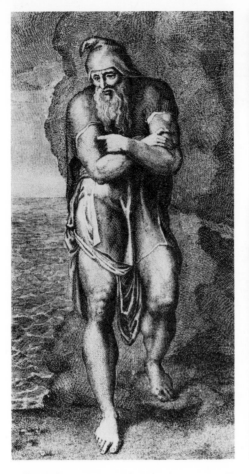

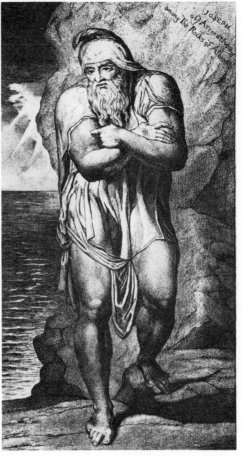

Top left: 1. *Joseph of Arimathea.* 1773. Engraving. England, private collection.

Top right: 2. *Joseph of Arimathea* (second state). Engraving. London, British Museum.

Bottom: 3. James Barry: *Job reproved by his Friends.* 1777. Engraving. London, British Museum.

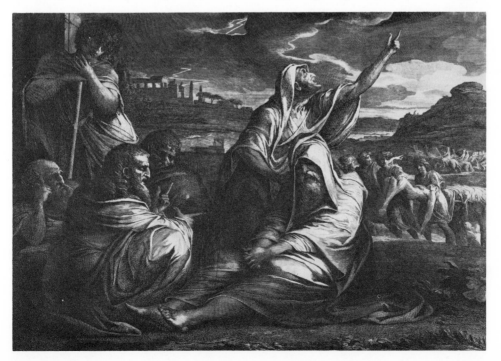

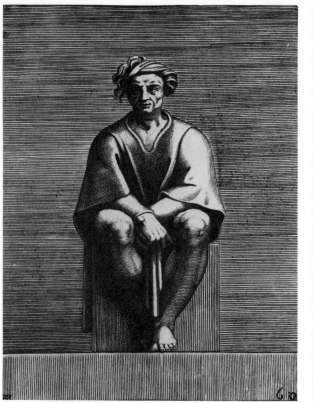

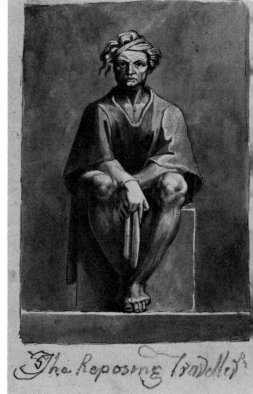

Top left: 4. Adamo Ghisi after Giorgio Ghisi after Michelangelo: *Figure from Sistine Chapel.* Engraving. London, British Museum.

Top right: 5. After Adamo Ghisi: *The Reposing Traveller.* Pen and wash. London, British Museum.

Bottom: 6. Copy of engraving in d'Hancarville, *Hamilton Collection*, 1766–7, Vol. II, pl. 57. Pen. London, British Museum.

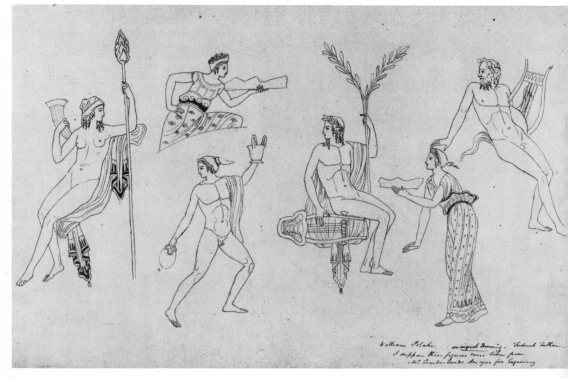

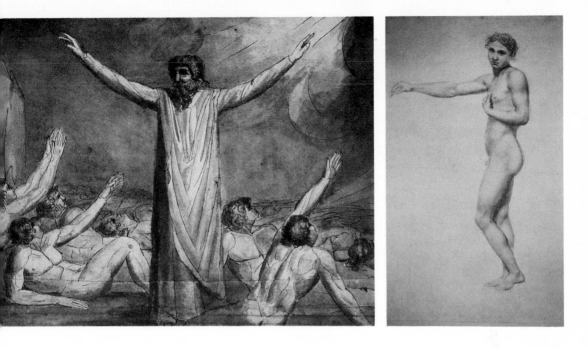

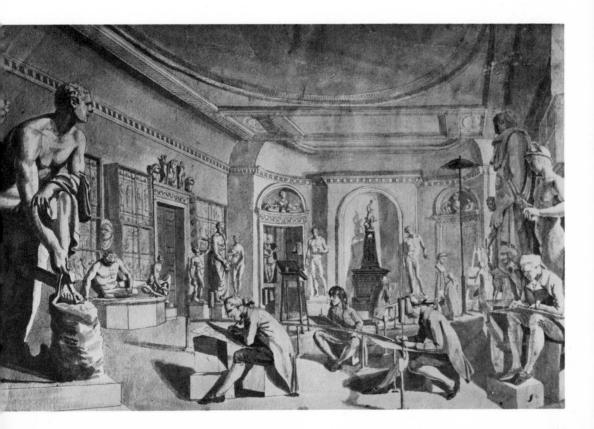

Top left: 7. *The Second Vision of Ezekiel.* Pen and wash. Washington, National Gallery of Art, Rosenwald Collection.

Top right: 8. *Drawing from life.* Chalk. London, British Museum.

Bottom: 9. E. F. Burney: *The Royal Academy Life School.* 1780. Watercolour. London, Royal Academy of Arts.

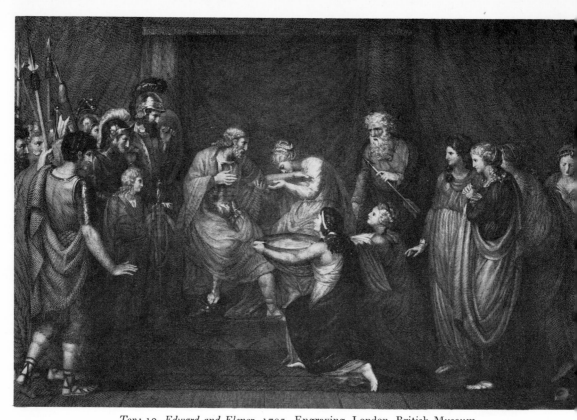

Top: 10. *Edward and Elenor.* 1793. Engraving. London, British Museum.

Bottom: 11. J. H. Mortimer: *Vortigern and Rowena.* Exhibited 1779. Oil. Private collection.

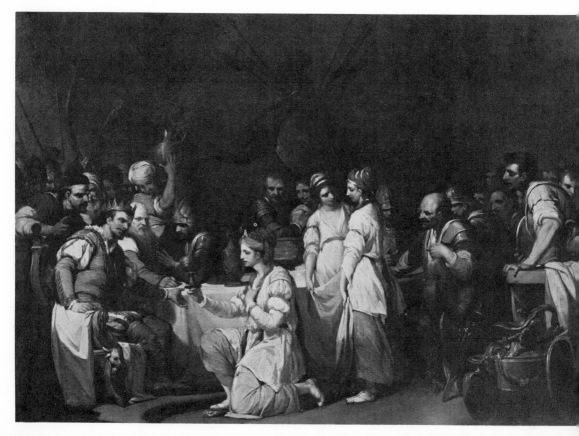

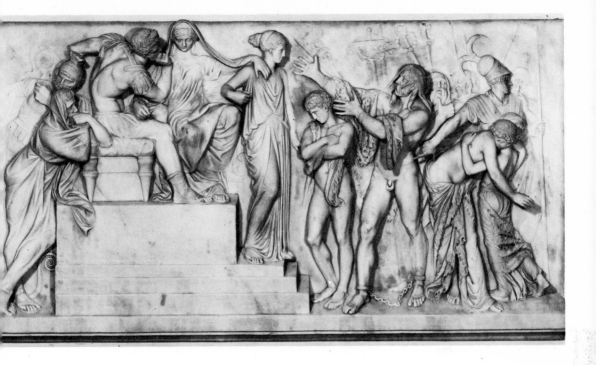

Top: 12. Thomas Banks: *Caractacus before Claudius*. 1777. Marble. Buckinghamshire, Stowe School.

Bottom: 13. *The Death of Earl Godwin*. 1779–80. Watercolour. London, British Museum.

Top: 14. *The Ordeal of Queen Emma.* Watercolour. England, private collection.

Bottom: 15. *Gregory the Great and the Captives.* Watercolour. London, Victoria and Albert Museum.

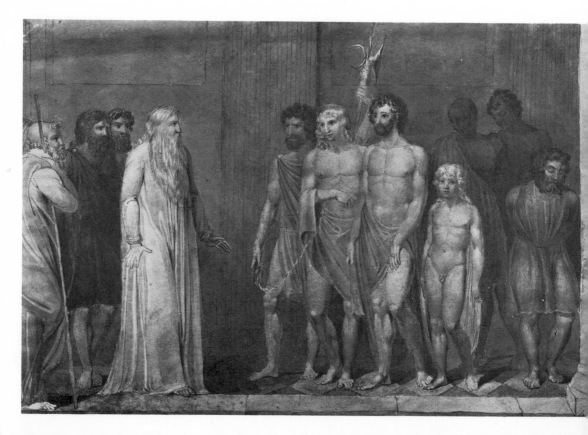

16. Thomas Stothard, engraved by William Sharp: *Declaration of Rights*. 1782. Engraving. London, British Museum.

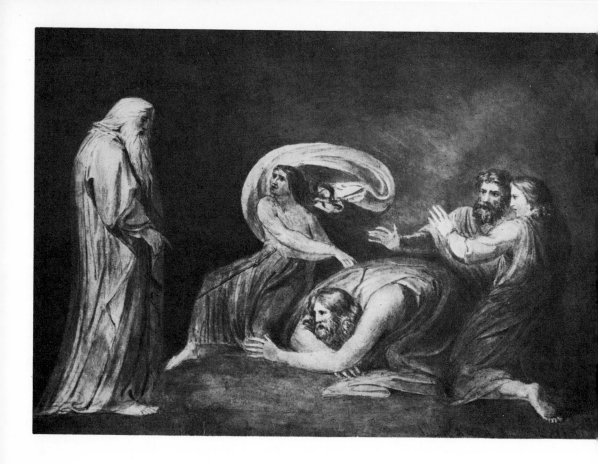

Top: 17. *Saul and the Witch of Endor.* 1783. Watercolour. New York Public Library.

Bottom left: 18. Benjamin West: *Saul and the Witch of Endor.* 1777. Oil. Hartford, Connecticut, Wadsworth Atheneum.

Bottom right: 19. Benjamin West: *Peter preaching at Pentecost.* Exhibited 1785. Oil. Greenville, South Carolina, Bob Jones University Collection.

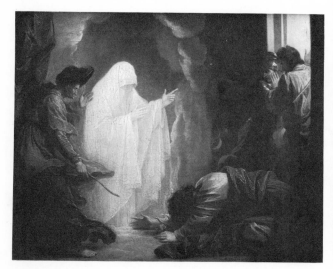

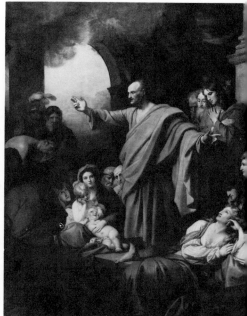

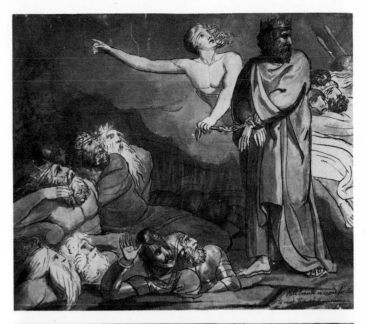

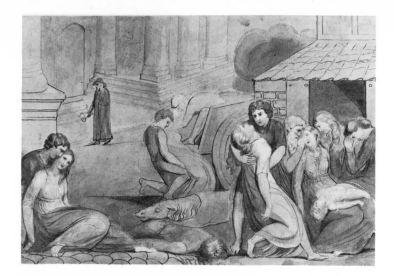

Top: 24. *Pestilence*. Watercolour. Los Angeles, Robert Essick Collection.

Centre: 25. Benjamin West: *Death on a Pale Horse*. 1783 (retouched 1802). Pen and wash. London. Royal Academy of Arts.

Bottom: 26. After Thomas Stothard: *Zephyrus and Flora*. 1784. Stipple engraving. England, private collection.

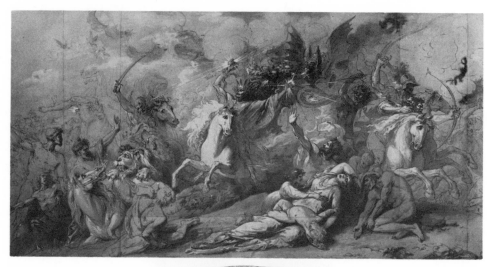

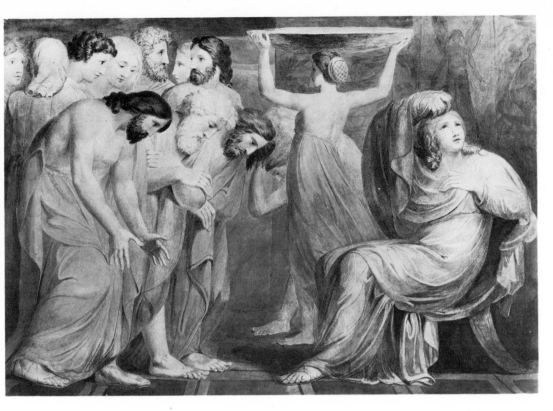

Top: 27. *Joseph's Brethren bowing down before him.* Exhibited 1785. Watercolour. Cambridge, Fitzwilliam Museum.

Bottom: 28. *Joseph making himself known to his Brethren.* Exhibited 1785. Watercolour. Cambridge, Fitzwilliam Museum.

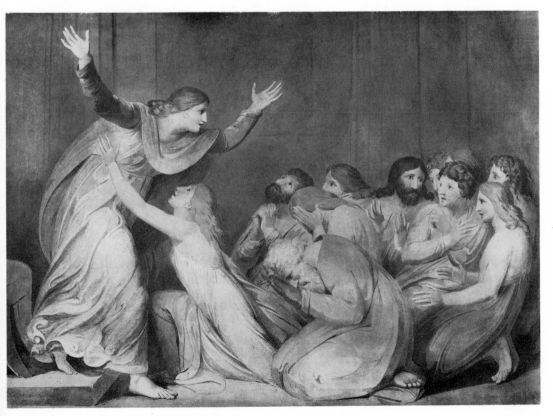

Top left: 29. *Job.* 1793. Engraving. London, British Museum.

Top right: 30. *Ezekiel.* 1794. Engraving. London, British Museum.

Bottom: 31. James Barry: *Lear and Cordelia.* Oil. London, Tate Gallery.

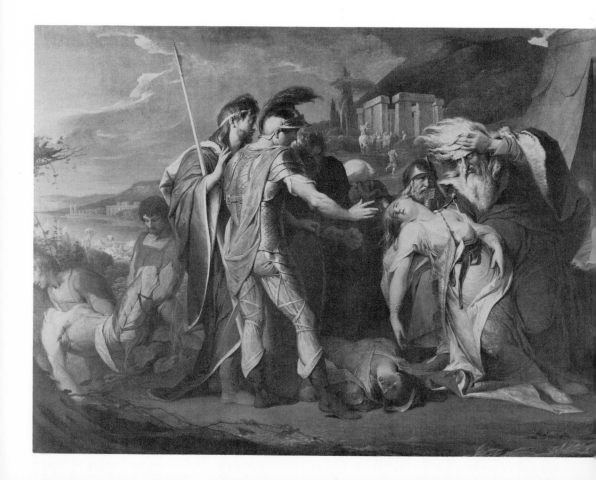

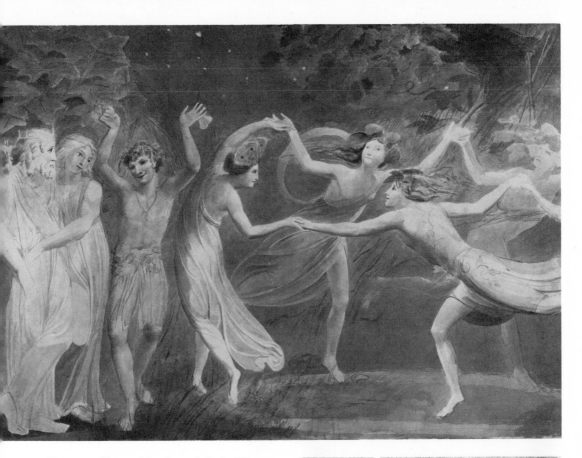

Top: 32. *Oberon, Titania and Puck.* Water-colour. London, Tate Gallery.

Bottom: 33. Thomas Stothard: Illustration to Thomas Tickell's *Kensington Gardens*, 1781. Engraving. London, British Museum.

TICKLE

Printed for John Bell, British Library Strand, London, Dec.r 27.th 1781.

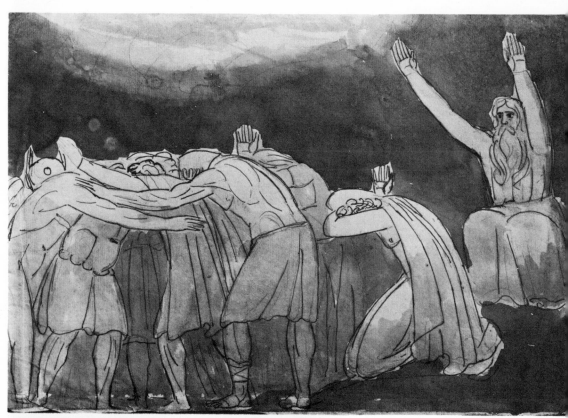

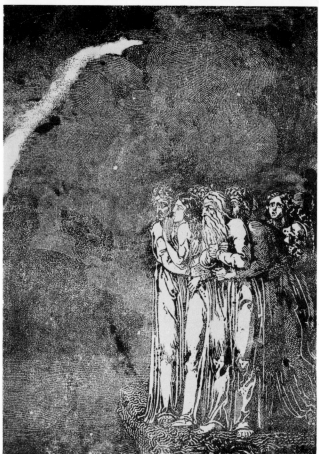

Top: 34. Robert Blake: Unknown subject. Pen and wash. Formerly Graham Robertson Collection.

Bottom: 35. 'The Approach of Doom'. Engraving and relief etching. London, British Museum.

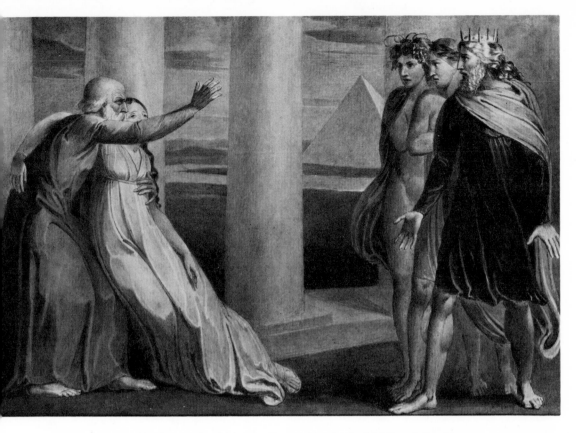

Top: 36. *Tiriel supporting Myratana.* Pen and wash. Paul Mellon Collection.

Bottom: 37. *Har and Heva bathing.* Pen and wash. Cambridge, Fitzwilliam Museum.

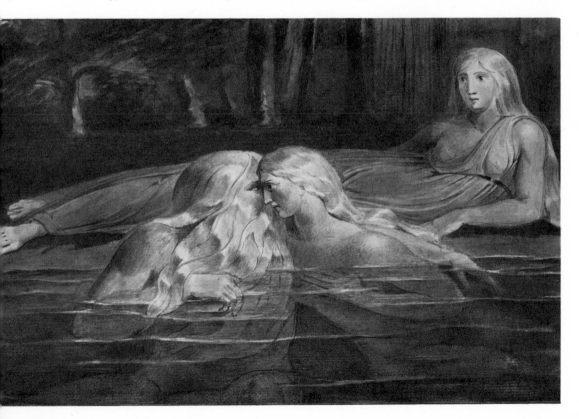

Top left: 38. There is no natural Religion (series a, Proposition II). Relief etching. London, Victoria and Albert Museum.

Top centre: 39. There is no natural Religion (series b, frontispiece). Relief etching. London, Victoria and Albert Museum.

Bottom left: 40. There is no natural Religion (series a, Proposition I). Relief etching. London, Victoria and Albert Museum.

Bottom centre: 41. All Religions are one. Frontispiece. Relief etching. San Marino, California, Huntington Library.

Right: 42. All Religions are one. Titlepage. Relief etching. London,

II
Man by his reason-
ing power. can only
compare & judge of
what he has already
percievd.

The Voice of one crying in the
Wilderness

Man cannot naturally Per-
cieve, but through his natural
or bodily organs

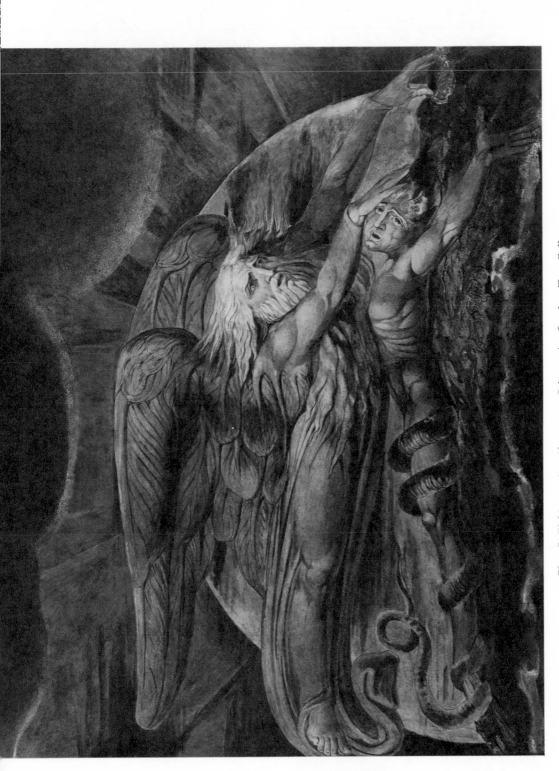

Plate I. *Elohim creating Adam.* *1795.* Colour print. London, Tate Gallery.

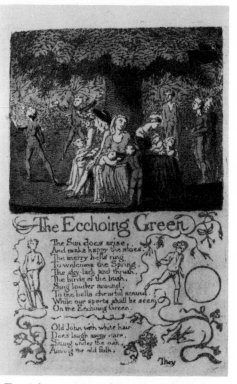

Top left: 43. *Songs of Innocence, Titlepage.*
1789. Relief etching (copy B). Washington,
National Gallery of Art, Rosenwald Collection.

Top right: 44. *Songs of Innocence, The Ecchoing
Green.* 1789. Relief etching (copy B). Wash-
ington, National Gallery of Art, Rosenwald
Collection.

Bottom left: 45. *Songs of Innocence, The Shep-
herd.* 1789. Relief etching (copy B). Wash-
ington, National Gallery of Art. Rosenwald
Collection.

Bottom right: 46. *Songs of Innocence, Little Boy
Found.* 1789. Relief etching (copy B). Wash-
ington, National Gallery of Art, Rosenwald
Collection.

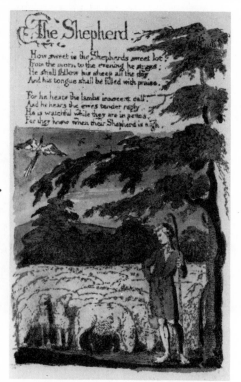

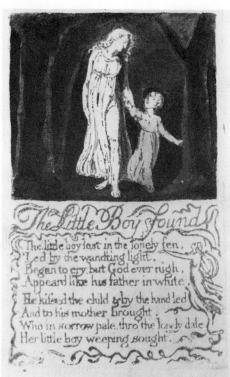

Top: 47. Thomas Stothard: *The Children in the Wood.* 1784. Stipple engraving. London, British Museum.

Bottom left: 48. J. Sturt: *The Orthodox Communicant.* 1721. Engraving.

Bottom right: 49. George Bickham: *Musical Entertainer* (p. 16). 1737–9. Engraving. Newcastle, King's College.

Top left: 50. *Book of Thel, Titlepage.* 1789.
Relief etching (copy H). Washington, National
Gallery of Art, Rosenwald Collection.

Top right: 51. *Book of Thel, Plate 5.* 1789.
Relief etching (copy O). Washington, National
Gallery, Rosenwald Collection.

Bottom: 52. Composition study for *The Book of Thel*. 1789. Pencil. Formerly Graham Robertson Collection.

As a new heaven is begun, and it is now thirty-three years since its advent: the Eternal Hell revives. And lo! Swedenborg is the Angel sitting at the tomb; his writings are the linen clothes folded up. Now is the dominion of Edom, & the return of Adam into Paradise; see Isaiah XXXIV & XXXV Chap:
Without Contraries is no progression. Attraction and Repulsion, Reason and Energy, Love and Hate, are necessary to Human existence.
From these contraries spring what the religious call Good & Evil. Good is the passive that obeys Reason Evil is the active springing from Energy.
Good is Heaven. Evil is Hell.

Those who restrain desire, do so because theirs is weak enough to be restrained; and the restrainer or reason usurps its place & governs the unwilling.
And being restraind it by degrees becomes passive till it is only the shadow of desire.
The history of this is written in Paradise Lost. & the Governor or Reason is calld Messiah.
And the original Archangel or possessor of the command of the heavenly host, is calld the Devil or Satan and his children are calld Sin & Death
But in the Book of Job Miltons Messiah is calld Satan.
For this history has been adopted by both parties
It indeed appeard to Reason as if Desire was cast out, but the Devils account is, that the Messi

Top left: 53. *The Marriage of Heaven and Hell, Plate 3*. Relief etching. Washington, National Gallery of Art, Rosenwald Collection.

Top right: 54. *The Marriage of Heaven and Hell, Plate 5*. Relief etching. Washington, National Gallery of Art, Rosenwald Collection.

Bottom left: 55. *The Marriage of Heaven and Hell, Plate 21*. Relief etching. Washington, National Gallery of Art, Rosenwald Collection.

Bottom right: 56. *Visions of the Daughters of Albion, Frontispiece*. 1795. Relief etching. London, Tate Gallery.

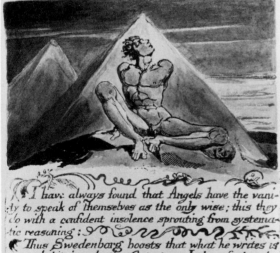

I have always found that Angels have the vanity to speak of themselves as the only wise; this they do with a confident insolence sprouting from systematic reasoning:
Thus Swedenborg boasts that what he writes is new; tho' it is only the Contents or Index of already publishd books
A man carried a monkey about for a shew, & because he was a little wiser than the monkey, grew vain, and conciev'd himself as much wiser than seven men. It is so with Swedenborg; he shews the folly of churches & exposes hypocrites, till he imagines that all are religious. & himself the single one

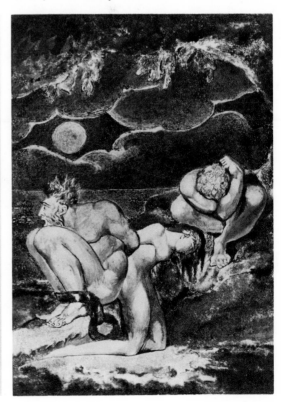

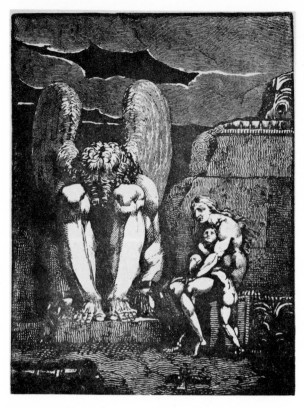

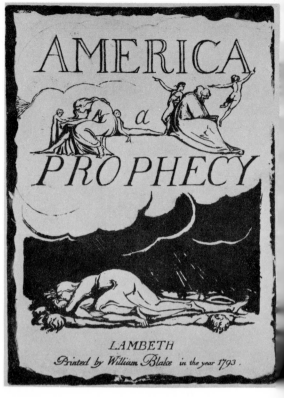

Top left: 57. *America, Frontispiece*. 1793. Relief etching. England, private collection.

Top right: 58. *America, Titlepage*. 1793. Relief etching. Cambridge, Fitzwilliam Museum.

Bottom: 59. *A Breach in the City*. 1805. Watercolour. Harvard, Fogg Museum.

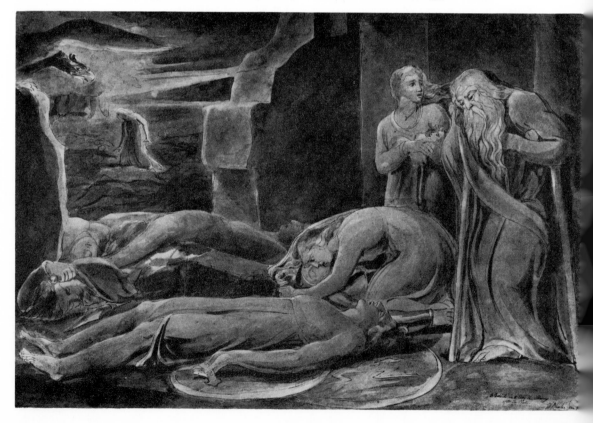

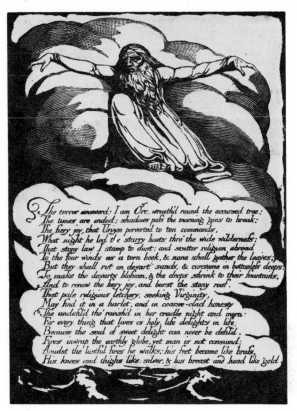

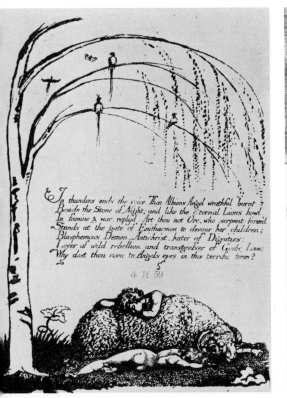

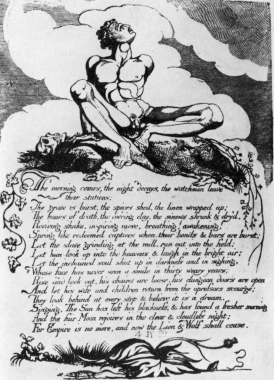

Top left: 60. *America, Plate 10.* 1793. Relief etching. Cambridge, Fitzwilliam Museum.

Top right: 61. *America, Plate 8.* 1793. Relief etching. Cambridge, Fitzwilliam Museum.

Bottom left: 62. *America, Plate 7.* 1793. Relief etching. London, British Museum.

Bottom right: 63. *America, Plate 6.* 1793. Relief etching. London, British Museum.

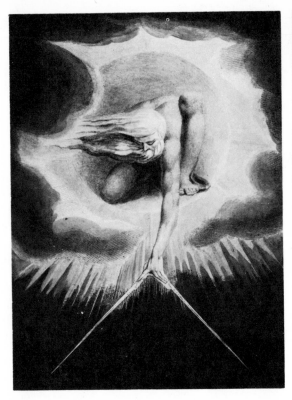

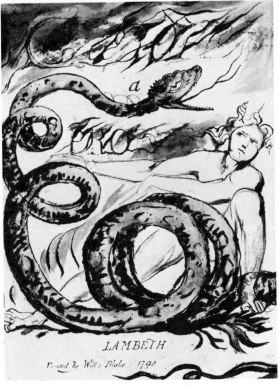

Top left: 64. *Europe, Frontispiece.* 1794. Relief etching colour printed. London, British Museum.

Bottom left: 66. *Europe, Preludium.* 1794. Relief etching colour printed. London, British Museum.

Top right: 65. *Europe, Titlepage.* 1794. Relief etching with pen. Scotland, private collection.

Bottom right: 67. *Europe, 'Plague'.* 1794. Relief etching colour printed. London, British Museum.

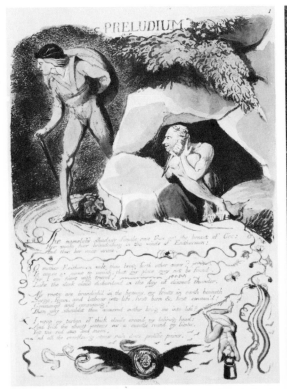

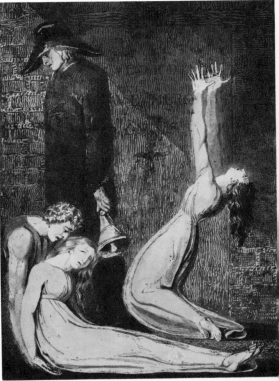

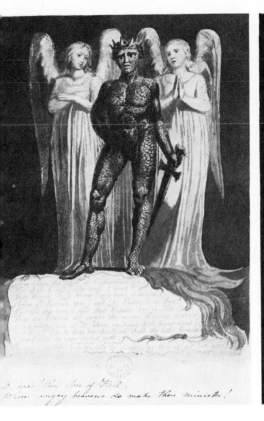

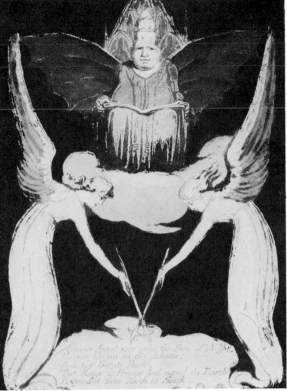

Top left: 68. *Europe, Plate 5.* 1794. Relief etching colour printed. London, British Museum.

Top right: 69. *Europe, Plate 10.* 1794. Relief etching colour printed. London, British Museum.

Bottom left: 70. *Song of Los, Frontispiece.* 1795. Relief etching colour printed. London, British Museum.

Bottom right: 71. *Song of Los, Frontispiece to* '*Asia*'. 1795. Relief etching colour printed. London, British Museum.

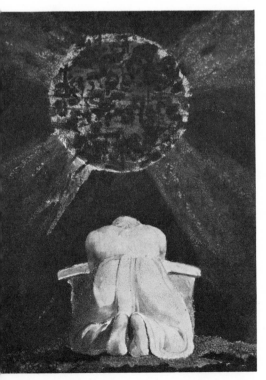

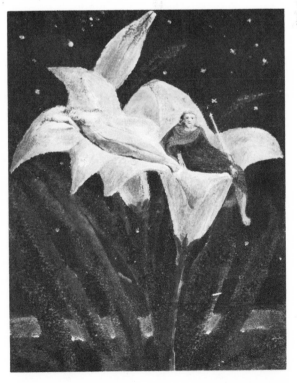

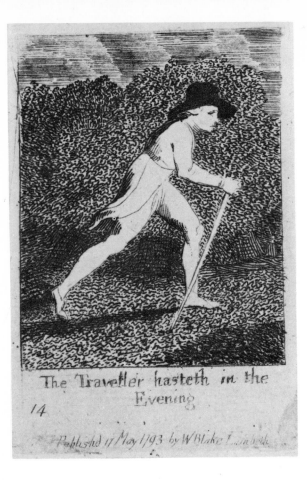

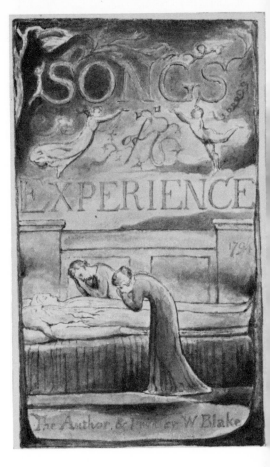

72. *Gates of Paradise, Plate 14.* 1793. Engraving. London, British Museum.

Left: 73. *Songs of Experience, Titlepage.* 1794. Relief etching (copy AA). Cambridge, Fitzwilliam Museum.

THE GARDEN of LOVE.

I went to the Garden of Love.
And saw what I never had seen:
A Chapel was built in the midst,
Where I used to play on the green.

And the gates of this Chapel were shut,
And Thou shalt not. writ over the door;
So I turn'd to the Garden of Love,
That so many sweet flowers bore.

And I saw it was filled with graves,
And tomb-stones where flowers should be;
And Priests in black gowns. were walking their
 rounds,
And binding with briars, my joys & desires.

Right: 74. *Songs of Experience, The Garden of Love.* 1794. Relief etching (copy O). Cambridge, Mass., The Houghton Library, Harvard College.

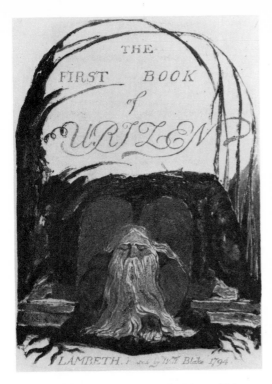

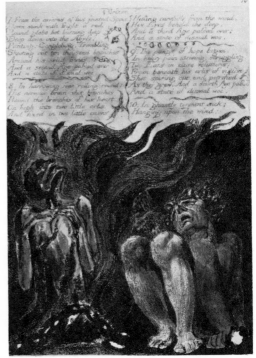

Top left: 75. The Book of Urizen, Titlepage. 1794. Relief etching colour printed. London, British Museum.

Top right: 76. The Book of Urizen, Plate 10. 1794. Relief etching colour printed. London, British Museum.

Bottom left: 77. The Book of Urizen, Plate 20. 1794. Relief etching colour printed. London, British Museum.

Bottom right: 78. The Book of Urizen, Plate 21. 1794. Relief etching colour printed. London, British Museum.

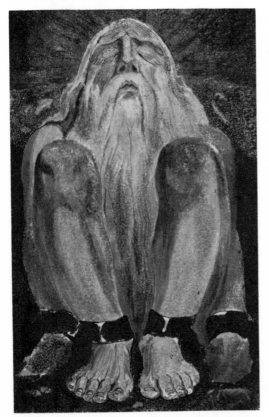

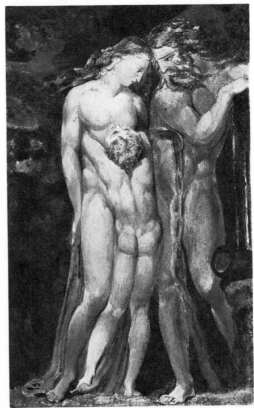

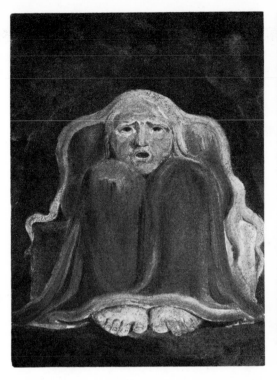

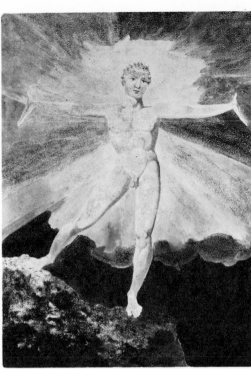

Top left: 79. *Book of Los, Frontispiece.* 1794. Intaglio etching colour printed. London, British Museum.

Top right: 80. *'Albion arose'.* Engraving colour printed. San Marino, California, Huntington Library.

Bottom: 81. *The Lazar House.* 1795. Colour print. London, Tate Gallery.

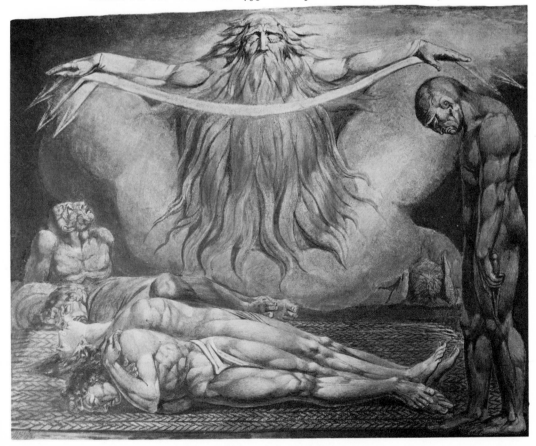

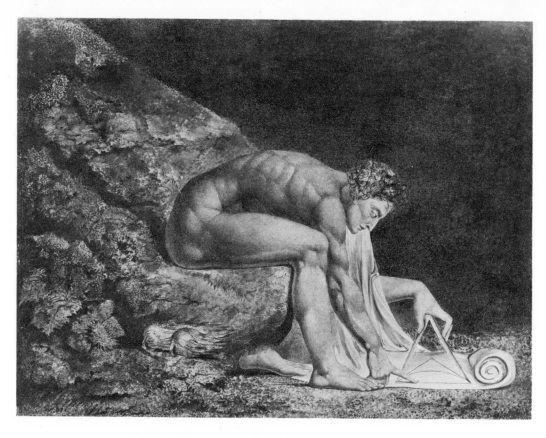

Top: 82. *Newton.* 1795. Colour print. London, Tate Gallery.

Bottom: 83. *Naomi, Ruth and Orpah.* 1795. Colour print. London, Victoria and Albert Museum.

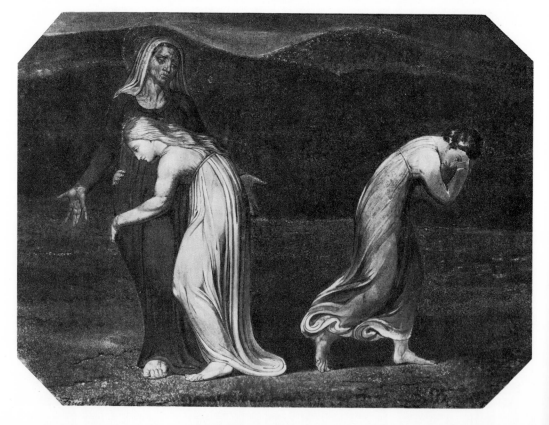

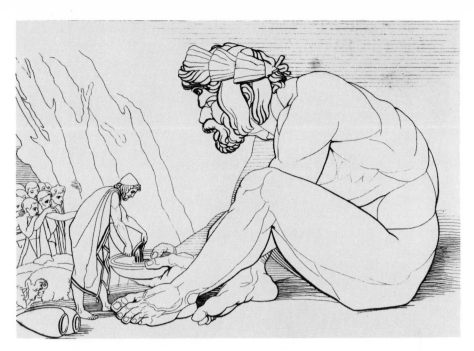

Top: 84. John Flaxman: *Odysseus gives wine to Polyphemus.* 1793. Engraving.

Bottom: 85. Henry Fuseli: *The Vision of Noah.* Drawing. Zürich, Kunsthaus.

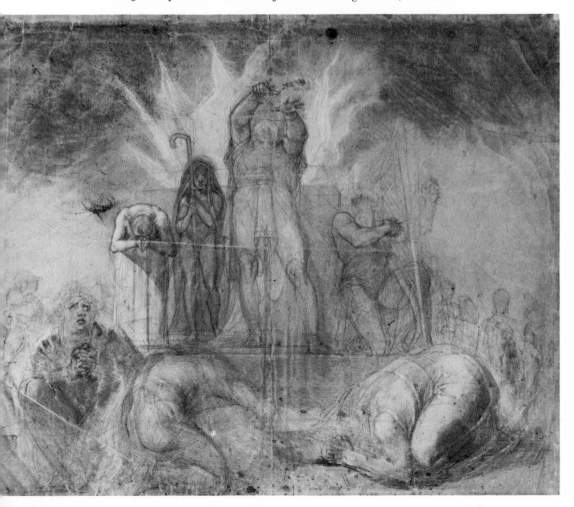

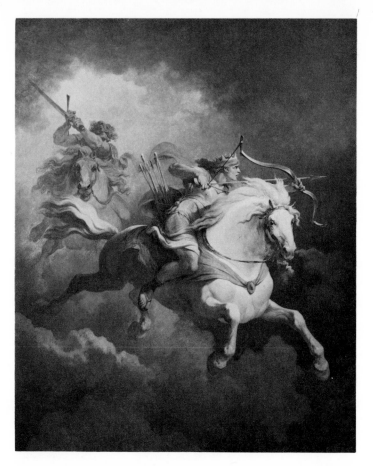

Top: 86. Philippe de Loutherbourg: *Vision of the White Horse.* 1800. Oil. London, Tate Gallery.

Bottom: 87. George Romney: *Satan, Sin and Death.* 1790. Pencil. Whereabouts unknown.

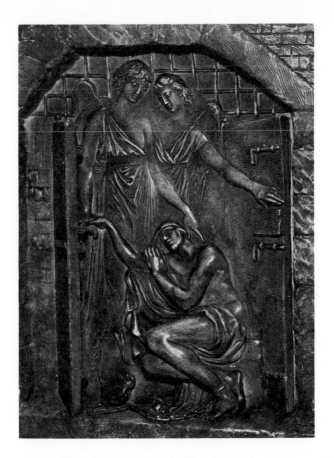

Top: 88. Thomas Banks: *Model for monument to the Hon. Mary Pakenham.* 1791. Plaster. London,
Sir John Soane Museum.

Bottom: 89. A. J. Carstens: *Nacht mit Ihren Kindern.* 1794. Pen and wash. Weimar, Schlossmuseum.

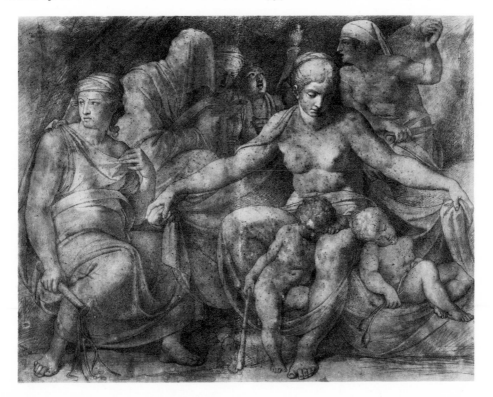

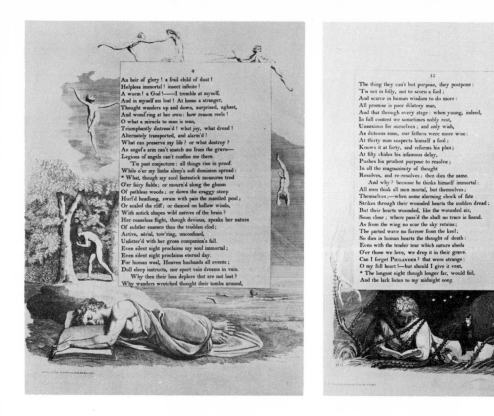

Top left: 90. Young's *Night Thoughts*, *Night* I, *p. 4.* 1797. Engraving. Cambridge, Fitzwilliam Museum.

Top right: 91. Young's *Night Thoughts*, *Night* I. *p. 15.* 1797. Engraving. Cambridge, Fitzwilliam Museum.

Bottom left: 92. Young's *Night Thoughts*, *Night* IV, *p. 10.* Watercolour. London, British Museum.

Bottom right: 93. Young's *Night Thoughts*. *Night* VIII, *p. 31.* Watercolour. London, British Museum.

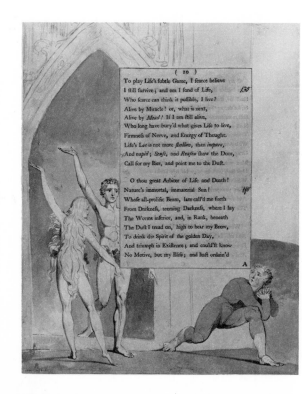

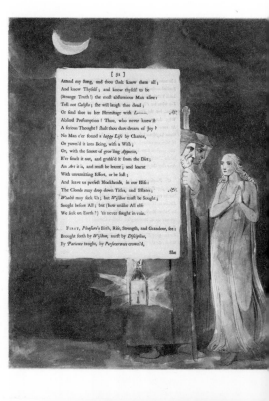

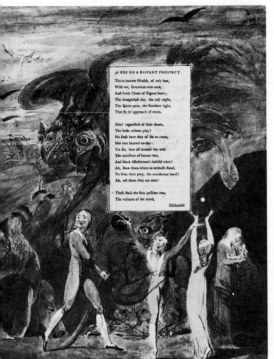

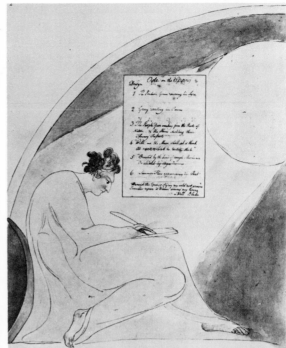

Top left: 94. Gray's *Poems, No. 18.*
Watercolour. Washington, Paul
Mellon Collection.

Top right: 95. Gray's *Poems, No.
2.* Watercolour. Washington,
Paul Mellon Collection.

Bottom: 96. *Malevolence.* 1800.
Watercolour. Philadelphia Mu-
seum of Art.

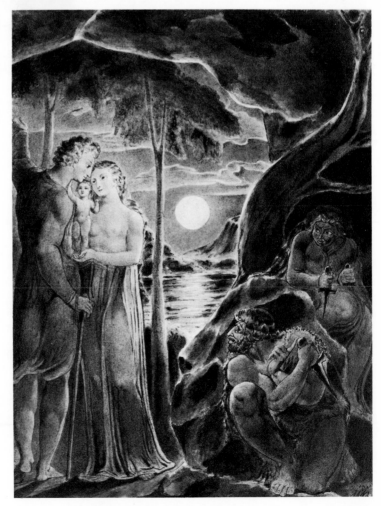

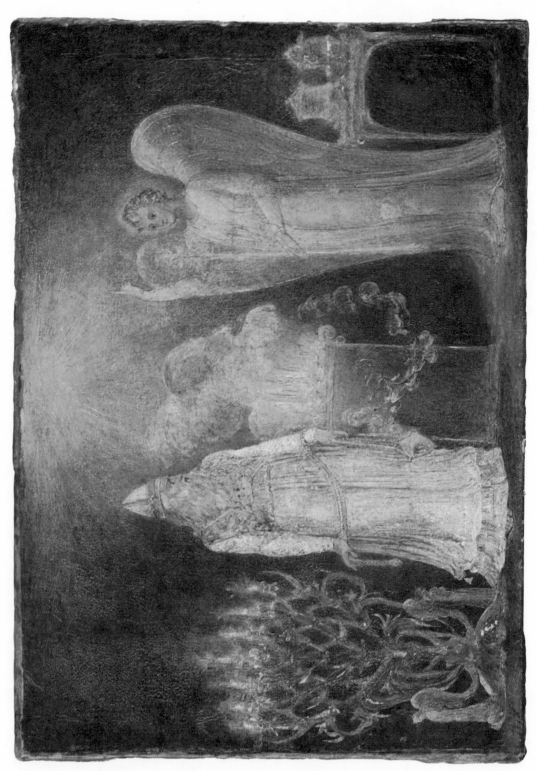

Plate II. *Zacharias and the Angel.* 1799–1800. Tempera. New York. Metropolitan Museum of Art. Bequest of William Church Osborn. 1951.

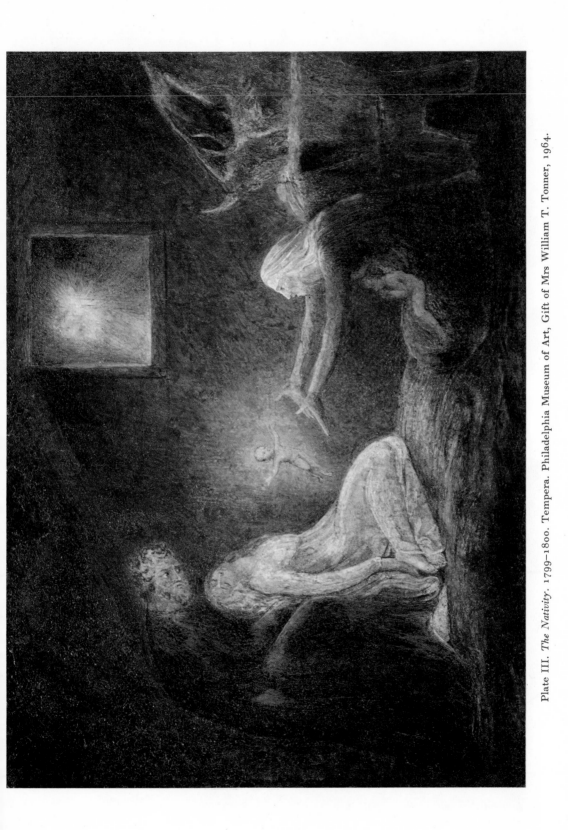

Plate III. *The Nativity*. 1799–1800. Tempera. Philadelphia Museum of Art, Gift of Mrs William T. Tonner, 1964.

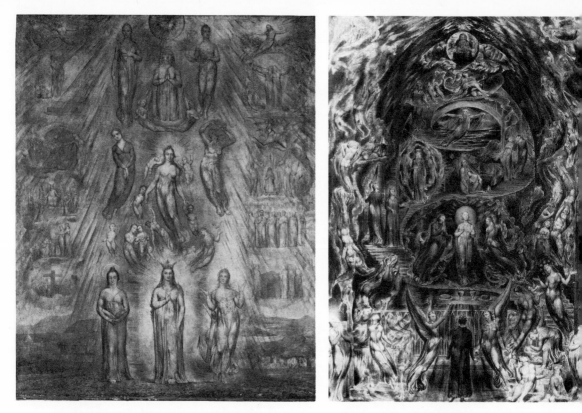

Top left: 97. *The Spiritual Condition of Man.*
Tempera, Cambridge, Fitzwilliam Museum.

Top right: 98. *Epitome of Hervey's 'Meditations among the Tombs'.* Watercolour. London, Tate Gallery.

Bottom: 99. *The Temptation of Eve.* 1799–1800. Tempera. London, Victoria and Albert Museum.

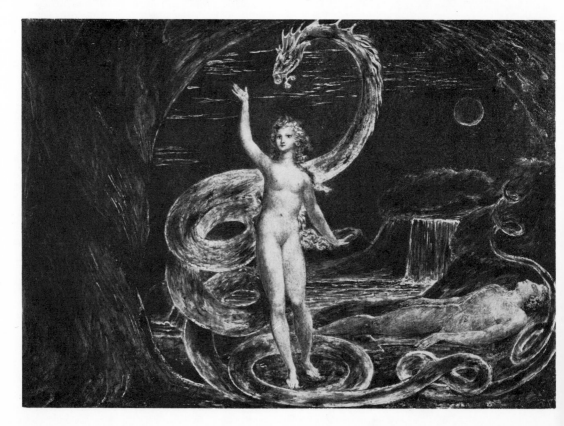

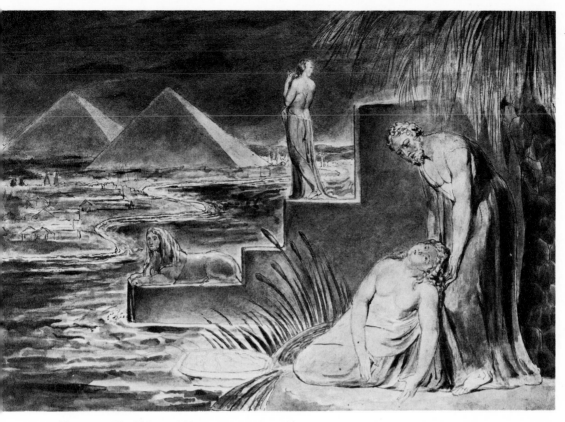

Top: 100. *The Hiding of Moses.* Watercolour. San Marino, California, Huntington Library.

Bottom: 101. *The Virgin hushing John the Baptist.* 1799. Tempera. San Francisco, Howell Books.

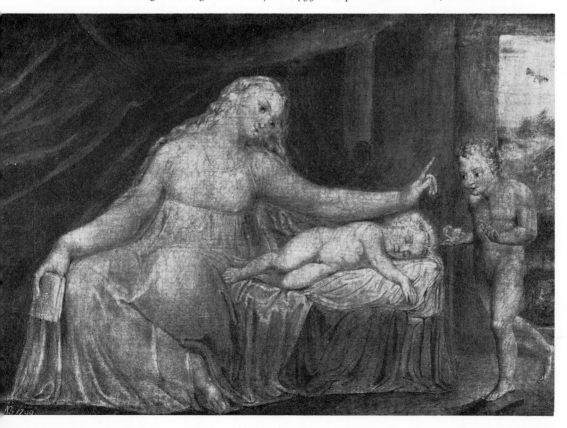

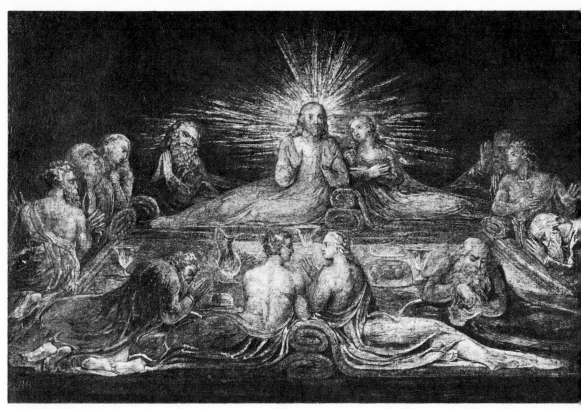

Top: 102. *The Last Supper.* 1799–1800. Tempera. Washington, National Gallery of Art, Rosenwald Collection.

Bottom: 103. *The Procession from Calvary.* 1799–1800. Tempera. London, Tate Gallery.

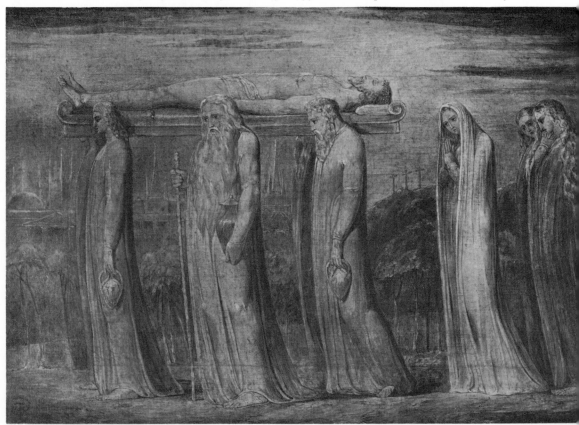

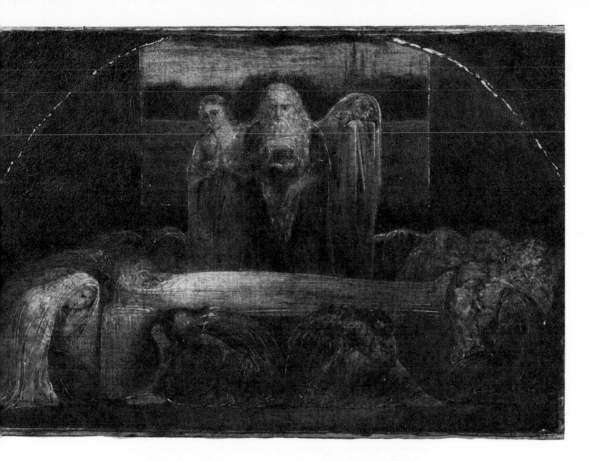

Top: 104. *The Entombment.* 1799–1800. Tempera. Glasgow, Pollok House.

Bottom: 105. Rembrandt: *Adoration of the Shepherds.* Oil. London, National Gallery.

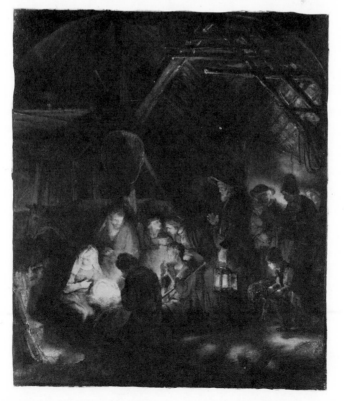

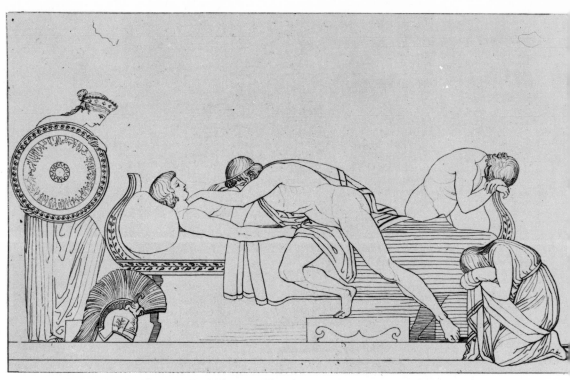

Top: 106. John Flaxman: *Iliad* (plate 31 : *Thetis bringing the armour to Achilles*). 1793. Engraving.

Bottom: 107. *Soldiers casting Lots for Christ's Garments*. 1800. Watercolour. Cambridge, Fitzwilliam Museum.

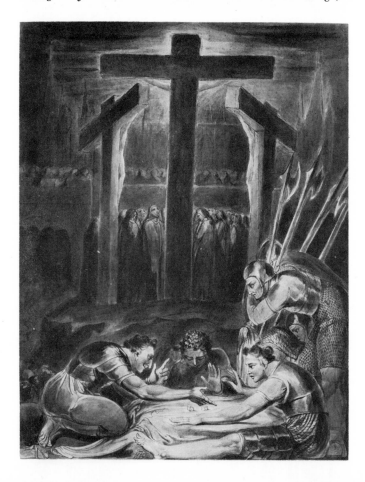

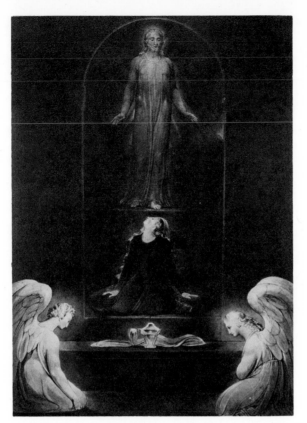

Top: 108. *Christ appearing to the Mary Magdalen.* Watercolour. New Haven, Yale Center for British Art. Paul Mellon Collection.

Bottom: 109. *Angels guarding Christ in the Tomb.* Watercolour. London, Victoria and Albert Museum.

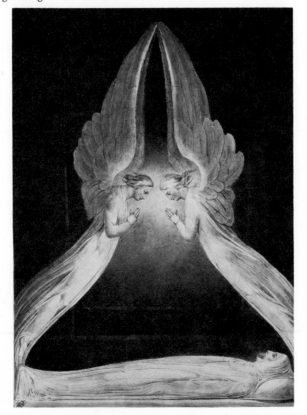

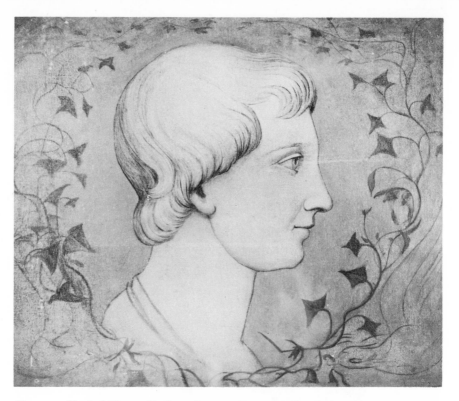

Top: 110. *Head of Thomas Hayley.* 1800–01. Tempera. Manchester City Art Gallery.

Bottom left: 111. *St Paul preaching at Athens.* 1803. Watercolour. Providence, Rhode Island School of Design.

Bottom right: 112. *The Angel of the Divine Presence clothing Adam and Eve.* 1803. Watercolour. Cambridge, Fitzwilliam Museum.

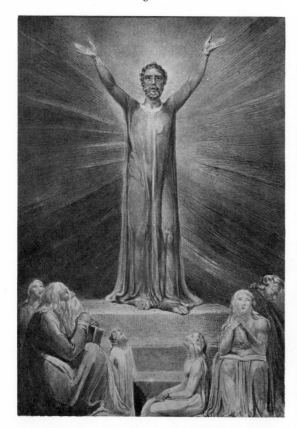

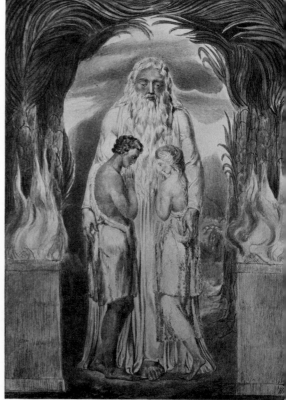

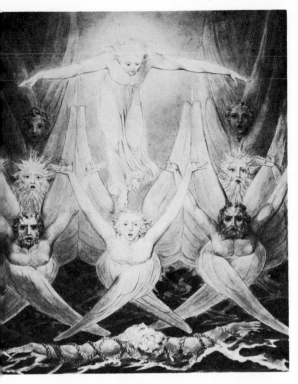

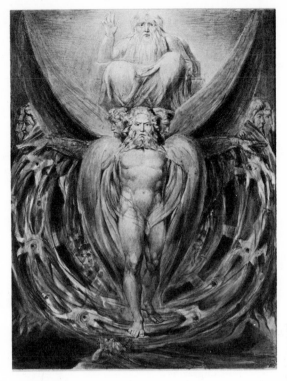

Top left: 113. *David delivered out of many Waters.* Watercolour. London, Tate Gallery.

Top right: 114. *The Vision of Ezekiel.* Watercolour. Boston Museum of Fine Arts.

Bottom: 115. '*Prone on the lonely grave*' for Blair's *The Grave.* Watercolour. New Haven, Yale Center for British Art. Paul Mellon Collection.

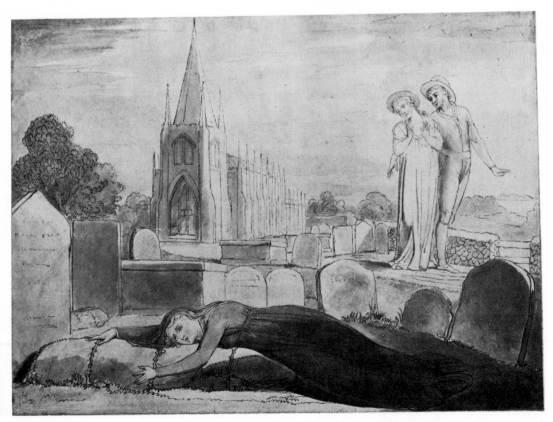

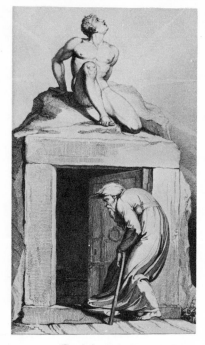

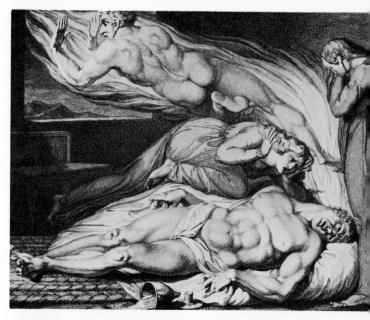

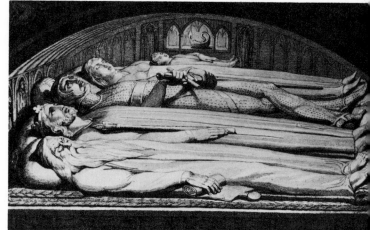

Top left: 116. 'Death's Door' for Blair's *The Grave.* 1808. Engraving.

Top right: 117. 'Death of the Strong Wicked Man' for Blair's *The Grave.* 1808. Engraving.

Centre right: 118. 'Counsellor, King, Warrior, Mother & Child in the Tomb' for Blair's *The Grave.* 1808. Engraving.

Bottom right: 119. 'Death of the Good Old Man' for Blair's *The Grave.* 1808. Engraving.

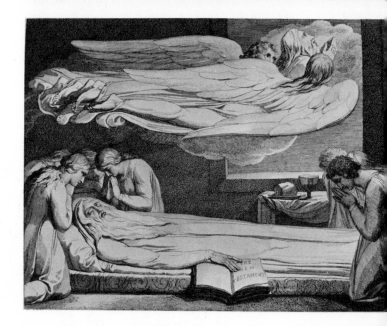

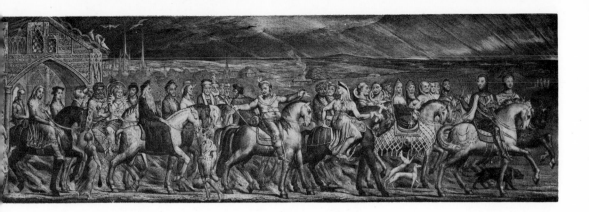

Top: 120. *Canterbury Pilgrims.* 1810. Engraving. Washington, National Gallery of Art, Rosenwald Collection.

Bottom left: 121. *The Spiritual Form of Nelson guiding Leviathan.* Tempera. London, Tate Gallery.

Bottom right: 122. Benjamin West: *The Apotheosis of Nelson.* 1807. Oil. London, National Maritime Museum, Greenwich.

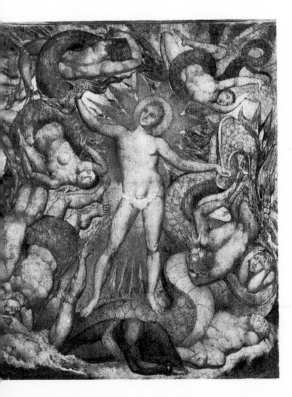

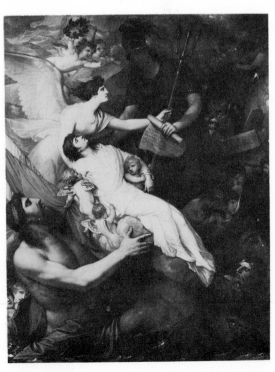

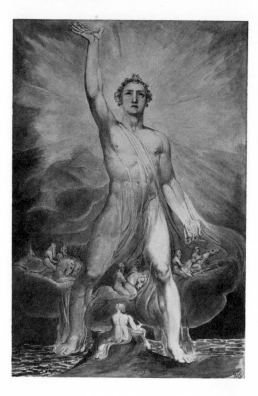

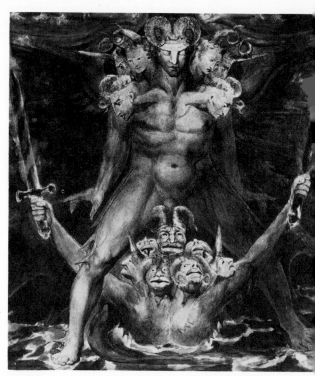

Top left: 123. *The Angel of Revelation*. Watercolour. New York, Metropolitan Museum of Art, Rogers Fund, 1914.

Top right: 124. *The Beast of Revelation*. Watercolour. Washington, National Gallery of Art, Rosenwald Collection.

Bottom: 125. *The Fall of Man*. 1807. Watercolour. London, Victoria and Albert Museum.

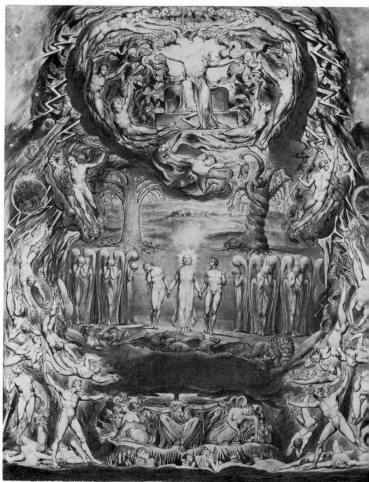

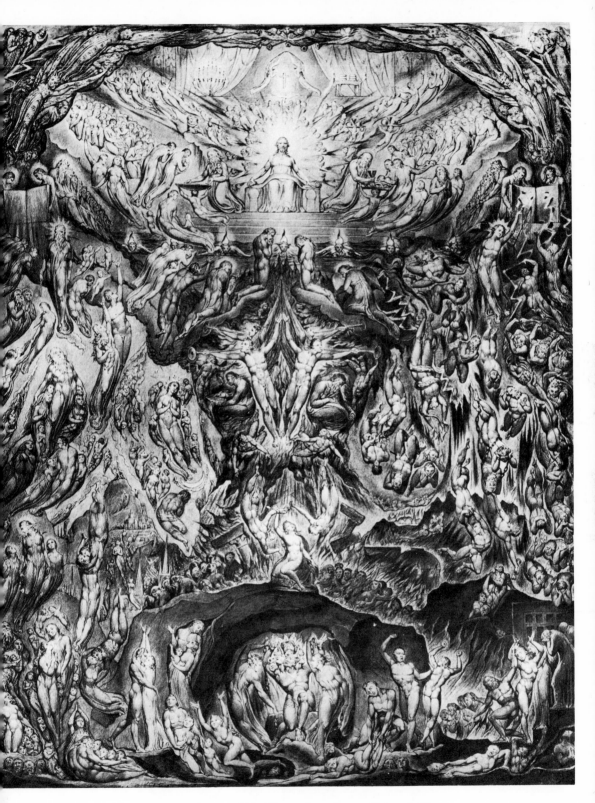

126. *The Last Judgment.* 1808. Watercolour. Sussex, Petworth House.

Top left: 127. *Adam naming the Beasts*. 1810.
Tempera. Glasgow, Pollok House.

Top right: 128. *Virgin and Child in Egypt*.
1810. Tempera. London, Victoria and Albert
Museum.

Bottom Left: 129. *Milton, a Poem, Plate 13*.
White line engraving. London, British
Museum.

Bottom right: 130. *Milton, a Poem, Plate 18*.
Relief etching. Washington, National Gallery
of Art, Rosenwald Collection.

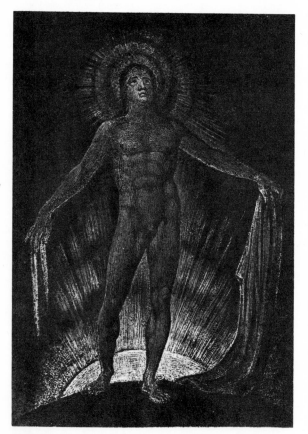

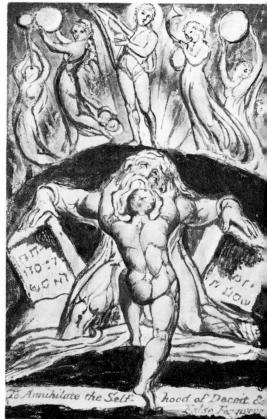

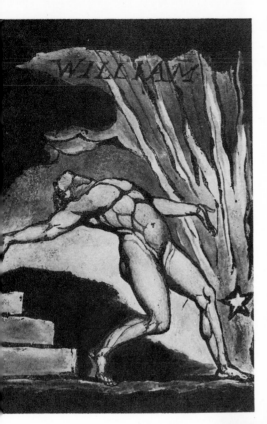

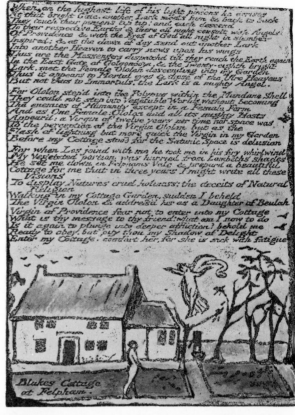

Top left: 131. *Milton, a Poem, Plate 29.* Relief etching. London, British Museum.

Top right: 132. *Milton, a Poem, Plate 36.* Relief etching. London, British Museum.

Bottom: 133. *Milton, a Poem, Plate 38.* White line engraving. London, British Museum.

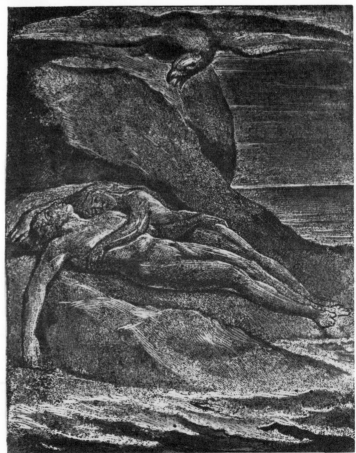

Top: 134. *Jerusalem, Frontispiece.*
White line engraving. Cambridge,
Fitzwilliam Museum.

Bottom left: 135. *Jerusalem, Title-page.* Relief etching. London, British
Museum.

Bottom right: 136. *Jerusalem, Plate 6.*
Relief etching. London, British
Museum.

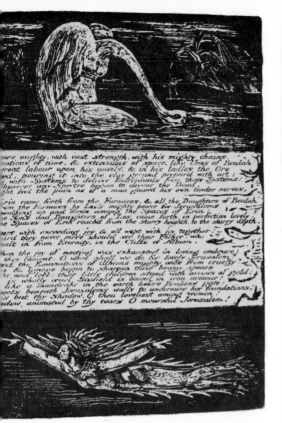

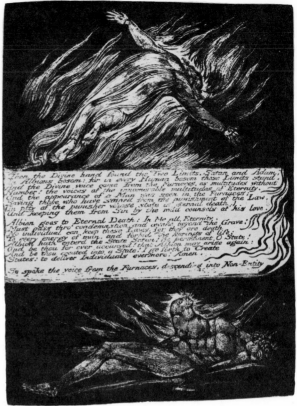

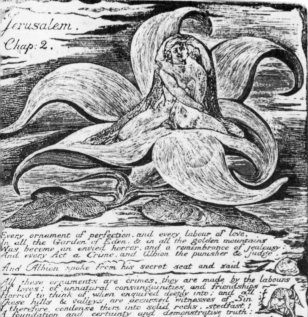

Top left: 137. *Jerusalem, Plate 11*. White line engraving. London, British Museum.

Top right: 138. *Jerusalem, Plate 31*. Relief etching. London, British Museum.

Bottom: 139. *Jerusalem, Plate 28*. Relief etching. London, British Museum.

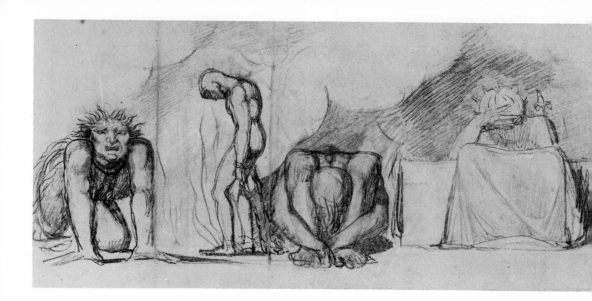

Top: 140. Jerusalem, *Study for Plate 51*. Black chalk. Hamburger Kunsthalle.

Bottom left: 141. Jerusalem, *Plate 56*. Relief etching. Paul Mellon Collection.

Bottom right: 142. Jerusalem, *Plate 76*. White line engraving. Paul Mellon Collection.

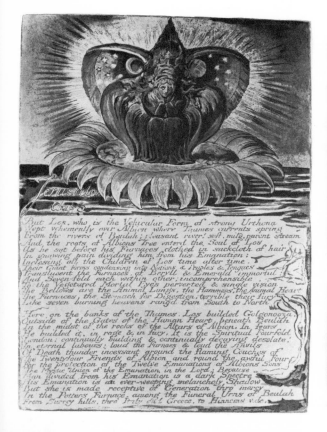

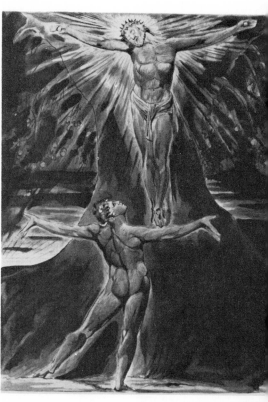

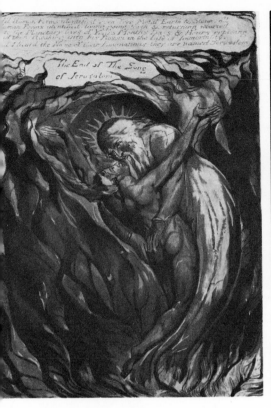

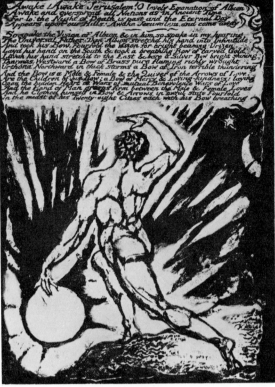

Top left: 143. *Jerusalem, Plate 99.* Relief etching. Paul Mellon Collection.

Top right: 144. *Jerusalem, Plate 97.* Relief etching. Cambridge, Fitzwilliam Museum.

Bottom: 145. *Jerusalem, Plate 51.* Relief etching. London, British Museum.

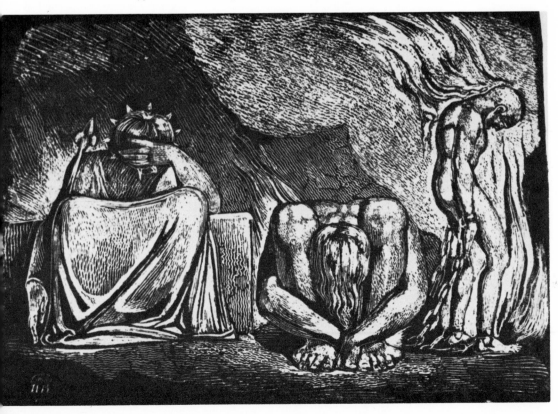

Plate IV *Beatrice on the Car, Dante and Matilda* (Dante, *Divine Comedy, Purgatory*, xxviii, xxix), 1824–7. Watercolour, London, British Museum

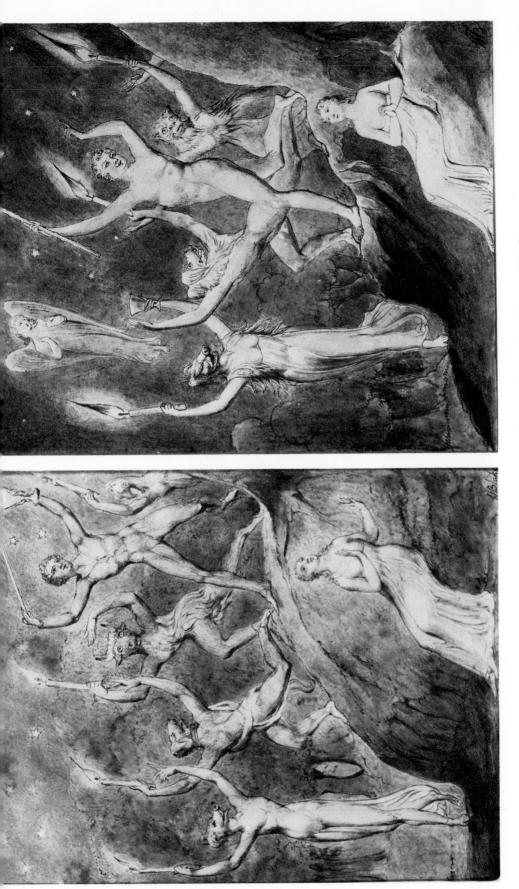

Left: 146. Comus series, *Comus and his Revellers.* Watercolour. Boston, Museum of Fine Arts.

Right: 147. Comus series, *Comus and his Revellers.* Watercolour. San Marino, California, Huntington Library.

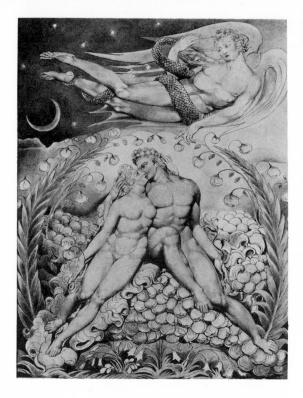

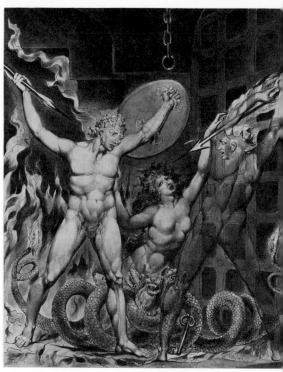

Top left: 148. *Paradise Lost. Satan watching the endearments of Adam and Eve.* 1808. Watercolour. Boston Museum of Fine Arts.

Top right: 149. *Paradise Lost. Satan, Sin and Death.* 1808. Watercolour. San Marino, California, Huntington Library.

Bottom left: 150. *Paradise Lost. Christ offers to redeem Man.* 1808. Watercolour. Boston Museum of Fine Arts.

Bottom right: 151. *Paradise Lost. The Creation of Eve.* 1808. Watercolour. San Marino, California, Huntington Library.

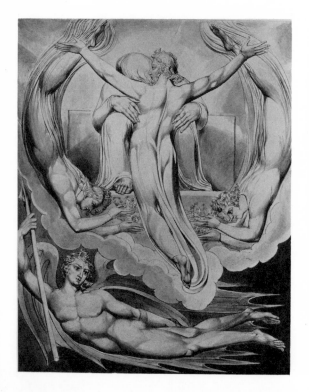

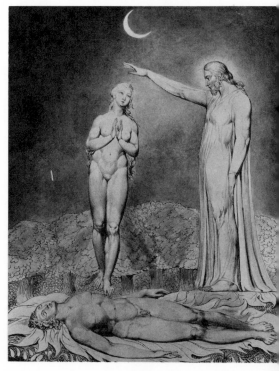

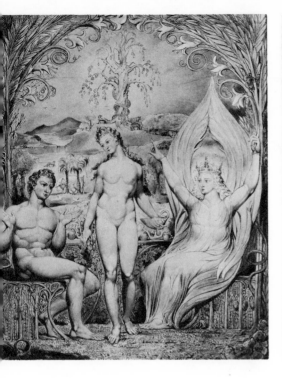

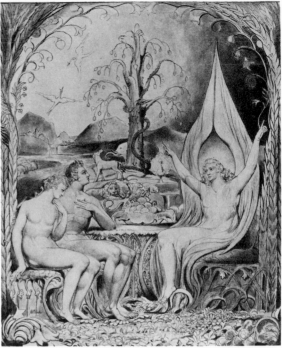

Top left: 152. *Paradise Lost. Raphael with Adam and Eve.* 1808. Watercolour. Boston Museum of Fine Arts.

Top right: 153. *Paradise Lost. Raphael with Adam and Eve.* 1807. Watercolour. San Marino, California, Huntington Library.

Bottom left: 154. Richard Westall: *Raphael with Adam and Eve.* 1795. Engraving. San Marino, California, Huntington Library.

Bottom right: 155. *Paradise Lost. The Temptation of Eve.* 1808. Watercolour. Boston Museum of Fine Arts.

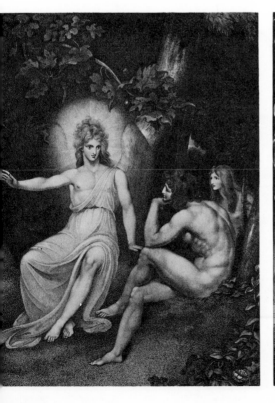

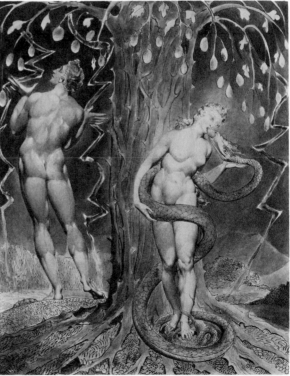

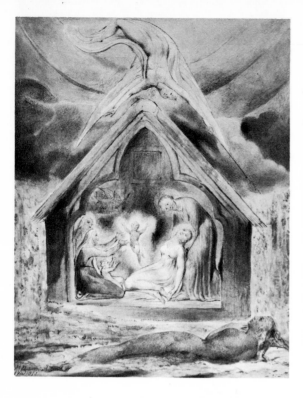

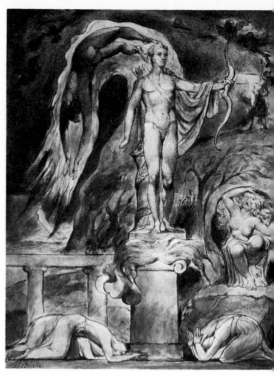

Top left: 156. On the Morning of Christ's Nativity. The Descent of Peace. Watercolour. San Marino, California, Huntington Library.

Top right: 157. On the Morning of Christ's Nativity. The Shrine of Apollo. San Marino, California, Huntington Library.

Bottom left: 158. Paradise Regained. Christ tempted by Satan. Watercolour. Cambridge, Fitzwilliam Museum.

Bottom right: 159. Paradise Regained. Christ refusing the Banquet. Watercolour. Cambridge, Fitzwilliam Museum.

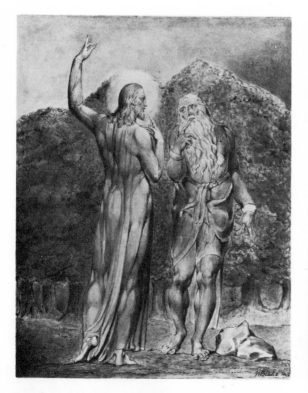

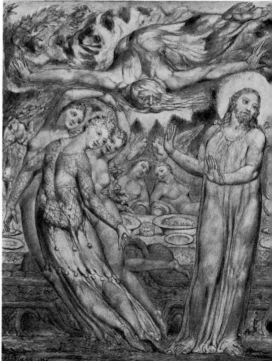

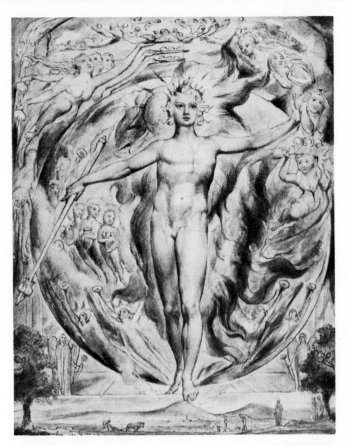

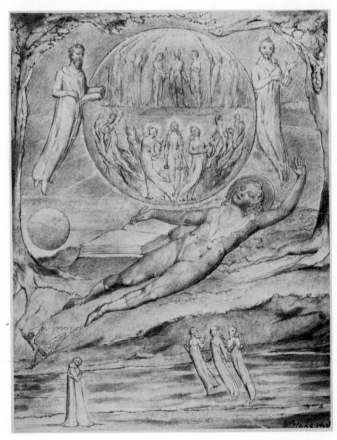

Top: 160. *L'Allegro. The Sun at his Eastern Gate.* Watercolour. New York, Pierpont Morgan Library.

Bottom: 161. *L'Allegro. The Youthful Poet's Dream.* Watercolour. New York, Pierpont Morgan Library.

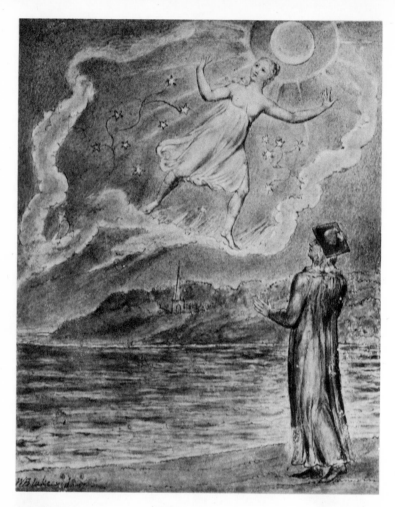

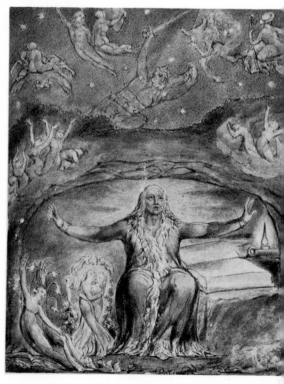

Top: 162. *Il Penseroso. The Wandering Moon*. Watercolour. New York, Pierpont Morgan Library.

Bottom left: 163. *Il Penseroso. The Spirit of Plato*. Watercolour New York, Pierpont Morgan Library.

Bottom right: 164. *Il Penseroso. Milton in Old Age*. Watercolour. New York, Pierpont Morgan Library.

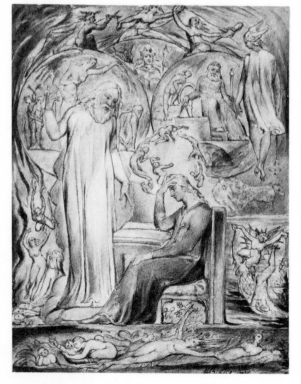

165. *Blake–Varley Sketchbook, Ghost of a Flea*. Pencil. London, Tate Gallery.

166. Thorton's *Virgil* (nos. 2–5). Wood engravings (uncut). London, British Museum.

Top: 167. 'The Arlington Court Picture'. 1821.
Watercolour. Devon, Arlington Court.

Bottom: 168. *The Book of Job.* Plate 1. 1825.
Engraving.

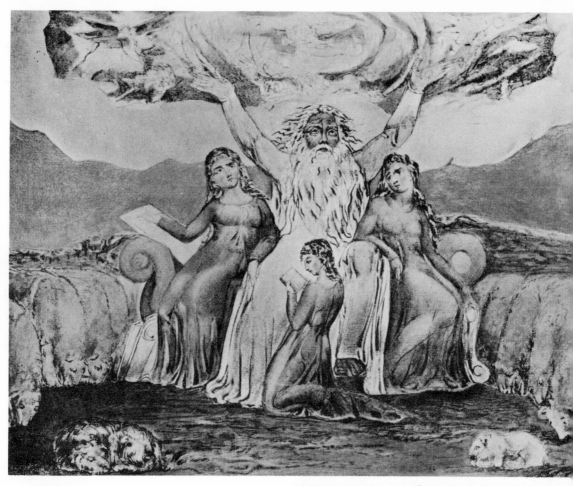

Top: 169. *The Book of Job. Job and his Daughters*.
Watercolour. New York, Pierpont Morgan
Library.

Bottom: 170. *The Book of Job. Plate 20. 1825*.
Engraving.

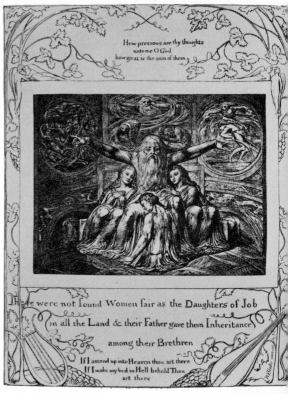

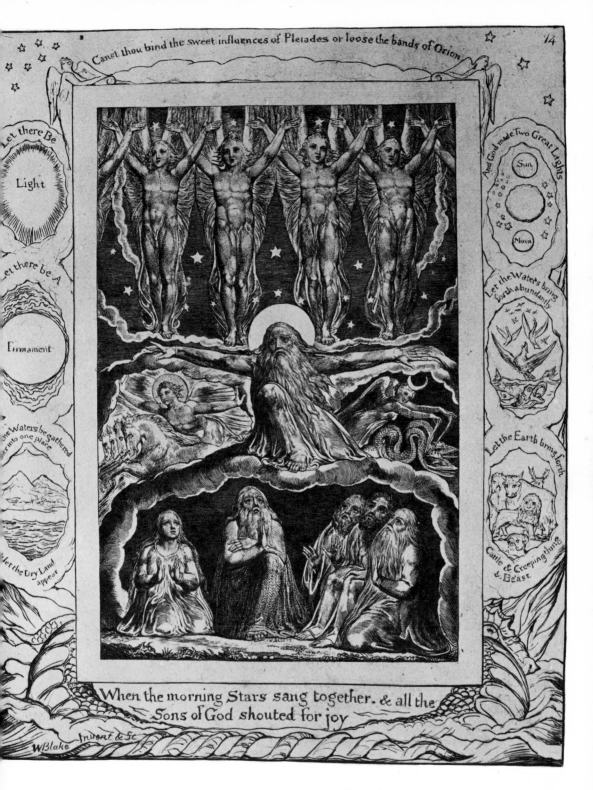

The following text appears within the illustration:

Canst thou bind the sweet influences of Pleiades or loose the bands of Orion

Let there Be

Light

Let there be A

Firmament

the Waters be gathered together into one place

Let the Dry Land appear

And God made Two Great Lights

Sun

Moon

Let the Waters bring forth abundantly

Let the Earth bring forth

Cattle & Creeping thing & Beast

When the morning Stars sang together. & all the
Sons of God shouted for joy

W Blake Invent & sc

171. *The Book of Job. Plate 14. 1825.* Engraving.

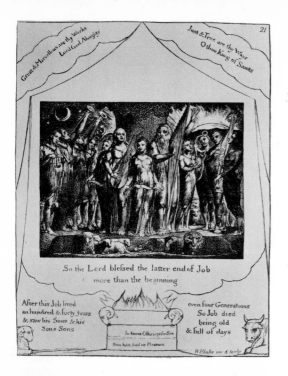

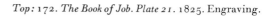

Top: 172. *The Book of Job. Plate 21. 1825.* Engraving.

Bottom: 173. *The Book of Job. Job restored to Prosperity.* Watercolour. Washington, National Gallery of Art, Rosenwald Collection.

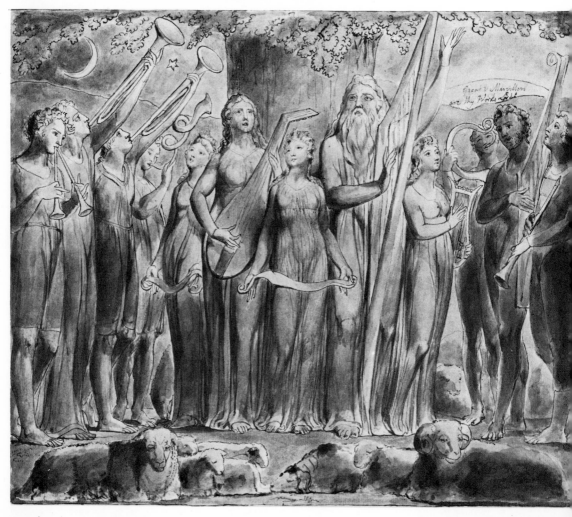

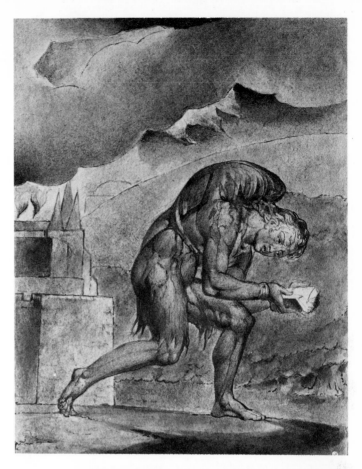

Top: 174. Pilgrim's Progress. Christian begins his Pilgrimage. Watercolour. New York, Frick Collection.

Bottom left: 175. Dante series, The Mission of Virgil. Watercolour. Birmingham City Art Gallery.

Bottom right: 176. Dante series, The Inscription over Hell-gate. Watercolour. London, Tate Gallery.

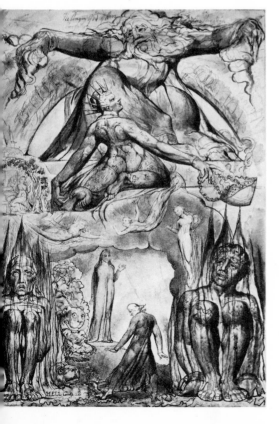

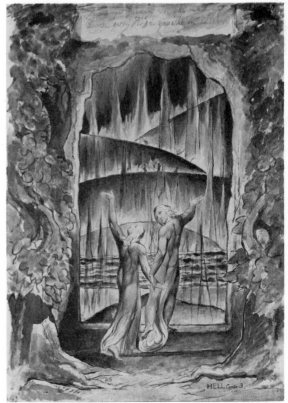

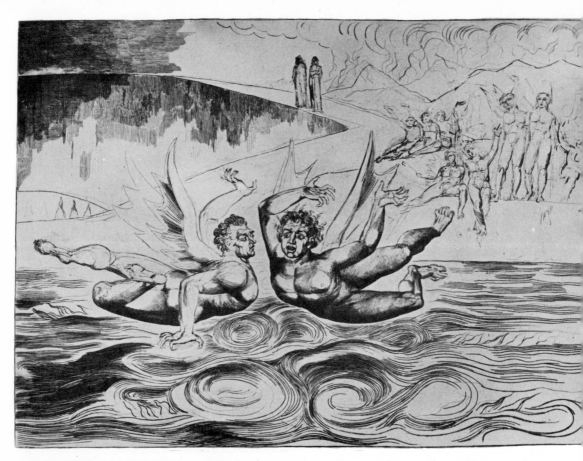

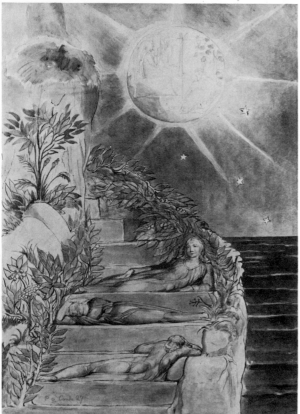

Top: 177. Dante series, *Baffled Devils Fighting*. Engraving. London, Westminster Public Library, Kerrison Preston Collection.

Bottom: 178. Dante series, *Dante and Statius sleeping*. Watercolour. Oxford, Ashmolean Museum.

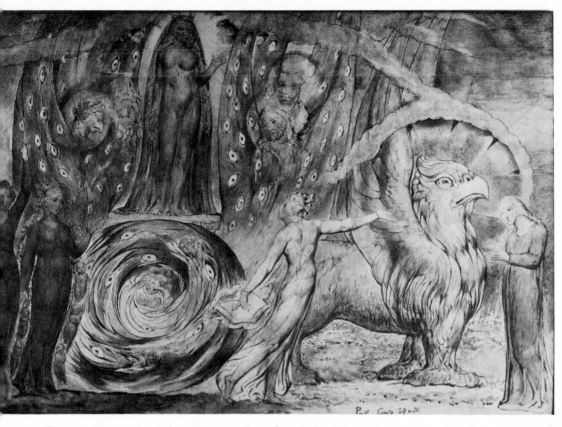

Top: 179. *Dante* series, *Beatrice addressing Dante from the Car*. Watercolour. London, Tate Gallery.

Bottom: 180. *Dante* series, *The Queen of Heaven in Glory*. Watercolour. Melbourne, National Gallery of Victoria.

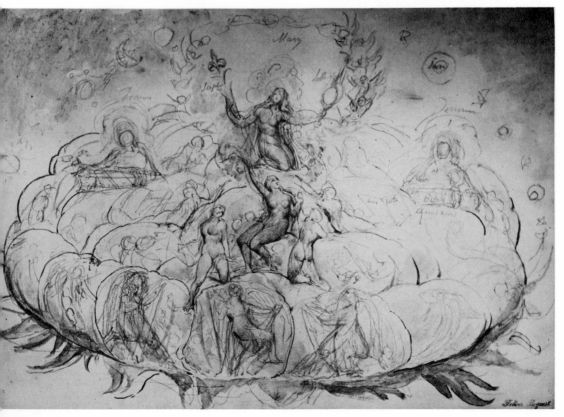

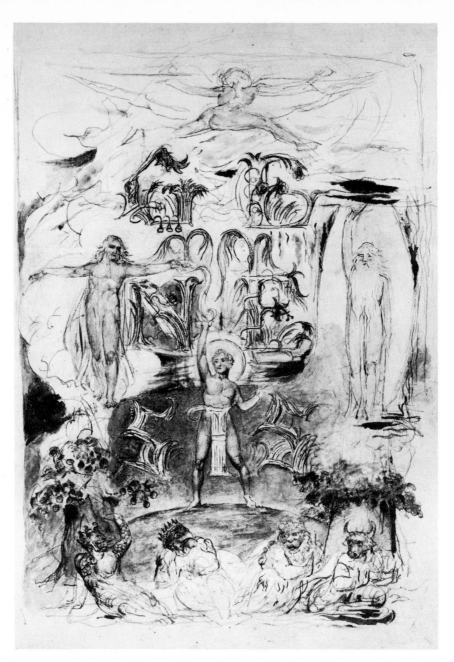

Top: 181. *Genesis* manuscript. *Titlepage.* Watercolour. San Marino, California, Huntington Library.

Bottom: 182. *George Cumberland's Card.* 1827. Engraving. Cambridge, Fitzwilliam Museum.

Failure and Self-Justification

CHAPTER SEVENTEEN

Blair's *Grave*

The visionary radiance of the Butts watercolours of *c.* 1805 reflects Blake's new confidence in his imaginative powers and a sense of artistic regeneration, but the 'corporeal' side of his life suffered a number of setbacks. His confidence in his ability as an engraver must have been damaged by the adverse criticisms he had received at Felpham, and he came to the conclusion that 'the neglect of his graver' was due not just to anonymous enemies but to the lukewarm advocacy of his friends. Flaxman continued to find him work, but Blake was impatient of its menial nature and felt underpaid; he still retained the hope that all would be put right if the world could see the products of his imagination, for enlightened patrons would inevitably recognize his worth and great commissions would follow. In 1805 he was commissioned by Robert Cromek to make engravings from his own designs for an elaborate edition of Robert Blair's *The Grave*. Blake had been waiting for such an opportunity, and omens from the start seemed favourable. Cromek had obtained as patrons of the publication many of the most distinguished members of the Royal Academy, including the President Benjamin West, Cosway, Flaxman, Stothard, Thomas Lawrence, James Northcote and John Opie.[1]

In 1805–6 Blake produced at least twenty highly finished drawings for *The Grave* and Flaxman reported not only his own admiration of some of them but that 'several members of the Royal Academy have been highly pleased with the specimens, and mean to encourage the work.'[2] Cromek, however, became alarmed—not, ironically, by Blake's imagination, but by reports he had received on Blake's competence as an engraver and possibly by seeing a proof of *Death's Door*, which exists in a single impression (Mrs Charles J. Rosenbloom Collection, Pittsburgh); accordingly he gave the engraving commission to Louis Schiavonetti, an associate of Bartolozzi and a practitioner in the 'modern' manner despised by Blake. Blake thought, probably justifiably, that he had been double-crossed by Cromek, for he had assumed that he would be asked to do the engraving as well as the designs.[3] Apart from the loss of a substantial income from the engraving, he felt cheated of the opportunity of showing his conceptions to the public in his own direct manner and not through the interpretation

K

of a 'soft' engraver in the Bartolozzi manner. The unique proof of *Death's Door* cut by Blake himself[4] makes it clear how regrettable was Cromek's lack of confidence in him, for it is executed in a vigorous and powerful manner. Even so, the circumstances behind the publication of Blair's *Grave* were not as inauspicious as Blake believed; the subscription list for the first edition of 1808 was extensive, and contained the names of many of the most important artists and patrons of the time, and it sold well enough to go into a second edition in 1813. Cromek had published a prospectus with a long commendation of the prints by Fuseli himself, and the book itself is a handsome production specifically intended as a vehicle for Blake's designs, including an engraved portrait of him by Thomas Phillips. It is clear from the correspondence at this time that Blake was extremely difficult to deal with in commercial matters; his belief in the parity of his designs with those of Michelangelo and Raphael had now become part of his everyday language, making him an embarrassment to his friends, and giving an impression of insanity to the outside world.

The watercolours for Blair's *Grave*, and to a greater degree the engravings, did public credit to Blake's powers, and it was as the designer of Blair's *Grave*, and also of Young's *Night Thoughts*, that he was best known to his contemporaries. Of the twenty illustrations originally proposed only twelve were actually published, but a number of unpublished designs have survived. Blake had a more elaborate edition in mind than was actually published, and a title-page watercolour dated 1806 (Huntington Library)[5] shows a complex design of the end of a tomb supported by sleeping angels while the soul, represented by a naked girl, flies upwards to heaven in radiance. The title in Blake's hand puts the emphasis on his own contribution:

<div align="center">

A Series of Designs:

Illustrative of

The Grave

a Poem

by Robert Blair.

Invented & Drawn by William Blake

1806.

</div>

The published title-page, however, has Blake's name following that of Schiavonetti, and the designs are now subtly reduced to the status of illustrations to the text:

<div align="center">

The GRAVE,

A Poem.

Illustrated by twelve Etchings

Executed

by

Louis Schiavonetti,

From the original

Inventions

of

William Blake

1808.

</div>

The actual title-page design is a version of the motif used in the engraved *Night Thoughts*, of the angel with a trumpet awakening the skeleton to eternal life at the Resurrection. The exquisite design for the Dedication page, 'To the Queen' (British Museum)[6] also remained unpublished, and when it was submitted by Blake to Cromek in 1807 it was refused sarcastically.[7] It shows the soul departing from the body and approaching a Gothic door, overhung with mournful branches, redolent of 'Gothick' sentiment, illustrating the lines of The Dedication to Queen Charlotte:

> *The Door of Death is made of Gold,*
> *That Mortal Eyes cannot behold;*
> *But, when the Mortal Eyes are clos'd,*
> *And cold and pale the Limbs repos'd,*
> *The Soul awakes; and, wond'ring, sees*
> *In her mild hand the golden Keys:*
> *The Grave is Heaven's golden Gate,*
> *And rich and poor around it wait.*[8]

Flaxman picked out for special approval the unpublished design 'Prone on the lowly grave she drops' (Mellon Collection) (plate 115), in which a widow throws herself on a grave in a country churchyard while a passing couple look on in astonishment.[9] The naturalistic landscape setting and the informal composition must have recalled to Flaxman Blake's *Illustrations to Gray* in his wife's possession, and would perhaps have confirmed his belief that Blake's real talent was for less elevated conceptions. Flaxman also took a playful delight in some of the other designs, one of which was of 'The Gambols of Ghosts according with their affections previous to the Final Judgment'.[10]

The unifying theme of the twelve published illustrations is, in the words of the commentator on the designs, probably Cromek, 'the regular progression of Man, from his first descent into the Vale of Death, to his last admission into Life eternal'. The first design shows *Christ descending into the Grave* as a kind of frontispiece to the series, while the second one, *The descent of Man into the Vale of Death*, shows all the ages and generations of man exploring the caverns of the grave in a mournful procession. *Death's Door* (plate 116) combines two motifs used earlier by Blake: the old man entering the door of the grave on crutches, with his regenerate self sitting on top of the tomb like the freed prisoner in *America*;[11] 'the renovated man seated in light and glory'. The following two, *The Death of the Strong Wicked Man* (plate 117) and *The Death of the Good Old Man* (plate 119), contrast the two manners of dying; the wicked man resists in terror while the good man accepts it with serenity, as a lifting of his worldly burden. The contrasting deaths are depicted in different artistic modes: the death of the wicked man is full of Sublime terror; his Michelangelesque body is contorted in pain, his head thrown back like the victim of the nightmare in Fuseli's painting *The Nightmare*, which it resembles in other ways.[12] The wicked man was evidently seated, before his sudden stroke, in the attitude of the voluptuary holding his glass out in plate 27 of the engraved illustrations to Young's *Night Thoughts*. *Death of the Good Old Man* shows

a benign patriarch full-length like a tomb effigy, while the youthful mourners form attitudes of prayer at the head and foot of the bed like supporting angels. His soul in prayer is borne off by two winged angels, and the whole group is redolent of the gentle piety of Flaxman's *Monument to Agnes Cromwell* (Chichester Cathedral, 1800).[13] In both engravings the window from which the soul departs establishes the room as representative of mortality, and it recurs in the following plate, *The Soul hovering over the Body*, for while the soul is still drawn to the body, mortal life remains.

The theme of the separation of body and soul is continued in the next plate, where the body, represented by a young man, searches for the soul, who, out of sight, explores the cavern of the grave with a candle. After this plate body and soul go separate ways—the body to be interred in a tomb, and the soul to pass through to the Last Judgement. *The Counsellor, King, Warrior, Mother and Child* (plate 118) is the high point of Blake's Gothic style, for it shows the final resting place of the body in a Gothic mausoleum, with elaborately studied tracery and attitudes derived from real medieval tomb effigies. This overt Gothicism draws together several threads in Blake's art. The motif of representative types of humanity lying stretched out in the equality of death is found in an early drawing dating from the early 1780s (private collection, Scotland), but there they rest on a smoke-filled battlefield over which hovers a barely discernible figure of Death. This early drawing may reflect in a general sense Blake's youthful observations of the tombs of Westminster Abbey, but the references to known tombs are more precise in the Blair's *Grave* engraving; the Warrior with his legs crossed is clearly derived from the type of the Aylmer de Valence tomb, and the Counsellor seems to be close in form to the tomb of Edward III. A renewed interest in the Westminster Abbey tombs about 1805–6 would be in keeping with Blake's pride, in his reminiscences to Malkin, in his early appreciation of Gothic sculpture. His particular emphasis is upon the 'levelling' effect of the tomb; the body suffers the same fate whether it be that of a warrior, counsellor, mother or child; only the fate of the soul matters. 'All are equal in the Grave. Wisdom, Power, Valour, Beauty and Innocence, at the hour of Death, alike are impotent and unavailing.'

The title-page design of the Angel awakening the skeleton by blowing the Last Trump belongs at this point, for it signifies the end of the material world, and impending reunion of body and soul, who in the next plate embrace exultantly, as the flames burn up the tombs. *The Meeting of the Family in Heaven* shows a family reunited after the dissolution of the Fallen world, under the protective arch of a pair of Flaxmanesque angels, whose wing tips meet over them, and the series ends with a splendidly Michelangelesque *Last Judgement*. The twelve engravings thus 'form of themselves a most interesting Poem', which is compatible with the stern, antimaterialist morality of Blair's poem, but the overriding unity is essentially Blake's own: a 'Series of Designs' 'illustrative' of the text, not subordinate to it.

The lukewarm critical reception of *The Grave* illustrations and Blake's increasingly irascible temperament excluded him from any more engraving commissions. In his despair he appears to have quarrelled with virtually all his friends,

particularly those who were willing to help, including Flaxman. He blamed Flaxman for underestimating his talents as an engraver, and he suspected treachery amongst his friends in general. Late in 1805 Flaxman had complained of Blake's 'abstracted habits which are so much at variance with the usual modes of human life';[14] for all practical purposes the weight of friendship devolved entirely upon Thomas Butts, who bought still more watercolours, and employed him as an engraving tutor to his son Tommy.[15]

Cromek attempted to distribute the Blair's *Grave* illustrations as widely as possible throughout England and Scotland. An original subscriber was Robert Scott of Edinburgh, the father of the painters David and William Bell Scott, and the latter has testified to the influence upon them of their father's copy of the book.[16] David Scott wrote in this copy his own appreciation of the designs in 1844, and it provides a useful corrective to the book's lack of critical success:

These, of any series of designs which art has produced, are the most purely elevated in their relation and sentiment. It would be long to discriminate the position they hold in this respect, and at the same time the disregard in which they may be held by some who judge of them in a material relation ; while the great beauty which they possess will at once be apparent to others who can appreciate their style in its immaterial connexion. But the sum of the whole in my mind is this: that these designs reach the intellectual or infinite, in an abstract significance, more entirely unmixed with inferior elements and local conventions than any others ; that they are the result of high intelligence of thought, and of a progress of art through many styles and stages of different times, produced through a bright generalizing and transcendental mind.[17]

CHAPTER EIGHTEEN

The Defence of Visionary Art

Blake had announced, in a letter of 19 December 1808, to George Cumberland, his intention of publishing an account of his special methods,[1] perhaps in conjunction with Cumberland himself. He wrote: 'I have, however, the satisfaction to inform you that I have Myself begun to print an account of my various Inventions in Art, for which I have procured a Publisher.'[2] The designs for *The Grave* had been condemned for the supposed indecency of some of the nude figures and the intimacy of some of the embraces, but more seriously Blake was criticized for mixing spirits with real bodies—an objection made forcefully by Robert Hunt of the *Examiner*, particularly in the cases of *The Death of the Strong Wicked Man* (plate 117) and *The Good Old Man* (plate 119). These criticisms undoubtedly contributed to Blake's decision to publish a defence of his art and to mount an exhibition, but he had already been meditating upon current artistic ideas before the publication of Blair's *Grave*. A record of these meditations remains in his annotations to his copy of the first volume of the Malone edition of *The Works of Sir Joshua Reynolds*, published in 1798 (British Museum). The annotations were not all written at once; he probably kept the book beside him over several years, appending comments, but the frequent erasures and invocations to the reader suggest that he had some notion of publishing it as a commentary upon Reynolds. Blake was certainly at work on it during the years 1805–6, but it is possible that some of the less heated comments belong to an earlier and calmer period.

Blake's hostility towards Reynolds in the Annotations is notorious, but it is by no means uniform. There are also many approving comments, and it is clear from an examination of the book itself that the headings to each chapter and the sarcastic comments upon Malone's introduction reflect a different state of mind from some of the brief notes upon the *Discourses* themselves. Blake's approval of much of the *Discourses* need not be surprising, and he had quoted Reynolds with approbation in a letter of 1802.[3] Although there are a number of anecdotes referring to supposed early personal disagreements between Blake and Reynolds,[4] there is no reason to

suppose that Blake before 1804 felt any special resentment towards Reynolds. Even artists who could have claimed to have suffered at the hands of Reynolds hesitated to criticize on theoretical grounds the revered author of the *Discourses*. Blake, like many other British artists, had heeded Reynolds' stirring call to the Great Style, but had lived to resent the latter's hypocrisy in pursuing a career as a fashionable and wealthy portraitist.

In the *Island in the Moon* manuscript of c. 1784 Blake had already satirized the kind of artist who was 'hang'd if I don't get up to-morrow morning by four o'clock & work Sir Joshua', and there can be no doubt that Blake had always objected to Reynolds' emphasis upon hard work at the expense of inspiration. Blake's sensitivity to the context in which the *Discourses* were delivered is revealed by his comment upon Reynolds' warning against artists who rely too much upon inspiration: Reynolds claimed that 'he who would have you believe that he is waiting for the inspiration of Genius is in reality at a loss how to begin; and is at last delivered of his monsters with difficulty and pain', which Blake annotated: 'A stroke at Mortimer!'[5] Reynolds' frequent warnings against the dangers of the artist exercising his imagination without having mastered basic techniques are seen by Blake as a denial of imagination, but it would be an over-simplification to see this kind of disagreement purely in terms of artistic theory. Blake's more extreme comments on Reynolds have to be seen in the context of his disturbed state of mind in the years of disappointment after the return from Felpham; and Reynolds' *Discourses* should be regarded not as a pure exercise in art theory but in the light of their political and pedagogical aims. Hazlitt also made much of the inconsistencies in the *Discourses*,[6] but both he and Blake failed to do justice to the fact that the *Discourses* were delivered over twenty years, and were subject to the specific demands of the time. Reynolds felt it necessary to emphasize the need for young artists to learn the 'language of art' before trusting to their imagination, particularly in the earlier *Discourses*; but this not unreasonable proposition is caricatured by Blake as follows: 'Reynolds's Opinion was that Genius May be taught & that all Pretence to Inspiration is a Lie & a Deceit to say the least of it.'[7] On the other hand, when Reynolds in the later *Discourses* claimed that hard work and imitation have only a partial role in the achievement of the Great Style, and that 'It is no use to prescribe to those who have no talents; and those who have talents will find methods for themselves',[8] Blake would undoubtedly have accused him of hypocrisy.

Such supposed contradictions were on the one hand used by Blake as evidence of the derivative nature of Reynolds' thoughts: 'The contradictions in Reynolds Discourses are Strong Presumptions that they are the Work of Several Hands, But this is no proof that Reynolds did not write them. The Man, either Painter or Philosopher, who Learns or Acquires all he knows from Others, Must be full of Contradictions.'[9] On the other hand they also enabled Blake to approve openly many of Reynolds' statements: 'What can be better said on this subject? but Reynolds contradicts what he says continually. He makes little Concessions that he may take Great Advantages.'[10] Blake's sympathy for much of the actual content of the *Dis-*

courses may be gauged from the fact that he frequently accuses Reynolds not of being wrong but of being a hypocrite. The *Discourses* were 'A Pretence of Art to destroy Art', and praised 'Michael Angelo for Qualities which Michael Angelo Abhorrd'. Even after he had established Reynolds as Antichrist, Blake could not escape the fact that they shared certain implicit assumptions about art, especially the traditional one that History painting was the highest form of expression, with the corollary that 'imitative' arts like landscape and portraiture were lesser genres. Reynolds, however, had some sympathy, as a practitioner of one of the lesser genres himself, with those artists who did not aspire to the Great Style, whereas Blake took a more uncompromising view of those who found the Great Style beyond them. The tolerance which Reynolds extended in Discourse XIV to Gainsborough, as an artist who knew his limitations and therefore avoided History, was not shared by Blake. Reynolds' commendation of Jan Steen, who Reynolds claims would have 'ranged with the great' if he had been taught by Michelangelo and Raphael, brought out in Blake an uncompromising attitude to Dutch painters of low-life, (which he had expressed in gentler terms in 1800), 'Jan Steen was a Boor and neither Rafael nor Mich Ang. could have made him any better.'[11]

Blake's angry desire to ridicule Reynolds and to prove that he was 'hired to Destroy Art' should not, therefore, disguise the true relationship of their theoretical positions. Reynolds in the *Discourses* sought both to make a case for idealist art, and to suggest practical ways of making works of art in an elevated manner. He made no claims to originality and there is little in the theoretical sections which cannot be found in such predecessors as Bellori. When Blake wrote his *Annotations* he was 'drunk with intellectual vision' and applied to his criticisms of Reynolds an uncompromising belief in the primacy of vision and the ideal, which he summed up by quoting Milton, alluding to Ezekiel's reception of the gift of prophecy, on the back of the title to Discourse III:

> *A work of Genius is a Work Not to be obtain'd by the Invocation of Memory &*
> *her Syren Daughters but by Devout prayer to that Eternal Spirit who can enrich*
> *with all utterance & knowledge & sends out his Seraphim with the hallowed fire*
> *of his Altar to touch and purify the lips of whom he pleases.*[12]

This is but another way of stating that the artist is 'the secretary of his Visions': a vehicle for the Divine spirit of prophecy. The process of receptivity to Visions can be intensified not by technical means but only by prayer; the Eternal is within and is not to be reached by the study of art or nature.

Even so, Blake and Reynolds shared a belief in a Platonic world of forms which transcended the imperfect form of empirical nature; that the artist was concerned not with mere reality or 'Dirty rags and old shoes', but with a universe beyond the transience of this world, was taken for granted by both. But the nature of that world of forms, and above all the way of apprehending it, reveals the incompatibility of their positions. For Reynolds the artist achieved his 'Central Form' by carefully studying the imperfections of nature with the aid of the great masters of the past, until he was able to see the true nature of that Central Form. He learns to recognize

from experience the perfect parts of an imperfect form until he is able to abstract from memory the perfect form which lies behind it, but which can never be wholly observed in nature. Blake argued simply that an artist 'traveled to Heaven in his Mind and Thoughts', passing straight to a perception of those ideal forms without reference to external nature. For Blake, vision is reality itself, which can and must be seen by the artist: 'A Spirit and a Vision are not . . . a cloudy vapour, or a nothing: they are organised and minutely articulated beyond all that the moral and perishing nature can produce.' Blake's essential argument falls squarely on the Platonic side of art-theoretical discussions of the Ideal from the sixteenth century onwards; his general position is only remarkable in being formulated at the beginning of the nineteenth century, for it ceased to be generally current after the early seventeenth century. Lomazzo, perhaps the most widely read Mannerist theorist, had argued that the 'Idea', the apprehension of ideal beauty, was dependent not on the observation of nature, but came through an infusion into the mind of the artist from God himself.[13] Blake reverts, whether consciously or not, to an artistic theory which had been generally replaced by the Aristotelianism of Bellori, of which Reynolds and the French academic theorists in the seventeenth century were heirs.[14] Lomazzo was both strongly anti-naturalistic and strongly anti-materialist, belonging as much to the Catholic reaction against the Reformation as Blake did to the reaction against the Enlightenment. Blake's kinship with Mannerist theorists is, however, in spirit rather than in practice; he is unlikely to have read any actual texts. Haydocke's translation of Lomazzo's *The Artes of Curious Paintinge, Carvinge and Buildinge* was published in 1598, but this is a craftsman's handbook, not a work of theory, and Blake's command of Italian at this point was probably not strong enough for him to read any Mannerist treatises in the original language. Fuseli, with the strong Mannerist tendency of his art, might seem to be an obvious source of such ideas, but his lectures and theoretical writings are overtly hostile to Platonic idealism.[15]

It follows that, if an artist's imagination is governed by a direct apprehension of Ideal forms, then he can learn little from copying nature or the work of earlier masters; but Blake makes a distinction between the 'language' of art and invention; the former can be learned, but emphatically not the latter. He therefore advocates copying the best masters: 'To learn the Language of Art Copy for Ever is my Rule',[16] and he comments 'Excellent' against Reynolds' remark that 'He who endeavours to copy nicely the figure before him, not only acquires a habit of exactness and precision, but is continually advancing in his knowledge of the human figure.'[17] But this applies only to the 'mechanical' part or 'the Grammar of Art', and Blake complains bitterly but quite unfairly that Reynolds blurs this vital distinction between execution and invention, and proclaims the Great Style to be accessible to 'Blockheads' who followed academic precepts literally. Blake concedes that a Blockhead can execute a work of art but only those who are divinely favoured can aspire to a glimpse of ideal forms, although all men may have such a potential. Thus he judiciously invokes Locke as an intellectual forebear of Reynolds: 'Knowledge of Ideal Beauty is Not to be acquired It is born with us. Innate Ideas are in Every Man Born with him.

They are truly himself. The Man who says that we have no Innate Ideas must be a Fool & a Knave.'[18]

Blake argues that the copying of earlier masters is acceptable so long as its limitations are realized, but he also claims that Reynolds advocates a generalized form of copying at the expense of precision and exactness. He argues forcibly against Reynolds' concept of Generalization, by which the Ideal is defined as 'nature in its more perfect form . . . above all singular forms, local customs, particularities and details of every kind'. Reynolds argues for a generalized style of painting, or broad handling, which would override detail and minute incident; not so much 'painterly' handling, as a relentless concentration upon the larger forms, a characteristic of his own painting. Blake claimed, however, that Ideal forms 'Really Exist' and that 'Singular & Particular Detail is the Foundation' of Ideal form; by this he did not mean a 'Dutch' technique of minute handling, which by now he had repudiated, but precision and clarity through a firm contour around each form. Blake remains faithful to the Neoclassical assumption that outline is the only suitable way of depicting the Ideal world. His formulation is in fact remarkably close to that of Winckelmann, who had noted that 'precision of contour [was a] characteristic distinction of the Ancients', and that 'The noblest Contour unites or circumscribes every part of the most perfect Nature, and the ideal beauties in the figures of the Greeks.'[19] Blake's attack on Generalization and broadness of handling was also indirectly aimed at Burke, one of the putative authors of Reynolds' *Discourses*, who had argued that a degree of obscurity was necessary to the Sublime. Blake claimed that he had annotated Burke in a similar fashion, with similar hostility.[20]

Blake's objection to a generalized way of painting was shared by Hazlitt, who had protested that 'The greatest grandeur may co-exist with the most perfect, nay with a microscopic accuracy of detail, as we see it often does in nature.'[21] But Hazlitt's stance is based essentially upon a new conception of nature, which would have been anathema to both Blake and Reynolds. Indeed Blake's assault upon Reynolds is still couched firmly in eighteenth-century terms. At the core of both their theories of art is the problem of the relationship between the empirical and ideal worlds, but Blake betrays a sensibility formed in the latter part of that century. Reynolds was still able to retain a faith in the seventeenth-century Bolognese eclectic painters; Blake, on the other hand, like his Neoclassical contemporaries, saw his own age as potentially one of awakening from the dark ages analogous to Periclean Athens and Trecento Florence. His apocalyptic rage at academic theorists can be paralleled by others on the Continent, particularly the group known as 'Les Primitifs' in France, whose syncretic mythological beliefs were accompanied by brutal denunciations of any vestiges discernible in the work of other artists of sensibility towards or imitation of nature.[22]

Blake began, probably in 1806, to consider producing a large engraving of *The Canterbury Pilgrims* (see plate 120) for commercial distribution. His commercial hopes were quickly blighted by the news that Stothard, under the auspices of Cromek,

was also planning to publish a large engraving of the same subject. It is fairly certain that Stothard or Cromek stole the idea from Blake, and in the event he assumed treachery on both their parts. Out of these disappointments he conceived the idea of a comprehensive exhibition of his paintings, including a new tempera painting of *The Canterbury Pilgrims*, which would be provided with a full commentary. The exhibition finally opened in September 1809 in Blake's house and a long account of the paintings, *A Descriptive Catalogue*, was offered at 2s. 6d. as a ticket. The exhibition was centred around a demonstration of Blake's tempera process, and it was announced by two prospectuses, which make extravagant claims for his art and his invention.[23] The principal exhibits were to be a large painting of *The Ancient Britons* (now lost), the *Canterbury Pilgrims* (Pollok House, Glasgow) and 'Two Pictures, representing grand Apotheoses of NELSON and PITT' (both Tate Gallery), all of which Blake described as being in 'Portable Fresco'. This term was based on the false assumption that the medium of early Italian panel painting was the same as that used for fresco upon walls, a confusion which would have been inconceivable to an artist who had travelled in Italy. Blake further argued that, if the support of the wall fresco were wood or canvas, it could also be portable. Hence an artist could 'divide Westminster Hall, or the walls of any other great building, into compartments and ornament them with frescos, which would be removable at pleasure'. In the Prospectus to the Exhibition Blake also made a notorious claim that oil paint was an invention of the seventeenth century, 'it was never generally used till after VAN-DYKE's time'. The absurdity of such an idea has tended to disguise his real point, which is that the manner of painting changed with the great Venetian artists and in the Baroque period when outline was rejected in favour of a more painterly approach.[24] In terms of his own time, Blake's query whether 'Rubens or Vandyke, or both, were guilty of this villainy', of practising a free handling of brushwork, makes sense in the light of Neoclassical hostility towards the Baroque. In the Advertisement of the *Descriptive Catalogue* Blake claims that his art has revived the Golden Age preceding the depredations of the Baroque: 'In this exhibition will be seen real Art, as it was left us by Raphael and Albert Durer, Michael Angelo, and Julio Romano; stripped from the Ignorances of Rubens and Rembrandt, Titian and Correggio.'[25] In a letter of 22 November 1802, he had argued, merely quoting Reynolds, that the Florentine and Venetian could not be mixed, but by 1809 the Venetian style is the enemy of art: 'Both Rafael and Michael Angelo knew the Venetian, and contemned and rejected all he did with the utmost disdain, as that which is fabricated for the purpose to destroy art.'

The argument of the *Descriptive Catalogue* emerges in the descriptions of the sixteen paintings in the exhibition, nine of which were in 'Fresco', and the rest watercolours, for the most part borrowed back for the occasion from Thomas Butts. The exhibition was held in the family shop in Golden Square, where what little attention it attracted was largely unwelcome. Apart from the major pictures Blake exhibited a number of demonstration paintings to explain the development of his fresco technique, and also a very early drawing of *The Penance of Jane Shore* to

show 'that the productions of our youth and of our maturer age are equal in all essential points'.[26] His account of the paintings in the exhibition elaborates many of the arguments in the *Annotations to Reynolds*, but often in an even more extreme way, so that artistic preferences take on apocalyptic meaning. The 'Venetian and Flemish Demons labour to destroy Imaginative power, by means of that infernal machine called Chiaro Oscuro'. Outline takes on an absolute moral force; it becomes 'the hard wiry line of rectitude', for clarity of expression is synonymous with the true perception of Vision itself. Greek sculptors are now seen as mere imitators of true art, not creators; the original inventors of art were the Jews, whose possession of the Divine Vision was just as surely to be found in art as in literature.

The idea of the Jews as makers of archetypal paintings and sculptures might seem improbable in view of the Commandment prohibiting graven images, but Blake would have argued that this prohibition was directed against idols and idol-worship, not Visions of Eternity. Although it was generally agreed that no Hebraic sculpture had survived, the descriptions of Cherubim on the Temple of Solomon were taken as proof, not only by Blake but also by Flaxman, that it had existed and had been sanctioned by Divine command: 'even among the Jews, who were particularly re-stricted concerning the use of images, on account of their proneness to idolatry, two figures were placed by divine command in the 'Holy of Holies', extending their wings over the ark, which contained the covenant between God and man.'[27] A vision of the ancient Middle East as being filled with fine buildings decorated with sculpture is again not unique to Blake, and Flaxman had lamented the loss of works of art mentioned by ancient authors as adorning the cities of Babylon, Tyre and Sidon.[28]

The theoretical problem for Blake lay in his continuing admiration for the great works of classical antiquity upon which he had been brought up. When after 1800 he began to turn against Greek philosophy because, like his German Romantic contemporaries, he was disturbed by its essential paganism, the idea of Greek sculp-tures as imitations of Hebrew originals would allow him to retain his admiration for such canonical works as the *Laocoön*, but attribute their true authorship not to the pagan Greeks but to the spirit which had infused the Bible. Blake was apparently unique amongst artists in applying this argument to painting and sculpture and taking it to its most extreme conclusion, but it can be paralleled by similar arguments applied to literature and architecture.[29] The literary theory of Hebrew primacy received its clearest and most accessible expression in Milton, who had adumbrated the distinction between the Hebrew 'muses' as Daughters of Inspiration, and the Greek Muses as Daughters of Memory. Milton had argued in *Paradise Regained*, through the mouth of Christ, that the Greeks had learned music and literature from the Jews:

> *All our Law and story strewed*
> *With hymns, our psalms with artful terms inscribed,*
> *Our Hebrew songs and harps in Babylon,*
> *That pleased so well our victor's ear, declare*

That rather Greece from us these arts derived;
Ill imitated, while they loudest sing
The vices of their deities, and their own
In fable, hymn or song, so personating
Their gods ridiculous, and themselves past shame.

Milton is here taking up a tradition alive in the seventeenth century, but going back as far as Josephus, that learning had been invented by the Jews, and had been transmitted to the Greeks through the Egyptians.[30] The contrast between Mnemosyne and Hebrew inspiration is also made clear in *The Reason of Church Government* where 'the invocation of Dame Memory and her Siren daughters' is contrasted with the Old Testament prophets' 'devout prayer to that eternall Spirit who can enrich with all utterance and knowledge'.[31]

Blake had argued in the Preface to *Milton* that 'The Stolen and Perverted Writings of Homer & Ovid, of Plato & Cicero . . . are set up by artifice against the Sublime of the Bible',[32] and in *A Vision of the Last Judgement*, 1810, he formulated the contrast between Hebrew inspiration and Greek imitation as between 'Eternal Vision' on the one hand and 'Fable or Allegory' on the other: 'The Hebrew Bible & the Gospel of Jesus are not Allegory, but Eternal Vision or Imagination of All that Exists.' Fable or Allegory are the expression not of insight into Eternal Vision, but only of a memory of such vision. It is an error to confuse Allegory and Vision, for 'Allegory & Vision ought to be known as Two Distinct Things, so call'd for the sake of Eternal life.'[33] But because Allegory is a Fallen form of real Vision, 'Fable or Allegory is seldom without some vision'; if Greek literature is but an imitation of the real Hebraic prototype, it is not without merit because it reflects, however dimly, something of the Divine Light. The process by which the Biblical inheritance of the Greeks became transformed from Vision to mere Allegory is described by Blake as follows:

> *Jupiter usurped the Throne of his Father, Saturn, & brought on an Iron Age & Begat on Mnemosyne, or Memory, The Greek Muses, which are not Inspiration as the Bible is. Reality was Forgot & the Vanities of Time & Space only Remembered & call'd Reality. . . . Let it here be noted that the Greek Fables originated in Spiritual Mystery & Real Visions, which are lost & clouded in Fable & Allegory.*[34]

By applying the theory of Allegory and Vision to art, Blake is obliged to fall back upon the Cherubim of the Temple of Solomon, who are described as symmetrically arranged angels with very long wings.[35] He claims, however, that the Cherubim were not just decorative figures, but true Visionary works of art, which were widely disseminated around the Middle East, where they could have been seen and copied by Greek travellers, who had also, it was generally agreed, made themselves familiar with Egyptian sculpture. Blake as a true visionary was able to see the originals himself without recourse to intermediaries: 'Those wonderful originals seen in my visions, were some of them one hundred feet in height; some were painted as pictures, and some carved as basso relievos, and some as groupes of statues, all con-

taining mythological and recondite meaning, where more is meant than meets the eye.' These then were the 'originals from which the Greeks and Hetrurians copied Hercules Farnese, Venus of Medicis, Apollo Belvidere, and all the grand works of ancient art'.[36] Their makers were merely imitators like Homer and Ovid, who converted Vision into Allegory: 'No man can believe that either Homer's Mythology, or Ovid's, were the production of Greece or of Latium; neither will any one believe, that the Greek statues, as they are called, were the invention of Greek Artists; perhaps the Torso is the only original work remaining; all the rest are evidently copies, though fine ones, from greater works of the Asiatic Patriarchs.' The forms of Greek sculpture were therefore, in one sense, exalted by their role as imitations of lost originals, for they enabled artists to be aware of their external form. The *Laocoön* group, for example, would reflect directly the Cherubim on Solomon's Temple despite its ostensible theme from Greek mythology.[37] But there was a danger in such imitative images, for they were used to deny Vision instead of providing a reflection of it:

> *These gods are visions of the eternal attributes, or divine names, which, when erected into gods, become destructive to humanity. . . . They ought to be made to sacrifice to Man, and not man compelled to sacrifice to them ; for when separated from man or humanity, who is Jesus the Saviour, the vine of eternity, they are thieves and rebels, they are destroyers.*[38]

Blake's conception of the Hebraic originals implied a wider definition of the Cherubim of Solomon's Temple, and he assumed that they encompassed all forms of sculpture rather than the decorative angelic forms described in the Old Testament. The corpus of 'Eternal' sculpture encompassed not only all the classes of men, but all their deeds. 'Los's Halls' in *Jerusalem* are sculpture galleries in which every moment of every man's existence is recorded.[39] In the account of the *Canterbury Pilgrims* painting in the *Descriptive Catalogue* Blake argues that the Greek sculptures represent 'the image of a class, and not of an imperfect individual'; therefore the character of individual Greek sculptures remains applicable to men of all periods, for the types of humanity remain constant. 'Chaucer's characters live age after age' because 'every one is an Antique Statue', and has an antique prototype: 'The Franklin is one who keeps open table, who is the genius of eating and drinking, the Bacchus; as the Doctor of Physic is the Esculapius, the Host is the Silenus, the Squire is the Apollo, the Miller is the Hercules, &c.'[40] This view of the Antique confirmed Blake's tendency to make the figures in his paintings representative of eternal types. The lost *Ancient Britons* concerned the only three survivors of King Arthur's last battle: 'the Strongest Man, the Beautifullest Man, and the Ugliest Man'. Prototypes for all three classes were readily to be found in Antiquity, and Blake claimed that even without imitating them the final result was still likely to be close to the Antique, for he had access to the prototypes imitated by the ancient sculptors:

> *It has been said to the Artist, 'take the Apollo for the model of your beautiful Man and the Hercules for your strong Man, and the Dancing Fawn for your Ugly*

Man.' Now he comes to his trial. He knows what he does is not inferior to the grandest Antiques. Superior they cannot be, for human power cannot go beyond either what he does, or what they have done; it is the gift of God, it is inspiration and vision. He had resolved to emulate those precious remains of antiquity; he has done so and the result you behold; his ideas of strength and beauty have not been so greatly different.[41]

In the account of the *Canterbury Pilgrims* painting Blake describes Chaucer as the 'great poetical observer of men, who in every age is born to record and eternize its acts';[42] the Pilgrimage is a journey of life, and the Pilgrims represent both the components of the human mind and eternal types: 'Every age is a Canterbury Pilgrimage; we all pass on, each sustaining one or other of these characters; nor can a child be born, who is not of these characters of Chaucer.' Although some of the characters can be made to correspond directly to Greek gods, in other cases Blake divides the classical archetype to show the two sides of the personality. Thus Hercules encompasses two Chaucerian characters: the Plowman, being 'simplicity itself, with wisdom and strength for its stamina', is Hercules 'in his supreme eternal state', but Hercules has also a 'spectrous' side, symbolized by the brutal strength of the Miller, who is 'a terrible fellow, such as exists in all times and places for the trial of men, to astonish every neighbourhood with brutal strength and courage, to get rich and powerful to curb the pride of Man'. The essential nature of a woman is divided between the Lady Prioress and the Wife of Bath, and these, like Enitharmon, are seen as a dominant influence on the age: 'The lady prioress, in some ages predominates; and in some the wife of Bath.' The two are obviously strongly contrasted; the Prioress is a model of demure piety, with 'the beauty of our ancestors, till after Elizabeth's time, when voluptuousness and folly began to be accounted beautiful'. The Wife of Bath, on the other hand, is the Whore of Babylon riding her horse side-saddle as if it were the Beast of Revelation; the wine-glass in her hand refers to 'the morning's draught of comfort' which she takes with her as she leaves, but it is a symbol of sensual transgression.

The heroes leading the procession are the Knight and the Squire, both treated with tender sympathy by Blake. The Knight represents 'that species of character which in every age stands as the guardian of man against the oppressor', while his son the Squire in addition 'blends literature and the arts with his warlike studies', a contrast suggested visually in the austere armour of the Knight and the plumed hat of the Squire. The obviously bad characters, like the Pardoner, 'the Age's Knave', also have their part in the grand design of humanity: 'This man is sent in every age for a rod and scourge, and for a blight, for a trial of men, to divide the classes of men; he is in the most holy sanctuary, and he is suffered by Providence for wise ends, and has also his great use, and his grand leading destiny.' The most sympathetic figure to Blake is the Good Parson, 'a real Messenger of Heaven' who is 'beloved and venerated by all' but neglected. He is the true Prophetic figure of his age, but men still find it hard to distinguish him from the Friar, who represents priestly hypocrisy, and the Par-

doner, who stands for worldly ambition. The true artist must possess the observation of Chaucer, the prophetic insight of the Parson, and the fighting spirit of the Knight and Squire, but in fact the one character who actually resembles Blake in the painting is the Plowman, whose complex character as described by Blake may also express something of his own. Benovolence is the Plowman's great characteristic, he is thin with excessive labour and not with old age, as some have supposed: '[He] is Hercules in his supreme eternal state divested of his spectrous shadow.'[43]

Representatives of all generations of humanity, from an old man to a child in arms, watch the procession as it leaves the gate. The journey is from Experience, symbolized by the elaborate Gothic architecture of the Tabarde Inn, into the countryside, over which the sun of Redemption is beginning to rise. The Cook and the Wife of Bath are most reluctant to leave and remain attached to the pleasures of the flesh, while the Parson has his face firmly set upon the journey. The procession is led, not by Chaucer or the Parson, but by those zealous spiritual warriors the Knight and the Squire, whilst Monk and Friar with true hypocrisy follow behind the Abbess.[44]

The distinction between Allegory and Vision enabled Blake to rationalize his use of antique prototypes in his own work and it also opened his eyes to other forms of art, many of which were either unfashionable or newly discovered. While the Grecian 'copies' of the lost 'Originals' were especially fine, other cultures also reflected in their visual remains the same Originals, or even ones unknown to the Greeks. Only the Jewish Antiquities in the form of the Old Testament survive in uncorrupted form, but the Antiquities of all nations contain allegories of the Divine Revelation:

> The antiquities of every Nation under Heaven, is no less sacred than that of the Jews. They are the same thing, as Jacob Bryant and all antiquaries have proved. How other antiquities came to be neglected and disbelieved, while those of the Jews are collected and arranged, is an enquiry worthy of both the Antiquarian and the Divine.[45]

Other cultures and artists could claim to have produced works equal to those of the Greeks, and they could with equal legitimacy provide images of the eternal prototypes: 'Milton, Shakspeare, Michael Angelo, Rafael, the finest specimens of Ancient Sculpture and Painting and Architecture, Gothic, Grecian, Hindoo and Egyptian, are the extent of the human mind.'[46] Blake now justifies his eclecticism no longer in terms of the common ground between the Gothic and the Antique, founding it instead upon the essential unity of all forms of art; for if all Religions are one, so too are their artistic manifestations.

This new tolerance for non-Grecian art was amply illustrated in the exhibition itself. The beautiful watercolour of *c.* 1805 made for Thomas Butts of *Angels hovering over the Body of Jesus in the Sepulchre* (Victoria and Albert Museum), his most complete 'Gothic' design, was shown and the 'Hindoo' is strongly represented by the two paintings of *The Spiritual forms of Nelson* and *Pitt*, which are 'compositions of a mythological cast, similar to those Apotheoses of Persian, Hindoo, and Egyptian Antiquity, which are still preserved on rude monuments, being copies from some stupendous originals now lost or perhaps buried till some happier age'. The figure of

Nelson himself seems to owe the angularity of the arms and the tilt of the head to an Indian Buddha,[47] while Pitt's huge nimbus is certainly indebted to standing Buddha figures which Blake could have known through engravings.[48] The curious circular movement of the composition in each picture may also owe something to the non-European reliefs he cites as being 'preserved on rude monuments'. Also in the 1809 exhibition was a drawing, now lost, entitled *The Bramins*, which he describes as follows:

> The subject is, Mr Wilkin translating the Geeta, an ideal design, suggested by the
> first publication of that part of the Hindoo Scriptures translated by Mr Wilkin.
> I understand that my Costume is incorrect, but in this I plead the authority of the
> ancients, who often deviated from the Habits to preserve the Manners, as in the
> instance of Laocoon, who, though a priest, is represented naked.'[49]

The influence of Indian forms can also be found in a number of motifs in the Prophetic Book *Jerusalem*, which was actively in progress about the time of the Exhibition. Blunt cites the dependence of the design in plate 53 of *Jerusalem*, of the female enthroned on a sunflower, upon a line engraving in Moor's *Hindu Pantheon*, a book readily accessible to Blake, and the design of the Chariot with human-headed bulls in plate 41 upon a human-headed bull from Persepolis.[50] Blake's interest in Hindu art was not unique at the time; he shared it with artists close to his circle. Banks had made reliefs of Hindu scenes for Warren Hastings at Daylesford, and in 1798 Flaxman had carved a monument to Sir William Jones in the University Church, Oxford, in which grateful Hindus look on as Jones collates their laws.[51] Flaxman also cited Moor's *Hindu Pantheon* with approval in his lectures.[52]

Blake's artistic theory was appropriate to an artist whose Platonic idealism had been tempered by a close experience of Neoclassicism in theory and practice. The oddities of some of Blake's arguments are the result of an intense desire to impose a unity upon two seemingly irreconcilable forces: his love of non-Christian art and his desire to be a purely Christian artist. His idealism led him to avoid the temptations of Reynolds' Aristotelianism: on the other hand he was equally, and in the future increasingly, wary of the claims of nature. Reynolds' prosaic academicism still presented a threat in the first decade of the nineteenth century, but in later years it was nature and nature-worship which was to exercise Blake's mind. His writings on art also reflect some of the tensions of his own work; they share its apocalyptic fervour, and they are in a certain sense bounded by the classical outline he imposed ever more rigorously upon his own designs in the years before the Exhibition.

The apocalyptic fervour of the *Descriptive Catalogue*, particularly the dismissal of Rubens, Rembrandt and the Venetians, inevitably invited criticism from the few people who noticed it. In a review in *The Examiner* Robert Hunt described Blake as 'an unfortunate lunatic, whose personal inoffensiveness secures him from confinement'. *The Catalogue* was condemned as 'a farrago of nonsense, unintelligibleness, and egregious vanity, the wild effusions of a distempered brain', and Blake's arrogance in claiming to restore 'the grand style of art' was castigated.[53] George Cumber-

L

land, one of his oldest friends, gave more balanced judgement: 'Blake's Cat. is truly original—part vanity part madness—part very good sense.'[54] Unknown to Blake the *Descriptive Catalogue* did attract one admirer, who was able to bring a wider literary perspective to it than anyone else in England. This was the dilettante Henry Crabb Robinson (1775–1867), who provided the most active link between the new German Romantic culture and English literary circles.[55] He did not meet Blake until 1824, but he was sufficiently struck by the Exhibition and the *Descriptive Catalogue* to write an account of his work for a German magazine, the *Vaterländisches Museum*, in January 1811.[56] Robinson observed that Blake's idea of the origin of art in the spirit paralleled ideas current in Germany amongst the younger Romantic generation. He complained of the extravagance of the *Catalogue*, but he saw that as 'even amid these aberrations gleams of reason and intelligence shine out, so a host of expressions occur among them which one would expect from a German rather than an Englishman'.[57] He aptly compared Blake with W. H. Wackenroder (1773–98), the most influential of the late eighteenth-century revivalists of medieval art: 'The Protestant author of *Herzensergiessungen eines kunstliebenden Klosterbruders* created the character of a Catholic in whom Religion and love of Art were perfectly united, and this identical person, singularly enough, has turned up in Protestant England.' Blake's rejection of materialism had, as Robinson noted, drawn him close to the first generation of German Romantics, many of whom had shown an increasing appreciation of the spiritual and national values of the Gothic. But as Crabb Robinson realized, this parallel was due not to the direct influence of German Romantic ideas, which were known in England almost exclusively at that time through Robinson himself, but to the peculiar circumstances of Blake's own background.

Apocalypse and Last Judgement

The *Descriptive Catalogue* is the longest and most sustained account of Blake's artistic ideas, but it is still tied to particular paintings. Some of these had been finished many years before, but others had been made with the Exhibition in mind because they were of the type to demonstrate the potentialities of 'Portable Fresco'. The two pictures of *The spiritual form of Nelson guiding Leviathan* (plate 121) and *The spiritual form of Pitt guiding Behemoth* (Tate Gallery) were conceived as samples of a heroic public art 'on a scale that is suitable to the grandeur of the nation who is the parent of his heroes'.[1] Blake undoubtedly had in mind Benjamin West's *Apotheosis of Nelson* (National Maritime Museum, Greenwich) (plate 122), of 1807,[2] which was the starting point for the Nelson and Pitt compositions. In West's painting Nelson is shown as a Christ-like figure borne aloft by Neptune and carried up to Heaven by personifications of Victory and England. The dead hero is depicted by West as a secular saint in an Apotheosis, but Blake takes a deliberately equivocal view of his subjects. Pitt, for example, is characterized not as a classical hero or orator, but as the Angel of Revelation, 'who, pleased to perform the Almighty's orders, rides on the whirlwind, directing the storms of war'. Blake's purpose in painting Nelson and Pitt was therefore not patriotic,[3] for he remained opposed to the rulers of This World, but to place Nelson and Pitt in an 'Eternal' perspective, by revealing their warlike activities as the fulfilment of the prophecy of Revelation, that God in his Wrath would send Angels to destroy the world before the Last Judgement. The aggressive campaigns of Pitt and Nelson were to be condemned by all just men, but if looked at *sub specie aeternitatis* they were portents of the impending fulfilment of man's final destiny.

A close examination of the two pictures leaves little doubt, despite their poor condition, of Blake's distaste for the corporeal Nelson. Nelson stands with what seems to be a Jovian thunderbolt[4] in his right hand, whilst with his left he directs the serpent Leviathan to encoil figures presumably symbolic of the nations at war with England. Under Nelson's feet lies the despairing figure of a black slave: a comment on the human consequences of conquest by sea. If Nelson wages war by sea, Pitt releases a

flood of destruction upon the Earth. He directs the Apocalyptic reapers to destroy the cities of the Earth in order to purge the fallen world in preparation for Redemption. The theme of both paintings returns in spirit to the lost painting of *War Unchained*, exhibited 1785, for they unite the history of England with the apocalyptic history of the world; they represent, therefore, a bizarre marriage between the tradition of 'Contemporary History' painting, initiated and sustained by Benjamin West, and Blake's apocalyptic vision of his own time.[5] The two paintings are, as Edgar Wind claimed, an illuminating footnote to the development of public History painting in England, for they transform the convention of public allegory into, as Blake claims, 'mythological and recondite meaning, where more is meant than meets the eye'.[6]

A small group of dramatic watercolours made for Butts from the Book of Revelation can be dated from *c.* 1805–9, and were certainly executed over an extended period.[7] Here the idols of mankind are depicted as sublime and demoniac parodies overshadowing tiny crowds of humanity who observe them with awe. For Blake the first stage of the fulfilment of Revelation is for the rulers of the world to reveal themselves in their monstrousness. In *The Whore of Babylon* (1809; British Museum) behind the tiny figures of warring soldiers can be seen the many-headed devouring Beast, upon which perches the voluptuous figure of the Whore of Babylon herself. The visionary splendour of the Apocalyptic watercolours of this period can be gauged by comparing them with *Death on a Pale horse* (Fitzwilliam)[8] of *c.* 1800, in which Blake had used simple allegory to depict sublime events; Death is a warrior in armour riding a fiery charger. The later *Revelation* series, on the other hand, is dominated by awe-inspiring images of the ineffable Great Red Dragon and the Seven-Headed Beast. The Dragon is a many-headed figure, with horns on the principal head, a long tail, and an immense bat-wing, which enshrouds the stars amongst its folds. His colouring is flame-like but the lineaments are sharp and clear, and he dominates the scene by his immense scale.

In *The Angel of Revelation* watercolour (Metropolitan Museum, New York) (plate 123), the Angel, in an aura of Divine light, is depicted as a colossal figure spanning land and sea, dispatching the horsemen on their work of destruction, as a tiny St John on Patmos writes down his Revelation.[9] There are two watercolours of *The Great Red Dragon and the woman clothed with the Sun* (Rosenwald Collection and Brooklyn Museum). In the Brooklyn design the Dragon dominates the picture, his tail enfolding the helpless woman, who represents the Spirit, but in the Rosenwald watercolour she rises up against the Dragon, and escapes from him by spreading her wings while tiny human figures are swept along by the deluge he creates. The Beast in the watercolour *The Number of the Beast is 666* (Rosenbach Foundation, Philadelphia) (plate 124), before whom all bow down, for 'power was given him over all kindreds, and tongues and nations', is seen from behind as a scaly, monstrous multi-headed humanoid, carrying a sceptre of authority over the worshipping peoples. He is a Moloch-like idol, but on a rock sits the Dragon, the source of power, who watches fearfully as he senses their impending destruction.

This magnificent group of *Revelation* watercolours does not form a coherent series:

The Angel of Revelation and *The Whore of Babylon* seem to belong to a slightly different period both from each other and from the others in the group, and they are quite different in spirit from the earlier *Revelation* watercolours of the *River of Life* and the *Four and Twenty Elders casting their Crowns before the Divine Throne* (both Tate Gallery).[10] The *Revelation* group just discussed were possibly the last of the Butts Biblical watercolours to be completed and they are a fitting conclusion. Their mastery of a visionary mode applied to the arcane imagery of *Revelation* is unsurpassed since Dürer, and they fuse Blake's mastery of unearthly light and scale with reminiscences of Fuselian grotesquery and exaggeration. In a sense they unite the 'Gothic' symmetry of the Redemptive subjects in the Butts series with the sublimity of the 1790s. At the same time their breadth of conception and handling look forward, or perhaps across, to Blake's increasing concern with the Last Judgement in the years around the 1809 Exhibition.

In those years Blake was beginning to work towards a synoptic view of the Redemption, in the form of an enormous picture of the Last Judgement, a scheme culminating in a vast fresco painting, now lost, on which he worked in his later years, containing 'upwards of a thousand figures'.[11] In preparation for this immense undertaking he made several watercolours and drawings, and also two separate manuscript descriptions.[12] The first public intimation of the composition was the engraving of *The Day of Judgement* for Blair's *Grave*, published in 1808, but the original design, now lost, probably dated from 1805. The composition is based, inevitably, on Michelangelo's *Last Judgement*, which Blake knew from engravings, but his Christ in the Blair's *Grave* version and in all the later ones is seated on a throne with steps beneath; the good souls ascend on the left, the damned souls fall on the right, and angels, shrouded in flames, blow the Last Trump beneath the throne. From this basic scheme Blake progressively elaborated the composition to include more and more figures, incorporating an ever-growing number of Biblical characters.

In the first watercolour for Butts of the *Last Judgement* (Pollok House, Glasgow) dated 1806,[13] Adam and Eve appear in contrition before the Throne, while the trump-blowing Angels descend to confront the Beast consumed in flames. The Pollok House version was until recently accompanied by a watercolour of the *Fall of Man*[14] (Victoria and Albert Museum) (plate 125) which, despite its date of 1807, must have formed a pair with it, showing in theological terms the circumstances which necessitated a Last Judgement. *The Fall of Man* provides a synoptic view of the moment of the Fall, showing not Michael but Christ leading the unhappy pair out of the Garden of Eden. God the Father, in anger, is enthroned in the sphere of Heaven, and at the bottom Hell gapes open: Sin and Death emerge, drawing out warriors and tyrants. Compositionally the *Fall of Man* parallels the *Last Judgement*: God the Father occupies the throne instead of Christ; the Angels form a sorrowful guard of honour instead of blowing the Last Trump, and the cave in which Sin, Death and Hell awake is still erect. The indignation of Jehovah at Adam and Eve's transgression is contrasted with Christ's mercy in accompanying them on their baleful journey. The presence of Christ at the Fall is apparently unique in art, but refers to

the literary and theological tradition of the 'Fortunate Fall'.[15] It is implicit in Christian theology that the Fall was necessary, for without it Christ would not have come to Earth for man's Redemption. In Blake's scheme, however, Christ accompanies Man in the Fallen World in the form of painting, poetry and music, which keeps him in contact with the Paradise from which he has been ejected. At the sides of the watercolour the Rebel Angels are cast out, and, following Milton, Satan unleashes the allegorical Sin and Death; the action of Books I and II of *Paradise Lost* is thus conflated into a single moment. As Blake indicates in an inscription on the back of the watercolour, the tranquillity is broken, and the predators attack the weaker animals. Adam and Eve pass through a gate formed by a fruitful tree of life and a thorny tree around which the serpent coils, and on the edge of Eden a group of symmetrical angels weep as they pass. This group of 'Pleurants' is puzzling but their origin must be in monumental design; they are perhaps a fanciful derivation from supporting figures on English medieval tombs.

Through his friend Ozias Humphry[16] Blake received a commission for a watercolour of the *Last Judgement* (Petworth, National Trust) (plate 126) from the Countess of Egremont, common-law wife of the Earl of Egremont, the great collector of British paintings, whose collection is still to be seen at Petworth House. In January/February 1808 Blake wrote for Humphry, perhaps at the request of Lady Egremont, a long letter describing the content of the watercolour, which is similar to the Pollok House version, but more elaborate in detail. Blake's letter does little more than identify the elements of the scene, but extensive fragmentary jottings in the *Notebook*, probably made in 1810, give a much fuller account of a painting of the *Last Judgement* which corresponds most closely to an elaborate pen drawing (Rosenwald Collection).[17] In these jottings, entitled by Rossetti 'A Vision of the Last Judgment', Blake describes the Last Judgement as the final event in the history of the world, when man has abandoned hope of Redemption:

> *When Imagination, Art & Science & all Intellectual Gifts, all the Gifts of the Holy Ghost, are looked upon as of no use & only Contention remains to Man, then the Last Judgment begins, & its Vision is seen by the Imaginative Eye of Everyone according to the situation he holds.*[18]

The Last Judgement is also the triumph of art, for 'The Last Judgement is an Overwhelming of Bad Art & Science.' His picture of the Last Judgement is then, 'a History of Art & Science, the Foundation of Society, Which is Humanity itself'. The Last Judgement occurs on an individual as well as a universal scale: 'Whenever any Individual Rejects Error & Embraces Truth a Last Judgment passes upon that Individual.' Thus the imagery of the *Last Judgement*, despite its ostensible orthodoxy, reflects the different levels of meaning of the Prophetic Books. The souls who appear in the painting of the *Last Judgement* are not historical individuals but representatives of the eternal states of humanity. By 'states' Blake means two things: on the one hand he means simply the ideal form in the sense that the Farnese Hercules is the archetype of the strong man through the ages; on the other hand he means the mental states through which a man travels in Experience:

Man passes on, but States remain for Ever; he passes thro' them like a traveller
who may as well suppose that the places he has passed thro' exist no more, as a
Man may suppose that the States he has pass'd thro' Exist no more. Every thing is
Eternal.

For Blake the notion of the Last Judgement as raising the good and punishing the
wicked is false, for that implied the necessity of Divine vengeance; the Last Judge-
ment is a purgation of the wickedness of the Fallen World, and of the domination of
wicked states over man, through the casting out of Corporeal understanding:

Truth is Eternal. Error, or Creation, will be Burned up, & then, & not till Then,
Truth or Eternity will appear. It is burnt up the Moment Men cease to behold it.
I assert for My Self that I do not behold the outward Creation & that to me it is
hindrance & not Action; it is as the Dirt upon my Feet, No part of Me. 'What',
it will be Question'd, 'When the sun rises, do you not see a round disk of fire some-
what like a Guinea?' O no, no, I see an innumerable company of the Heavenly
host crying 'Holy, Holy, Holy is the Lord God Almighty.'[19]

The states are not only eternal but immutable; one state cannot be transformed into
another, therefore metamorphosis should not be taken literally, for example, 'Lot's
Wife being changed into a Pillar of Salt alludes to the Mortal Body being render'd a
Permanent Statue, but not Changed or Transformed into Another Identity while it
retains its own Individuality.' Thus the masses of almost undifferentiated figures in
the Last Judgement designs are in theory precisely identifiable states containing
within themselves a specific allegorical meaning. In the bottom right-hand corner of
the Rosenwald drawing, for example, a man is seen pulling a woman from the earth
by the hair; according to *A Vision of the Last Judgment* this represents the 'Inqui-
sition', while above a man strangling two women represents a 'Cruel Church'. On
the far right are 'three fiery fiends with grey beards & scourges of fire' who 'represent
Cruel Laws'. The Furies are represented by three men instead of women, for 'The
Spectator may suppose them Clergymen in the Pulpit, scourging Sin instead of
Forgiving it.' Many states are represented by Biblical characters of some obscurity:
'by the side of them is a Mighty fiend with a Book in his hand, which is Shut; he
represents the person nam'd in Isaiah, xxii, c. 20 v., Eliakim, the Son of Hilkiah.'
Some personifications relate closely to the travails of man on earth, and Blake shows
'various figures in attitudes of contention representing various States of Misery,
which, alas, everyone on Earth is liable to enter into' as despairing figures clutching
their heads in anguish.

Many of Blake's states make conventional associations with Biblical archetypes:
Adam and Eve represent Humanity before the throne of Christ, while Cain as
representative of Murder is seen falling downwards 'with a flint in his hand with
which he slew his brother', the Whore of Babylon and the Beast of Revelation also
find a place. Others, however, are shown in a more distinctively Blakean light.
Moses is shown casting 'his tables of stone into the deep', for the Ten Command-
ments represent Legalism; Satan is shown in the Rosenwald drawing falling bound
by the coils of a serpent nailed to the Cross as prophesied by Michael in *Paradise*

Lost. Abraham is seen in the drawing hovering over his posterity, 'which appear as Multitudes of Children ascending from the Earth, surrounded by stars', while Elijah represents all the 'Prophetic Characters'. Blake also reveals a singular conception of the antediluvian period: Noah is the principal representative of the Holy Men who lived before the Flood, and some of these antediluvian men, like Enoch, had a greater knowledge of the Eternal World because they were nearer to it in time. Those that 'walked with God' like Enoch, who oddly appears not in *A Vision of the Last Judgment*, but in an independent lithograph of approximately the same period,[20] were in constant contact with the Infinite world, and Enoch is shown in the lithograph immersed in Divine light accompanied by the arts of painting, poetry and music. The Flood, however, swept away all memories of the Eternal world and ways of 'conversing with Paradise', except those immortalized in Poetry, Painting and Music, represented in the *Last Judgement* by Noah, Shem, and Japhet. The Last Judgment comes about, therefore, 'when Men of Real Art Govern & Pretenders Fall'. Blake's picture 'is a History of Art & Science', for without art Vision would be lost to men. The Last Judgement is the central icon of the true artist, for it encompasses the whole vision of Redemption, and draws into a single Vision all the States of mankind; it is in itself a state, for it represents the Eternal moment of Redemption, which the artist must have before him at all times. The Last Judgement draws together and identifies all states, whether Good or Evil, providing in a single Vision a guide to the Internal sense of the Bible, for the characters of the Bible are nothing more than 'Visions of those States as they were reveal'd to Mortal Man in the Series of Divine Revelations as they are written in the Bible'. Blake's vision of Paradise, which follows, is therefore an artistic one; it is conjured up by the sound of angels blowing the Last Trump, and accompanied by exultant souls shouting for joy. It is a place not of passive contemplation, but of the exercise of the Imagination:

> *The Temple stands on the Mount of God; from it flows on each side the River of Life, on whose banks Grows the tree of Life, among whose branches temples & Pinnacles, tents & pavilions, Gardens & Groves, display Paradise with its inhabitants walking up & down in Conversations concerning Mental Delights. Here they are no longer talking of what is Good & Evil, or of what is Right or Wrong, & puzzling themselves in Satan's Labyrinth, But are Conversing with Eternal Realities as they Exist in the Human Imagination.*[21]

True art itself is symbolized in the *Last Judgement* painting by a Gothic Church, which is 'representative of true Art, Call'd Gothic in All Ages by those who follow'd the Fashion, as that is call'd which is without Shape or Fashion'. Blake is referring to the current but increasingly unfashionable usage of the word Gothic as a synonym for crudity and barbarity.[22]

Blake's vision of the Last Judgment encompasses also the national myth of Albion, which was to form the core of his last Prophetic Book, *Jerusalem, The Emanation of the Giant Albion.* In the bottom left-hand corner a patriarchal figure is awakened by his wife; Blake describes him as follows: 'He is Albion, our Ancestor, patriarch of the Atlantic Continent, whose History Preceded that of the Hebrews & in whose Sleep.

or Chaos, creation began.' Blake also finds a place for representatives of other nations, especially those sympathetic to Vision in warlike nations: 'A Mother Meets her numerous Family in the Arms of their Father; these are representations of the Greek Learned & Wise, as also of those of other Nations, such as Egypt & Babylon, in which were multitudes who shall meet the Lord coming in the Clouds.'

The Rosenwald drawing is certainly one of the final surviving versions of the *Last Judgement* composition. Albion does not appear in the earlier versions, nor does the Angel of the Divine Presence, who in the Rosenwald version is made into a Recording Angel 'having a writing tablet & taking account of the numbers who arise'. Compositionally the Rosenwald version is also the most highly developed; the figures are now unified by powerful rhythms formed by arabesques of linking figures. Christ's radiance encompasses within its divisions the whole of the heavenly company above and around his throne, who in the earlier versions are represented rather unimaginatively by banked rows of the Blessed. Blake undoubtedly continued to add to his conception, for there are two reports of a large tempera version from later years. One version can be glimpsed in a letter to George Cumberland from his son, of 21 April 1815: 'We called upon Blake yesterday evening found him & his wife drinking Tea, durtyer than ever however he received us well and shewed his large drawing in Water Colours of the last Judgment he has been labouring on it till it is nearly as black as your Hat—the only lights are those of a Hellish purple.'[23] The fact that he had laboured it to darkness suggests that it had suffered a similar fate to his first version of *Satan calling his legions* (Victoria and Albert Museum) which he showed in his Exhibition as an example of his early lack of success with his new method.[24] He probably abandoned the version described by Cumberland, for the one seen by J. T. Smith was notable for its exquisite finish. Smith records that it contained

> upwards of one thousand figures, many of them wonderfully conceived and grandly drawn. The lights of this extraordinary performance have the appearance of silver and gold; but upon Mrs Blake's assuring me that there was no silver used, I found upon closer examination, that a blue wash had been passed over those parts of the gilding which receded, and the lights of the forward objects, which were also of gold, were heightened with a warm colour, to give the appearance of the two metals.[25]

This description is all that remains of Blake's final *Last Judgement*, which he had apparently intended to exhibit at the Royal Academy in the year of his death. It would have been his masterpiece, and its disappearance leaves a major gap in his œuvre.

The *Last Judgement* was intended as a summation of all Blake's visionary ideas, but other works of the years 1808–10 are also dictated in form by a synoptic structure. Blake's attempt to encompass a whole work of literature within a single painting in *The Canterbury Pilgrims* may be paralleled in two other works of the same period or later, also previously mentioned. The *Epitome of Hervey's Meditations among the Tombs* (Tate Gallery) (plate 98), as the title suggests, is based upon James Hervey's

Meditations, first published in 1746: an apparently slender peg upon which to hang such a complex composition. Hervey's reflections upon death and early mortality, written in a similar spirit to Blair's *Grave* and Young's *Night Thoughts*, are transformed into a vision of the Fall and Resurrection. The scene is set in a church and Hervey stands before an altar, escorted by two angels; the vision of the Redemption forms part of a gigantic Gothic window behind the altar. This vision shows the history of man, from the Fall to the coming of Christ, in the form of a curving staircase, with Christ as the fulfilment of Hebrew prophecy. In the Transfiguration group above the altar, Christ is adored by Elijah and Moses. At the top Adam and Eve suffer the wrath of Jehovah, while the antediluvian patriarchs Enoch and Noah stand in front of the Ark. 'The mother of Leah and Rachel' and the 'Mother of Rebecca' pass each other on the stairway, while further down on the central axis is a scene of Abraham and Isaac. Aaron the High Priest is next on the staircase, while beneath him David and Solomon pass each other, Solomon holding a pair of compasses.

Apart from the fact that it was bought by Thomas Butts, nothing is known about the painting; even the date is unclear. Despite the identification of characters from Hervey's book, there is not much to connect the painting with it. Indeed there is nothing in the book quite like the vision in the window, except a brief account at the beginning of an altarpiece above the altar at the Church. But this induces in Hervey not a vision of the Old Testament but reflections upon the pious gratitude of the donors of the altarpiece, which is compared to Solomon's modesty in presenting the Temple to God. Equally puzzling is the large and damaged painting in the Fitzwilliam Museum known as *The Spiritual Condition of Man*, 181(1?) (plate 97), a title given to it by W. M. Rossetti.[26] As in the *Epitome of Hervey's Meditations*, Blake applies his vision of Salvation to a text from an earlier writer, presumably on the theme of the Theological Virtues. The text is unrecorded, but may also be an eighteenth-century devotional work. Of the three standing figures Hope can be identified by her anchor and Faith by her book and attitude of piety; but the crowned figure in the middle is not the usual personification of Charity, although there are representations of Charity as a Queen in Italian medieval sculpture.[27] The female figure floating above the crowned figure with a group of children is closer to the conventional idea of Charity, and above her a female soul carried aloft by angels towards the Holy Ghost appears to be a transformation of the figures beneath. So the central episode must relate to the idea of the Redemption of the human soul through the Theological Virtues. The scenes which flank the main group tell once again the story of the Fall and Redemption. On the left-hand side a series of self-contained scenes show the history of the Old Dispensation, from the Creation to its cruel conclusion in the Crucifixion of the body of Christ. On the right can be seen the triumph of the New Dispensation from the discovery of the empty Sepulchre until the final enthroning of Christ in Glory. Despite abrasion of the surface of the painting an extensive landscape can be made out; on the left, under the Old Testament scenes, a classical temple and some Stonehenge-like structures emphasize the connection between 'mathematical' art, sacrificial religion and the Synagogue; on the other side

under an arbour of trees a shepherd sits piping to his flock, alluding to Innocence, Imagination and the Revelation of Christ. The Old Testament scenes show the establishment of the Jews as the Chosen People through *Abrahan and Isaac* and *Moses casting the Egyptians into the Red Sea*, but the following scenes, the *Judgement of Solomon*, the *Babylonish Captivity* and the *Crucifixion* seen from behind, show the usurpation of Divine authority and the fall into spiritual despair, which leads inevitably to the crucifixion of the Messiah. The triumph of Christ, on the right, is represented by scenes mainly from the Gospels and the Book of Revelation. *The Three Marys at the Sepulchre* opposes the spiritual nature of Christ to the corporeal represented by the Crucifixion of his body. *The Pentecost* represents Prophecy, while the two images of *St Peter escaping from prison*(?) and a *Martyrdom by burning*, whatever their precise subjects, stand for release from the body and purgation of the flesh. The next stage is the casting out of the Great Beast of *Revelation* as the angels blow the Last Trump, and the Saved rise up to the Judgement seat of Christ.

The monumental size of *The Spiritual Condition of Man* and its probable date of 1810–11 make it clear that the failure of the 1809 exhibition and the poor response to the *Canterbury Pilgrims* plate did not affect Blake's ambitions or productivity, nor Butts' loyalty to him. From 1809 until about 1818 he was living in dire poverty, supported almost entirely by Thomas Butts. Apart from the Milton watercolours, which will be discussed in the next chapter, Butts also bought a set of tempera paintings, which may have formed part of a decorative scheme. Of the four surviving paintings two are dated 1810 and are of half-length figures, almost life-size. *Adam naming the beasts* (Pollok House, Glasgow) (plate 127) is based upon a similar composition made in 1802 for the frontispiece of Hayley's *Designs to a Series of Ballads*.[28] Adam's rigid frontality gives an almost Byzantine formality to the image as he names the serpent, but *Eve naming the birds* (Pollok House, Glasgow) is too damaged to be very revealing. *The Madonna and Child in Egypt* (Victoria and Albert Museum)[29] shows the Madonna, also a severely frontal figure, in adoration of the Christ Child upon her lap; in the distance are pyramids and a sphinx, symbols of 'Egyptian' materialism (plate 128). A half-length figure of *Christ Blessing* (Fogg Museum) also seems to belong with the set, and it is possible that they form together a complete series, for the cycle of Fall and Redemption is encompassed within the four paintings even as they stand.[30] We have no evidence of the arrangement of the paintings in Butt's house, but it is not inconceivable that *The Spiritual Condition of Man* and the four tempera paintings may have formed part of one decorative scheme, perhaps in conjunction with the small Biblical tempera paintings of 1799–1800.

Milton and the Epics

Milton and *Jerusalem*

Blake's two final Prophetic Books, *Milton* and *Jerusalem*, are both dated 1804 on the title-page, but neither was finished until many years later.[1] *Milton* could not have existed in a finite state before 1809. One copy at least is post–1815 and *Jerusalem* was still being revised at least as late as 1820.[2] The bridge between the 1790s Prophecies and the final epics is the complex and heavily reworked manuscript known as *Vala, or the Four Zoas* (British Museum), its double title reflecting its confused character. The manuscript was certainly begun shortly after the publication of the Young's *Night Thoughts* engravings, and it was probably abandoned about 1805.[3] Although the order of composition is still a matter of dispute, it is clear that in the course of working on the manuscript Blake developed a more positively Christian attitude, restructuring the work around the archetypal man, Albion, and a four-fold vision which governs the system of correspondences in *Milton* and *Jerusalem*. The legendary figure of Albion came, according to Blake, out of a native British mythology even older than that of the Hebrews. These 'British Antiquities' were of equal value to the Hebrew Antiquities, and they told of the primitive golden age when 'All had originally one language, and one religion: this was the religion of Jesus, the everlasting Gospel'. The story of Albion was revealed to Blake through his exploration of a number of recent publications on the Druids and Welsh mythology. 'The Giant Albion, was Patriarch of the Atlantic; he is the Atlas of the Greeks, one of those the Greeks called Titans. The stories of Arthur are the acts of Albion, applied to a Prince of the fifth century, who conquered Europe, and held the Empire of the world in the dark age, which the Romans never again recovered.'[4] The full title of the first version was *Vala*, or 'The Death and Judgment of the Ancient Man', but it was changed at some point to read, 'The Four Zoas The torments of Love & Jealousy in The Death and Judgement of Albion the Ancient Man'.[5]

The *Vala, or the Four Zoas* manuscript is partly evidence of Blake's spiritual crisis in the Felpham years, and its resolution is contained in *Milton*, an Illuminated Book of 45–50 pages, existing in four hand-coloured copies.[6] The theme of the poem

is 'the Spiritual Acts of my three years Slumber on the banks of the Ocean' expressed through Blake's struggle with the spirit of Milton. In essence it tells of the resolution of the crisis in his renewed conviction of his prophetic destiny, achieved through an imaginative recreation of Milton's mental battles. The focus of the poem is not Milton but Blake himself, whose Redemption begins when he realizes that Milton is not a separate spirit, but himself as yet unredeemed. The poem opens with Milton and Blake still divided; the former 'unhappy tho' in heaven', and the latter adopting the role of Palamabron 'the mild and piteous artist' in his subservience to Hayley. But Milton becomes aware that his own failure to cast out Error has led to the captivity of artists by Satan, for, as Blake was painfully aware, Milton could provide as much comfort for the worldly as for prophetic poets.

The book is introduced by a magnificent title-page in which a naked Milton, depicted in white line-engraving, is seen from behind striding forward into a realm of billowing smoke, his arm heroically extended to force his way through, in obedience to his quest (engraved beneath him) 'To Justify the Ways of God to Men'. His action prefigures his descent to earth later in the poem, and it is evidently a counterpart of the equally splendid Plate 13, which depicts the same action from a different viewpoint. The Bard's Song which recounts the Satan-Palamabron episode is illuminated by several minor designs. On Plate 3[7] the invocation to the Muses, the Daughters of Beulah, is illustrated by Blake as a star passing through the realms 'of terror and mild moony lustre'. Plate 4 contains an illustration of an immense trilithon with a rock in front of it; a tiny rider emerging from the arch represents Druidism, complementing a passage on the same page in which 'stony Druid temples overspread the Island white', as a consequence of Milton's Error.[8] In the full-page illustration on page 8 Hayley-Satan reveals his true nature before the assembly of the immortals at the instigation of the gentle Palamabron, who has now, within the person of Blake, joined with Rintrah, his wrathful voice, to expose Satan. This parallels the 'earthly' episode when Blake, realizing the futility of his submission to Hayley, exposes the latter's Satanic nature by denouncing him in anger. Blake's wrathful voice gives sculptural form to Satan, who stands on a plinth frozen in flames of anger, his form perpetuated as Error.

The drama of Blake's confrontation with Hayley reveals to Milton in Heaven that 'the Nations still follow after the detestable Gods of Priam', and he is in his own 'selfhood' Satan himself. He resolves to descend to earth—even in 'self-annihilation and eternal death', a gesture which the Heavenly company see as one of heroic self-abnegation leading only to eternal torment:

The whole Assembly wept prophetic, seeing in Milton's face
And in his lineaments divine the Shades of Death and Ulro.

After a tragic speech of renunciation Milton 'took off the robe of the promise, & ungirded himself from the oath of god'. The full-page illustration on the facing page (13) depicts Milton's renunciation, which follows his proclamation of self-sacrifice. The illustration is redolent of Redemption, and suffused with holy radiance. Milton looks upwards, as he throws off the garments, his face full of prophetic acceptance.

The upward movement is inescapable and Milton's renunciation is implicitly com-
pared with Christ's own renunciation of His place in Heaven; Milton goes not to
death but to the promise of eternal life. Milton now meditates upon his previous
incarnation, 'his bright pilgrimage of sixty years', which in Blake's eyes had not
culminated in his eternal Redemption. The principal illustration to this section,
Plate 15, reveals Milton's mortal life as a struggle with Urizen, yet it is also clear that
this Urizen is his own creation. Milton thus appears in the design both wrestling with
Urizen and moulding him:

> But Milton took of the red clay of Succoth moulding it with care
> Between his palms: and filling up the furrows of many years
> Beginning at the feet of Urizen, and on the bones
> Creating new flesh on the Demon cold and building him
> As with new clay a Human form in the valley of Beth Peor.[9]

This confrontation with Urizen is the central one of his first 'pilgrimage' on earth,
for out of it comes *Paradise Lost*, the great achievement of which Blake felt to be
the depiction of Satan, who is Error. Milton's principal achievement as a poet, then,
is to give form to Error, just as Los had given form to Urizen in the *Book of Urizen*;
by sculpting Urizen in his character as the giver of the Ten Commandments, Milton
reveals his own God to be Reason and not Imagination. The form of Urizen bears a
strong resemblance to the Trojan High Priest in the *Laocoön* group, which was itself,
as Blake argued later, a Greek copy of the Cherubim of the Temple of Solomon,
which were also cast with 'the red clay of Succoth'.[10] In the struggle between Milton
and Urizen; 'one (is) giving life, the other giving death'; the artist gives a living
form even to error, while Urizen can only offer the aridity of the Ten Command-
ments. But giving form to evil is only one function of the poet, and Blake believed
Milton to have failed, in his first incarnation, to achieve a vision of Redemption.
Milton under the influence of Tirzah uses the forms of Allegory rather than Vision,
because of his immersion in 'the cold learning's streams' of Cambridge, where he
has learnt to 'bring with (him) Jerusalem with songs on the Grecian lyre'.[11]

As Milton falls through the 'heart of Albion' in his journey towards Blake, Los
appears to Blake, and the scene is illustrated on Plate 21:

> While Los heard indistinct in fear, what time I bound my sandals
> On; to walk forward thro' Eternity, Los descended to me:
> And Los behind me stood: a terrible flaming Sun: just close
> Behind my back; I turned round in terror, and behold
> Los stood in that fierce glowing fire.[12]

Milton has already entered Blake's left foot, and Blake's union with Los takes place
in 'the vale of Lambeth', so the illustration refers to Blake's assumption of the pro-
phetic mantle in the 1790s, when Los himself trembled in fear, the Prophetic Books
being 'a black cloud redounding [which] spread over Europe' from his left foot. Blake
argues, therefore, that in the Lambeth Books he had taken on the mantle of the
corporeal Milton in giving form to the Error of his own time, his creative struggle
being reflected in Los's forging of the form of Urizen in the *Book of Urizen*. Blake's

meditation upon his previous understanding of Milton is presented through Rin-trah and Palamabron, who blame Milton for the creation of Natural Religion and the Enlightenment; but Los argues that Milton's impending descent 'is the signal that the last vintage now approaches'; for when Milton through Blake realizes his own error and is ready to go forward to Redemption, then the Last Judgement is immi-nent. This argument between Los and Palamabron takes place at Felpham and it is at the centre of the crisis which accompanied 'the Spiritual Acts of my three years Slumber on the banks of the Ocean'. The first book ends with a vision of the world at the time of Milton's descent, in which the Napoleonic wars and the political repression of the English nation are signs of the degradation which will precede the final Apocalypse.

The magnificent full-page plate (29) inscribed W I L L I A M (plate 131), of Milton as a star entering Blake's foot, introduces the second Book and brings the action back to Blake as the agent of Milton's Redemption; the motif acts as a pivot for the whole work, for all the events in *Milton a Poem* radiate forwards and backwards from it. As the comet makes a fiery track towards Blake's foot, he throws back his head and stretches out his palms in total receptivity to the dictates of the Divine Vision, while black clouds of war and discord float overhead. This arresting image finds a counterpart on Plate 33 inscribed R O B E R T, where a star is about to enter the right foot of Robert Blake. He is a mirror-image of the form of William, but the colouring is more sombre and the track of the star entering his right foot does not cast much illumination. Robert is not mentioned at all in the text of the poem, but Blake evi-dently wished here to commemorate his dead brother's constant influence upon him. He wrote to Hayley on the death of the latter's son Thomas Alphonso on 6 May 1800: 'Thirteen years ago I lost a brother & with his spirit I converse daily & hourly in the Spirit and See him in my remembrance in the regions of my Imagination. I hear his advice & even now write from his Dictate.'[13]

Early in Book II another character enters the story: Ololon, Milton's true emana-tion, with whom he is to unite in order to achieve Redemption. Ololon watches the descent of Milton into Blake's foot, and Milton's track is represented on Plate 32 by a remarkable diagram of the Blakean cosmos, which shows the four Zoas intersecting in the centre of the Mundane Egg, confined within the limits of contraction, Adam and Satan. Milton enters on the intersection of Urizen and Luvah, and proceeds through the realm of Satan to Adam, to become enfolded by Urthona, the spiritual existence of Los. Milton, therefore, enters the world equally through Luvah, whose realm is Beulah, the land of 'soft sexual delusions' and through the domain of Reason. He passes into Error or Satan, but the Divine Mercy establishes a limit to Satan's realm, so he is able to return into the realm of prophecy. Ololon enters Milton's track, and appears to Blake at Felpham in the form of a lark. Ololon's appearance is depicted on Plate 36 (plate 132) by a view of Blake's cottage at Felpham, where he stands greeting her as a lark but revealed in the form of a young girl, her robe billowing behind her. The text and illustration provide a naturalistic and personal note after the sublimity of the previous illustration; but Ololon's appearance is more

than an interlude, for her intervention inaugurates the final phase of Milton's Redemption through Blake's mental struggle at Felpham. At Lambeth Blake assumed Milton's earthly role of revealing Satan; now at Felpham he can purge Milton of error and effect his reunification with his emanation.

Plate 38 (plate 133) clearly represents the sleeping Albion, national archetype as well as universal man, on the 'Rock of Ages', which also implies the shores of Britain. The overt sexuality of the image, notably in the British Museum copy of the book, makes it clear that Albion is in the state of Beulah, as he awaits the national awakening which will come when Milton rises up in Redemption. The eagle above is not the Eagle of Inspiration, but 'the strong Eagle . . . watching with Eager Eye till Man shall leave a corruptible body',[14] for the sleeping Albion is the prize in the impending conflict between Milton and Satan. The now regenerate Milton re-enacts the struggles of his former incarnation, and confronts again the enemies he had failed to recognize and subdue in his earthly life. Plate 41 shows Milton struggling again with Urizen, and the whole image acts as a counterpart to the plate of Milton giving form to Urizen in the first book; but Milton now completes the process by casting out Urizen. Urizen 'faints in terror striving among the Brooks of Arnon with Milton's spirit', and he can be clearly identified in his embrace with Milton by his hairy 'mantle of years'.

The minor illuminations to the text also serve to emphasize the contrast between Milton's first and second incarnations. The design at the bottom of Plate 42 shows Milton's mental struggle to reach the state of Eden as a battle in a dark wood with serpents, and the six intertwined females at the top of Plate 43 show the reunification of the Sixfold Emanation, as Milton makes his final speech of self-renunciation and casts off Error. This vignette appears to be a counterpart of that of the divided emanation at the head of Plate 16, which falls at a comparable place in the first incarnation. The book ends with an image of the Apocalyptic harvest, which can now begin as the regenerate Milton-Blake proclaims the Great Day of His Wrath.

The illuminations to *Milton* appear to have an unusually clear relationship to the text, and they present relatively few problems of interpretation. The technique of the full-page plates, however, is less harmonious, for several of them are printed in white line-engraving, including the title-page and Plates 13, 38, and 41. At first sight this technique would appear to be associated with the person of Milton, whose heavenly existence is rendered in the title-page and Plate 13, and it may have been intended initially to draw a contrast between actions taking place in heaven or earth. But if that was Blake's intention then it has not been carried through consistently, for Plate 42 does not depict Milton nor is it set in heaven. The use of white line is probably, therefore, a vestige of an abandoned stage in the development of the book, which shows important variations from copy to copy. Thus Plate 21, of Blake turning round to see Los, is placed in Book II in copies C and D, where it would take on a different significance.[15] A comparison of the four copies of *Milton* makes it clear that copies C and D, with their additional plates, were printed some years later than A and B.

Much the same may be said of Blake's final great epic *Jerusalem*, which, although it shares a date of 1804 with *Milton*, was even longer in gestation and is infinitely more complex in its range of allusions and variety of visual imagery. It also has its origins in Blake's 'three years slumber on the banks of the Ocean', but variations in printing and references to contemporary events reveal that it underwent a complex process of change from its beginning in the aftermath of the Felpham period to the end of the following decade.[16] By 1807, according to Cumberland, Blake had completed 60 pages of a prophecy which may have been *Jerusalem*,[17] but watermarks confirm that none of the five complete copies were printed before 1820.[18]

Artistic creation is one of the major themes of *Jerusalem*, but whereas *Milton* focuses upon Blake's own personal dilemma within a universal context, *Jerusalem* encompasses the whole of human history from Fall to Redemption. Thus the story of Albion's sleep and awakening is paralleled by Los's endeavours to give form to the poem *Jerusalem*, and his travails and eventual triumph are interwoven with those of Albion. Albion's struggle with Vala is paralleled by Los's struggle with Enitharmon, who again represents non-prophetic art, and Albion's progress towards Redemption is reflected in Los's battle with the sons and daughters of Albion. Vala's role in concealing Eternal forms expresses in allegorical form the artistic idea that the depiction of empirical nature veils the clarity of true Vision. In *Jerusalem* Blake perpetually returns to ideas adumbrated in the *Descriptive Catalogue*, and elevates them into universal principles:

I tell how Albions Sons by Harmonies of Concords & Discords
Opposed to Melody, and by Lights & Shades opposed to Outline
And by Abstraction opposed to the Visions of Imagination
By cruel Laws divided Sixteen into Twelve Divisions.[19]

England's enslavement by the Covering Cherub of Ezekiel is expressed by Blake as 'Israel in bondage to his Generalising Gods',[20] and the 'minute particulars' are now brought into a larger conception of the Divine Vision:

He who wishes to see a Vision: a perfect whole
Must see it in its Minute Particulars: Organised & not as thou
O fiend of Righteousness pretendest: thine is a disorganised
And snowy cloud: brooder of tempests & destructive War

. . .

You accumulate Particulars, & murder by analysing, that you
May take the aggregate: & you call the aggregate Moral Law
And you call that swelld & bloated form; a Minute Particular
But General Forms have their vitality in particulars: & every
Particular is a Man: a Divine Member of the Divine Jesus.[21]

The frontispiece to *Jerusalem* (plate 134) shows ostensibly a nightwatchman with a lamp entering a Gothic door in a wall, a motif which may be related to the bellringer in the full-page design of the *Plague* in *Europe* (plate 67).[22] The nightwatchman is obviously an archetype of the poet, and in a unique early proof of the plate he is specifically identified as Los himself.[23] One of Los's many roles in *Jerusalem* is to

M

keep watch over the furnaces of creation, and the idea of the prophet as watchman over his people can be found in the Old Testament prophets.[24] The Gothic door in the wall allows Los to enter into the secrets of the Grave, for he 'enter'd the Door of Death for Albion's sake Inspired'.[25] This image of Los entering the Grave, therefore, conflates two motifs familiar from Blake's earlier imagery; one is the artist as a seeker after truth in the darkness of the material world, and the other the transition of the material body through the Grave to a regenerate existence beyond. The artist here enters the Grave in order to bring back to man the secrets of Eternal Life, an idea used previously by Blake in his illustrations to Blair's *Grave* of 1808:

> To dedicate to England's Queen
> The Visions that my Soul has seen,
> And, by Her kind permission, bring
> What I have borne on solemn Wing
> From the vast regions of the Grave,
> Before Her Throne my Wings I wave;
> Bowing before my Sov'reign's Feet,
> 'The Grave produc'd these Blossoms sweet
> In mild repose from Earthly strife;
> The Blossoms of Eternal Life.'[26]

By entering the Grave the artist makes the self-sacrifice necessary for Redemption, echoing Christ's own sacrifice in dying for mankind, and Milton's posthumous sacrifice in *Milton a Poem*, in order to redeem Albion and call his countrymen back to the ways of righteousness. The image also refers back to the traditional frontispiece in which the author is depicted receiving inspiration from his Muse,[27] but here the poet depicts himself not as a passive recipient of inspiration, but as a mental explorer who enters fearlessly into the mysteries of Human life.

The frontispiece of *Jerusalem* also refers forward to the first chapter, where Los descends to the sleeping Albion in his Fallen state, confined to the island of Britain. The full-page designs before the other three chapters may also serve to introduce the substance of the text which follows. Plate 26, which acts as frontispiece to Chapter II, 'To the Jews', shows Jerusalem looking in horror at the naked figure of Hand wreathed in flames. Jerusalem represents 'Liberty among the sons of Albion', but she is cast out by the sons of Albion hostile to Visionary art. Jerusalem's appearance foreshadows the contest between Vala and Jerusalem in Book II, but that Book also marks Christ's intervention in Albion's fate and through his mercy Albion enters the state of Generation after his sojourn in Ulro. Jerusalem, or the knowledge of the Eternal world, enters Albion's consciousness, so the wicked sons of Albion no longer have complete dominance over his mind. Hand stands in a crucified position, a serpent entwined around his arms, and appears to have nails through his hands, indicative of his role as a false Christ, for in *Jerusalem* he is one of the founders of Natural Religion or Deism. The third chapter, 'To the Deists', is introduced by Plate 51 (plate 140), showing *Vala, Hyle and Skofeld*,[28] the presiding deities of Deism, in despair and agony. Vala is the seductive 'shadow' of Jerusalem and offers a religion

of nature rather than of the spirit; Hyle represents spiritual nullity, like his prototype Hayley, a 'corporeal friend but spiritual enemy', while Skofeld stands for war and destruction. In a recently discovered preliminary drawing (Hamburg, Kunsthalle) (plate 145),[29] Blake appears to have originally conceived this plate with a fourth monstrous figure, who must be another of the Sons of Albion.

The fourth and final chapter, 'To the Christians', is introduced on Plate 76 (plate 142) by a redemptive image, for the end of the age of Deism inaugurates the phase leading to the Last Judgement. Albion is shown from behind, his arms raised in exultation before the crucified Christ on the Tree of the Knowledge of Good and Evil, for through Christ's sacrifice Albion is able to achieve Redemption. The new dawn for humanity is suggested by the morning light, which picks out the forms. In this glorious image Blake draws together Albion's awakening with Christ's sacrifice. The motif of Albion's exultation returns to Blake's earliest years as an artist; Albion in adoration adopts a posture which is essentially that of the engraving of *Albion Arose*,[30] seen from behind. In an uncoloured version *Albion Arose* is dated 1780, presumably the date of the first conception, and it may have been intended from the beginning as a national archetype.[31] In the final state of the engraving, dating from after 1800, Blake added the inscription: 'Albion rose from where he laboured at the Mill with Slaves: Giving himself for the Nations he danc'd the dance of Eternal Death.' The exultant image of Albion is, therefore, a 'dance of Eternal Death' for it implies the annihilation of selfhood, and it is also a radiant image of spiritual regeneration.

If the full-page plates adumbrate the central theme of the poem, the head- and tail-pieces of each chapter have a more oblique function. The title-page (plate 135) itself establishes the order of reality for the head-pieces, for it is a 'fairy' design showing a re-enactment by insect and bird forms of the lamentation of the daughters of Albion over Jerusalem. An evanescent butterfly with human form and bespangled wings represents Jerusalem in her desolation, mourned by humanized birds and insects, who hover about her and around the lettering of the title, creating an effect of astonishing and sinister beauty. The natural spirits in the title-page descend from similar ones in Blake's earlier Illuminated Books, and they have again the effect of revealing the process of human Redemption throughout the whole natural cycle. The head-piece to Chapter I (Plate 4) shows a cowled female figure turning the head of a man away, while on the other side of her the attention of another man is distracted by a floating procession led by a naked female, who points towards the moon and at an inscription in Greek 'Movos o Iesous', which means 'only Jesus'. The cowled figure, possibly Vala, diverts youth from salvation, while the naked female figure, presumably Jerusalem, leads the way to Christ: perhaps a visual parallel to Blake's division of his public in the previous plate into 'Sheep' and 'Goats'.

The tail-piece to the chapter (Plate 25) shows Albion lamented by three Daughters of Beulah, who draw a thread from his navel, like the three Fates 'weaving the Thread of Mortal Life'.[32] Albion's posture reflects that of the victim in the Butts watercolour of *The Blasphemer*,[33] and two related drawings (Fogg Museum and

Keynes Collection)[34] show an Albion-figure as a sacrificial victim at an altar in a ritual performed by the daughters. Albion's agony is here related directly to the main action of the poem, for he is seen at his most tormented and self-divided before the advent of Christ's mercy.

The beautiful head-piece to Chapter II (Plate 28) (plate 139) shows a couple in a water-lily, locked in a close embrace, the sexuality of which is more apparent in the first state in the Morgan Library.[35] Their apparently innocent union may have been intended by Blake to contrast with the horror of the Hebraic Moral Law, imposed in the second chapter by the Fallen Albion:

Every ornament of perfection, and every labour of Love,
In all the Garden of Eden, & in all the golden mountains
Was become an envied horror, & a remembrance of jealousy
And every Act a Crime, and Albion the punisher & judge.[36]

This poetic image is equalled by the lovely head-piece for Chapter III (Plate 53), in which a winged spirit sits upon a sunflower. If the couple in the water-lily suggests the 'soft sexual delights' of Beulah, this radiant if mournful figure, enthroned in gorgeous raiments and crowned with a triple tiara, is more likely to be Vala, perhaps referring obliquely to the Deistic age which followed Christ's first incarnation. The man apparently with a cock's head who contemplates the sun in the head-piece to Chapter IV (Plate 78), also belongs to the order of humanized nature forms, perhaps heralding the dawn of inspiration.

The Great Red Dragon at the end of Chapter II (Plate 50) has three crowned heads, and from the torso of their single body a stream of figures is pouring, to generate their own tyrannies. The Dragon sits on a rock by the sea, signifying the island of Britain, so he may represent the proliferating religions of falsehoods 'Swayed by a Providence opposed to the Divine Lord Jesus'.[37] The Dragon's partner, the Whore of Babylon, appears in the tail-piece of the following book (Plate 75), for at this point it is revealed that Rahab is 'Mystery Babylon the Great'. The exultant union between Albion and Christ at the end of Chapter IV (Plate 99) (plate 143) can be seen, therefore, as in one sense completing this sequence of tail-piece images by a scene of Redemption after the destruction of the Great Dragon and the Whore of Babylon at the Last Judgement.

The fate of Albion can be traced equally through the design and the text, for he is the subject of designs throughout all four chapters. In Plates 9 and 19 he appears as a sleeping giant lamented by the daughters of Beulah, his agony reaching a culmination in the tail-piece to Book I (Plate 25), where the daughters unweave his mortal coil. In Book II Christ intervenes to delimit Albion's Fall, translating him from the single sleep of Ulro to Generation, and in a remarkable design on Plate 35, as Christ descends towards Albion's body, a head, representing Albion's dormant desire for Redemption, emerges from his breast while the rest of the body sleeps.[38] The figure descending can be identified as Christ by the stigmata on his outstretched hands, but although He descends into 'non-Entity' to redeem Albion, Albion is not yet aware of His sacrifice. In Plate 33 a figure, probably Los, leans back against a

radiant and comforting Christ, perhaps showing Los's return to the Divine Body in despair at Albion's refusal to reject his spectre.[39] The figure on the sepulchre would, therefore, be Albion, shrouded in a garment of Cherubs' wings, while the hideous spectre, his wings fully extended, hovers over him.

Albion reaches the nadir of his cycle in Plate 37, where he sits with his head upon his knees in an attitude of Despair. He has, however, reached the limit of 'Opakeness', for the mercy of Christ will not allow him to fall further towards Eternal Death. The inscription, therefore, contains the seed of hope, for Albion can now begin to throw off his spectre and regain his true humanity:

Each man is in
his Spectre's power
Untill the arrival of that hour,
When his Humanity
awake
And cast his Spectre
into the Lake.[40]

This state of Despair also brings self-knowledge:

Thus Albion sat studious of others in his pale disease:
Brooding on evil; but when Los opened the Furnaces before him;
He saw that the accursed things were his own affections.

Albion does not reappear in visual form until the frontispiece to Book IV, when he realizes the significance of Christ's crucifixion; and his final awakening comes on page 95, when he rises in flames, speaking the words of Eternity as he prepares to unite with Christ.

Discriminating between Albion and Los in the designs to *Jerusalem* can present difficulties, for each is depicted as a similar Apollonian figure. The illustration on Plate 14, for example, is more likely in the context to be Los beholding 'the mild Emanation Jerusalem' enclosed in a rainbow, but his prone position, apparently beside the sea and attended by weepers at the head and feet, could suggest Albion.[41] Los, however, is without doubt the figure at the forge in Plate 6 (plate 136) conversing with his spectre, which hovers over him interrupting his labours. The spectre urges him to hate the enemies who have wounded him and leave Albion to his fate; a thought which must have tormented Blake in his effort to create *Jerusalem*:

and the Spectre stood over Los
Howling in pain: a blackning shadow, blackning dark & opake
Cursing the terrible Los; bitterly cursing him for his friendship
To Albion suggesting murderous thoughts against Albion.[42]

Los reappears on Plate 30 with his spectre and emanation, and in other illustrations he is shown active at his forge, but like Albion he arises in splendour in Book IV. In Plate 97 (plate 144) he is seen naked, holding a fiery globe and shielding his eyes from the light of the rising sun, calling Jerusalem to awake:

Awake and overspread all Nations as in Ancient Time

For lo the Night of Death is past and the Eternal Day
Appears upon our hills.[43]

This vision of Los is a Redemptive counterpart to the frontispiece; the nightwatch-
man entering the Grave is now regenerated as the herald of the new dawn. A pencil
drawing (British Museum)[44] of a figure in a similar posture, carrying a staff, is
inscribed by Blake 'the Journey of Life', for Los, on the one hand, is a creator
hammering out forms for the sake of Albion's Regeneration, and on the other hand
he is the Mental Traveller, like Christian in *The Pilgrim's Progress* journeying to
the Holy City of Jerusalem.

The figure of Jerusalem herself is coupled with her shadow Vala, the goddess of
nature and the vision of earthly delight. In Plate 32, Vala is shrouded, while Jeru-
salem stands naked protecting the Daughters of Beulah, for Vala hides human form
while Jerusalem in her nakedness protects the fledgling arts. Next to Vala is the
dome of a classical temple surmounted by a cross, a symbol of institutional religion,
while Jerusalem is associated with a Gothic church, 'representative of true art'. This
design seems to look forward to Plate 81, where the daughters of Albion are engaged
in debate over the question of Chastity. The nude female figure on the left is probably
Gwendolen, a daughter of Albion, hiding a 'falsehood behind her loins', to entice the
sisters to Babylon; her counterpart in the centre stands in the position of the Venus
Pudica, hiding her sexual attributes in false modesty.[45] Plate 92 is inscribed in the
background 'Jerusalem', but the female figure who laments amongst the ruins is
more likely to be Enitharmon; the inscription must, therefore, refer to the ruins in
the background, for the physical ruin of the city precedes its regeneration in the
spirit. Jerusalem makes her final appearance in Plate 96, emerging as a regenerate
female form, embraced by Christ in Albion's vision.

The illuminations discussed so far have either a structural role in relation to the
four chapters of *Jerusalem* or they depict the central characters of the cosmic drama,
but some of the most vivid and haunting designs are difficult to interpret within the
larger themes. Plate 11 (plate 137), for example, despite its extraordinary beauty,
has not, so far, been satisfactorily explained; a swan had been used as a 'chariot of
Inspiration' in the frontispiece to the *Illustrations to Gray*,[46] but Blake's swan here is
evidently female, blowing bubbles upon the water, while a humanized fish swims
beneath.[47] The humanized swan might suggest a reference to the legend of Cycnus,
who defied the might of Achilles and was turned into a swan;[48] but he was undubi-
tably male and there is nothing in the text which might refer to his legend. A more
plausible reading might be that it is a reference to the river Severn, whose goddess is
Sabrina, one of the daughters of Albion mentioned on the same page.[49] Sabrina is
not identified as a swan either in British legend or in Milton's *Comus*, but it is not an
unlikely metamorphosis for a river goddess. The fish in that case would be Ignoge,
another daughter of Albion, but the association between the daughters of Albion and
animal forms seems to be unresolved in Blake's system of correspondences.

Some of the illuminations cast light on local episodes within each chapter. Reuben
the 'vegetative man', from his association with the mandrake in the Old Testament,

is seen in Plate 15 turning into a root-form as 'Abraham flees from Chaldea shaking his goary locks'.[50] The Ark of the Covenant appears twice: once moon-shaped and adrift on the sea, with a cherub form inside, on Plate 18,[51] as the prelapsarian world is recalled by Los; and in Plate 44 as a more substantial houseboat with cherub's wings, guarded by angels as it escorts Albion through 'Los's Gate to Eden'. On Plate 39 'Satans Watch-fiends' are represented by a bearded fiend on horseback with an extended bow, searching the earth for Los's Gate.

In some designs reference is made to Blake's earlier work and certain visual leit-motivs reappear. The Druid trilithon, seen previously in *Milton a Poem*, returns on Plate 70, where its tripartite symmetrical form is directly associated in the text with Bacon, Newton and Locke. On Plate 84 the old man led by a boy through the streets of the city, used previously to illustrate the poem *London* in *Songs of Experience*, is again associated with London, and the lines:

I see London blind and age-bent begging thro' the Streets
Of Babylon, led by a child ; his tears run down his beard.

On Plate 94, a warrior lies dead on the battlefield, embraced by his wife, as on the title-page to *America*.

In addition to the pictorial designs of the type discussed above, almost every plate is decorated on the borders or between the lines with animal, vegetable or human forms. In some cases these make quite elaborate but oblique comments upon the text; the figures running up the right-hand border of Plate 12 evidently form an allegory of Vanity, symbolized by a female figure in an elaborate hat at the top of the page, and the sequence apparently begins at the bottom with a figure applying compasses to a globe, alluding probably to Reason.[52] In the margin of Plate 13 a man mysteriously reaches up to grasp the wing of a huge insect. In some plates the orna-mental images relate directly to the text; in Plate 22, for example, the lines: 'Why should Punishment Weave the Veil with Iron Wheels of War, When Forgiveness might it weave with Wings of Cherubim'[53] are illustrated by a continuous design of cog-wheels and cherubim. Even where the design on the page is nothing more than a few vegetable or ornamental forms, an emblematic meaning can be discerned; as in *Songs of Innocence*, the vine suggests the Divine Vision. But in reality the mar-ginal images are a minor adjunct enlivening the page and referring to the contraries of good and evil often in a playful and humorous way.

Jerusalem ends with a series of magnificent images in which all the divisions are reconciled and the enemies of Imagination are brought in Regeneration into the Di-vine Vision, as are all 'the Living Creatures of the Earth'. The union of Jerusalem with Christ, witnessed by Albion, is transcended in Plate 99 by the final reunion in flames of an exultant naked figure who could be either male or female, with a bearded figure, who is either Christ or Jehovah.[54] The ambiguity must surely be intentional, for the image was intended to signify the uniting of all contraries both physical and mental, so the exultant figure may be taken as a composite of those striving for the spirit, and the bearded man as the spirit with which they seek to embrace. This great vision is not the end, however, for the poem is followed by a full-page plate

of three figures against the background of the serpent-temple, which covers the whole island of Britain. Los stands in the middle, holding a hammer and a pair of tongs, between Enitharmon winding fibre from a shuttle, and a figure, presumably 'the spectre of Urthona', shouldering a burden, which glows like the sun in the Mellon copy.[55] The plate seems to refer back to the creation of *Jerusalem* itself, for Los appears to be resting from his labours as he does in the final plate of the *Song of Los*.[56] It may also refer to the necessity for continuous creation, because false religion symbolized by the Druid serpent-temple would still exist as the reader finishes the poem.

With *Jerusalem* Blake completed the cycle of Illuminated Books which he had inaugurated in 1788 with the three small tracts. Although he lived for many years after its completion he attempted no further work of prophecy in Illuminated printing, reserving the medium for occasional tracts. *Jerusalem* encompasses all the themes adumbrated in the previous books, and it represents his thought on sublime issues in its final form. With his system completed the work left to him was the continuation of his efforts to apply the system to the writings of the few authors of all ages he believed to have partaken, even if imperfectly, of the Holy Spirit.

Comus and Paradise Lost

Milton a Poem points in two directions: towards the final epic *Jerusalem*, also a product of 'the three years slumber on the banks of the Ocean', and towards the two series of watercolour illustrations of Milton's poetic works, made for the Rev. Joseph Thomas and for Thomas Butts. There were obvious reasons why Milton should have seemed a logical candidate for illustration after the virtual completion of the Biblical watercolours for Butts. Blake had hopes of making some designs for Hayley's edition of Milton's *Poems* which was eventually published in 1808, but with two plates after Flaxman.[1] Most of Blake's Milton illustrations date from 1807 and later, but the first series was begun and probably completed at Felpham for the Rev. Joseph Thomas, a friend of Flaxman and a passionate enthusiast for Blake's art.[2] Blake records in a letter to Flaxman of 1801 that he will send on his 'designs for Comus' when he has finished them, and these can be identified on stylistic grounds with the set of eight watercolours for *Comus* in the Huntington Library.[3]

Why *Comus* was chosen as a theme for the watercolours is not known; it would not appear to be the most congenial of Milton's works to Blake, but the Rev. Thomas was later highly impressed by Blake's illustrations to Gray's poems, which he had borrowed from Flaxman,[4] so the choice of one of Milton's lighter poems may well have been his. Even so, *Comus* gave plenty of scope to Blake, for it tells the story of the confrontation of the Lady's innocence with the Bacchic Comus, of the soul beset by worldly temptation. The lady is a Thel-like figure, and Blake seems to have seen her temptation in the light of the entry of an Innocent soul into Experience, a notion not alien to Milton. The Attendant Spirit as the guardian of the soul, who adopts the guise of the shepherd, may be seen as an archetype of the artist, for he guides the Lady towards the other world; but his despairing flight as the Lady returns to her parents at the end suggest that she, like Thel, does not ultimately choose the path to Redemption. The Miltonic triumph of Virtue apparently becomes in Blake's interpretation of the poem a failure to confront Experience. The Satanic identity of Comus is made clear by strong visual parallels: in illustration 2, *Comus disguised as a*

shepherd addressing the Lady in the wood, the motif suggests the temptation of Christ in the Wilderness by Satan disguised as an old man,[5] and the envy felt by Comus at the sight of the *Brothers plucking grapes* (ill. 3), suggests the envy of Satan at the first sight of Adam and Eve in Paradise (see plate 148);[6] the *Magic Banquet* (ill. 5) hints at Satan's offer of sensual fulfilment to Christ in the Wilderness, while *The Brothers driving out Comus* (ill. 6) suggests more the fall of the Rebel Angels than the Expulsion from Eden.

Blake made another set of illustrations to *Comus* for Butts, probably about 1815 (Boston Museum of Fine Arts).[7] The changes in motif are minor and there is no substantial alteration in the iconography, but there is a tremendous gain in grace and elegance and in the sense of atmosphere. In the earlier version of *Comus and his revellers* (ill. 1), Comus' attitude is clumsily Bacchic, and there is little interconnection between the figures. In the Boston version (plate 146) Comus is seen frontally, landing on one foot, while he and the monsters are disposed in procession with balletic elegance. Blake also shows an improved command of anatomy: the torso of Comus in the Huntington version (plate 147) is rather amorphous, the outline is hesitant, the transition from the torso to the right leg is particularly unhappy, and there is little interior modelling of the body; in the later version, although the format is smaller, the drawing is much tighter, the body no longer so dependent on the contour, and the interior forms are now convincingly defined in terms of shadow. The uniform contour gives more sense of the edge of the form, and an even greater change can be seen in the use of light and colour. The woodland setting in the later version pervades the space occupied by the figures instead of being purely a background; in illustration 7 of *Sabrina disenchanting the Lady*, for example, a rainbow is introduced, which arches over the figure of Sabrina, giving a radiant, bejewelled effect to the whole work. The heavily outlined trees in the background of the earlier version are replaced by an undefined but luminous landscape which recedes gently to the sunrise at the back. The softness and variety of emphasis in the contours of the figures are compatible with the elegiac feeling of the landscape. The early *Comus* designs should be seen, by contrast, in the context of Blake's attempt to create a new linear style after the completion of the Butts tempera paintings of 1799–1800.

Blake's next series of Miltonic designs dates from 1807 and consists of twelve small-scale watercolour illustrations of *Paradise Lost* (Huntington Library).[8] In the following year Butts commissioned his own set on a much larger and grander scale; nine of these watercolours are in the Boston Museum of Fine Arts, and single examples are in the Huntington Library, the Houghton Library, Harvard College, and in the Victoria and Albert Museum.[9] While Comus had only rarely attracted the attention of the previous artists, *Paradise Lost* had been illustrated in engraving and painting throughout the eighteenth century, and had been a particular favourite of those artists with whom Blake felt the most affinity.[10] Of these Barry, Fuseli, Romney, Stothard, Westall and Burney had actually painted or engraved series of designs for *Paradise Lost*,[11] and if one takes account of the more popular Sublime subjects like *Satan calling up his legions* or *Satan, Sin and Death*, one can include not only

virtually every English painter of History, but also Hogarth and Sir Thomas Law-rence.[12] The two major History painters who apparently did not paint subjects from *Paradise Lost* in the late eighteenth century were Reynolds and West, who might have been sensitive to the widespread imputation that Milton was, in Dr Johnson's words, a 'surly and acrimonious Republican'.[13] By the early nineteenth century, however, a love of Milton implied little more than conventional liberalism of the kind professed by Hayley; Milton's status as a national poet had by then almost universally transcended political partisanship. For artists of the late eighteenth century Milton provided subjects of the highest seriousness and of a sublimity which challenged the artist to realize the poetic visions in pictorial terms; but it gradually became more common to see *Paradise Lost* as a source of landscape compositions rather than of Sublime drama; the depiction of Satan's revolt recedes in favour of the Garden of Eden, and the earlier books of *Paradise Lost* become less favoured by painters than the later ones.[14]

Because of his passionate concern with the theological issues raised by Milton, Blake often treats unusual subjects in order to reveal Milton's, and his own, view-points; but in the 1807 and 1808 series he also gives attention to the lyrical aspects of Milton's account of the Garden of Eden, and the Satanic episodes are made less dramatic than in, say, the two tempera paintings of *Satan calling up his Legions* (Petworth and Victoria and Albert Museum).[15] In Fuseli's *Milton Gallery* the four paintings of Adam and Eve in Books IV and V are full of foreboding,[16] and Blake's illustrations are, in general, closer to those of gentler spirits like William Hamilton and Burney. But, whereas almost all other illustrators avoid the intricate theological drama of Christ's act of heavenly renunciation in Book III, Blake creates out of it one of his most imaginative conceptions. Nevertheless his treatment of the subjects is to a surprising extent based on conventions familiar from other artists. The fron-tality of *Satan calling up his Legions* and the large scale of the figures in relation to the picture area has a conspicuous precedent in Thomas Lawrence's painting of the same subject, exhibited in the Royal Academy in 1799,[17] and *Adam and Eve and Raphael in the Garden of Eden* (plate 152) is compositionally close to the Westall engraving of the subject.[18] Blake's compositions, however, particularly in the second series, are governed by strong central axes; in the *Expulsion from Eden*, for example, Adam and Eve are led towards the spectator—himself in the world of Experience—by Michael.

The restraining effect of the strong centrality which Blake tended to impose upon his designs after 1800 is also augmented by the 'hard wiry line of rectitude' he had urged so passionately in the *Descriptive Catalogue*. The horror implicit in Milton's account of *Satan and his Legions* is mitigated in both of Blake's watercolours of the subject by the Apollonian beauty of Satan himself and the clear outlines of his minions, who are represented by only seven figures; there is also little sense of the horrific atmosphere of Milton's description of Hell, or Fuseli's depiction of it as a dark, horrid abyss. Blake's insistence upon clarity meant the sacrifice of the expressive possibilities of an 'indefinite' pictorial handling. The problem can be seen in a classic

form in the treatment of *Satan, Sin and Death*, a favourite subject of 'Romantic-classical' painters. Burke had selected Milton's description of Death as a prime example of the way in which the Sublime can be achieved by an indefinite description, arguing that Death is all the more horrifying because one cannot grasp the shape of his form from the description.[19] In Blake's first watercolour of *Satan, Sin and Death* (plate 149) Death appears as an old man, not as a skeletal decaying figure, and Blake has preserved Death's clear contour, conforming to Milton's description by making the figure transparent, so that the gates of Hell show through his body. In the second watercolour of the *Expulsion from Eden* the horrors of Experience, which the unhappy pair are about to enter, are suggested not by an ill-defined foreboding, but by sharp thorns, which cross their way. Blake's insistence on outline does not, however, just serve the cause of expressive clarity; in the remarkable treatment of the arbour beneath which Adam and Eve entertain Raphael in both watercolours of *Adam and Eve and Raphael in the Garden of Eden*, the seats and table are supported by decorative 'Gothic' foliage interwoven with obsessive intricacy.[20]

It would be overstating matters to regard Blake's *Paradise Lost* illustrations (see plates 148–55) as a coherent and detailed critique of Milton's 'errors' in the poem, but there are indications of a personal interpretation and an unusual sensitivity to the meaning behind Milton's text. This can be seen especially in Blake's treatment of the figure of Christ. In *The Creation of Eve* watercolours (see plate 151) the act of creation is carried out not by God the Father but by Christ. For Blake the creation of Eve was a consequence of the mercy of Christ, for Eve was to be a companion to Adam, and as the agent of the Fall caused Him to come to earth to redeem man.[21] As Christ is identified with artistic creation, he is the giver of human form; so the act of human creation is within the power of Christ. Christ's creative role here is also indicative of a shift of emphasis in Blake's watercolours towards increasing the importance of Christ in the story of Man's Redemption, which he felt had been sadly distorted by Milton. If, as he believed, Satan were the hero of *Paradise Lost*, then Blake has attempted to redress the balance in the illustrations in favour of Christ; he is the protagonist in five of the twelve illustrations, and Satan is predominant only in the first illustration, when he calls up his legions, and possibly in the second, at the gate of Hell. Blake's emphasis upon the role of Christ sets his watercolours apart from all earlier illustrations to *Paradise Lost*; Christ was very rarely depicted by other artists. This predominance of Christ has the effect of emphasizing the power of the Divine Mercy at the expense of Satan, who appears not as threatening, but as a pathetic failure, whose attempts to subvert Adam and Eve are provoked by jealousy of their happy state: a notion again implicit in Milton, but given tangible form by Blake.

In *Paradise Lost* Christ casts out the Rebel Angels, but in the watercolours of *The Casting of the Rebel Angels into Hell* Blake depicts Christ not as the ferocious charioted warrior described by Milton, but as the epitome of mildness. His sacrifice is revealed in the remarkable illustration of *Christ's promise of Redemption* (plate 150), which has no precedent in previous art. At the beginning of Book III, God the Father looks down on Satan's journey towards the world, and predicts his ultimate success at

subverting Adam and Eve, unless one of the heavenly company is prepared to die for the sake of man's Redemption. Blake depicts Christ's sacrifice of His place in heaven as an exultant renunciation, contrasting with God the Father, who enfolds Christ's body in a gesture of despair. Milton also contrasts the hidden nature of Jehovah,

fountain of light, thyself invisible
amidst the glorious brightness where thou sitst
Thron'd inaccessible . . .

with the openness of Christ:

Divine Similitude,
in whose conspicuous count'nance, without cloud
made visible, th' Almighty father shines,
whom else no Creature can behold.[22]

For Blake this contrast in physical attitude reflects a dialectic between a tyrant who must be propitiated by sacrifice, and the son who rejoices in self-sacrifice and mercy. Christ's gesture is seen by Blake, therefore, as one of revolt; he takes on the Divine Mercy not as the delegate of God, but in his own right, exposing the empty tyranny of the vengeful Jehovah. Satan, flying through the air beneath the scene in Heaven, seems to pause in dismay at the heavenly sacrifice, and his realization of his inevitable failure gives pathos to his mission.

The rare subject of *The Judgement of Adam and Eve by Christ* (ill. 10) depicts the release by God of Sin and Death upon humanity, and the judgements upon Adam and Eve and Satan. Christ brings the promise of Redemption to mankind and reduces Satan to a serpent, for His judgement is merciful compared to the wrath unleashed by God the Father. In both the Boston and Huntington versions Christ is a hieratic figure occupying the central axis, but in the later watercolour Adam looks directly and lovingly towards Christ, instead of sharing Eve's shame and making a gesture of submission. The meaning of Christ's incarnation is revealed to Adam through Michael's prophecy in the penultimate illustration of *St Michael foretelling the Crucifixion*. Michael reveals how Sin and Death, which were released upon the world at the Fall, will be destroyed through Christ's sacrifice, for in Christ's death is Adam's salvation. Blake shows the Crucified Christ resting upon the bodies of Sin and Death, with the nail in His foot piercing the head of the Serpent, illustrating the passages in Book XII:

naild to the cross . . . he nails thy enemies,
The law that is against thee, and the sins
of all mankind, with him there crucified

and

this act

Shall bruise the head of Satan, crush his strength
defeating Sin and Death, his two main armes,
and fix farr deeper in his head their stings
Then temporal death shall bruise the Victor's heel.[23]

Eve is depicted asleep underneath the cross nestling into the ground, for she

represents in one sense man's material desires, which will be left behind in his Re-
demption. There is little difference in the treatment of the subject between the
Huntington and Boston sets, but in a third version (Fitzwilliam Museum), made for
John Linnell in 1822,[24] the body of Christ emits a powerful radiance and Eve is
shown as wakeful so that she also glimpses man's eternal salvation.

In the watercolours Satan's bleak journey to his ignominious end contrasts strongly
with Milton's depiction of his magnificent and tragic fate. Blake's Satan is a complex
figure, but he is too self-divided to appear threatening. In *Satan calling up his
legions* (ill. 1), especially in the second version (Victoria and Albert Museum), the
myriads of the Satanic army are reduced to a pathetic group of fiends, who represent
not a huge force but forms of Satan's own despair, exposing the hollowness of his
hopes of empire over the universe. In the first version of *Satan, Sin and Death*,
illustration II (Huntington Library), Death is a white-bearded figure but in the
second version (also Huntington, but part of the Boston series), he is a young man,
his stance a mirror image of Satan's, emphasizing their incestuous relationship. In
Christ's Promise of Redemption from Book III, Satan is an uncomfortable witness of
Christ's decision to sacrifice himself for Man, and in the watercolour in the 1807
Huntington series of *Satan's and Raphael's entries into Paradise* (replaced in the
Boston series by *Adam and Eve sleeping*), Satan enters the Garden of Eden enfolded
by the serpent enviously watching the happy pair. Satan's union with the snake be-
comes a kind of demonic parody of that of Adam and Eve, and in *Satan watching
Adam and Eve* (ill. V, Huntington Library, and ill. IV, Boston) (see plate 148),
Satan's bleak embrace with the snake is explicitly contrasted with the tender em-
braces of Adam and Eve as he points enviously towards them. This aspect of Satan is,
of course, present in Milton's text, but the motif of Satan embracing the serpent is
Blake's own, and it serves to emphasize again the essential pathos of Satan rather
than his more forceful qualities. Satan's sexual aspect is particularly evident in the
Temptation and Fall of Eve (ill. 9) (plate 155), for, as in the Butts tempera painting
of the subject, the snake offers Eve the apple from his own mouth.

The alienated sexuality of Adam and Eve in Blake's view is expressed in the delu-
sive nature of the Paradise they inhabit.[25] The bower in which they live is brimful
with the delights of Nature, but that in itself makes it fraught with the danger of
'soft sexual delusions'. The supposed incompleteness of their lives in Paradise is
emphasized particularly in the second series, where Blake has included an illustration
of *Adam and Eve sleeping* (ill. V, Boston only), while Satan in the form of a toad
attempts the seduction of Eve. In *Satan watching Adam and Eve* the pair are united
in an embrace, forming a pyramid with their bodies, which they mutually support;
in their sleep, in *Adam and Eve sleeping*, they become separated, and their separation
is even greater in *Adam and Eve and Raphael in the Garden of Eden* (ill. IV), where
they have become mutually distinct in character, at least in the Boston version (plate
152). In the Huntington version (plate 153) Adam and Eve are seated together at the
opposite side of the bower from Raphael; Adam reacts with interest to the words of
Raphael while Eve looks demure and uncomprehending. In the Boston version,

however, Adam is in the same position, but questions Raphael boldly, while Eve, now standing, acts as handmaiden offering refreshments. Blake has here emphasized the roles of Adam and Eve as representatives of Reason and the Senses, a distinction implied by Milton, who depicts Adam as avid for knowledge of the cosmos and Eve as mentally confined by the requirements of the body. That Blake should have emphasized this distinction is less remarkable than that he should have failed to do so in the first version, for even earlier engravers were aware of it.[26] Furthermore he had also alluded to the idea in a design for Young's *Night Thoughts*, where the poet's reference to Reason and Sense is illustrated by figures of Adam and Eve, even though they are not mentioned specifically in the text.[27]

The division of Adam and Eve in this watercolour implies that the process of the Fall has already begun, for man's fall into division is virtually synonymous with the Fall into Experience. The process may be said to have begun with the *Creation of Eve*, for in Blake's ideology the sexes were in a state of androgyny before the Fall. It is Adam's divided part, that is Eve, which is susceptible to Satan's wiles, for it is in Adam's divided state that Eve is seduced by his serpentine form. In the striking design of *The Temptation and the Fall* (ill. X) Adam is seen in the background, his back to the scene of temptation, but reacting to it in horror, for all nature is caught up in Eve's deed. Lightning flashes and, in the Boston version, the tree exposes thorny roots and surface:

Earth felt the wound, and nature from her seat
sighing through all her works gave signs of woe,
that all was lost,

Adam is shown dropping

from his slack hand the garland wreathed for Eve

. . .

speechless he stood and pale.[28]

In contrast to the *Temptation of Eve*[29] tempera of 1799–1800 (Victoria and Albert Museum) the natural forms respond dramatically to the actions of the participants, giving an unsurpassed tautness to the interaction between design and text. In the second version of *The Judgement of Adam and Eve* (Houghton Library), Adam's gesture and glance towards Christ are hopeful, while Eve buries her head in her hands in shame. They are united finally in their expulsion, for in the final watercolour (ill. XII) they are led out of the Garden of Eden by the bearded warrior-figure of Michael. In the earlier version Adam and Eve look wonderingly towards the flame which hovers over their heads, but in the later version they look downwards in horror at the thorns which lie across their path as they enter the realm of Experience.

The Boston series is in every way more carefully worked out and monumental than the earlier Huntington series. The only major structural change is the replacement of *Satan's and Raphael's entries into Paradise* by *Adam and Eve sleeping*. The effect is to make more coherent the interaction between Satan and Adam and Eve, and reveal Satan's relationship with the snake as part of Adam's and Eve's own thoughts in their progress to the Fall. The rejected illustration is a conflation of

scenes from Book IV, when Satan enters Paradise, and from Book V, when Raphael descends, and it may have been intended to represent the contest between good and evil for the mind of man, and to emphasize Satan's permanent presence in Eden. The divided composition is, however, clearly unsatisfactory and its replacement by a watercolour of Satan's seduction of the mind of Eve, as Ithuriel and Zephon pass over, gives the whole series greater unity. The Boston set can now be seen as organized according to a fourfold division: the first group of three watercolours depicts the revolt of Satan until Christ offers himself in sacrifice; the second, Adam and Eve in Paradise; the third, their division and previous history; and the final group the consequences of the Fall. The later designs are also unified by subtle interrelationships, which can be multiplied endlessly throughout the series: such as Christ's gesture of sacrifice in illustration III, which contrasts with Satan's gesture in calling up his legions, and the transition from the centralized figure of Christ in *The Judgement of Adam and Eve* to his crucified figure in *St Michael foretelling the Crucifixion*. Above all, the Boston *Paradise Lost* series is united by a rhythmic and monumental solemnity which places it amongst Blake's greatest achievements.

Illustrations to Milton's Minor Poems

Despite Blake's failure to interest Hayley in the *Paradise Lost* designs, they were clearly well received by his two patrons, for they were followed, if not immediately, by commissions for further Miltonic illustrations. There are two series of water-colours to Milton's *Hymn on the Morning of Christ's Nativity*; the first, dated 1809 (Whitworth Art Gallery, Manchester) was almost certainly commissioned by the Rev. Joseph Thomas,[1] and the second (Huntington Library) (plate 156), dating from probably about 1816–17, was commissioned by Butts.[2] Each set consists of six illustrations, on a much smaller scale than the monumental second *Paradise Lost* series. They do not differ substantially from each other in iconography or composition, but they are quite different in handling. The Manchester set is strongly linear, with each human form clearly outlined, in accordance with the *Descriptive Catalogue* of the same year; the Huntington series, on the other hand, like the second *Comus* series, is painted in a free and atmospheric technique; the forms are suggested rather than defined, and delicate touches of pure colour abound, giving them a subtle poetry, which cannot be perceived in reproduction.

The structure of the designs, like that of the poem, is circular, beginning with the newborn Christ in the manger, and returning there at nightfall after the destruction of the old gods. The old gods are: the Old Dragon of Revelation, who tremors with his scaly throng underground at the sight of Christ's crib; Paganism, symbolized by *The Shrine of Apollo*, where the spirit is seen departing from an idol in the form of the Apollo Belvedere; and Moloch, the idol who can only be propitiated by human sacrifice, from whom the evil spirit departs as the infant Christ appears at the mouth of the sacrificial furnace.

The first design, *The Descent of Peace*, shows some change between the two ver-sions, both set in a Gothic stable. In the Manchester version the Nativity scene is of the Virgin Mary cradling the Christ Child on her lap watched by Joseph, while two oxen eat from the trough. In the Huntington version, however, Blake returns to the striking motif of the Philadelphia *Nativity* tempera painting (plate III),[3] and shows

the Christ Child leaping from his mother at the moment of birth, while St Elizabeth reaches out to catch him. The first version is closer to the literal sense of the Miltonic text, which begins not with the birth but as 'the Heaven-born child, All meanly wrapt in the rude manger lies'; but the later version expresses more clearly the sense of the dramatic collapse of the old gods at the moment of Christ's birth. In both versions there is a strong Gothic feeling in the shape of the stable, the solemn air of piety, and the haloes around the heads of Joseph and the Virgin Mary, all of which partake of the spirit of early Italian altarpieces. The descending figure of peace is depicted as a personified lark,[4] arms outstretched parallel to the Gothic roof of the stable, awakening from slumber the female figure of Nature, who 'woos the gentle air To hide her guilty front with innocent snow'. In the Huntington version the snow is dappled freely with watercolour and the figure of Nature conveys a sense of wintry awakening.

In the second illustration, the angels appear in the sun, personified by cherubim and seraphim giving off a divine radiance, to the shepherds who look towards it in wonder, their mental captivity symbolized in the Huntington version by Egyptian pyramids in the distance. The stable remains in the distance of both versions, but is barely perceptible in the Huntington watercolour. Blake's vision of the sun follows Milton's description:

At last surrounds their sight
A Globe of circular light,
That with long beams the shame-fac't night array'd,
The helmed Cherubim
and sworded Seraphim
Are seen in glittering ranks with wings displaid,
Harping in loud and solemn quire,
With unexpressive notes to Heav'ns new-born Heir[5]

The design is also full of personal intimations; the sun reveals itself in its true imaginative form on the birth of Christ, and the event is proclaimed in heavenly music; the cherubim throw up their arms in exultation while the seraphim accompany them on musical instruments. The birth of Christ is a visible manifestation of the Divine Spirit to benighted humanity, here represented by the shepherds, who live under the Old Dispensation.

In the third illustration the Old Dragon is seen just below the surface of the earth, accompanied by his cohorts, who start up in alarm at the vision of the stable behind. The Old Dragon is symbolic of false religion in general, and the reptilian and animal-formed fiends who accompany him represent particular false religions interrupted in a grotesque ritual by the sudden awareness of the existence of the stable. In the Huntington version three worshippers who have deserted the Old Dragon appear outside the entrance to the stable, while his tail streams out in stars about it; he,

wroth to see his Kingdom fail,
Swinges the scaly Horror of his folded tail.

The interior of the stable in the Huntington version is a barely defined patch of

luminosity, which draws the eye towards the new light more eloquently than the elaborate drawing of the Manchester version.

The defeat of the Pagan world is expressed in the poem in a brief account of the fall of the Delphic shrine at the advent of the Christ Child. In Blake's watercolours, a statue of Apollo is adored by worshippers, but the shrine is on fire, and as the spirit leaves Apollo's head the cave in which the Oracle sits seems to close in on her. In the Manchester version the statue is an amorphous classical figure holding a snake, but in the Huntington version he follows an eighteenth-century reconstruction of the *Apollo Belvedere*; a snake is entwined around the column behind him, and he carries a bow in his outstretched right arm. Flaxman claimed in his introductory lecture to the Royal Academy of 1810 that the Apollo Belvedere was 'in reality, the Deliverer from Evil' and had been 'both philosophically and popularly considered as a form animated by such a sentiment as might become a supernatural power revealed to mortal sight'.[6] The lecture was delivered between the painting of the two versions of the watercolour, and it might have encouraged Blake to see the Apollo Belvedere as an archetypal pagan idol. In the background of the Manchester version there is apparently a scene of Egyptian idol-worship; dog- and bull-headed monsters are seen flying out from a figure on the ground, and the only reference to Christ's Nativity is the star of Bethlehem in the sky near the falling spirit of Apollo. The composition of *The Shrine of Apollo* is more complex than others in the series, and it reveals a tendency towards compartmentalism, in which several scenes are depicted simultaneously within the same composition, foreshadowing later developments in Blake's art. *Sullen Moloch* completes the expulsion of the old gods. The religion of Moloch is based on human sacrifice, and the illustrations in both versions show a ceremony with figures dancing to timbrels. In a radical departure from Milton's text the parents are apparently in the act of throwing their child into the furnace, but it emerges exultingly from the inferno, suffused with radiance revealing itself as the Christ Child, and causing the spirit to leave the horrific idol.

The series closes with *The Virgin Blest*, in which the Christ Child is seen asleep after his day's work. The scene now reverts to the stable, but this time seen at night, the star of Bethlehem overhead instead of the rising sun. Guardian Angels watch over the scene, the wings of two of them resting symmetrically on the roof like the Cherubim guarding the Ark of the Covenant. The changes between the two versions reflect again the greater intensity of poetic feeling in the Huntington set. In the Manchester version the Child and the Virgin Mary have fallen asleep, but Joseph remains awake and watchful, the whole composition being a gentle counterpart to the opening design, *The Descent of Peace*. In the Huntington version Joseph, Mary and the Christ Child are all shown asleep, but Mary's head rests against the Christ Child's; Joseph, although asleep, leans over them protectively. The sparseness of the background and the originality of the motif make this one of Blake's most beautiful creations, a fitting counterpart to the exultant birth in the *Descent of Peace*.

The Huntington series of illustrations to *On the Morning of Christ's Nativity* apparently belongs to a group of Miltonic illustrations made for Butts, about 1816–17,

which includes also sets of illustrations to *Paradise Regained* and *L'Allegro* and *Il Penseroso*, distinguished by their brilliant quality and careful technique. Almost nothing is known of Blake's activities at that time except that he was extremely poor; he had virtually no engraving work, but his art had reached a new level of accomplishment, perhaps because the frustration of his monumental ambitions forced him to seek a modest scale more congenial to his talents.

The set of twelve illustrations to *Paradise Regained* (Fitzwilliam Museum) (see plates 158, 159) was still in Blake's possession in 1825, when he sold them to John Linnell, so if they were made for Butts he might have refused to buy them.[7] The series as a whole, it must be admitted, lacks the energy of the other Miltonic illustrations, as Rossetti noted in 1862: 'The designs were shown to me by John Linnell as being more than usually beautiful, and I do not directly dissent from the terms used in the slip you send me; only my feeling is that Blake has here been less inspired than usual, and the result comparatively tame.'[8] The reason may lie in the nature of Milton's poem itself, for it must have lacked, for Blake, the ambiguity he found in *Paradise Lost*; he seems to have found little drama in Christ's final struggle with Satan. In the watercolours Satan appears something of a comic figure, whose disguises are more laughable than sinister.

Even so, the *Paradise Regained* watercolours are indicative of Blake's tendency after 1810 towards a greater interest in atmosphere and setting. In a general sense the Miltonic watercolours of *c.* 1816–17 represent both a withdrawal from the doctrinaire linearism of the *Descriptive Catalogue* and a diminution of apocalyptic energy. The intense allegorical relationship between figures and setting in the *Paradise Lost* watercolours has become diffused, and one notes a sensual delight in nature and colour which is quite unexpected from his writings. The wilderness in the background of *Christ tempted by Satan to turn the stone into bread* (plate 158), for example, has no sympathetic suggestion of mental torment, nor is there any tension in the argument between Christ and Satan over spirit and matter. In the *Angels ministering to Christ* Blake adopts a rigidly emblematic style almost decorative in its symmetry but in *Christ's troubled sleep* and *Morning chasing away the phantoms* there are remarkable effects of light and colour; the contrast between the haunted darkness of the former and the radiant sunrise in the latter reflects Christ's mental transformation with great delicacy. *Christ refusing the banquet* (plate 159) reveals also a delightful wit, as Christ turns away in horror from the temptation of gluttony and the ladies of the Hesperides.

The sets of illustrations to *L'Allegro* and *Il Penseroso* (Pierpont Morgan Library)[9] were made about the same time as those to *Paradise Regained*; but their allegorical richness provides a more fitting conclusion to Blake's corpus of Miltonic illustration (see plates 160–64). He has superimposed, upon the two short poems, the story of the spiritual life of Milton, by seeing them as essentially autobiographical. Blake's designs, therefore, chart the course of Milton's artistic inspiration from the descent to earth of his poetic spirit through his youthful works and his struggle with Experience, to resolution in the composition of *Paradise Lost*. The *Allegro* and *Penseroso*

watercolours are each accompanied by an explanation in Blake's own hand, citing the passages which he has illustrated with a brief explanation,[10] presumably for the benefit of Butts, but they would hardly have been explicit enough to help anyone not spiritually in tune with Blake's higher intentions.

L'Allegro and *Il Penseroso* were recognized in Blake's time as early poems;[11] and regarded as poetic meditations contrasting the temperaments of Mirth and Melancholy with appropriate imagery.[12] On the rare occasions they were illustrated, Milton himself is shown in a state either of Mirth or Melancholy, as, for example, in Hayman's engravings, where *Il Penseroso* is visualized in the form of Milton seated in meditation by a pool, visited by the shrouded figure of Melancholy; *L'Allegro*, on the other hand, is represented by Mirth showing to a cheerful Milton the delights of rusticity.[13] The idea of Milton as the central actor in the two poems was therefore not new to Blake, but Milton could not have intended them to be seen as providing a consecutive account of his own poetic life, and such a conception of the two poems is apparently unprecedented before Blake. Blake makes it perfectly clear that Milton himself is to be recognized as the poet. *The Youthful Poet's Dream* (ill. VI), for example, is identified by Blake as that of the young Milton himself, and the image of the moon led astray at the beginning of *Il Penseroso* (ill. VIII) is illustrated by Milton in mortarboard and gown 'in his character of a student at Cambridge'; the watercolour illustrating the hope of Melancholy to achieve old age in a 'peaceful Hermitage', is entitled by Blake 'Milton in his Old Age' (ill. VII). In the watercolours the two tempers preside over Milton's youth and maturity respectively, and they correspond to Blake's states of Innocence and Experience; the reign of Mirth leads to the production of Milton's early poems like *Comus* and *L'Allegro* and *Il Penseroso*, but he needed to pass through the realm of Melancholy before he could produce a true epic like *Paradise Lost*.

The *L'Allegro* watercolours begin with a personification of Mirth, accompanied by humanized 'Quips and Cranks & wanton wiles, Nods & becks & wreathed smiles' and the rest of her company. Blake's laborious depiction of each personification is reminiscent of Fuseli's painting of the same subject in the *Milton Gallery*[14] (Heidelberg, Kurpfälzisches Museum), but the scene is more light-hearted in Blake's version. Mirth's domain is the diurnal world and in a unique state of an engraving of the subject, probably of a later date,[15] a sunlit radiance breaks out behind her. In the second illustration, entitled by Blake *The Lark*, a lark depicted, according to the manuscript commentary, as 'an angel on the Wing' casts out 'Dull Night' from his watch-tower, as dawn starts up with her horses, and awakes the female figure of Earth. The motif of the angel waking the Earth is borrowed most immediately from the *Descent of Peace* in the *On the Morning of Christ's Nativity* watercolours, but here the Lark portends not Christ but Los, whose messenger she is: 'the Lark's Nest is at the Gate of Los, at the eastern/Gate of wide Golgonooza, & the Lark is Los's Messenger.'[16] The startled figure of Dull Night is Urizenic, and suggests the flight of reason in the face of the portent of prophecy. In the third illustration, *The Sun at his Eastern Gate* (plate 160), we see 'The Great Sun . . . represented clothed in

Flames Surrounded by the Clouds in their Liveries'. This Apollonian personification of the sun is an allegory of the Poetic Spirit who descends from heaven to earth. Milton himself is depicted beneath 'walking by Elms on Hillocks green', so we are witnessing not the physical birth of Milton, but the birth in him of poetry, which arises in the first instance from meditation upon nature. Illustration IV, *A Sunshine Holiday*, shows a peaceful village with youth dancing around the maypole, while all the generations are in attendance. The scene is suggestive of Innocence, and recalls the *Ecchoing Green* from *Songs of Innocence*, but Blake gives a personified form to the vegetation and mountains in the background because 'Mountain Clouds Rivers Trees appear Humanised on the Sunshine Holiday'. Blake creates through the personifications a cycle of fecundity which passes through all the elements of nature; the clouds give off water like a mother producing milk, in order to create the river, while the insects and birds and the tree itself are shown in their mutual inter-dependence. The vision of Innocence is conjoined with the Divine Vision in which natural forms are seen in their humanized or 'real' form. Music is present in the form of a fiddler and a fledgling shepherd playing a pipe, who might represent the youthful spirit of Milton making his first attempts at artistic creation.

If *A Sunshine Holiday* represents childhood, then the following illustration, *The Goblin*, may represent the trials of adolescence.[17] The gigantic figure is put to flight by the rising sun, according to the story of the Goblin and Queen Mab told by 'he' and 'she' at the inn; 'she' recounts her torments at the mercy of 'The Sports of the Fairies' depicted in the left-hand corner, while 'he' is led off towards the convent. The meaning of the episode is not quite clear, but the convent may suggest the con-straints of institutional religion upon Milton's poetic spirit, which are foiled by the arrival of a new day putting the Satanic Goblin to flight. The torments of adoles-cence would, therefore, lead into the intense creativity of early manhood, and in *The Youthful Poet's Dream* (plate 161) the young Milton is seen stretched out on a river bank, writing in a book to the dictate of an enormous personified sun which is, according to Blake's commentary, 'the more bright Sun of Imagination'. Blake has placed within the sun the subject of the poet's dream:

> *There let Hymen oft appear*
> *In saffron robe with Taper clear*
> *And pomp and feast of revelry*
> *With mask and antique Pageantry.*

On one side of it is the learned Ben Jonson with pen and book, and on the other Shakespeare with a set of pipes warbling 'his native wood notes wild'. Blake has transformed Milton's account of the delightful reverie of a youthful poet into an analysis of Milton's early poetic imagination. The young poet is truly inspired be-cause he works at the dictate of 'the Sun of Imagination', but as the scene of Hymen at a marriage and the 'antique pageantry' make clear, his vision is dominated by classical antiquity. The Sun of Imagination under the joint auspices of the 'learned' Jonson and 'Fancy's child' Shakespeare, expresses the tension in Milton's early poetry between learning and lyrical fancy. The enclosing trees at the top suggest the

limits of Milton's youthful vision, and the three figures above the stream, presumably the 'native wood notes wild', apparently show signs of distress.[18] The lyricism and classical learning which characterize the early poetry are, Blake appears to argue, produced by an imagination which has not yet confronted Experience, but remains under the domination of Euphrosyne alone. *The Youthful Poet's Dream* is the point of nemesis for the dominion of Mirth, and Milton's dream heralds the transition into maturity of Experience.[19]

The domain of Experience is introduced in the next illustration by 'the pensive Nun' Melancholy, who is, like Mirth, surrounded by the personifications who accompany her in the opening lines of *Il Penseroso*. In the next plate, *The Wandering Moon* (plate 162), Milton is seen, according to Blake's commentary, 'in his character of a Student at Cambridge' looking at the 'Moon terrified as one led astray'. Blake, then, supposes Milton's early poems to have been preceded by his induction into learning at Cambridge, which, Blake implies, destroyed his innocence by leading him into a world of abstract speculation. The moon is associated by Blake with the state of Beulah,[20] where Doubt may stalk those who pursue learning for its own sake. In his state of Doubt Milton is visited by *The Spirit of Plato* (plate 163) in the form of a Urizenic old man, who leads him into the labyrinths of platonic philosophy, which Blake renders by a brilliant pictorial interpretation of the role of the Elements in the Platonic system.[21]

Milton's immersion in 'false' philosophy incurs the wrath of the Prophetic Spirit and in the following illustration, *The Sun in His Wrath*, he enters a dark wood, led by the nun Melancholy, while the Sun God fires darts of anger at him. Milton's entry into the dark wood, led by Melancholy, signifies the abandonment of his muse, and perhaps Blake intends to refer here to Milton's involvement in religious controversy; the book he carries might represent the prose pamphlets he wrote in defence of Cromwell. The trees and insects which settle on them are sinisterly personified, and Blake comments: 'The Spirits of the Trees on each side are seen under the domination of Insects raised by the Sun's heat.' The penultimate illustration, *A Mysterious Dream*, shows Milton asleep by a river-bank again, his sleep suggesting transition to another state of being. Milton's poetic image of 'dewy-feathered sleep' is rendered by an angel ascending and enfolding the form of the sleeping Milton; he brings with him 'scrolls & Nets & Webs', unfolded by spirits, whilst 'around Milton are Six Spirits or Fairies, hovering on the air, with Instruments of Music'. The unfolding of the scrolls suggests removal of mental shackles from Milton, and the music-playing spirits symbolize the awakening in him of artistic inspiration after his sojourn in Experience. The final illustration, *Milton in Old Age* (plate 164), is exultant, and we see the aged poet looking up to the signs of the Zodiac in the heavens, his arms outstretched as he receives the Divine Vision, which he apparently transfers to a large book beside him, which must represent *Paradise Lost*. The aged Milton is depicted not blind but seeing plainly into the Eternal World, as 'he bursts forth into a rapturous Prophetic Strain'. Nature spirits burst out of the ground and embrace each other, while Milton observes the constellation with

his spiritual eye. He has now found inspiration within himself, and not in other poets or in nature as he had in his youth.

In *Milton a Poem* Blake had identified his own mature inspiration as a process of taking on the mantle of Milton. In a sense the account of Milton in the *Allegro-Penseroso* could also be applied to Blake, and it would equate his own mature epics, *Milton a Poem* and *Jerusalem*, with *Paradise Lost* as works in which the tribulations of the artist in This World were finally resolved in epic form. Milton's seduction by Platonism and abstract learning were as vital for him as Blake's despair at the reactions of his critics. The artistic fruits of maturity therefore transcended the achievements of youth; Milton had 'returned back to God whom he had had in his childhood',[22] but at a deeper level of understanding, for by sinning himself he could now understand the meaning of forgiveness of sin.

As so often in Blake's art, one is led back to the predicament of the artist himself, and in this case to the fact that at the same time he was also engaged upon his final epic, *Jerusalem*. The radiant set of watercolours to *L'Allegro* and *Il Penseroso* can be enjoyed as superlative illustrations of the Miltonic text, and a cogent commentary upon Milton's poetic career, but in the profoundest sense they are about Blake's own artistic problems; they are in a covert sense a justification for the epic form of *Jerusalem* as the only fit expression of a prophetic artist who has transcended the neglect and contempt of the world.

SECTION SEVEN

The End of the Pilgrimage

CHAPTER TWENTY-THREE

The New Public

For nearly the whole decade, from the failure of the 1809 Exhibition onwards, Blake attracted very little attention, but in 1818 he began gradually to emerge from obscurity as a tutelary spirit to a small group of 'Young Men of the New Age'.[1] The generation which came to maturity in the early 1820s had in a sense begun to catch up philosophically with Blake's anti-materialism; his devotion to the spirit was by the 1820s more likely than hitherto to be taken as evidence of artistic integrity and not of unbalance. The attention he received from the older Romantics like Coleridge, Hazlitt and Wordsworth[2] was usually tinged with a certain condescension, but for young men of Platonic leanings like the landscape painters John Linnell and Samuel Palmer, his moral appeal was unequivocal. It was by no means coincidental that the only person outside Blake's circle to have expressed appreciation of the *Descriptive Catalogue* when it came out was the Germanophile Henry Crabb Robinson, for it was largely through the influence of German idealism, both directly and indirectly, that Blake achieved a small reputation amongst acquaintances of Coleridge. Nor should it be unexpected that he was taken particularly seriously in the home of Charles (Carl) Aders, a German merchant and collector of pre-Renaissance art.[3]

Aders and his wife had an important collection of paintings and prints by early Northern masters, including a copy of a wing of Van Eyck's *Ghent Altarpiece*,[4] and they regarded Blake as the modern representative of their 'Primitive' spirit. Crabb Robinson describes an occasion in 1825 when he met Blake at the Aders' house:

> He [Blake] was shown soon after he entered the room some compositions of Mrs. Aders, which he cordially praised. And he brought with him an engraving of his Canterbury Pilgrims for Aders One of the figures resembled one in one of Aders' pictures They say I stole it from this picture, but I did it 20 years before I knew of the picture—however in my youth I was always studying this kind of paintings. No wonder there is a resemblance.[5]

The Aders circle was perhaps the most important conduit into England for German Romantic ideas in the early 1820s and Blake was able to meet Crabb Robinson for

the first time, and almost certainly Coleridge, himself an early sympathizer with 'German philosophy'. Aders had known the Schlegels,[6] and his collection of early Northern art was of the kind favoured by such pioneers of the taste for 'Primitives' as the Boisserée brothers.[7]

Blake appears in the voluminous reminiscences of his later acquaintances not as a fiery prophetic figure, but as genial, friendly and paternal. After the completion of *Jerusalem* he no longer sought public commissions, nor railed against those who had neglected him, and in 1822 he accepted a small gratuity from the Royal Academy, offered through the influence of John Linnell.[8] To judge by the diary of Crabb Robinson and the reminiscences of Linnell, Palmer and others in his circle, gathered so assiduously by Gilchrist many years after Blake's death, Blake's last years were marked by personal serenity, a delight in the simpler things of the world, and cheerful acceptance of death. Linnell found work for Blake, usually designing rather than reproductive engraving, and he acted as publisher of the engravings to *The Book of Job* and to *Dante*. Linnell even found customers for the Illuminated Books, and he commissioned from Blake a magnificent coloured set of his own.[9]

Soon after Linnell met Blake he probably introduced him to his former master, the landscape watercolourist John Varley, for whom Blake made what are known as the 'Visionary Heads' in 1819. This episode was made much of by Victorian commentators, for it would confirm an impression of Blake as a naive enthusiast who believed he could conjure up spirits of the dead. In fact it seems to have been a kind of parlour game, commemorated in the now dismembered *Blake-Varley Sketchbook*, in which, at the instigation of Varley, Blake drew historical figures whose spirits he called up.[10] It seems clear that Blake did not take the exercise seriously, and Linnell reports that 'Varley believed in the reality of Blake's visions more than even Blake himself'.[11] Many of the Visionary Heads are, however, of great charm, and there is a delightful note of 'Gothick' whimsy in the drawings of the Empress Maud in a Strawberry Hill-type chapel (page 23), and lying in a Gothic canopied bed (page 25). The 'Ghost of a Flea' also appears in the *Sketchbook* (plate 165), and was later used as the basis of a tempera painting commissioned by Varley (Tate Gallery).[12] Linnell was also instrumental in widening Blake's acquaintance with other artists, often with decisive results for them. Samuel Palmer was brought round perhaps as late as 1824,[13] and Edward Calvert and George Richmond became spiritual disciples. Despite their personal devotion to Blake and their admiration for his spiritual authority, 'the Ancients', as they called themselves, were not really followers of Blake in the artistic sense. Linnell and Palmer were essentially landscape painters, for whom the human figure was a secondary means of expression, although Richmond made a number of figure compositions in a Blakean manner.

Crabb Robinson describes Blake in later years as talking with two voices: 'In this he seemed to explain *humanly* what he had done—but he at another time spoke of his paintings as being what he had seen in his visions—and when he said *my visions* it was in the ordinary unemphatic tone in which we speak of trivial matters that everyone understands & cares nothing about.'[14] While the world of the spirit

remained a reality for Blake, there are glimpses of an unforced delight in Nature, and even landscape painting. Palmer, for example, records Blake's sensitive appreciation of Claude:

Among spurious old pictures, he had met with many 'Claudes', but spoke of a few which he had seen really untouched and unscrubbed, with the greatest delight; and mentioned, as a peculiar charm, that in these, when minutely examined, there were, upon the focal lights of the foliage, small specks of pure white which made them appear to be glittering with dew which the morning sun had not yet dried up. His description of these genuine Claudes, I shall never forget. He warmed with his subject, and it continued through an evening walk. The sun was set; but Blake's Claudes made sunshine in that shady place.[15]

Blake was also in his last years on friendly terms with John Constable.[16] He had not, however, recanted his previous convictions; Crabb Robinson was baffled and finally exasperated by the fact that Blake's lucidity on most matters was not carried through to metaphysics: 'Among the unintelligible sentim[ent]s which he was continually expressing is his distinction between the natural and the spiritual world—the natural world must be consumed—.' After three visits Crabb Robinson became bored with Blake's repetitiousness: 'The same half crazy crotchets abot. the two worlds— the eternal repetition of which must in time become tiresome—Again he repeated today—I fear Wordsworth loves Nature—and Nature is the work of the Devil—The Devil is in us as far as we are Nature.'[17] The 'Sybilline Leaves', which Blake issued probably in the 1820s, *On Homer's Poetry and On Virgil* and the *Laocoön* engraving, are more uncompromising than ever in their equation of art with true religion:

You must leave Fathers & Mothers & Houses & Lands if they stand in the way of Art. Prayer is the study of Art. Praise is the Practice of Art. Fasting etc. all relate to Art. The outward Ceremony is Antichrist.[18]

While Blake does not add much in substance to the opinions expressed in the *Descriptive Catalogue*, he emphasizes more thoroughly the destructive nature of the Classics, and now sees Classical and Gothic art as opposite poles:

Grecian is Mathematic Form: Gothic is living form, Mathematic Form is Eternal in the Reasoning Memory: Living Form is Eternal Existence.[19]

Blake's increasing consciousness of the Gothic, in its widest sense, in the 1820s is well documented by Samuel Palmer in particular: 'Everything connected with Gothic Art and churches, and their builders was a Passion with him.'[20] Palmer also claimed that 'he fervently loved the early Christian art, and dwelt with peculiar affection on the memory of Fra Angelico, often speaking of him as an inspired inventor and as a Saint'.[21] But Blake also saw Raphael and Michelangelo as 'Gothic' artists and he regarded even the Raphael school as a kind of monastic endeavour: 'He delighted to think of Raphael, Giulio Romano, Polidoro, and others, working together in the chambers of the Vatican, engaged, without jealousy, as he imagined, in the carrying out of one great common object; and he used to compare it (without any intentional irreverence) to the co-labourers of the holy Apostles.' The recollections of Blake by Palmer and Linnell should, however, be treated with caution, for after his death

their strong religious convictions occasioned a retrospective embarrassment at the heretical or revolutionary implications of his thoughts. Palmer's fervent High Anglicanism and reactionary political attitudes led him to ignore as far as possible Blake's unorthodoxy, but Linnell was more candid about it: 'with all the admiration for Blake it must be confessed that he said many things tending to the corruption of Xtian morals—even when unprovoked by controversy and when opposed by the superstitious, the crafty or the proud he outraged all common sense and rationality by the opinions he advanced, occasionally even indulging in the support of the most lax interpretations of the precepts of the scripture'.[22]

In 1819 Linnell also introduced Blake to Dr Robert John Thornton, who was about to publish an illustrated school edition of Virgil. He commissioned Blake to make a number of woodcuts to illustrate the Ambrose Philips translation of the *Eclogues*, of which seventeen were published, and three others were re-engraved by other hands, but Thornton was disappointed with the results (see plate 165).[23] It was only apparently because he heard a number of artists at Aders' house expressing admiration for them that most of them were saved for publication, but they were introduced by an apology from Thornton: 'The Illustrations of this English Pastoral are by the famous BLAKE, the illustrator of Young's *Night Thoughts*, and Blair's *Grave*; who designed and engraved them himself. This is mentioned as they display less of art than genius, and are much admired by some eminent painters.'[24]

These tiny woodcuts are unusual in Blake's oeuvre not only in their medium and their landscape subjects, but because of their power of poetic suggestion. Samuel Palmer described their 'mystic and dreamy glimmer' and he interpreted them essentially as Platonic visions of Paradise: 'They are visions of little dells, and nooks, and corners of Paradise; models of the exquisitest pitch of intense poetry.'[25] But Palmer underestimated, perhaps, the seriousness with which Blake took the dialogue between Colinet and Thenot in Philips' version of the *Eclogues*. Thus Blake is particularly sensitive to the implications of artistic crisis in Colinet's melancholy, and in the Frontispiece Colinet is shown to have hung his pipe and reeds upon a tree. Colinet's refusal to take the advice of the aged Thenot to enjoy the fruits of the pastoral world leads him into a journey of Experience, through which he passes before taking up his pipe and his flock again. Thus in the second woodcut Thenot remonstrates with Colinet, offering him worldly delights much as Satan tempts Christ in the Wilderness in the *Paradise Regained* watercolours. In his despair he departs the pastoral life, and his entry into the other world is symbolized by plate VI, which contains no human figures or animals, and as a pure landscape would seem to correspond most closely to Palmer's 'visions of little dells, and nooks, and corners of Paradise'. In fact, the scene is one of destruction and foreboding:

> Sure thou in hapless time wast born,
> When blightning mildews spoil the rising corn,
> Or when the moon, by wizard charm'd, foreshows,
> Blood-stain'd in foul eclipse, impending woes.

Colinet eventually returns to the pastoral world he has left, chastened by the woes

and mockery he has endured in the world; but he now takes up his pipe and is proof against the blandishments of Thenot. Blake's version of the pastoral world is, therefore, not a wholly approving one; it is, like nature herself, a transitory state in which man lingers at his peril. It may have the attributes of Paradise, but a conventional one, not Blake's more exalted understanding of the highest state of spiritual existence. Palmer in his description of the woodcuts has imposed upon them a mood alien to Blake's intentions, but closely allied to his own vision of landscape. In plate VI the moon is a portent of impending woes, while in Palmer's own landscapes it presides benignly over the 'Valley of Vision'. For Palmer nature gave intimations of the higher Platonic reality, which is the goal of all true art.[26] For Palmer, as for Wordsworth and Blake's German contemporaries, nature provided a way to the apprehension of the Divine; but for a man like Blake, with intellectual roots in the seventeenth and eighteenth centuries, nature was equivocal and tainted by the Fall. On the other hand there is some visual truth in Palmer's commentary upon the woodcuts; whatever Blake's higher intentions may have been, the woodcuts suggest a delight in twilight effects, and a sense of a harmony between man and nature compatible with Blake's profound sensitivity to the paintings of Claude and earlier landscape painters.

Blake's essentially eighteenth-century artistic sensibility can also be demonstrated in other ways. Palmer remembered 'the quiet hours passed with him in the examination of antique gems, choice pictures and Italian prints of the sixteenth century' and Blake's admiration for Dürer was still tempered by his classical training:

> No man more admired Albert Dürer; yet, after looking over a number of his designs, he would become a little angry with some of the draperies, as not governed by the forms of the limbs, nor assisting to express their action; contrasting them in this respect with the draped antique, in which it was hard to tell whether he was more delighted with the general design, or with the exquisite finish and the depth of the chiselling; in works of the highest class, no mere adjuncts, but the last development of the design itself.'[27]

Blake still insisted on the classical precept that drapery should reveal and follow the form of the limbs; his drapery remains translucent, acting as a veil over the human form rather than a covering. Amongst his contemporaries he retained the greatest admiration for Flaxman, who had pre-eminently brought antique style into the service of Christian art: 'When Michael Angelo or Raphael or Mr. Flaxman does any of his fine things he does them in the spirit.'[28]

A difference of generation accounts, therefore, for Blake's distance from the controversies which raged around the Royal Academy in the 1820s. One might have expected Blake to side with Benjamin Robert Haydon in his battle against the Royal Academy, for both aspired to redeem the Great Style; but in fact their attitudes towards History painting were quite different. Haydon regarded the empirical study of the human body as essential for the revival of art; ideal form needed to be wedded to objective truth. For Haydon the arrival of the Elgin marbles in England in 1808 was a personal revelation, which would provide the means for the art of painting to

rise again. The marbles were for him proof that the ancient Greeks achieved ideal form and had expressed it through exact observation; he marvelled not only at their grandeur but at the precision of the rendering of the veins in the arm.[29] Blake, however, was less enthusiastic, and did not place the Elgin Marbles in the highest class: 'Thus he thought with Fuseli and Flaxman that the Elgin Theseus, however full of antique savour, could not, as ideal form, rank with the very finest relics of antiquity.'[30] Blake remained loyal to the Vatican marbles; the 'Theseus', however beautiful, could not surpass the Apollo Belvedere.

One further example underlines the difference of generations. Haydon describes how Benjamin West, on being confronted with the Elgin Marbles, did not pore over them in wonder, but sat at a distance to capture their general effect, in order to incorporate attitudes and motifs into his pictures.[31] West, in other words, 'borrowed' from them. Samuel Palmer by contrast ran into difficulty with his teachers at the Royal Academy for drawing an antique cast by copying the surface laboriously inch by inch, without regard to the attitude of the figure.[32] Blake would have denied being a 'generalizer', but his concern would also have been to think first of capturing the attitude of a figure, rather than exploring its surface. Blake's devotion to the spirit and his imagination inspired the deepest respect of his younger friends, but his art must have looked a little old-fashioned to them. Palmer never doubted that Blake was 'The Maker, the Inventor, one of the few in any age', but despite the intensely visionary quality of his landscape paintings he felt strongly the pull of nature against the demands of Vision: 'While I am drawing from Nature vision seems foolishness to me—the arms of an old rotten tree trunk more curious than the arms of Buonarotis Moses—Venus de Medicis finer than the "Night" of Lorenzo's tomb & Jacob Ruysdael a sweeter finisher than William Blake.'[33]

The Book of Job

The year 1821 saw the publication of the book containing the *Thornton's Virgil* woodcuts (see plate 166), but it was also productive in other respects. The date is inscribed upon the remarkable *Arlington Court Picture* (Arlington Court, Devon) (plate 167), a highly finished and elaborate watercolour found in mysterious circumstances in 1947 in the Chichester family house.[1] The house was built for and remained in the possession of the Chichester family, but there is no record of any association, however remote, between Blake and the Chichesters. The first owner of the painting was probably Colonel John Palmer Chichester, a Member of Parliament, but why and how he acquired it is not known.[2] It was framed by John Linnell's father, which would suggest Linnell as the intermediary, but the preliminary drawing for the picture belonged to John Flaxman (Pierpont Morgan Library).[3] There is a remote possibility that the painting might be identifiable with the otherwise unknown picture mentioned by Samuel Palmer in a letter to Gilchrist: 'He delighted in Ovid, and, as a labour of love, has executed a finished picture from the *Metamorphoses*, after Giulio Romano. This design hung in his room.'[4] This statement is extremely puzzling and the painting in no way resembles any of Giulio Romano's *Metamorphoses* designs but Palmer could have been thinking of engravings after parts of Giulio Romano's frescoes in the Sala di Psiche in the Palazzo del Tè in Mantua.[5] It seems unlikely that Blake would have copied faithfully a Giulio Romano, but there is nothing further to connect the frescoes with the *Arlington Court Picture*.

The picture itself is of very high quality, and although the subject is not identified there can be little doubt that it is derived from the *Odyssey* and that the principal figure, picked out strongly in red and apparently characterized as a 'wily Greek', is Ulysses himself.[6] The pointing figure next to him must, therefore, be Athene and the woman in the water Leucothea receiving her girdle, thus, as Miss Raine points out, conflating the two landings on Phaeacia (Book V) and Ithaca (Book XIII).

Ulysses appears to be about to dive into the water, but Athene seems to be calling him back by revealing to him a vision of a sleeping Helios in a chariot about to be engulfed by flames. Athene also points down towards the ground, like Satan in illustration 2 of the *Paradise Regained* designs.[7] It is possible, therefore, that Athene is offering Ulysses a material vision of the universe based upon Greek myth, and signs of distress at his dilemma are registered upon the faces of the Fates in the water and the spinners on the steps. Ulysses, by taking the way of Athene, returns to Ithaca, which in the spiritual sense would mean a return to Greek religion and paganism and, therefore, a rejection of the Divine Vision. Whatever explanation may be offered of the puzzling central group, there is no reason to doubt Blake's hostility, particularly in his later years, to Greek philosophy. On one of the Dante watercolours he drew a map of the classical conception of the universe with Homer in the centre of the circle, and inscribed it as follows: 'Round Purgatory is Paradise, & round Paradise is Vacuum or Limbo, so that Homer is the Center of All—I mean the Poetry of the Heathen, Stolen and Perverted from the Bible, not by chance but by design, by the kings of Persia & their Generals, The Greek Heroes & lastly by the Romans.'[8]

As a representation of a classical subject the *Arlington Court Picture* is not unique in Blake's oeuvre; he painted for Butts finished watercolours of *The Judgement of Paris* (British Museum)[9] in 1811 (or possibly 1817) and *Philoctetes and Neoptolemus on Lemnos* (Fogg Museum) in 1812. The *Arlington Court Picture*, however, seems to have less in common with these than with the *Spirit of Plato* illustration for *Il Penseroso* (plate 163), in which an account of the Platonic system is given in visual form to tempt the melancholic Milton.[10] Blake may have intended something similar here, for the presence of Helios, Athene and the Fates suggests that he was proffering an oblique criticism of the Homeric universe, but it is also clear that the last word has not been said upon this fascinating picture.

In 1821 a set of 21 watercolour illustrations to *The Book of Job* (Pierpont Morgan Library), made by Blake for Thomas Butts probably in 1805–10,[11] were seen for the first time and admired by Linnell. The other surviving set[12] of *Job* watercolours (Fogg Museum etc.) is known to have been made in 1821, for Linnell began tracing outlines from 'Mr. Blake's designs for Job all day' on 8 September 1821, continued with the task on 10 September and on the same day Blake himself finished the outlines.[13] Most of this set in the Fogg Museum show signs of tracing, but the later ones in the series have a freedom of handling which suggests that they are entirely drawn by Blake, and the colouring throughout seems also to have been added by Blake. Linnell and Blake worked from the earlier set of watercolours owned by Butts, who presumably lent them back to Blake for copying. Linnell's admiration for the *Job* watercolours was combined with a belief in their commercial possibilities, and in March 1823 Blake and Linnell made a formal agreement for Blake to engrave the designs and for Linnell to publish them.[14] The next stage was for Blake to produce a series of reduced drawings (Fitzwilliam Museum),[15] in which he made a few indications of borders, but the elaborate borders of the final prints evolved during the

process of engraving.[16] The twenty-one engravings, with the addition of a title-page, have a publication date of 8 March 1825, but probably did not appear until the following year.

The Fitzwilliam Museum set of reduced drawings contains an additional design, an alternative design for *Every Man gave him a piece of money*,[17] which exists in two other versions, but the watercolour sets and the engravings are identical in the distribution of subjects. The one major change in the treatment of an individual subject comes in plate 20, *Job and his daughters*; in the Pierpont Morgan Library version the scenes to which Job is pointing float in the sky like cloud-forms, but in the final version Job and his daughters are in an enclosed room, the visions painted or sculpted on the wall, thus reverting approximately to the scheme of the Butts tempera version of *c*. 1799–1800 (Rosenwald Collection). The repetitions of the *Book of Job* designs and the need to produce highly finished engravings for the market enabled Blake to refine his conception over several years and to eliminate the hesitation which can be seen in some of the Pierpont Morgan Library watercolours. The precise occasion of the commission for the *Job* watercolours is unknown,[18] but Blake had been interested in the story from his early years. In two early engravings[19] Job is paired with Ezekiel as men of Divine knowledge set apart and misunderstood by their fellows, and other early drawings may also represent episodes from the life of Job.[20] Blake may well have been aware of earlier engraved series on the life of Job, especially that by Heemskerk, although there is little resemblance between the two series.[21]

The crux of Blake's interpretation of the Book of Job is that the eternal drama of the Fall and Redemption is acted out within the mind of Job himself: the physical action of the book, the destruction of his children, crops etc., reflect his own mental processes, by which ultimately, after much travail, he perceives the falseness of his former obedience to Jehovah. Thus the life of Job parallels the transition from the Old to the New Dispensation; from Hebraic legalism to salvation in Christ. Job's journey of Redemption parallels that of Albion, for his initial complacency in his prosperity is a kind of spiritual sleep. In the Biblical account Job's punishment seems arbitrary and a cruel test of his faith in God, but Blake implicitly argues in the designs that Job's latter end is not a return to former prosperity but a new beginning in renunciation of his former state. Job's fall into spiritual complacency is symbolized in the first plate, *Thus did Job continually* (plate 168), by the external forms of religion. Job's way of life is outwardly one of content and harmony; he is depicted as a benign *paterfamilias*, presiding over a pious and attentive family, amidst every sign of pastoral felicity: spreading oak, a multitude of sheep and busy shepherds. But this prosperity is essentially a material one and is achieved at the expense of the spirit. In sinister fashion musical instruments, as in the Butts watercolour of the *Babylonish Captivity* (Fogg Museum), are hung on the tree which shades the family, revealing a denial of art, which is a denial of the spirit. Job's wife and children kneel in attitudes of prayer redolent of conventional piety; guided not by the Holy Spirit, but by the books resting on the knees of Job and his wife. According to the borders of the engraved version they are reciting the Lord's Prayer: 'Our Father which art in

O

Heaven hallowed be thy Name', but the true nature of their prayer is made clear by an inscription on an altar in the border beneath the scene:

The Letter Killeth

The Spirit giveth Life

It is Spiritually Discerned.[22]

Job has bound himself to the letter of the Moral Law rather than to its spirit; he has lost contact with his own humanity and is teaching his children to follow him. Other symbols also contribute to the imagery of spiritual complacency: the sheep in the foreground are asleep and the Gothic church in the background evidently stands here for institutional religion.

The spiritual void in which Job lives brings about a Fall, and it can be contrasted with the final illustration, in which the same scene is re-enacted after Job's realization of his error. The family now stand up, praising the Lord exultantly in song and accompanying themselves with the musical instruments taken down from the tree. The church has disappeared; the sheep in the foreground are now awake, and the sun and moon have changed positions. Job and his family no longer recite the Lord's Prayer thoughtlessly but praise God with all their hearts: 'Great & Marvellous are thy Works Lord God Almighty Just and true are thy Ways O thou King of Saints.' After passing through despair and spiritual torment, Job has reached the state of Eden, where, rather than accepting bounty passively, he praises God actively through art.

Job's road to salvation is the same as that trodden by Albion; he enters the state of despair and self-division, until by the mercy of Christ he is shown the error of his ways and in self-knowledge finds his way to Eden. His division is expressed in his separation from his wife and children, who are reunited with him at the end. Like other men of Biblical and pre-Christian times Job believes in the righteousness of Jehovah despite the punishment inflicted upon him, and it is the mercy of Christ which enables him to see Jehovah as the Avenger of Sin and to achieve Redemption. Although 'just and upright', he lives in darkness until he sees the light of Christ, who appears to him as the visions of the Messiah appeared to the prophets of the Old Testament. His spiritual journey is depicted according to his relationship with Jehovah and with Christ, who are in essence different conceptions of the Godhead and who are made identical in appearance to Job himself, for they are, as he comes to realize, also aspects of himself.[23] The visual identity of the three major participants in the drama is the key to Job's Fall and Redemption, for the turning point comes when he recognizes that Jehovah himself can be Satanic.

This moment is depicted in plate 11, 'With Dreams upon my bed thou fearest me & affrightest me with Visions' (plate 169). Job is seen on his bed tormented with flames by demons, as Jehovah appears to him. But Jehovah reveals a cloven hoof, is encoiled by a gigantic mortal worm, and points to the Tablets of the Law. Job now realizes that his tormentor is not the true God but Satan, who 'himself is transformed into an Angel of Light & his Ministers into Ministers of Righteousness'. He now affirms his faith in the true Redeemer; 'destroy thou This body yet in my flesh shall

I see God whom I shall see for Myself and mine eyes shall behold & not Another tho consumed be my wrought Image Who opposeth & exalteth himself above all that is called God or is Worshipped.' To reach this revelation, Job has passed through the torments of Experience, still in thrall to the God of this World, who in plate 2 responds favourably to Satanic entreaties. Job exposes himself to torment because he attempts to appease the Lord through propitiatory gestures: in plate 5, for example, he is seen giving bread to an aged beggar, again the image of himself, and the conventionality of the gesture is confirmed by the two Flaxmanesque haloed angels who, their hands raised in approbation, hover on either side of the group. He still believes that he has displeased Jehovah by his lack of righteousness, but the Druidic trilithon in the background shows him to be in Error, in a land of false gods.

If Jehovah and Satan dominate the Fallen existence of Job, then Christ presides over his Redemption. Job's recognition of the true nature of Jehovah in plate 11 is confirmed in the following plates, when it is explained to him by the young Elihu that his punishment has been necessary for him to see the light: 'Lo all these things worketh God oftentimes with Man to bring back his Soul from the pit to be enlightened with the light of the living.' At the bottom of the plate there is a vignette of Job's dream in which the mental covering is removed from him by a swarm of tiny spirit forms, just as the net is removed from the sleeping Milton in the penultimate watercolour of the *Allegro-Penseroso* series. The young Elihu, as his gestures indicate, is a John the Baptist figure, heralding simultaneously the beginning of Job's Redemption and the advent of Christ. Christ appears to Job in a whirlwind in plate 13 and his attitude, arms outstretched, is comparable to his first appearance to Albion in plate 35 of *Jerusalem*. Christ again resembles Job in appearance, and he is distinguished from previous representations of Jehovah by, in this case, a whirlwind, but in the later plates by a radiant aura. Christ then acts as explicator of all things in heaven and earth, like Raphael in *Paradise Lost*, and in plate 14, *When the morning stars sang together* (plate 171), He re-enacts the Creation of the world. Job and his wife and friends look upwards as Christ releases the sun and the moon, while above cherubim exult, their arms interweaving in a continuous pattern. This glorious design, which Samuel Palmer wished to see installed as the great window in Westminster Abbey,[24] reflects the tripartite design of plates 2 and 5, but now Christ is installed in the centre, in the position usurped by Satan.

In plate 15, Christ explains the dominance of evil in the world in terms of Leviathan and Behemoth, who present a tangible image of man's lust for domination and war. They are seen inside a globe divided into land and sea; Behemoth as a curious heraldic rhinoceros, and Leviathan as a fearsome sea-serpent. Job has had revealed to him the true meaning of the world through Divine Allegory, and in the next plate he witnesses the Last Judgement, in which Satan is cast out by Christ enthroned in mercy. In plate 17, Job, having purged himself of evil, is now ready to enter Christ, for he receives the supreme revelation that Christ resides within him: 'we know that when he shall appear we shall be like him for we shall see him as He Is.' Christ appears to Job in an aura of light and blesses him and his wife,

but the light is too strong for the comforters, who withdraw from it in terror; but in the following plate, by praying for them, Job offers them the Christian mercy of forgiveness. Christ is no longer separate from Job, and in plate 19, he and his wife, in a sense, re-enact the Adoration of the Kings by becoming the recipients of the gifts of others. In plate 20 (plate 170), Job 'converses in Visionary Forms Dramatic' with his three daughters before uniting with them in a final hymn of praise to the Eternal Humanity Divine.

The wealth of meaning in the *Job* watercolours and engravings was lost on most of Blake's contemporaries, and the engravings might have been regarded at the time of their publication as a welcome return to sanity after the Prophetic Books.[25] Even so, they were not universally admired, and complaints continued to be made especially of the 'hardness' of the technique with its echoes of Dürer, who was still generally unfashionable. In 1830 Bernard Barton, the Quaker poet and friend of Linnell, volunteered to try to sell some copies of the engravings, but his experience was not auspicious; 'his style is little calculated to take with admirers of modern engraving. It puts me in mind of some old prints I have seen, and seems to combine somewhat of old Albert Dürer with Bolswert. I cannot but wish he could have clothed his imaginative creations in a garb more attractive to ordinary mortals, or else given simple outlines to them.'[26] Barton in general was right, for Blake was a pioneer in the revival of Dürer in England; he had an impression of Dürer's *Melancholia* on his wall, and his long-standing interest in early German engraving was probably stimulated by his contact with the Aders circle.[27] But there is evidence that in addition to early German engravings, Blake looked at sixteenth-century Italian engravings, which he would no doubt also have regarded as 'Gothic'. George Cumberland was an enthusiastic collector of early Italian prints, particularly of Bonasone, of whom he had an almost complete collection, and he owned also a number of Mantegna prints. In 1793 he published a book on Bonasone[28] and he compiled a catalogue of his print collection, which he eventually deposited at the British Museum and the Royal Academy.[29] This catalogue, which covered Italian engravers 'from the Earliest practice of the art in Italy to the Year 1549' was not published until 1827, but he is recorded as having lent a copy of the manuscript to Blake in November 1823.[30]

Bonasone's work cannot have been new to Blake in the 1820s, but there is something in the conscious ungainliness of the figures and in the density of imagery in his *Job* plates which suggests the influence of Dürer in particular. The construction of the figures is more consciously volumetric than in the earlier engravings, and there is great variety of texture and light. In plate 1, *Thus did Job continually* (plate 168), for example, the technique varies from the stippled cross-hatching in the landscape to the emphatic cross-hatching of the garments. The effect of sunlight in the background is achieved by parallel hatching and lines of varying thickness. The stippling effect is to be found in some of Bonasone's engravings, but the sharp cross-hatching is closer to Dürer. Remarkable effects of luminosity are achieved throughout the series; the radiance of the sun or Holy light casts a silvery glow over all the

forms. Light also acts symbolically; the earlier plates show Job plunging further into the dark night of Experience while his Redemption is heralded by dawning light. The sun begins to set in plate 1, and by plate 8, *Job's Despair*, it has gone down and darkness has almost fallen. Job's redemption begins at night, for he is rescued from eternal darkness by Christ's mercy, and in the final plate the sun has moved to the other side of the picture, in the ascendant.

As so often with Blake's designs, many motifs in the *Book of Job* can be traced back to his earlier work. Plate 8, *Job's Despair*, returns in its essentials to a drawing of *c.* 1785 (Tate Gallery)[31] and an intermediate stage may be found in the lithograph of *Enoch* of *c.* 1807.[32] The motif of the Comforters in plate 10, *The Just Upright Man is laughed to scorn*, relates to *Jerusalem*, plate 93, where Anytus, Melitus and Lycon point scorn at Socrates: a telling analogue of Job's condition. The most immediate source for the motif is Fuseli's *Three Witches*, and Blake has emphasized the primitivism of the gestures by emulating the gauche sincerity of 'Gothic' art, evoking also the remote Hebraic world in which Job lived. The comforters are depicted as Pharisees, and their grouping in unison implies their hostility or incomprehension of the spirit.

Ruskin made a specific exception of 'the majestic series of designs from the book of Job'[33] from his strictures upon Blake's art, but further study only emphasizes the essential unity of the *Job* designs with Blake's 'difficult' works. Job is a universal man like Albion, and we can look upon his story, in Bo Lindberg's words, as 'the acts of Albion, applied to a patriarch of about 1200 B.C.'.[34] But Job is in a way also Los, for he is an artist as well, and it is through Vision that he achieves Redemption. The arts of painting and music, and especially architecture, all play a central role in the drama, where they are associated with the polarities of idolatry and true worship. Job's eldest son's house is pillared in a primitive architectural order, rather like the simplified Doric in the background to David's *Oath of the Horatii*, but whereas David meant to suggest heroic simplicity Blake's primitive order seems to imply false values. Blake evidently regarded the trilithon as a primitive altar based on the principle of threefold symmetry,[35] suggesting the worship of reason, and he implies that Classical architecture developed directly from it in its symmetry and clear rectilinearity. Job's act of prayer in plate 18 is accompanied by his three daughters, who presumably stand for the three arts of painting, poetry and music, and in the margin below are other emblems of the arts: a Bible open to words of Jesus, a palette with brushes and an engraver's burin, between which Blake has placed his signature, for Job's act of prayer is also Blake's own through the creation of the image itself.

If harsh and unadorned architecture is associated with the Fallen World, in plate 20 a glimpse is given of the architecture of Eden (plate 170). The halls of Los in Eternity contain sculptures which record every emotion or thought throughout the lifespan of every man,[36] and Blake's vision of Jerusalem and 'the early Patriarchates of Asia' is that they were filled with a profusion of recondite imagery; 'the Cherubim were sculptured and painted on walls of Temples, Towers, Cities, Palaces.'[37] The walls of Job's house, in plate 20, which he points out to his daughters, seem to depict

the events of Job's spiritual progress to Eden, and a full view of the chamber would no doubt contain images of his whole life. The creator of these paintings or reliefs would have been Job himself, for the making of art is the prayer of the Redeemed. These images were not meant for aesthetic contemplation, and certainly not for worship in themselves, but for the instruction of future generations, who may learn through art the necessity of their sojourn in Experience.[38] Plate 20 is Blake's most succinct account of the Eternal role of art, for it shows visual images as playing a part in an intense dialogue which transcends verbal conversation, for it draws together all man's faculties in the praise of God; at its highest level Redemption brings the union of all the arts. The last two plates of the *Book of Job* (see plate 173) predicate a vision of Redemption in which all divisions are transcended, and men converse not through the separate arts but

in Visionary Forms Dramatic which bright
Redounded from their Tongues in thunderous majesty in Visions
In new Expanses creating exemplars of Memory and of Intellect.[39]

The Last Works

The *Book of Job* engravings were the last important designs Blake was able to bring to completion. The remaining projects were all left unfinished upon his death on 4 August 1827. Though his health began to decline in 1825, and he was intermittently bed-ridden until the end, he continued working as intensively as ever, working often in bed, where, he sat, as Palmer described him, 'like an Antique patriarch'.[1] In 1824–5 he probably began the set of twenty-eight watercolour designs for *The Pilgrim's Progress* (Frick Collection).[2] They are on the same scale as the *Book of Job* engravings, and despite their many felicities, signs of overworking and carelessness suggest that they were left unfinished because Blake, or perhaps Linnell, was not satisfied with them. The heavy colouring in many of the plates has been attributed to the intervention of another hand, perhaps Catherine Blake, or Frederick Tatham, who added titles, but some of the watercolours are clearly entirely from Blake's own hand. The colouring is densest in the designs pertaining to the obstacles besetting Christian; in *Christian beginning his Pilgrimage* (ill. II) (plate 174), the weight of the colour seems to reflect the heaviness of his burden. *The Man who dreamed of the Day of Judgement* (ill. XIII), and *Christian climbs the Hill Difficulty* (ill. XVI) are also painted sombrely. But after Christian has entered the Delectable Mountains (ill. XXVI), a dramatic change in colour takes place; the harsh purply-reds of the early illustrations are now tempered with softly modulated greens, pinks, blues and yellows, evocative of Paradise. The way to the states of Eden and the Last Judgement is radiant with Divine light as Christian crosses the river Jordan and enters the Gate of Heaven, where angels are blowing the Last Trump (ill. XXVII).

Bunyan's allegory proved easily adaptable to the imposition of Blake's interpretation, and it must itself have influenced his vision of the Christian path to Redemption.[3] Evangelist appears as a Urizenic type, who does not remove Christian's burden, but extracts his submission (ill. III). Help, who lifts Christian from the Slough of Despond (ill. VI), is a Christ figure with a small beard and curly hair. The Wicket Gate (ills. X and XI) is a Gothic door with a decorative frame of angels, signifying

the entrance to the Grave through which Christian is welcomed by Goodwill. The Interpreter is the agent of Christian's enlightenment and presents to him a man in a cage, who stands for the enslavement of the material body (ill. XII), and he removes Christian's burden by revealing to him a vision of the Cross (ill. XIV).[4] Christian 'now stands upright in exultation', and he no longer wears a tight-fitting garment, but a flowing white cloak and carries a shepherd's crook; the road to Redemption is open to him.

In *A Vision of the Last Judgment*, Bunyan's *Pilgrim's Progress* is classified as a work of 'Fable or Allegory' which is nevertheless full of Vision. Otherwise the book is not mentioned in any of Blake's reported conversations, although he himself was known to Palmer and his friends as 'The Interpreter'.[5] The *Divine Comedy*, on the other hand, is mentioned frequently by Blake in his conversations with Crabb Robinson in 1825. By this time he was already engaged upon his illustrations to Dante, but it is also evident that Dante presented a problem which exercised his mind profoundly, in contrast to *The Pilgrim's Progress*, which he must have known from his earliest youth. Dante, like Milton, gave rise to conflicting emotions in Blake's mind.

Blake began work on the Dante watercolours at Linnell's behest in 1824, in a large folio volume of drawing paper.[6] Crabb Robinson found him at work on them on 17 December 1825, and remarked of the drawings that 'they evince a power of grouping & of throw(in)g grace & interest over conceptions most monstrous & disgusting which I shod not have anticipated'.[7] In their conversation about Dante, Blake shocked Robinson by calling Dante an atheist: 'He was an atheist—A mere politician busied abt this world as Milton was till in his old age he returned back to God whom he had had in his childhood.'[8] This remark as Robinson reported it is ambiguous, for it is not clear whether Milton or Dante returned to the God of his childhood, and it is an important question. As in the case of Milton, Blake had fundamental objections to the *Divine Comedy*. He abhorred the unchristian vengefulness of the *Inferno*, and felt that Dante had an unhealthy preoccupation with evil: 'Dante saw Devils where I see none—I see only good,'[9] but the problem still remains as to whether Dante returned to God in the realization of his errors.[10]

Virgil is Dante's guide, and in Blake's interpretation he leads Dante through a vision of Hell in which Dante's tormentors take on the forms of real enemies and are not recognized as states of mind. Virgil acts as the reasoning faculty of the poet, and he remains dominant until Dante falls in thrall to Beatrice. The *Inferno* is identified by Blake as Experience, and in *The Mission of Virgil* (Roe 3; Birmingham City Art Gallery) (plate 175)[11] Dante is led through the heavily-guarded gates of the temporal world by Virgil, while above the entrance stands the raging figure of Jehovah, inscribed by Blake 'The angry god of this world', hurling thunderbolts, as Satan, wearing a crown and wielding a censer, reports to him. Dante is reluctant to enter, but Virgil, his perceptions confined by antique philosophy, does not fear the world of Experience. *The Inscription Over Hell-Gate* (Roe 4; Tate Gallery) (plate 176) also depicts the entry of Dante and Virgil into Hell, but in the previous design

it is revealed in its Eternal sense, as the entry into This World, while here it is depicted from Dante's point of view. The humanoid guardians in the former are seen by Dante simply as trees, for he cannot perceive their hidden reality, because of his material vision.

In the designs for the *Inferno* Blake has inevitably emphasized Dante's preoccupation with vengeance, but he has also made it clear that Dante's enemies are within himself, just as salvation would lie within himself. Thus in the watercolour and engraving of *Paolo and Francesca* (Roe 10; Birmingham City Art Gallery) Paolo lifts Francesca through a smaller whirlwind emanating from the prone figure of Dante. The unhappy lovers represent the struggle of Dante's own body and spirit in Experience, symbolized by the promontory covered in thorns, upon which he lies. The larger whirlwind apparently shows the progress of sexual desire as it passes from physical existence into higher union. In the water, 'the sea of time and space', naked figures writhe in isolation and despair; the fleeting union of those who attempt to embrace as the whirlwind makes its first curve is dashed upon Dante's promontory, but those who pass beyond this obstacle ascend in close union to heaven. This ascent is denied to Dante, for as Paolo and Francesca live in frustration, so his own male and female portions are divided.[12]

The overriding theme of the *Inferno* watercolours is division. In Flaxman's designs for the *Divine Comedy* Dante and Virgil are pure angels venturing into a horrific netherworld, but Blake's Inferno, like Dante's, is a place where man is divided against himself; the fiends do not attack Dante and Virgil but destroy themselves, sometimes as in the case of *The Baffled Devils Fighting* (Roe 42 and 42E) (plate 177), for the delight of others. *The Ireful Sinners* (Roe 15) direct their anger against each other not the outside world, and related to Blake's vision of the Inferno is the imagery of the *Lazar House* colour print,[13] where life on earth is seen as an endless round of self-torment.

The *Inferno* illustrations, which comprise nearly three-quarters of the total, are, therefore, 'an exploration of the Fallen world', in which the horrors and temptations of mortality are depicted not only with vivid imagination, but with the use of atmospheric suggestion distinctive of works of the 1820s, achieved in some cases by subordinating drawing to the effect of colour and wash. In *Dante and Virgil Crossing towards the City of Dis* (Roe 17; Fogg Museum), the two figures are barely indicated in pencil and the sinister effect of the whole scene is achieved largely through broad washes of colour. In *The Inscription over Hell-Gate* (Roe 4) the infernal landscape is depicted as a series of tiered hills lit up by columnar flames, while despairing figures in the distance are given the merest indication with the pen and brush. In a way that Blake would have condemned in his *Descriptive Catalogue*, indefinite forms are used to suggest awe and terror; and in the trees which surround the Gate, the penstrokes work with speed through the foliage, suggesting movement rather than defining form with precision.[14]

The *Purgatorio* illustrations are quite different in feeling from the *Inferno*, expressing with incomparable beauty the idea of the ascent into a higher realm of

existence. In *Dante and Virgil Ascending the Mountains of Purgatory* (Roe 74; Tate Gallery), Dante and Virgil ascend the rocky path with a graceful and joyous rhythm; *Lucia Carrying Dante in his sleep* (Roe 77; Fogg Museum) is a night scene depicting the actual transition into the higher state. The design pivots around the point at which Lucia's foot lightly touches the ground, the direction of her body suggesting rapid movement through space. The darkness is just beginning to be relieved by the dawn, and night and day are held in the same delicate balance as the pose of Lucia. The mountain path which they ascend is stepped and the rich vegetation intimates Paradise ahead. A sense of interval and rhythm is also evident in *Dante and Statius sleeping, Virgil watching* (Roe 86; Ashmolean Museum, Oxford) (plate 173), where the languid posture of the reclining and sleeping figures delicately suggests the sense of awakening in a different and purer atmosphere. This watercolour begins a sequence which carries Dante towards the thrall of Beatrice and his vision of *Paradise*. In the following watercolour, *Beatrice on the car, Dante and Matilda* (Roe 87; British Museum) (plate IV) the floral carpet on both sides of the river is made up of free pen-strokes and tiny touches of pure colour, which give a radiant and jewelled effect, redolent of the earthly Paradise, and in *Beatrice addressing Dante from the car* (Roe 88; Tate Gallery) (plate 179), the wings of the Evangelists and the vortex wheels of the car shimmer with a myriad of contrasted strokes of unmodulated colour.

The radiance of these two watercolours, however beautiful, is not to be mistaken for the light of Eternity; it is still the beauty of This World, which like the beauties of nature can be a snare, particularly to poetic souls. The sinister connotations become evident if *Beatrice addressing Dante from the car* is seen in relation to the following design, *The Harlot and the Giant* (Roe 89; Melbourne Art Gallery).[15] In the former, Dante approaches close to the procession led by Beatrice, which he had first glimpsed from the other side of the river. Beatrice is an alluringly veiled figure wearing a crown and standing on the car, enveloped in gorgeous raiments and surrounded by emblems of the Evangelists. Dante is completely seduced by the vision of delight and makes a gesture of submission to Beatrice. Dante in the *Divine Comedy* intended Beatrice to lead his soul back to the Church, to which he was reconciled in the radiant vision of *Paradiso*, but it is equally clear that Blake has identified Beatrice as Vala.[16] Dante offers submission, therefore, to the Goddess of Nature, who, Blake implies, was the true object of Dante's worship rather than the Divine Vision: 'Every thing in Dante's Comedia shews That for Tyrannical Purposes he has made This World the Foundation of All, & the Goddess Nature Memory is his Inspirer & not the Imagination the Holy Ghost.'[17] The meaning of Dante's submission is revealed in the following watercolour, for the gorgeous vision is suddenly transformed into a scene of the Whore of Babylon in a lascivious embrace with a Giant Warrior; she rides the Beast with several heads caricaturing the powers of This World, and the Beast's serpentine body curves round to parody the vortex wheels of Beatrice's car. Thus Beatrice is revealed to Dante as but a beautiful veil over the eternal Whore of Babylon, just as the ritual of the medieval Church was a

veil for paganism masquerading as Christianity.[18] In this realization Dante passes into Paradise and is vouchsafed a vision of Christ. In *Dante adoring Christ* (Roe 90), Dante's exultant apprehension of Christ follows from his realization of the true form of Vala, and contrasts with his gesture of submission to Beatrice.

The vision of Christ would seem to ensure Dante's ultimate Redemption, but his eternal fate is left undetermined in the final designs to *Paradiso*, although Blake's remarks on Dante to Crabb Robinson suggest a belief in Dante's final salvation.[19] Blake's hostility to the theology of the *Divine Comedy* is made plain in the remarks he scrawled upon some of the unfinished watercolours, but in conversation with Crabb Robinson in 1825 'he spoke of M. [Milton] as being at one time—a sort of classical Atheist—And of Dante as being now with God'.[20] By coupling Dante with Milton, Blake strengthens the impression that he believed Dante to have repented of error. The watercolours to *Paradiso*, however, tend to suggest that Blake did not believe that Dante had repudiated the Catholic Church. The text of the *Paradiso* left Blake little opportunity to 'redeem' Dante, for Beatrice has taken over from Virgil as guide, and leads Dante willingly to Redemption through the gates of Peter. *The Deity from Whom Proceed the Nine Spheres* (Roe 97) is plainly the 'Angry God of this World', who presided over Dante's fall, and in the final watercolour, *The Queen of Heaven in Glory* (Roe 99; Melbourne) (plate 180), the Virgin Mary is enthroned as Queen of Heaven holding the mirror of vanity and the sceptre of earthly authority. In this parody of the Last Judgement the Virgin is seated on a giant flower, the petals of which seem to act as cages for writhing prisoners. Blake's Dante would seem, therefore, to have returned to conventional theology and repudiated the vision of Christ he had been vouchsafed in Paradise.

The 100 unfinished watercolours for the *Divine Comedy* make a majestic conclusion to Blake's career, for they reveal no diminution of his imaginative powers or executive ability; indeed their freshness and fluidity suggest new possibilities opening up for Blake in the use of colour. Another unfinished work of his very last years also suggests a beginning rather than an end. A few illuminated leaves from Genesis, known as the *Genesis Manuscript* (Huntington Library)[21] reveal tentative intimations of a scheme (see plate 181): to create an illuminated manuscript of the Bible, with designs and written headings to point to the internal meaning. He had begun colouring the first few pages, and the script is in a Gothic hand (used before in the title to the *Book of Job*), evoking strongly the feeling of a medieval manuscript. There are two attempts at the title-page, one more highly finished than the other, and in both Jehovah presides over elaborately Gothic letters forming the word 'Genesis'; each letter is carefully separated and in the more finished versions they sprout vegetation in profusion. The letters are supported on either side by Christ and a bearded prophetic figure (Elijah?), carrying what appear to be palm fronds. The figure in the centre who has the 'I' of Genesis as a garment, is probably Adam receiving from Christ a scroll of the Divine Mercy. At the bottom the four Evangelists are represented by humanized attributes. The first page of Chapter I is the most finished; God the Father directs the Creation, and Blake has added the

chapter heading 'The Creation of the Natural Man'. Text and design are sketched in
roughly as far as Chapter IV, the story of Cain and Abel. The designs, though sketchy,
give promise that the manuscript would have been one of Blake's greatest achieve-
ments—it would also have clarified his interpretation of the Bible, for the headings
of the first four chapters impose a firm Blakean structure upon the Biblical text:
Chapter II, 'The Natural Man divided into Male and Female & of the Tree of Life &
of the Tree of Good & Evil'; Chapter III, 'Of the Sexual Nature & its Fall into Gener-
ation & Death', and Chapter IV 'How Generation & Death took possession of the
Natural Man & the Forgiveness of Sins written upon the Murderers Forehead'.

It is especially poignant that Blake at the very end should have returned to the
Bible, for it had always provided the thread of meaning behind his visual imagery;
but he did not regard death as a curtailment. He saw his impending death as a
release from Mortality, as he wrote to George Cumberland on 12 April 1827:

> I have been very near the Gates of Death & have returned very weak & an Old
> Man feeble & tottering, but not in Spirit & Life, not in the Real Man. The
> Imagination which Liveth for Ever. In that I am stronger & stronger as this
> Foolish Body decays. . . . Flaxman is gone & we must All soon follow, every one
> to his Own Eternal House, Leaving the Delusive Goddess Nature & her Laws to
> get into Freedom from all Law of the Members into the Mind, in which every one
> is King & Priest in his own House. God send it so on Earth as it is in Heaven.

In the same letter Blake mentioned a tiny visiting card which he had designed and
engraved for Cumberland (plate 182), his final completed work, and a touching
reminder of his career as a journeyman engraver. Amid scenes of youthful pastime
and innocent joy, a Fate holds out the mortal thread above a cornfield; as three
angels exult above, an angel with a sickle descends to cut the thread. The angel is
the Angel of Revelation come to gather the harvest and with it the soul of the seventy-
year-old artist.

A Brief Guide to the Illuminated Books

All numbers of existing copies should be taken as approximate. For a full account of the Illuminated Books see G. L. Keynes and E. Wolf, *William Blake's Illuminated Books: A Census*, 1953. The plates have been measured according to the printed area, and the plate sizes given are the averages for each book.

There is no Natural Religion,
 series *a* and *b*, *c*. 1788

number of plates: *a* 9, *b* 12
size of plates: 60 × 40 mm.
number of known examples: 13
 (all incomplete)

All Religions are One, c. 1788

number of plates: 10
size of plates: 60 × 40 mm.
number of known examples: 1

Songs of Innocence, 1789

number of plates: up to 31
size of plates: 110 × 70 mm.
number of known examples: 22

The Book of Thel, 1789

number of plates: 8
size of plates: 155 × 107 mm.
number of known examples: 15

Marriage of Heaven and Hell, c. 1790

number of plates: 27
size of plates: 165 × 102 mm.
number of known examples: 9

Visions of the Daughters of Albion, 1793 number of plates : 11
size of plates: 222 × 171 mm.
number of known examples: 16

America, A Prophecy, 1793 number of plates: 18
size of plates: 241 × 171 mm.
number of known examples: 16

Europe, A Prophecy, 1794 number of plates: 17–18
size of plates: 241 × 171 mm.
number of known examples: 12

Songs of Innocence and Experience, 1794 number of plates: 54
size of plates: 115 × 70 mm.
number of known examples: 27

The (First) Book of Urizen, 1794 number of plates: up to 28
size of plates: 150 × 105 mm.
number of known examples: 7

The Song of Los, 1795 number of plates: 8
size of plates: 225 × 152 mm.
number of known examples: 5

The Book of Ahania, 1795 number of plates: 6
size of plates: 135 × 75 mm.
number of known examples: 1

The Book of Los, 1795 number of plates: 5
size of plates: 136 × 98 mm.
number of known examples: 1

Milton a Poem, 1804–*c.* 1815 number of plates: 45–50
size of plates: 110 × 155 mm.
number of known examples: 4

Jerusalem, 1804–*c.* 1820 number of plates: 100
size of plates: 222 × 165 mm.
number of known examples: 5
 (plus 2 posthumous copies and 1 of
 first chapter only)

A Glossary of Blakean Terms

This glossary is intended as a guide to the most frequently recurring Blakean terms, including Biblical terms to which Blake attaches a special meaning. It must be emphasized that these definitions are extremely simplified and over-schematic. For more detailed accounts the reader is referred to S. Foster Damon, *A Blake Dictionary*, 1965.

ALBION, 'The Ancient Man' who stands both for England and for mankind. *Jerusalem* tells the story of Albion in his Fallen state and his regeneration through Jesus Christ. The Fall is a consequence of Albion's division into the four warring ZOAS, and in his regeneration man becomes whole again.

ALBION, DAUGHTERS OF, The women of England enslaved by society, who yearn, in *Visions of the Daughters of Albion*, towards America and freedom. In *Jerusalem* they are twelve in number, and have a sinister role.

ALBION, SONS OF, The rulers of England who have made the country a slave to materialist philosophy. They are also twelve in number; in *Jerusalem* several are given the names of Blake's judges and accusers in his trial of January 1804.

BABYLON, The coupnter-rinciple to JERUSALEM and the city devoted to the worship of This World, presided over by the Whore of Babylon. Blake had in mind *Revelation*, xvii, 5: 'Mystery, Babylon the Great, the mother of harlots and abominations of the earth.'

BEULAH, As in the Bible a state of delight and peace, like the garden of Eden; but it is not to be confused with Blake's EDEN. Beulah is an intermediate stage, for the pursuit of its pleasures may lead to spiritual negation and a fall into Despair or ULRO. It is a passive state under the domination of the moon.

EDEN, The highest state of being, whither the artist travels to bring back his Visions of Eternity, and where men converse in 'Visionary Forms Dramatic'. Eden is only open to man through the Imagination, but it is not a peaceful place like BEULAH, rather one of active mental struggle.

EMANATION, The female portion of man, which controls his affections, but may attempt to dominate him. It exists only in the states beneath EDEN, for in Eden man is no longer divided into sexes. LOS's Emanation is ENITHARMON, who comforts him but also emasculates him artistically.

ENITHARMON, LOS'S EMANATION, and mother of ORC. The counter-principle to Imagination, she embodies both the indulgence of the senses and their repression through the code of chastity. She is also art in the service of false religion and concomitantly the decorative and frivolous arts.

GENERATION, Man's earthly existence or Fallen state, from which he may pass into EDEN through his Imagination and thus achieve Redemption through Christ's mercy.

HAR, THE VALES OF, A false Eden for those who seek an easy road to Redemption. Also art without spiritual purpose: closely related to BEULAH.

JERUSALEM, The EMANATION of ALBION, with whom she is reunited in his Redemption in Christ, at the end of *Jerusalem*. She is contrasted with BABYLON, and she also represents Liberty and man's desire to unite with Christ.

LOS, The central figure in Blake's thought: he is Imagination and represents the dilemma of every man in his pursuit of Redemption who yet must inhabit the temporal world. He is the beleaguered spiritual artist and prophet, whose Imagination can perceive Eternal truth, but is thwarted by his EMANATION and SPECTRE. His prophetic role is to give form to evil, and to reveal the true Vision. In Blake's Creation myth (see mainly the *Book of Urizen*) Los creates the form of URIZEN, but he becomes a slave to his own creation. Because Los or Imagination is enslaved the Fallen world is tolerated by man, and in the Prophecies of the 1790s Energy, ORC, is bound by his father Los.

LUVAH, The emotions, and one of the Four ZOAS, whose separation from the others is a consequence of Man's Fall.

ORC, Energy and the spirit of Revolution, who breaks from his chains at the outbreak of the American Revolution. His challenge to the kings of the earth heralds the New Order, for he bursts from the confines of the Old, represented by URIZEN. Orc's fires are purgative, for they burn up the hypocrisy of conventional morality. He is the son of LOS and ENITHARMON, who in their jealousy bind him to a rock.

PALAMABRON, The 'mild arts' or contemplative state, which can act as a hypocritical pretence to holiness, or a state of withdrawal from the world, cf. RINTRAH.

RINTRAH, The wrathful state, which can be merely aggression or, in a positive sense, the righteous indignation of the prophet, cf. PALAMABRON.

SPECTRE, Man's reasoning component, or Doubt: hostile to Vision, and tormenting especially to the artist.

THARMAS, One of the Four ZOAS representing the senses.

ULRO, The lowest state of being or Despair. Single vision as opposed to the fourfold vision of EDEN, and the consequence of a total surrender to materialism.

URIZEN, A tyrannical and vengeful Jehovah, representing the legalism of the Old Testament. He is Reason opposed to the Imagination, drawing mankind into war, misery and submission to false religion; but as one of the Four ZOAS an essential component of the complete mind.

URTHONA, The spiritual existence of LOS as one of the Four ZOAS.

VALA, Nature, especially the religion of Nature, whose beauty is delusive and leads ultimately to Despair.

ZOAS, The Greek name for the Four Beasts of *Revelation*, seen also by Ezekiel. The Four Zoas correspond with the four aspects of man: the body (THARMAS); reason (URIZEN); emotion (LUVAH); and imagination (LOS-URTHONA): in their division is the Fall, and in their union is Redemption.

Abbreviations for Frequently Cited Works

The abbreviation 'K.' in the text and in the notes refers to the Nonesuch edition of *The Complete Writings of William Blake*, 1957, edited by Sir Geoffrey Keynes. The pagination of the original edition has been retained in subsequent reprints.

Bibliography	G. E. Bentley and M. K. Nurmi, *A Blake Bibliography*, 1964
Blake, Bible	G. L. Keynes and G. Goyder ed. *William Blake's Illustrations to the Bible: A Catalogue*, 1957
Blunt	A. Blunt, *The Art of William Blake*, 1959
Boston cat.	P. A. Wick and H. D. Willard ed., *Blake's Watercolour Drawings in the Boston Museum of Fine Art*, 1957
Burl. Mag.	*The Burlington Magazine*
Damon, *Dictionary*	S. Foster Damon, *A Blake Dictionary*, 1965
Erdman, *Poetry and Prose*	D. V. Erdman ed., *The Poetry and Prose of William Blake*, 1965
Erdman, *Prophet*	D. V. Erdman, *Blake: Prophet Against Empire*, revised ed., 1969
Essays for Foster Damon	A. H. Rosenfeld ed., *William Blake: Essays for S. Foster Damon*, 1969
Essays in Honour of Sir Geoffrey Keynes	M. D. Paley and M. Phillips ed., *William Blake: Essays in Honour of Sir Geoffrey Keynes*, 1973
Fitzwilliam cat.	D. Bindman ed., *Catalogue of the Blake Collection, Fitzwilliam Museum, Cambridge*, 1970
Gilchrist	A. Gilchrist, *Life of William Blake*, 2 vols, 1863

Graham Robertson cat.	Kerrison Preston, *The Blake Collection of Graham Robertson*, 1952
Hamburg cat.	D. Bindman, *William Blake (Kunst um 1800)*, (catalogue for exhibition at Hamburger Kunsthalle and Städelsches Kunstinstitut, Frankfurt), 1975
Huntington cat.	C. H. Collins Baker, *Catalogue of William Blake's Drawings and Paintings in the Huntington Library* (enlarged and revised by R. R. Wark), 1957
Illuminated Blake	*The Illuminated Blake*, annotated by D. V. Erdman, 1974
Irwin	D. Irwin, *English Neoclassical Art*, 1966
J. W. (C.) I.	*Journal of the Warburg (and the Courtauld) Institute(s)*
K.	see above
Keynes, *Drawings*	G. L. Keynes, *Drawings of William Blake, 92 Pencil Studies*, 1970
Keynes, *Studies*	G. L. Keynes, *Blake Studies*, 2nd ed., 1971
Keynes and Wolf	G. L. Keynes and E. Wolf, *William Blake's Illuminated Books: A Census*, 1953
Records	G. E. Bentley, *Blake Records*, 1969
Separate Plates	G. L. Keynes, *Engravings by William Blake: The Separate Plates*, 1956
Schiff	G. Schiff, *Johann Heinrich Fuseli, Catalogue Raisonné*, 1973
Tate cat.	M. Butlin, *William Blake: A Complete Catalogue of the Works in the Tate Gallery*, revised ed., 1971
Visionary Forms Dramatic	D. V. Erdman and J. E. Grant ed., *Blake's Visionary Forms Dramatic*, 1970
Whitley, 1700–1799	W. T. Whitley, *Artists and their Friends in England 1700–1799*, 2 vols, 1928
Whitley, 1800–1820	W. T. Whitley, *Art in England 1800–1820*, 1928

Notes

Introduction

1. Reynolds, *Discourses*, Wark ed., Discourse V, 84–5.

1. The Visionary Apprentice

1. *Records*, p. 2.
2. *Records*, pp. 7–8.
3. E. P. Thompson, *The Making of the English Working Classes*, 1965, pp. 28–58.
4. Letter to John Flaxman, 12 September 1800 (K. p. 799).
5. Gilchrist, p. 7.
6. *The Works of Jacob Behmen, The Teutonic Theosopher*, Vols I and II, 1764; Vol. III, 1772; and Vol. IV, 1781 (*Bibliography*, no. 559).
7. Damon, *Dictionary*, p. 40.
8. Gilchrist, p. 9.
9. D. G. C. Allan, *William Shipley: Founder of the Royal Society of Arts*, 1968, pp. 76–88.
10. H. T. Wood, *History of Society of Arts*, 1913, p. 9.
11. M. Kitson, 'Hogarth's "Apology for Painters" ', *Walpole Society*, Vol. XLI, p. 65.
12. 'Memoirs of Thomas Jones.' *Walpole Society*, Vol. XXXII, p. 21. Thomas Jones left an amusing account of his time at the Pars School in 1761–2. 'Here I was reduced to the humiliating Situation of copying drawings of Ears, Eyes, Mouths and Noses among a group of little boys of half my age who had the start of me by two or three years.'
13. Whitley *1700–99*, p. 342. See also painting by Mortimer of himself in the Duke of Richmond's gallery (op. cit., pl. 2).
14. Blake's name does not appear on any of the lists of winners of premiums. Wood, op. cit., pp. 162–212.
15. Gilchrist, p. 13.
16. *Records*, p. 10.
17. *Memoirs and Recollections of the late Abraham Raimbach Esq.*, 1843, p. 5. According to Raimbach 'the usual fee' was £100 in 1789.
18. B. H. Malkin, *A Father's Memoirs of his Child*, 1806 (*Records*, pp. 421–2).
19. According to the anonymous Advertisement they 'were the production of an untutored youth, commenced in his twelfth, and occasionally resumed by the author till his twentieth year'. (*Records*, p. 25).
20. Malkin (*Records*, p. 422).
21. J. Pye, op. cit., p. 158.
22. *Public Address* (K. p. 591).
23. See R. Strange, *An Inquiry into the Rise and Establishment of the Royal Academy*, 1775, and Pye, op. cit., pp. 187–90, Whitley *1700–99*, p. 307ff.
24. *Records*, p. 12.
25. Keynes, *Studies*, p. 17.
26. D. Bindman, 'Blake's Gothicised Imagination and the History of England' in *Essays in Honour of Sir Geoffrey Keynes*, pp. 31–3.
27. Malkin (*Records*, p. 422).

28. Gilchrist, Vol. I, p. 18: 'He pored over all with a reverent good faith, which, in the age of Stuart and Revett, taught the simple student things our Pugins and Scotts had to learn near a century later.'

29. Malkin (*Records*, p. 422).

30. Bindman, op. cit., pp. 30–1.

31. Keynes, *Studies*, pp. 16–19 and plates 5–9.

32. *Separate Plates*, no. 1.

33. Philipp Fehl 'Michelangelo's *Crucifixion of St Peter*', Art Bulletin, 1971, 340; see also Leo Steinberg, *Michelangelo's Last Paintings*, 1975, p. 59, figs 95–6.

34. *Separate Plates*, no. 1.

35. K. p. 39.

36. M. Phillips, 'Blake's Early Poetry' in *Essays in Honour of Sir Geoffrey Keynes*, pp. 16–26.

37. Harold Fisch, *Jerusalem and Albion*, 1964, pp. 117–27.

38. Anon., *The Holy Disciple; Or the History of Joseph of Arimathea*, Newcastle, 1740?, p. 12. See K. p. 552 for a short poem by Blake on Joseph of Arimathea.

39. J. Milton, *The History of Britain*, 1670, p. 80.

40. F. I. McCarthy, 'The Bard of Thomas Gray: its Composition and Use by Painters', *Bulletin of the National Library of Wales*, XIV, Vol. I, 1965, pp. 105–13.

41. J. Sunderland, 'John Hamilton Mortimer and Salvator Rosa', *Burl. Mag.*, Vol. 112, p. 520.

42. From Discourse II. *Annotations to Reynolds* (K. p. 457).

43. *John Hamilton Mortimer*, exhib. cat. Eastbourne, 1968, p. 6.

44. Mellon Collection and National Portrait Gallery respectively. See J. Sunderland, 'Mortimer's Self-Portrait in Character', *Burl. Mag.*, Vol. 111, p. 518. I owe this convincing attribution to Mr Timothy Clifford.

45. *The Works of James Barry Esq.*, 1809, Vol. 1, p. 330.

46. *Annotations to Reynolds* (K. p. 446).

47. Irwin, pp. 39, 40, 118, and pl. 18.

48. Blunt, pl. 9C. The dedication to his 'friend' Edmund Burke may have been intended ironically.

49. From the accompanying description to published engravings of Adelphi paintings, presumably written by Barry himself (British Museum Print Room).

50. Phillips, op. cit., p. 28.

51. The volume Blake used seems to have been Adamo Ghisi's engravings from Giorgio Ghisi's large engravings after Michelangelo (British Museum Print Room).

52. *Huntington cat.*, p. 52.

53. Inscribed by Tatham: 'most likely by Blake after Cumberland', but Blake's drawings are copied without significant variation from Vol. II, pl. 68, and Vol. III, pl. 12, of d'Hancarville, *Collection of Etruscan, Greek and Roman Antiquities from the Cabinet of the Hon. W. Hamilton . . . Naples, 1766–7. See D. Bindman, *The Artistic Ideas of William Blake*, Ph.D. thesis, London University, 1972, p. 56.

54. R. Rosenblum, *Transformations in Late 18th Century Art*, 1967, pp. 164–5, and also Dora and Erwin Panofsky, *Pandora's Box*, p. 90ff.

55. R. Rosenblum, op. cit., p. 163.

56. *Blake Studies*, p. 29.

57. Doubt has been cast on the authenticity of this drawing, but, regrettably, it seems to be perfectly authentic. The one other possible candidate might be Blake's brother Robert, for whose work see plate 34.

58. K. p. 40.

59. K. p. 3.

60. K. p. 13.

61. K. p. 1.

62. K. p. 34.

2. Student and Independent Engraver

1. *Records*, pp. 15–16.

2. Register of students admitted to Royal Academy (Royal Academy Library). He is described under profession as 'Engr'; this does not seem to imply that he was there to study as an engraver, as Bentley suggests (*Records*, p. 16). Engravers were admitted to the school but were only allowed to become Associate members at the time.

3. See account in *Records*, pp. 16–17.

4. Malkin (*Records*, p. 423).

5. For example, *An Antique satyr and faun*, British Museum, 1867–10–12–

202; and possibly *Charon* (Tate Gallery) cat. no. 82.

6. Reproduced Keynes, *Pencil drawings*, 1927, no. 3 and Blunt, pl. 3b.

7. Keynes, *Studies*, p. 4.

8. Cat. of the *Age of Neoclassicism* exhibition, Royal Academy, 1972, nos 521–2. The suggestion that the young Blake himself can be seen in the second drawing has no foundation.

9. Introduction to *Works of Sir Joshua Reynolds*, by E. Malone, 2nd ed. 1798, p. xlviii. Hogarth had also quarrelled with Moser, see Kitson, *Walpole Society*, Vol. XLI, p. 61.

10. *Annotations to Reynolds*, K. p. 449. Although Moser was Keeper, he was also appointed to the post of deputy librarian in 1781, a possible clue to the date of the dialogue.

11. In 1775, Romney wrote from Venice: 'I met with great entertainment from the old masters, in particular Cimabue and Masaccio; I admired the great simplicity and purity of the former and the strength of character and expression of the latter. I was surprised to find several of their ideas familiar to me, till I recollected having seen the same thoughts in M. Angelo, only managed with more science.' (J. Romney, *Memoirs of the Life and Works of George Romney*, 1830, p. 107.) See also a sketchbook by Romney dating from 1774 of paintings in Florence, including some by 'Cimabue' (whereabouts unknown. Photographs in Witt Library).

12. G. Previtali, *La Fortuna dei Primitivi*, 1964, p. 138 passim.

13. J. J. Winckelmann, *Geschichte der Kunst des Alterthums*, 1764; see especially Book VIII.

14. Reynolds, *Discourses*, II, pp. 32–3.

15. Previtali, op. cit., pp. 164–74.

16. J. Galt, *The Life of Benjamin West*, 1820.

17. E. Waterhouse, *Three Decades of British Art*, 1965, pp. 53–77.

18. Erdman, *Prophet*, pp. 20–9.

19. Whitley *1700–99*, pp. 337–8.

20. J. Sunderland, 'Mortimer, Pine and some political aspects of English history painting', *Burl. Mag.*, June 1974, pp. 317–26.

21. *The Resurrection of Democracy*. The finished drawing is reproduced in the catalogue *La Peinture Romantique anglaise*, Petit Palais, Paris, 1972, no. 2. It is possible that the motif of the print may have influenced the opening lines of the Prophetic Book *America*.

22. Exhib. cat. *Lady Hamilton*, Kenwood, 1972, ed. Mrs P. Jaffé, p. 45.

23. E. Wind, 'The Revolution of History Painting', *J. W. I.*, Vol. II, 1938–9, pp. 116–27.

24. Sunderland, op. cit., p. 317.

25. Malkin (*Records*, p. 423).

26. *Separate Plates*, no. VI.

27. Blunt, pl. 56.

28. Photograph in the Witt Collection, Courtauld Institute, London.

29. Irwin, pp. 31–50.

30. J. Flaxman, *Lectures on Sculpture*, 1838, ed., *An Address on the Death of Thomas Banks*, p. 291.

31. Photographs of both works in the Witt Library. The story of the former is taken from Leland's *Itineraria*, VIII, 1710, p. 58. The latter was exhibited in *Benjamin West* at Allentown Art Museum, Pa., 1 May–31 July 1962, no. 12.

32. F. Antal, *Fuseli Studies*, pl. 126.

33. The proof that 'Candid' was George Cumberland is contained in a letter by Cumberland to his brother of 6 May 1780 in the *Cumberland* correspondence, British Museum. (*Records*, p. 17.)

34. D. Bindman, 'Blake's "Gothicised Imagination" and the History of England' in *Essays in Honour of Sir Geoffrey Keynes*, 1973, pp. 29–49. The known subjects listed there are as follows: *The Landing of Brutus; Lear and Cordelia; The Landing of Caesar; St Augustine converting Ethelbert of Kent; The Death of Earl Godwin; The Finding of the Body of Harold; The Making of Magna Carta; The Keys of Calais; The Penance of Jane Shore.* Since the publication of the *Essays* a further example from the series has turned up, *The Great Plague of London*, see p. 32.

35. Erdman, *Prophet*, pp. 46–7.

36. P. de Rapin-Thoyras, *The History of England*, trans. by N. Tindal, 1723–31, II, pp. 75–6.

37. T. D. Kendrick, *British Antiquity*, 1950.

38. J. Milton, *History of Britain, That part especially call'd England*, 1670, p. 3.

39. It is perhaps worth noting at this point that Blake seems to have been working on an abortive *Paradise Lost* series about 1780, for which a number of drawings have reappeared recently including *Satan Meeting Chaos* (Lady Melchett) and *Warring Angels* (Messrs Agnews).

40. J. Evans, *A History of the Society of Antiquaries*, 1956, p. 154.

41. Bindman, op. cit., p. 41.

42. Butlin, for example, thinks the Tate version of *The Penance of Jane Shore* could have been executed as late as 1793, in connection with the proposed publication of a book of engravings on *The History of England*. (*Tate cat*. no. 9, p. 31.)

43. For other versions see Blunt, p. 6.

44. For differing views on this question see Erdman, *Prophet*, p. 47, Blunt, p. 9, and Blunt's review of the first edition of *Prophet, Burl. Mag*. Vol. 99, p. 101.

45. Sunderland, op. cit., p. 320.

46. Blunt, pp. 7–8.

47. K. p. 208.

48. For Flaxman's work of the early 1780s see I. O. Williams, 'An identification of some Early Drawings by John Flaxman', *Burl. Mag.*, Vol. 102, p. 246.

49. E. Hindmarsh, *Rise and Progress of the New Jerusalem Church*, 1861, p. 23.

50. Erdman, *Prophet*, pp. 35–6.

51. M. Paley, 'William Blake, The Prince of the Hebrews and the Woman Clothed with the Sun', *Essays for Sir Geoffrey Keynes*, pp. 260–93.

52. Stothard painted a watercolour in 1780 of *Alfred as a Minstrel at the Danish Court* (formerly Rye Gallery, Sussex) which is close in technique to Blake.

53. For an account of Cumberland see Keynes, *Studies*, Ch. 29, p. 230.

54. *Records*, p. 362.

55. R. Gunnis, *Dictionary of British Sculptors, 1660–1851*, p. 39.

56. C. F. Bell, *Annals of Thomas Banks*, 1938, p. 56. Letter to E. L. Loveden, 19 August 1783.

57. Apparently unpublished; there are two impressions in the British Museum Print Room.

58. See list in *Records*, p. 609.

59. *Separate Plates*, nos XXIII, XXIV, XXV, and XXVI.

60. See J. Pye, op. cit., pp. 244–6.

61. See W. S. Baker, *William Sharp, Engraver*, 1875.

62. Letter to William Hayley, 26 April 1784. (*Records*, p. 27).

63. *Public Address* (K. p. 592).

64. *Public Address* (K. pp. 601–2).

3. Painting and Prophecy

1. Smith (*Records*, p. 456).

2. *Records*, p. 24.

3. *Records*, pp. 27–8.

4. *A Book for a Rainy Day* (*Records*, p. 26).

5. *Records*, p. 457.

6. *A Book for a Rainy Day* (*Records*, p. 26).

7. *Bibliography*, nos 337 and 338.

8. Mrs A. E. Bray, *Life of Thomas Stothard*, 1851, p. 112.

9. See Mortimer's *Sextus the son of Pompey applying to Erictho before the battle of Pharsalia*, from Lucan, *Pharsalia*, Book VI, 1776 (Irwin, pl. 104) and Benjamin West, *Saul and the Witch of Endor*, 1777 (Hartford, Conn., Wadsworth Atheneum).

10. Butlin, in *Bulletin of Philadelphia Museum*, July–September 1972, Vol. LXVII, pp. 6–7. Butlin suggests that the style of the watercolour might be earlier than 1783.

11. For the Windsor Castle scheme see J. Galt, *Life of Benjamin West*, 1820, pp. 40–50. According to Galt (p. 44), West complained to the King about Italian painters that 'many of their noblest efforts (were) devoted to illustrate monkish legends in which no one took any interest, while the great events in the history of their country were but seldom touched . . . and the King, recollecting that Windsor Castle had, in its present form, been erected by Edward the Third, said that he thought the achievements of his splendid reign were well calculated for pictures, and would prove very suitable ornaments to the halls and chambers of that venerable edifice.'

12. Galt, op. cit., pp. 52–6. See also the catalogue of West's paintings in the Bob Jones University, Greenville, S.C.

13. See, for example, Flaxman's *The Massacre of the Britons by Hengist at Stonehenge*, dated 1783 (Cambridge, Fitzwilliam Museum). Flaxman has filled in the background in dark wash, giving something of the impression of a Greek vase-painting.

14. Butlin, *Tate cat.* no. 3, cites six variants.

15. Reproduced in *Blake's Illustrations to the Book of Job*, New York, Pierpont Morgan Library, 1935.

16. Reproduced in C. Ryskamp, exhib. cat. *William Blake Engraver*, Princeton, 1969, no. 7. Lindberg suggests that the subject might be 'Moses Speaking, his face shining' (Lindberg, p. 17).

17. See Blunt, 'Blake's "Ancient of Days" ', *J. W. I.*, 1938–9.

18. Now titled by Butlin 'An Allegory of the Bible'. The reference to Bunyan was due to W. M. Rossetti.

19. The earliest version is that published by Cummings in the Carnegie Institute, Pittsburgh (*Romantic Art in Britain*, Detroit, 1968, no. 93), but it seems too accomplished to allow an identification with the work actually exhibited in 1784, unless Blake re-worked it later. There are two other versions (Ackland Memorial Art Centre, Chapel Hill, and Fogg Art Museum, Harvard), both of which may be post-1800.

20. M. Butlin, 'Five Blakes from a Nineteenth Century Scottish Collection', *Blake Newsletter*, Vol. 7, no. 1, pp. 4–5.

21. *Illustrations to the Bible*, no. 38a.

22. See p. 22f.

23. See D. Bindman, 'Blake's "Gothicised Imagination" and the History of England', *Studies in Honour of Sir Geoffrey Keynes*, 1973.

24. See Irwin, pp. 138, 163, and pl. 143.

25. See Barry's own account accompanying the engravings after the Adelphi scheme (British Museum Print Room).

26. Whitley, *1700–99*, pp. 389–91.

27. See *The Age of Neo-Classicism* exhib. cat., R.A. 1972, pp. 382–3.

28. Gilchrist, p. 55.

29. *Separate Plates*, nos XXVII and XXVIII.

30. *Separate Plates*, nos. XXV–XXVI.

31. Letter to Hayley, 23 October 1804, K. pp. 851–2.

32. *Fitzwilliam cat.* no. 4.

33. Erdman, *Prophet*, ch. 5, 'English Genius and the Main Chance', pp. 89–114.

34. K. p. 51.

35. K. p. 57.

36. Erdman, op. cit., pp. 98–9.

37. K. p. 51.

38. K. p. 52. Erdman, op. cit., pp. 109–10, identifies Steelyard as John Flaxman.

39. Martha W. England, 'Apprenticeship at the Haymarket?' in *Visionary Forms Dramatic*, pp. 3–29.

40. The Rev. John Romney's copy is in the Courtauld Institute Library.

41. *Fitzwilliam cat.* nos 1A, B and C.

42. See a drawing, recto and verso, of the same subject in Philadelphia Museum of Art, reproduced in Keynes, *Drawings*, 1970, pl. 48, and the tempera version, *Tate cat.* no. 48, probably in Blake's 1809 Exhibition.

43. The manner of their reappearance, as recounted by Gilchrist (p. 57), suggests that Blake might have disposed of them during his lifetime.

44. 'Spiritual War: Israel deliver'd from Egypt, is Art deliver'd from Nature and Imitation', *Laocoön* (K. p. 776). See also A. S. Roe, 'The Thunder of Egypt' in A. H. Rosenfeld ed., *Essays for Foster Damon*, pp. 158–98.

45. Erdman (op. cit., p. 99) noted that the paintings sent to the Academy exhibition in 1785 'may reflect some of the artist's feelings of self-justification.'

46. From two preliminary studies for *Joseph Revealing Himself* it is clear that Joseph's exultant gesture of revelation was a late development in the composition. A. P. Oppé, *English Drawings at Windsor Castle*, 1950, no. 65 recto and verso).

47. For an account of Robert Blake see pp. 39–40.

48. *Milton a Poem*, Preface (K. p. 480).

49. The *Job* is known in a first state, which can be dated approximately 1786, and a second state, heavily re-worked, dated 1793. There is no first state of the *Ezekiel*, but its existence can be inferred from the two highly finished drawings of both subjects (Aschenbach Foundation, San Francisco and Phila-

delphia Museum of Art) which must date from the same period as the first state of *Job*. Despite Lindberg's (pp. 12–13) later dating of the original conception of these designs there can be no doubt that the drawings belong to the 1780s.

50. James Barry, *The Works of James Barry, Esq.*, 1809, Vol. II, p. 238.

51. E. Burke, *A Philosophical Enquiry into the Origin of our Ideas of the Sublime and Beautiful*, 1757, 7th edition, 1773, pp. 108–17.

52. See D. Bindman, 'Hogarth's *Satan, Sin and Death* and its influence', *Burl. Mag.*, March 1970.

53. Burke, op. cit., p. 108.

54. *Annotations to Reynolds* (K. p, 476).

55. See R. R. Wark, 'A Note on James Barry and Edmund Burke', *J. W. C. I.*, 1954, pp. 382–4.

56. J. J. Winckelmann, *Gedanken über die Nachahmung der griechischen Werke*, 1755. For Blake's presumed early reading of Winckelmann see p. 17.

57. T. S. R. Boase, 'Illustrations of Shakespeare's Plays in the Seventeenth and Eighteenth Centuries', *J. W. C. I.*, 1947, pp. 83–103.

58. Probably early 1780s; reproduced in *Boston cat.* 1957.

59. *Titania & Bottom*, Tate Gallery; Schiff, p. 753; *Titania's Awakening*, Winterthur, Kunstmuseum; Schiff, p. 754.

60. There are innumerable earlier prototypes for such a motif of the measured dance. Marcantonio's engraving after Raphael (Bartsch, XIV, p. 217) and Poussin's *Dance to the Music of Time* (London, Wallace Collection), are both possible influences upon Blake's design.

61. *A Midsummer Night's Dream*, Act V, sc. ii.

62. An early drawing of a 'Fairy' Character is the watercolour study of a hooded figure (New York, Pierpont Morgan Library) which was later adapted for the design of the 'Caterpillar' in *Gates of Paradise*.

63. *Descriptive Catalogue* (K. p. 570). 'Shakspeare's Fairies also are the rulers of the vegetable world, and so are Chaucer's; let them be so considered and then the poet will be under-

stood, and not else.'

64. *Records*, p. 47 and pl. VI. Another example of Blake's influence upon Flaxman may be seen in a drawing by the latter, almost certainly of the 1780s, of *Baruch writing from the Mouth of Jeremiah in Prison* (York City Art Gallery).

4. Illuminated Printing and Private Mythology

1. Gilchrist, p. 59.

2. *Records*, p. 460.

3. For a detailed and fully illustrated account of Robert Blake see Keynes, *Blake Studies*, pp. 1–7. The authenticity of the joint sketch-book in the Huntington Library seems to me highly doubtful, though Robert's participation is slightly more plausible than William's. Discussion of it has, therefore, been omitted from the present text.

4. *Separate Plates*, no. VII.

5. *Kensington Gardens* in *The Poems of Thomas Tickell*, Bell's British Library, 1781. The design was adapted by Frederick Shields at D. G. Rossetti's behest for the cover of the second edition of Gilchrist's *Life of Blake*, published in 1880. Rossetti, of course, assumed that the design was by William, but Keynes in *Blake Studies* has established Robert's authorship.

6. *Separate Plates*, no. IV.

7. *The Ghost of Abel* (K. p. 781).

8. Blake was to receive only two plates from Boydell and none from Macklin after the early mezzotints made in 1783. He later blamed Flaxman for his lack of success with Macklin (*Public Address*; K. p. 592).

9. A. S. Roe, 'The Demon behind the Pillow: A Note on Erasmus Darwin and Reynolds', *Burl. Mag.*, Vol. 113, p. 460; and Draper Hill, *Mr. Gillray The Caricaturist*, 1965, p. 35.

10. John Knowles, *The Life and Writings of Henry Fuseli*, 1831, Vol. I, p. 174. The scheme decided upon by Fuseli was, of course, for the ill-fated *Milton Gallery*, see p. 104.

11. James Harrison ed., *Printing Patents: Abridgements of Patent Specifications*

relating to Printing 1617–1857, 1859, reprinted 1969. Between 1778 and 1780 several inventions were related to casting types in a body, and in 1784 one to cast words rather than letters (no. 1431).

12. Harrison, op. cit., p. 93.

13. Harrison, op. cit., pp. 93–5.

14. *Records*, p. 58.

15. *Valuable Secrets concerning Arts and Trades*, n.d., p. 2.

16. G. L. Keynes, *William Blake: Poet, Printer, Prophet*, 1965, p. 13.

17. pp. 318–19. The full text of Cumberland's note is as follows:

'NEW MODE OF PRINTING. By Mr. Cumberland.

It had long been conjectured by the author of this paper, in the course of his practice of etching on copper, that a new mode of printing might be acquired from it, viz: by writing words instead of delineating figures on plates. As this is in the power of almost every man, it requires only to know the facility with which it may be accomplished for it to be generally practised.

The inventor in January last, wrote a poem on copper by means of this art; and some impressions of it were printed by Mr. Blake,* in Exchange-alley, Cornhill, which answered perfectly well, altho' it had cost very little more time than common writing. Any number of impressions, in proportion to the strength of the biting in, may be taken off.

The method of performing it is as follows:

Heat a copper plate over a fire, holding it in a hand-vice, then anoint it with a hard varnish tied up in a piece of silk, which is composed of the following ingredients.

Two ounces of virgin wax, two ounces of aspaltum, half an ounce of burgundy pitch, and half an ounce of common pitch, melted together.

Afterwards, whilst the plate is still warm, smooth the ground with a dabber made of thin silk stuffed with cotton, and then smoke the whole surface over the flame of a candle till it is quite black.

All these operations a servant may be taught to execute. Next you are to write with a pen (of gold if possible) on the varnished plate, so as to leave the copper bare; and lastly after making a ridge of wax round the plate, and searing it down, (which in small works, will be best done with a common bougie flattened on account of the cotton wick which keeps it from separating) pour on it a mixture of one third strong aquafortis, and two-thirds common water, which must remain on it a longer or shorter time as the engraving is designed to be deep or faint.

The author thinks this mode of printing may be very useful to persons living in the country, or willing to print very secretly.'

* Unfortunately the Blake mentioned is the wrong one. See 'Engravers called Blake' in Keynes, *Studies*.

18. *Cumberland Papers*, B. M. Add. MS. 36491, Vol. IV, p. 232.

19. Partly quoted by Keynes in *Poet, Printer and Prophet*, p. 13.

20. *Cumberland Papers*, Vol. IV, p. 243f.

21. K. p. 62.

22. *Cumberland Papers*, Vol. IV, p. 363 ff.

23. Keynes, *Poet, Printer and Prophet*, p. 14.

24. R. Todd, 'The Techniques of William Blake's Illuminated Printing', *Print Collector's Quarterly*, November 1948, pp. 25–36.

25. It is worth remarking, perhaps, that there seems to have been an upsurge of interest in methods of engraving amongst English artists in this period. Both Gainsborough and Stubbs experimented with methods in which the qualities of their paintings and drawings were directly communicated in their printing techniques. See J. Hayes, *Gainsborough as Printmaker*, 1971, and B. Taylor, *The Prints of George Stubbs*, exhib. cat. V & A., 1969.

26. For a reconstruction of the manuscript with the existing drawings see G. E. Bentley, Jr., *William Blake: Tiriel*, 1967.

27. Bentley, op. cit., p. 26.

28. Blunt, 1959, p. 11, n. 29, dates them 1789, and Bentley, op. cit., tentatively to the same year. Anne Mellor suggests between 1789–91 (*Blake's Human Form Divine*, 1974, p. 28).

29. For a different interpretation of *Tiriel* see Mellor, op. cit., pp. 28–35.

30. K. p. 103. Mellor argues that the 'vales of Har' have strong positive aspects.

31. Butlin has noted the derivation of Har and Heva's embrace from James Barry's *Jupiter and Juno on Mount Ida* (Sheffield Art Gallery). *Master Drawings*, 1968, p. 279.

32. See for example Lucas de Heere's painting of that subject in the Pinacoteca, Turin.

33. Gilchrist, Vol. II, p. 253, no. 156. Rossetti was able to see the whole group together, before they were dispersed.

34. K. p. 107.

35. *Separate Plates*, no. III.

36. Keynes, *Pencil Drawings*, 1970, no. 8.

37. Bentley, *Tiriel*, op. cit., p. 29.

38. John, xv., 1.

39. K. p. 109.

40. Keynes, *Pencil Drawings*, 1970, no. 5. The verso is also reproduced by Keynes.

41. Keynes suggests Tiriel (*Pencil Drawings*, 1970, no. 5). Butlin has suggested a later date than the period of *Tiriel*.

42. *Fitzwilliam cat.* no. 4 and pl. 7.

43. The discovery was announced by M. J. Tolley in *Blake Studies*, Vol. 3, no. 2, pp. 107–28. They are on the verso of *God appearing to Adam and Eve* and *A couple embracing* in the same series (B. M. 1874–12–12–138 and 1874–12–12–124).

44. For a discussion of this watercolour see p. 138.

45. Butlin suggests that it was painted shortly before the *Tiriel* series (*Tate cat.* no. 6, p. 29).

5. Swedenborg and Swedenborgianism

1. *Records*, p. 35.

2. R. Hindmarsh, *The Rise and Progress of the New Jerusalem Church*, 1861, p. 23. Flaxman did not go on to join the New Church itself.

3. *Records*, p. 432.

4. Charles Augustus Tulk also bought Illuminated Books from Blake. See biographical appendix in exhib. cat. *William Blake*, Hamburg and Frankfurt, 1975, p. 241.

5. The principal commentary is contained in *Arcana Coelestia* (8 vols., 1756).

6. Hindmarsh, op. cit., p. 9. Hindmarsh gives a unique, if one-sided insight into the foundation of the Swedenborgian movement in England, and the ferment it caused in London.

7. Hindmarsh, p. 13, reports that in 1782–3 'on almost all the walls in and for miles round London, the following words were chalked out in large legible characters, viz. 'CHRIST IS GOD'. Wherever the eye was turned this inscription met it; and no one could tell by whom it was done, or when it was done. It continued, however, to excite the attention of the public for several years.'

8. There are copies of Swedenborg annotated in Blake's hand as follows:
 1. *Wisdom of Angels concerning Divine Love and Divine Wisdom*, 1788 (K. p. 89).
 2. *The Wisdom of Angels concerning Divine Providence*, 1790 (K. p. 131).
 3. *Heaven and Hell*, 2nd ed., 1784 (K. p. 929).

9. Reynolds, *Discourses*, III, p. 42.

10. See especially Reynolds, *Discourses*, III, p. 45ff.

11. Swedenborg, *True Religion Revealed*, n. 204–5.

12. *True Religion Revealed*, n. 206–7.

13. Swedenborg, *Doctrine of the Sacred Scripture*, n. 97.

14. See E. H. Gombrich, 'Icones Symbolicae' in *Symbolic Images*, 1972, pp. 123–98.

15. See p. 11 of the present book.

16. Swedenborg, *Arcana Coelestia*, n. 7097.

17. Swedenborg, *True Religion Revealed*, nn. 204, 205.

18. See Blake's lithograph of *Enoch*, *Separate Plates*, no. XVI, also Swedenborg, *True Religion Revealed*, n. 202.

19. Beryl Smalley, *The Study of the Bible in the Middle Ages*, 1941.

20. Gombrich, op. cit., p. 151.

21. *Descriptive Catalogue* (K. p. 581). 'The works of this visionary (Swedenborg) are well worthy the attention of Painters and Poets; they are foundations for grand things.'

22. K. p. 92.

6. The Three Tracts:
There is no Natural Religion,
series *a* and *b*,
and *All Religions are One*

1. This has been done by Sir Geoffrey Keynes in his facsimile editions for the Trianon Press: *There is no Natural Religion*, 1971, and *All Religions are One*, 1970. These editions completely supersede all other editions.

2. Keynes, *There is no Natural Religion*, Bibliographical Statement.

3. Huntington Library (Keynes & Wolf, p. 8). This copy can now be 'completed' by the relatively recently discovered title-page, impressions of which are in a private collection and in the Victoria and Albert Museum.

4. There is no reason to suppose that it had the same title as series *b*: in fact it is highly unlikely, but the title has been retained for the sake of clarity.

5. Muir in his facsimile edition of 1886 interpolated his own suggestion for Proposition III: 'The perceptions of the poetic or prophetic character are not bounded as the perceptions of the senses are.'

6. K. p. 98.

7. See *A vision of the Last Judgement* (K. pp. 604–5).

8. G. L. Keynes ed., *All Religions are One*, 1970. Keynes argues that *All Religions are One* was completed first. (Trianon Press ed., Bibliographical Statement).

9. *Letter to Trusler*, 23 August 1799 (K. p. 793).

10. See particularly the unpublished design 'To the Queen'. British Museum, 1894–6–12–14.

11. Keynes ed., *There is no Natural Religion*, op. cit., Bibliographical Statement.

7. The Landscape of Innocence

1. See *Island in the Moon* (K. p. 59). For Blake singing his poems at a soirée at the Mathew household see Smith, *Records*, p. 457.

2. Keynes and Wolf, list nine copies produced 1789–94, to which may be added the incomplete copy in the Raymond Lister Collection (see *Hamburg cat.* nos 21–7). See also *Illuminated Blake*, p. 69.

3. The colouring of many copies has been attributed to Mrs Blake, but it is difficult in practice to distinguish her hand from that of William.

4. Keynes and Wolf, copy E.

5. Keynes and Wolf, copy P.

6. *Bibliography*, no. 401.

7. *Lady's Poetical Magazine*, Vol. I, 1787.

8. Published by Stothard himself. See R. Balmanno Album of Stothard engravings, British Museum Print Room.

9. Balmanno Album. This fascinating design is an even clearer precedent for Robert Blake's design of the king and queen in a flower (Notebook f. 4), which Blake adapted for plate 5 of the *Song of Los*. See p. 84 and pl. 71.

10. See *Farington Diary*, ed. J. Grieg, Vol. I, pp. 151–2.

11. See also the Butts tempera painting of the *Christ Child riding a Lamb* (Victoria and Albert Museum, *Ills. to Bible*, no. 100).

12. For example two paintings by Titian in the National Gallery: *The Holy Family with a Shepherd* (no. 4) and *Madonna and Child with Saints* (no. 635).

13. Despite the dispute in the *Blake Newsletter* (nos 1, p. 9; 2, pp. 7–9 'Recognising Father'; 3, pp. 17–18 'Recognising Mother') it is inconceivable to me that the figure leading the boy could be anyone but Christ.

14. Blake may have known Raphael's composition through one of the many painted versions or engravings after it. (L. Dussler, *Raphael: A Critical Catalogue*, 1971, pl. 73).

15. I am deeply grateful to Mr E. Croft-Murray who introduced me to the work of John Sturt and gave invaluable advice on eighteenth-century illustration and printing. The most convincing evidence of direct medieval influence upon the *Songs of Innocence* is Blunt's suggestion (p. 48) that the *Introduction* page could be derived from a Jesse-Tree motif.

16. A remarkable visual parallel to the *Songs of Innocence* can be found in certain French *Livres de piété* of the late eighteenth century. See A.-J.

L'Héritier, *La Messe Pascale, Poème,* Paris, 1772; discussed in *Bulletin Pierre Berès,* no. 77, November 1964. I am indebted to Professor Sir Anthony Blunt for this reference.

17. H. Helsinger, 'Images on the *Beatus* Page of some Medieval Psalters', *Art Bulletin,* June 1971, pp. 161–76.

18. For a different view see J. H. Hagstrum, *William Blake: Poet and Painter,* 1964, p. 27ff.

19. Keynes and Wolf, pp. 19–25.

20. For a completely different view of *The Book of Thel* see Mellor, op. cit., pp. 34–9. See E. S. Darwin, *The Loves of the Plants,* part II of *The Botanic Garden,* but first issued separately in 1789. (Bibliography, 363A.)

21. Not previously reproduced. Preston, Graham Roberston Collection, 199, no. 89.

22. For another depiction of 'moans' see Young's *Night Thoughts,* Night III, no. 6, watercolour (British Museum).

23. *Gates of Paradise* (K. p. 770).

24. For the eagle as 'Inspiration' see *Marriage of Heaven and Hell,* pl. 15.

25. Notably on pl. 11 of *America.*

26. Keynes and Wolf list fifteen copies.

27. For Isaac d'Israeli as a collector of Blake's Illuminated Books, see p. 96 and *Records,* pp. 243–4.

28. See particularly the copies of *Songs of Innocence* and *Experience,* and *America* and *Europe* in the Fitzwilliam Museum, Cambridge (cat. nos 5, 13 and 15).

29. New Haven, Conn., Yale University Library.

30. Keynes and Wolf, p. 10.

31. Keynes and Wolf, copy A, Harvard College Library.

32. Keynes and Wolf, copy E, Yale University Library.

33. Keynes and Wolf, copy M, private coll., Scotland.

34. See for example Stothard's illustrations to Langhorne's *The Fables of Flora,* 1794 (impressions in Balmanno Album).

8. Revolutionary Intimations

1. See M. D. Paley, *Energy and the Imagination,* 1970, 'The Sublime of Energy', pp. 1–28.

2. Blake's own copy of *Heaven and Hell* was a second edition of 1784, but he was not the first owner. For his annotations see K. p. 929 (supplement).

3. *The Marriage of Heaven and Hell,* pl. 3 (K. p. 149).

4. Ibid., pl. 6 (K. p. 150).

5. Ibid., pl. 12 (K. p. 153).

6. Ibid., pl. 13 (K. p. 154).

7. Cf. Michelangelo's definition of sculpture, as created by removal, 'per forza di levare', as opposed to painting, which he declared to be additive. G. Milanesi, *Le Lettere di Michelangelo Buonarroti,* 1875, p. 522.

8. *The Marriage of Heaven and Hell,* pl. 14 (K. p. 154).

9. *Annotations to Reynolds.* K. p. 454. For a different interpretation of the 'printing house' see *Illuminated Blake,* pp. 18–19.

10. *The Marriage of Heaven and Hell,* pl. 20 (K. p. 157).

11. Northrop Frye, 'Poetry and Design in William Blake', in *Discussions of William Blake,* J. E. Grant ed., 1961.

12. See W. T. Mitchell, 'Blake's Composite Art', in *Visionary Forms Dramatic,* p. 57.

13. Mitchell, op. cit., p. 65.

14. For Rintrah and his passive counterpart, Palamabron, and their appearance in *Europe* and *Milton a Poem,* see pp. 79–80, 173.

15. *The Marriage of Heaven and Hell,* pl. 2 (K. pp. 148–9).

16. See, for example, Mitchell in *Visionary Forms Dramatic* op. cit., and Erdman et al., 'Reading the Illuminations of Blake's *M. H. H.*'. *Essays in Honour of Sir Geoffrey Keynes,* pp. 162–207.

17. Fitzwilliam Museum. Reproduced in Blunt, *Art of William Blake,* pl. 32C.

18. See p. 38.

19. *Tate cat.* no. 23. The title was given to it by Blake in an account with Butts of 3 March 1806.

20. *The Marriage of Heaven and Hell,* pl. 5 (K. p. 150).

21. L. Goldscheider, *Michelangelo Drawings,* 1966, no. 93.

22. See E. Arwaker's preface to H. Hugo's *Pia Desideria or Divine Addresses,* 1712: 'As in the first Poem of the

second Book, where the Author brings in Phaethon as an example of Mens' desiring Liberty in choosing, tho' their choice proves oftentimes their Ruin. I have used the Prodigal Son as more suitable in that Design.' I owe this reference to Miss Frances Carey.

23. Erdman in *Essays in Honour of Sir Geoffrey Keynes*, p. 174.

24. K. p. 154.

25. *Keynes and Wolf*, p. 85, copy A.

26. See p. 80.

27. See Keynes and Wolf, copies H and I.

28. Keynes and Wolf, copy D.

29. 'Why is one law given to the lion & the patient Ox?'

30. Gilchrist, Vol. I, p. 88.

31. E.g. Keynes and Wolf, copy H.

32. *Fitzwilliam cat.* nos 9 and 10.

33. D. V. Erdman, *Poetry and Prose of William Blake*, 1965, p. 723, 'from evidence of historical allusions in the "Song of Liberty".'

34. Keynes and Wolf, copy C. This Morgan copy is completely different in character from the more familiar late copies. In the title-page, for example, red watercolour is washed in carefully within the contours of the flames, and the general tint throughout the book is a pale blue. In fact this early dating would fit in with Erdman's 'g-hypothesis', see *Blake Newsletter*, Summer 1969, Vol. 3, no. 1, p. 8.

35. For example the Berg copy (Keynes and Wolf, copy E).

9. The Continental Myth

1. M. D. Paley, 'William Blake, The Prince of the Hebrews and The Women Clothed with the Sun', in *Essays for Sir Geoffrey Keynes*, pp. 260–93.

2. Often called the 'Lambeth Books' but it is now known that Blake began to live in Lambeth in 1790 and not 1793 (*Records*, p. 560).

3. K. pp. 134–48. See Gilchrist, Vol. I, pp. 92–5, and Erdman, *Prophet*, p. 153f., and also W. F. Halloran, 'The French Revolution: Revelation's New Form', in *Visionary Forms Dramatic*, p. 30.

4. D. V. Erdman, 'Blake's Vision of Slavery', *J. W. C. I.*, XV, 1952, pp. 242–52.

5. For examples of each arrangement see Keynes and Wolf, pp. 27–8.

6. Erdman, 'Blake's Vision of Slavery', op. cit., p. 242.

7. *The Marriage of Heaven and Hell*, pl. 14 (K. p. 154).

8. Jacob Bryant, *A New System; or an Analysis of Antient Mythology*, 3rd ed., 1807, Vol. III, p. 295 and pl. XXV.

9. For a selection of explanations see J. A. Warner, 'Blake's use of gesture', in *Visionary Forms Dramatic*, pp. 193–4.

10. Erdman, 'America: New Expanses', in *Visionary Forms Dramatic*, p. 95.

11. For 'A breach in a city' see pp. 31–2.

12. Erdman, 'America', op. cit., p. 100.

13. For example in a mysterious print dated 1812. *Separate Plates*, no. XVIII, 'The Chaining of Orc'.

14. For another explanation see Erdman, 'America', op. cit., pp. 100–1.

15. K. p. 233.

16. K. p. 263.

17. For Adam and Eve as representative of Reason and the Senses, see p. 111. Martin Butlin has pointed out the parallel between the *Chaining of Orc* motif and the subject of *The Discovery of the Body of Abel* (Tate Gallery).

18. K. p. 198.

19. K. p. 198.

20. K. p. 198.

21. For a suggestive interpretation of this plate see R. Essick, 'Blake and the Traditions of engraving' in *The Visionary Hand*, 1973, pp. 509–10.

22. Erdman, 'America', op. cit., pp. 110–11.

23. Erdman, 'America', op. cit., p. 109.

24. M. Tolley, 'Europe: "to those ychain'd in sleep" ' in *Visionary Forms Dramatic*, pp. 115–45. For the present purposes the copy normally referred to is Keynes and Wolf, copy D (in the British Museum Print Room). This copy has written in it poetic parallels to each image in an early hand, identified by Keynes and others as George Cumberland, but this copy, according to Bentley, was owned by Ozias Humphry, who might have lent it to Cumberland (letter to author, 2 December 1975). I am not completely convinced, however, that the hand in *Europe D* is Cumberland's.

25. Tolley, op. cit., pp. 119ff.

26. Newton, because he gives form to the 'atheism' of Natural Religion, represents the last stage of the Old Order, *Europe*, pl. 13, p. 243.

27. *Paradise Lost*, Book VII, 194–6.

28. Northrop Frye, 'Poetry and Design in William Blake', in J. E. Grant ed., *Discussions of William Blake*, 1961.

29. The early hand has transcribed in the British Museum copy at this point the poem *The Pilgrim* by Ann Radcliffe.

30. Erdman, *Prophet*, p. 219.

31. This motif of a malevolent fiend pushing down ascending souls can also be seen in designs by Flaxman, but they cannot be firmly dated (University College, London). Erdman argues that the motif is derived from Gillray, see 'William Blake's debt to James Gillray', *Art Quarterly*, XII, 1949, pp. 165–70.

32. See Pauly-Wissowa, *Real-Encyclopädie der classischen Altertumswissenschaft*, Elfter Band.

33. For differing interpretations see A. Blunt, review of *Visionary Forms Dramatic* in *Yale Review*, Winter 1972, LXI, no. 2, p. 301.

34. I. Chayes, 'The Presence of Cupid and Psyche' in *Visionary Forms Dramatic*, p. 219.

35. See pp. 31–2.

36. Blake may also have had in mind the association of the prophet as a watchman over his people in Isaiah, xxi, 6 and also *Jerusalem*, frontispiece and pl. 85.

37. See also *Tiriel denouncing his Four Sons and Five Daughters* (Bentley, *Tiriel*, drawing no. 8).

38. Not observed by Erdman, but clear in lightly colour-printed copies.

39. Keynes and Wolf list only 5 copies.

40. See pp. 39–40.

10. The Process of Creation:
from the *Notebook*
to *Songs of Experience*

1. K. p. 825.

2. Pencil drawing in the British Museum, no. 1874–12–12–147.

3. Keynes and Wolf, proof a. See also the fragment of a plate for this page in the Rosenwald Coll.

4. There are two editions of the *Notebook*, often known as the *Rossetti Notebook* because it was owned by D. G. Rossetti: G. L. Keynes, ed., *The Notebook of William Blake*, 1935; and D. V. Erdman ed., *The Notebook of William Blake*, 1973.

5. Keynes, *Blake Studies*, 'Blake's Notebook', pp. 8–14.

6. Erdman *Notebook*, n. 14. Erdman suggests 1787 as the year of conception.

7. Erdman, *Notebook*, p. 49.

8. Erdman, *Notebook*, pp. 47–8.

9. The actual numbering of 'Ideas of Good and Evil' is highly confused, therefore Erdman's numbering has been adopted for the sake of clarity.

10. See pp. 31–2.

11. K. p. 6. This motif seems to derive from Quarles' *Emblemes*, Book 5, no. x: 'Bring my Soule out of Prison that I may Praise thy Name, Ps. 14, 2, 7.'

12. A drawing of a similar motif inscribed 'Fate' is in a private coll.

13. For a diagrammatic analysis of the changes see Erdman, *Notebook*, p. 64.

14. G. L. Keynes ed., *The Gates of Paradise*, Trianon Press, 1968. Introductory volume, pp. 1–2. This edition also contains a facsimile of the considerably revised version of c. 1818 entitled 'For the Sexes', instead of 'For Children'.

15. K. pp. 207–8.

16. The Emblem 'Water' is derived from the man contemplating suicide in 'Emblems of Good and Evil' no. 61, while 'Air' is derived from no. 60, which is captioned in the *Notebook* 'Thou hast set thy heart as the heart of God—Ezekiel.'

17. The superb colour-printed copy of *Experience* alone in a Scottish private coll. (Keynes and Wolf, copy H) was probably originally part of a composite volume.

18. Keynes and Wolf, copy A.

19. The germ of this motif may possibly be found in a drawing from life by Flaxman of a boy carrying a younger one on his shoulders (Christopher Powney Coll.).

20. For a survey of the widely differing

interpretations of the poem and design of *The Tyger* see M. D. Paley, 'Tyger of Wrath', P. M. L. A., Vol. LXXXI, December 1966, no. 7.

11. The Myth of Creation:
The Completion of the Bible of Hell
and the Large Colour Prints

1. All copies but one are entitled by Blake *The First Book of Urizen*, but no other books followed, although he may at one point have thought of the *Books of Ahania* and *Los* as part of the same series.
2. See Erdman, *Illuminated Blake*, p. 182, and Keynes and Wolf for the ordering of each copy.
3. The only non-colour-printed copy, Keynes and Wolf copy G, is evidently much later, dating from after 1818. See G. L. Keynes, *The Book of Urizen*, Trianon Press facsimile, 1958.
4. *The Marriage of Heaven and Hell*, copies E and F. *Visions of Daughters of Albion*, copy F.
5. Keynes and Wolf, copies F, G, and H.
6. 'He who does not imagine in stronger and better lineaments, and in stronger and better light than his perishing and mortal eye can see, does not imagine at all.'
7. For Tatham's account and Butlin's commentary upon it and for further bibliography see *Tate cat.* p. 34.
8. Keynes and Wolf, copy H.
9. As in, for example, the Isaac d'Israeli copy in the Morgan Library (Keynes and Wolf, copy B).
10. *Annotations to Reynolds* (K. p. 446).
11. *Illuminated Blake*, p. 183. Erdman claims that Urizen is copying from 'nature's book'.
12. The numbering of the plates adopted here follows Keynes and Wolf, pp. 70–2.
13. *Farington Diary*, Grieg ed., op. cit., Vol. I, years 1793–5.
14. See, for example, *Annotations to Reynolds* (K. pp. 445–6).
15. J. Flaxman, *Compositions from the Tragedies of Aeschylus*, 1793, pls 3, 4.
16. For Hephaestus as Mulciber see *Paradise Lost*, I, 730–46.
17. Cupid is, however, very rarely depicted as an adolescent, and Los's jealousy may also reflect Vulcan's jealousy of Mars whose adultery with Venus was an equally popular Renaissance subject.
18. K. p. 98.
19. *Descriptive Catalogue*, K. p. 565: 'neither will any one believe, that the Greek statues, as they are called, were the invention of Greek Artists'.
20. The plate is omitted in Keynes and Wolf, copies D, E, F and G.
21. The Isaac d'Israeli copy (Pierpont Morgan Library) is an early one and the numbering of the plates is certainly in Blake's hand, while the Dimsdale copy (Mellon Coll.) is probably a little later. The full-page ills. in *The Book of Urizen* can be roughly divided into two groups: those which pertain to the creation of Urizen, and those which show him as an active force. In the Dimsdale copy this division is not followed in the order of the plates. Pl. 22, showing Urizen fettered, for example, which seems to belong with the creation of the form of Urizen, is placed towards the end of the Dimsdale copy, but in the Morgan copy it follows, as one might expect, the plate of Los resting next to the half-formed, skeletal form of Urizen (pl. 11), which is also chained. The essential coherence of the Morgan copy is, however, evident upon close examination. Here the normally rejected pl. 4 is followed by the figure of Los or Urizen diving to the bottom of the sea (pl. 14), an image redolent of chaos; the incoherent figure of Urizen floating in the water (pl. 12) is related to Los's mental agony as the rocks close in upon him, instead of, as in Dimsdale, following on from an image of Urizen squatting inside a cave. The sequence of the fall of Los and union with Enitharmon is also perfectly clear in the Morgan copy; Los's weariness (pl. 18) is followed by: the astonishing image of the apparent emergence of Enitharmon from, in the Morgan copy, a veinous blood-filled globule (pl. 17); her rejection of Los (pl. 18); the emergence of the four senses (pl. 24); the birth of Orc (pl. 20); and the taming of Orc at the forge of the fallen Los (pl. 21).

22. Keynes and Wolf, pp. 94–7.

23. This image contains an unmistakable reflection of Giulio Romano's *Sala dei Giganti* in the Palazzo del Tè in Mantua, perhaps through an engraving or through a Wedgwood plaque of the *Fall of the Titans* (example in the Sir John Soane Museum, London).

24. *Dictionary of National Biography*.

25. Keynes and Wolf, xviii.

26. *Hamburg cat*. pp. 240–1.

27. Keynes and Wolf, copy A.

28. *Thel*, copy I, and *Marriage*, copy B.

29. *Hamburg cat*. pp. 240–1.

30. Keynes and Wolf, copy B. New York, Pierpont Morgan Library.

31. Keynes and Wolf, copy K.

32. Letter to Dawson Turner, 9 June 1818 (K. p. 867).

33. According to Keynes, Humphry went blind in 1797 (Keynes and Wolf, p. 85).

34. Keynes and Wolf, pp. 85 and 89.

35. Letter to Dawson Turner, 9 June 1818 (K. p. 867).

36. Keynes and Wolf, p. 86.

37. *Separate Plates*, no. II. See D. V. Erdman, 'The Dating of William Blake's Engravings', R. Essick ed., *The Visionary Hand*, 1973, p. 161.

38. *Separate Plates*, no. VII.

39. *Separate Plates*, no. X. The scene shows Joseph's staff miraculously flowering into a thorn tree.

40. *Separate Plates*, no. XIII. The uncoloured engraving was only discovered after publication of *Separate Plates*.

41. *Boston cat*. 'The King of Babylon'.

42. Keynes and Wolf, *America*, proof d.

43. M. Butlin, 'The evolution of Blake's Large Colour Prints' in *Essays for S. Foster Damon*, 1969, pp. 109–16.

44. *Records*, p. 572.

45. Letter to Dawson Turner, 9 June 1818 (K. p. 867).

46. Quoted from Gilchrist by Butlin, *Tate cat*. no. 34.

47. *Tate cat*. nos 16 and 17.

48. *Tate cat*. no. 14.

49. For the relatively recent identification of this subject see M. Butlin, 'Blake's "God judging Adam" rediscovered', *Burl. Mag.*, CVII, 1965, pp. 86–9.

50. Paley, *Energy and the Imagination*, op. cit., pp. 81–8.

51. Genesis, 4, 23–4.

52. See p. 35.

53. *Tate cat*. no. 22.

54. See *Jerusalem*, pl. 51.

55. See J. Gage, 'Blake's *Newton*' in *J. W. C. I.*, 1971, p. 376.

56. Newton blows the trump which awakens Enitharmon in *Europe*, K. p. 243.

12. The Lambeth Books and Blake's Contemporaries

1. *Records*, p. 50.

2. *Records*, pp. 57–8.

3. He was eventually expelled from the Royal Academy in 1799, an apparently unique distinction. See Whitley, *1700–99*, Vol. II, p. 227f.

4. R. Gunnis, *Dictionary of British Sculptors, 1660–1851*, n.d., p. 39.

5. Fuseli was able to take over the Professorship of Painting from Barry in 1799 when the latter was expelled.

6. W. Hayley, *Life of George Romney, Esq.*, 1809, p. 203.

7. *Records*, p. 45.

8. K. p. 564 et al.

9. Bentley, *Bibliography*, no. 362.

10. Cumberland, op. cit., p. 22.

11. Letter to Dr Trusler, 16 August 1799 (K. pp. 791–2).

12. Fuseli, *Lectures on Painting to the Royal Academy*, 1801, Lecture I.

13. Fuseli, *Lectures on Painting*, 1801, Lecture I, pp. 71–2.

14. Fuseli, in *Analytical Review*, October 1792. Quoted in E. C. Mason, *The Mind of Henry Fuseli*, 1951, p. 216.

15. J. J. Winckelmann, *Gedanken über die Nachahmung der Griechischen Werke*, 1755, part IV.

16. Reynolds, *Discourses*, no. XV; Wark ed., 1959, p. 275.

17. See also the letter to Cumberland of 2 July 1800: '[Fuseli] is not naturally good natured, but he is artificially very ill-natured.' (K. p. 798).

18. *Farington Diary*, *Records*, p. 52.

19. See Schiff, 1973, Vol. II, Abbildungen, p. 384, no. 1226.

20. See William Bell Scott's reference to Fuseli in *Autobiographical Notes*, 1892, pp. 22–3.

21. Knowles, *The Life and Writings of Henry Fuseli*, 1831, Vol. I, p. 172.

22. Reproduced G. Schiff, *J. H. Fuseli's*

Milton-Galerie, 1963, pl. 21. Schiff, 1973, dates the drawing 1794–6 (no. 1020).

23. See Blunt, *The Art of William Blake*, pls 27a and b.

24. As in, for example, the painting *Melancholy*, c. 1799–1801; Schiff, 1973, no. 908.

25. Catalogue of *Milton Gallery*, picture IV, Book I, 781. The painting is now in the Tate Gallery.

26. Cat. of *Milton Gallery*, picture VIII, Book II, 662.

27. See W. Rensselaer Lee, *Ut Pictura Poesis*, 1967.

28. Burke, op. cit., p. 43.

29. See Lessing, *Laokoon*, Section II, passim.

30. Lessing, op. cit., section XIII.

31. Fuseli, *Analytical Review*, June 1788. Quoted in E. C. Mason, *The Mind of Henry Fuseli*, 1951, p. 204.

32. Fuseli, *Analytical Review*, November 1794. Quoted by Mason, op. cit., pp. 206–7.

33. See D. Irwin, ed., *Winckelmann, Writings on Art*, 1972, p. 146.

34. W. Hindmarsh, *The Rise and Progress of the New Jerusalem Church*, 1861, p. 23. See also R. Joppien, exhib. cat. *Philippe de Loutherbourg*, Kenwood, 1973.

35. *Macklin Bible*, 1800.

36. The original painting is in the Tate Gallery.

37. W. Hayley, *Life of George Romney*, 1809, p. 212.

38. See P. Milne-Henderson, exhib. cat. *The Drawings of George Romney*, Smith College Museum, Northampton, Mass., 1962.

39. The former is cited in R. Lister, *British Romantic Painting*, 1973, p. 85, and the latter is in the British Museum Print Room.

40. *Records*, p. 341. Linnell apparently took Ottley to meet Blake for the first time on 17 April 1827.

41. E. F. Bell, *Annals of Thomas Banks*, 1938, pp. 83–4.

42. See R. Rosenblum's essay in exhib. cat. *Romantic Art in Britain*, 1968; Detroit and Philadelphia, pp. 11–16.

43. L. Fernow, *Leben des Künstlers Asmus Jakob Carstens*, 1806, pp. 69–70 passim.

Q

13. Young's *Night Thoughts* and Gray's *Poems*

1. For the difficult problem of dating this manuscript see G. E. Bentley, ed., *Vala or The Four Zoas*, 1963, and the review by D. V. Erdman in *The Library*, Vol. XIX, 1964.

2. *Farington Diary, Records*, p. 52. For a further account of the *Night Thoughts* project see M. D. Paley, 'Blake's *Night Thoughts*: an exploration of the Fallen World' in *Essays for Foster Damon*, pp. 131–57. At the time of writing there is no complete edition of the *Night Thoughts* ills.

3. Bentley, *Bibliography*, no. 422.

4. See also Blake's satirical reference on the taste for 'Churchyard' poets in *Island in the Moon* (K. p. 52).

5. The Nine Nights are titled as follows: 1. *Life, Death and Immortality*; 2. *Time, Death and Friendship*; 3. *Narcissa*; 4. *The Christian Triumph*; 5. *The Relapse*; 6. *The Infidel Reclaim'd*; 7. *The Infidel reclaim'd* (part II); 8. *The Man of the World answered*; 9. *The Consolation*.

6. See also Blake's quotation from Milton in the *Annotations to Reynolds*, heading to chapter III (K. p. 457).

7. In the *Paradise Lost* ills, no. 12 (Boston Museum of Fine Arts), Adam steps on a thorny branch as he enters Experience.

8. *Illuminated Blake*, p. 169.

9. There are two modern editions of the Gray illustrations: Irene Tayler, *Blake's Illustrations to the Poems of Gray*, 1971, and G. L. Keynes, ed., *William Blake's Water-colour Designs for the Poems of Thomas Gray*, 1972.

10. For this relatively recent discovery see the announcement by Mary K. Woodworth, *Notes and Queries*, CCXV (new series, XVII), August 1970, pp. 312–13.

11. *Fitzwilliam cat.*, no. 45. A drawing of Blake was included in this volume.

12. Irwin, *English Neoclassical Art*, pp. 141–3.

13. I. Tayler, *Illustrations to Gray*, op. cit., p. 10.

14. The Butts Tempera Series

1. For Butts see G. E. Bentley, 'Thomas Butts, White Collar Maecenas', *P. M. L. A.*, LXII, 1956, pp. 1052–66.
2. K. p. 792.
3. M. Butlin, 'The Blake Collection of Mrs W. T. Tonner', *Philadelphia Museum of Art Bulletin*, July–September 1972, Vol. LXVII, no. 307, pp. 13–16.
4. K. p. 793.
5. See especially Reynolds, *Discourses*, III, Wark ed., pp. 44–5.
6. K. pp. 794–5.
7. *Advert. for Exhibition*, 1809 (K. pp. 560–1).
8. J. T. Smith, *Nollekens and his Times*, 1828 (*Records*, p. 472). See also *Fitzwilliam cat.*, pp. 21–2.
9. Gilchrist, Vol. II, p. 201f. Hereafter referred to as 'Rossetti'; 'C.W.' for 'Works in Colour'.
10. Rossetti mentions the following tempera paintings, but none of them is known today:
 i. *The expulsion from Eden* in 'Tempera on black ground', belonging to Lord Coleridge. (Rossetti, C. W. 110.)
 ii. '*The sons of God saw the daughters of men*'. Genesis, vi, 2. dated 1799. This identification seems unlikely from the description of the painting. (Rossetti C. W. 27.)
 iii. *Rachel giving Joseph the coat of many colours.* (Rossetti C. W. 25.)
 iv. *Moses placed in the ark of the bulrushes.* (Rossetti C. W. 14.) The painting is lost, but from Rossetti's description it is clear that the composition is closely reflected in a late watercolour, *c.* 1824, in the Huntington Library, and in an engraving for *Remember Me!*, 1824. (*Bibliography*, no. 400A.)
 v. '*Pharaoh's Daughter and Moses*' in the Butts sale of 1853 may be the same as no. 4 above.
 vi. *Samson pulling down the Temple.* Rossetti's description suggests that subject might be correct. (Rossetti C. W. 122.)
 vii. '*The Plague stayed at the threshing-floor of Araunah the Jebusite*'. An unlikely subject, but it might from the description be the panel known as *Moses indignant at the Golden Calf.* (Rossetti C. W. 127.)
 viii. *Esther Before Ahasuerus.* (Rossetti, C. W. 131.)
 ix. *Susannah and the Elders.* (Rossetti, C. W. 130.)
11. *Fitzwilliam cat.* no. 33.
12. *Tate cat.* no. 45.
13. 'Abraham, Moses, Solomon, Paul, Constantine, Charlemane, Luther; these seven are the Male-Females, the Dragon Forms. Religion hid in War, a Dragon red and hidden Harlot.' *Milton a Poem*, pl. 37 (K. p. 528).
14. See T. D. Meyer, 'Benjamin West's Chapel of Revealed Religion: A study in Eighteenth-Century Protestant Religious Art', *Art Bulletin*, Vol. LVII, no. 2, June 1975, pp. 247–65. West's scheme was apparently divided according to the following Dispensations: Antediluvian and Patriarchal; Mosaical; Gospel; and Revelation.
15. See C. Harbison, *Symbols in Transition*, exhib. cat. Art Museum, Princeton University, 15 March–13 April 1969.
16. Blake's painting is particularly close in composition to the well-known engraving after Paolo de Mattheis of the *Judgement of Hercules* in the Earl of Shaftesbury's *Characteristics of Man*, 1714, Vol. III, the subject of the celebrated essay '*A Notion of the Historical Draught or Tableture of the Judgement of Hercules.*'
17. K. p. 580.
18. K. p. 578.
19. Numerous examples are to be found in medieval Biblical cycles.
20. In *An Epitome of Hervey's Meditations among the Tombs* (Tate Gallery) and *The Spiritual Condition of Man* (Fitzwilliam Museum).
21. See note 10.
22. A. S. Roe, 'The Thunder of Egypt' in Rosenfeld ed., *Essays for S. Foster Damon*, pp. 158–98.
23. The subject is not uncommon in Italian art but it occurs usually in cycles of the life of John the Baptist. In the depiction by Giotto in S. Croce in Florence the transition between the two Dispensations is made explicit by the placing of Temple celebrants on the left, with Zacharias and Mary and

Elizabeth on the right with the Angel. There is also an engraving by Heemskerk (Hollstein, p. 290) which Blake must surely have known.

24. M. Butlin, 'The Blake Collection of Mrs W. T. Tonner', *Philadelphia Museum of Art Bulletin*, July–September 1972, Vol. LXVII, no. 307, p. 17ff.

25. *Infant Sorrow* in *Songs of Experiences* (K. p. 217).

26. See pp. 193–4.

27. Rossetti, C. W. 136.

28. The originator of the motif seems to have been Michelangelo in his drawing of the subject, and Blake may have known it through Bonasone's engraving of 1561. In the Michelangelo drawing it is St John who raises his finger in silence. See Enriqueta Harris Frankfort, 'El Greco's Holy Family with the sleeping Christ child' in R. Enggass and M. Stokstad ed., *Hortus Imaginum*, 1974, pp. 103–11.

29. For other intimations of the legend of Cupid and Psyche see I. Chayes, 'The presence of Cupid and Psyche', *Visionary Forms Dramatic*, pp. 214–43.

30. Blunt, *The Art of William Blake*, p. 66.

31. A copy is in the Tate Gallery, cat. no. 34.

32. Blunt in *J. W. I.*, II, 1938–9, p. 60, pl. 100.

33. See for example the classical temple and primitive constructions of Druid character under the Biblical scenes at the bottom left of the Fitzwilliam Museum *Spiritual Condition of Man*.

34. Rossetti, C. W. 32. Apparently dated 1799 and described by Rossetti as 'An inferior specimen'.

35. Rossetti, C. W. 137.

36. Rossetti, C. W. 141.

37. *Tate cat.*, no. 26.

38. Rossetti, C. W. 198.

39. Rossetti, List 3, 'Works of unascertained method', no. 15.

40. The former is in Rossetti, list 3, no. 8, and the latter is mentioned in 1853 and 1854 Butts sales.

41. K. p. 794.

42. A. Blunt, 'The Triclinium in Religious Art', *J. W. I.*, Vol. II, 1938–9, pp. 271–6.

43. *Tate cat.* no. 27.

44. *Tate cat.* no. 28.

45. See note 40.

46. Apart from references in the volumes of Whitley the chief source of information upon the sales of French collections in London is W. Buchanan, *Memoirs of Painting, with a chronological history of the Importation of Pictures by the Great Masters into England*, 1824.

47. K. p. 792.

48. National Gallery, no. 47. According to the catalogue the painting was bought by an English collector in Paris in February 1801, and reached the Angerstein Coll. by 1807. Blake is unlikely to have seen the actual painting but there was an engraving after it by S. Bernard.

49. According to the National Gallery catalogue the painting did not arrive in England until after 1827, but it was engraved earlier.

50. See John Gage, *Colour in Turner*, 1969, p. 60f.

51. See Buchanan, op. cit., p. 19. The exhibition opened on 26 December 1798.

52. See, for example, the affair of the Venetian Secret in 1797. Whitley, *1700–99*, Vol. II, p. 209f.

53. K. p. 797–8.

54. Blunt, *Poussin*, catalogue, nos 105–18. The First Series, now mainly at Belvoir Castle, was exhibited at the Royal Academy in 1787; the Second Series, now on loan to the National Gallery of Scotland, was in the Orléans coll. and was bought in 1798 by the Duke of Bridgewater.

55. Blunt, *Poussin*, cat. no. 11. It was exhibited with the Orléans Coll. in 1798–9, before being acquired by Richard, Earl Temple. For Blake's approval of Poussin see K. p. 477.

56. From Willoughby, *Practical Family Bible* (Schiff no. 320).

57. *Advert. for 1809 Exhibition* (K. p. 561).

58. All three were bought from the Orléans Coll. by the Duke of Bridgewater in 1798, and were exhibited subsequently. (Dussler, pls 59, 60 and 99.)

59. See p. 17. Cf. also Francis Haskell's fascinating suggestion that the profusion of High Renaissance works in

London about 1800 served to retard taste for earlier art (*Rediscoveries in Art*, 1976, p. 25f).

60. See M. Whinney, 'Flaxman and the 18th century', *J. W. C. I.*, XIX, 1956, pp. 269–82.

61. R. Rosenblum, *Transformations in later Eighteenth-Century Art*, 1970, pp. 161–2 and figs 190 and 191.

62. Rosenblum, op. cit., p. 28ff.

63. See p. 36.

64. M. Whinney, *Sculpture in Britain, 1530–1830*, 1964, p. 192 and pl. 145.

65. *Fitzwilliam cat.* no. 24.

66. *Fitzwilliam cat.* no. 22.

67. *Tate cat.* no. 37.

68. *Fitzwilliam cat.* no. 22. This observation was made by Mr Malcolm Cormack.

69. *Tate cat.* no. 36.

70. This watercolour is sometimes dated 1808, presumably because of its presence in Blake's 1809 Exhibition (*Descriptive Catalogue*, K. p. 584), but this must be too late.

71. Blunt, *The Art of William Blake*, p. 73. For an interesting analogy between this design and a description of Albion in the *Four Zoas* see Mellor, op. cit., pp. 209–10.

72. See W. D. Robson-Scott, *The Literary Background of the Gothic Revival*, 1965.

15. Felpham

1. Letter to John Flaxman, 21 September 1800, (K. p. 802).

2. Letter to John Flaxman, 21 September 1800 (K. p. 802).

3. For a full account of Hayley see Morchard Bishop, *Blake's Hayley*, 1951.

4. There are three miniatures of the Butts family in the British Museum and one of the Rev. Johnny Johnson is reproduced in *Records*, pl. XIV.

5. K. p. 808.

6. *Records*, p. 72.

7. See W. Wells, *William Blake's Heads of the Poets*, Manchester City Art Gallery, 1969, p. 15.

8. K. pp. 186–7.

9. See M. D. Paley, 'Cowper as Blake's Spectre', *Eighteenth-Century Studies*, 1968, Vol. I, no. 3, pp. 236–52.

10. *Records*, p. 91.

11. Bentley, *Bibliography* no. 377A.

12. Preface to W. Hayley, *Designs to a Series of Ballads*, 1802 (*Records*, p. 93).

13. *Records*, pp. 105–6.

14. K. pp. 808–10.

15. K. p. 812.

16. For an interesting discussion of these designs see Mellor, op. cit., pp. 167–77.

17. *Milton a Poem* (K. 496).

18. K. p. 814.

19. Blake is quoting a letter from Reynolds to William Gilpin quoted in the latter's *Three Essays on Picturesque Beauty*, 1792, p. 35.

20. K. p. 824.

21. J. Gage, 'Blake's *Newton*', *J. W. C. I.*, Vol. XXXIV, 1971, p. 376.

22. *Fitzwilliam cat.* no. 25.

23. *Fitzwilliam cat.* no. 24.

24. 20 December 1802; *Records*, p. 112.

25. K. p. 819.

26. K. p. 825.

27. *Tate cat.* no. 79.

28. See letter to Flaxman, 19 October 1801 (K. p. 810): 'Mr. Thomas your friend to whom you was so kind as to make honourable mention of me, has been at Felpham & did me the favour to call on me. I have promis'd him to send my designs for Comus when I have done them, directed to you.'

16. The Return to London

1. Finally published in 1809, with one engraving by Blake after Romney.

2. K. p. 851.

3. K. p. 852.

4. K. p. 480.

5. See Whitley, 1800–1820, p. 63. There are two paintings, both Netherlandish of the late fifteenth century, in the Walker Art Gallery, Liverpool, from the Truchess Coll.

6. B. H. Malkin, *A Father's Memoirs of his Child*, 1806 (*Bibliography*, no. 391); the account of Blake is in introductory letter, pp. XVIII–XLI.

7. *Tate cat.* no. 30.

8. Reproduced in Blunt, *The Art of William Blake*, pl. 54b.

9. *Hamburg cat.*, no. 106.

10. K. p. 565.

11. K. p. 775.

12. *Tate cat.* no. 33.

13. I am indebted for this suggestion to Mr Anthony Garlick, formerly of Westfield College.

14. Blunt, *The Art of William Blake*, pls 42a and b.

15. *Fitzwilliam cat.* no. 23.

16. *Tate cat.* no. 40.

17. *Tate cat.* no. 41.

18. *Boston cat.* (unnumbered).

19. *Hamburg cat.* 1975, no. 105.

20. *Tate cat.* no. 29.

21. *Boston cat.* (unnumbered).

22. See exhib. cat. *Romantic Art in Britain*, 1968, Detroit and Philadelphia, pp. 159–60.

23. *Hamburg cat.*, no. 6, where it is incorrectly dated *c.* 1806.

17. Blair's *Grave*

1. See *Prospectus for Blair's Grave engravings, Records*, p. 168f. See also G. E. Bentley, 'Blake and Cromek: The Wheat and the Tares', *Journal of Modern Philology*, Vol. LXI, 1974, pp. 366–9.

2. Letter from Flaxman to Hayley, 18 October 1805 (*Records*, pp. 166–7).

3. For Cromek's side of the story see his letter to Blake of May 1807 (*Records*, pp. 184–5).

4. *Separate Plates* no. XV.

5. *Huntington cat.*, p. 39. R. Essick and M. D. Paley in their forthcoming book on *The Grave* have revived a suggestion of Collins Baker that the Huntington watercolour was intended as a frontispiece to a separate portfolio of watercolours.

6. *Hamburg cat.*, no. 143.

7. *Records*, p. 184.

8. K. p. 442.

9. Letter to Hayley, 18 October 1805 (*Records*, p. 166).

10. Flaxman, op. cit. (*Records*, p. 166). Martin Butlin has suggested that a drawing on loan to the Fitzwilliam from Mrs Charles Hill can be identified with the drawing mentioned by Flaxman.

11. *Illuminated Blake, America*, pl. 6.

12. Fuseli's drawing of 1810, showing the horse departing, may itself have been influenced by Blake's design (Schiff no. 1445).

13. M. Whinney, *Sculpture in Britain, 1530–1830*, 1964, pl. 151.

14. Letter to Hayley, 1 December 1805 (*Records*, p. 172).

15. *Records*, pp. 175–6.

16. W. B. Scott, *Memoirs of David Scott, R.S.A.*, 1850, p. 30.

17. Quoted in Gilchrist, Vol. I, p. 377.

18. The Defence of Visionary Art

1. K. p. 865.

2. K. p. 865.

3. Letter to Butts, 22 November 1802 (K. p. 814).

4. See Gilchrist, Vol. I, p. 267.

5. K. p. 457.

6. W. Hazlitt, 'On certain inconsistencies in Sir Joshua Reynolds' Discourses', *Table Talk*, n.d., pp. 175–211.

7. K. p. 452.

8. *Discourses*, XII, p. 59.

9. K. p. 449.

10. K. p. 463.

11. K. p. 472.

12. J. Milton, *The Reason of Church Government Urg'd against Prelacy*, 1641, p. 41. K. p. 457.

13. See A. Blunt, *Artistic Theory in Italy 1450–1600*, pp. 137–59, and Panofsky, *Idea*, 1968, pp. 69–101.

14. R. Wark, ed., Reynolds, *Discourses on Art*, op. cit., Introduction, p. XIXf.

15. E. C. Mason, *The Mind of Henry Fuseli*, p. 158.

16. K. p. 446.

17. *Discourses*, I (K. p. 454).

18. K. p. 459.

19. J. J. Winckelmann, *Reflections on the Painting and Sculpture of the Greeks*, Fuseli's translation, 1765, p. 22.

20. K. pp. 476–7.

21. Hazlitt, op. cit., p. 176.

22. See J. H. Rubin, 'New Documents on the Méditateurs', *Burl. Mag.*, Vol. CXVII, December 1975, p. 785.

23. K. pp. 560–2.

24. This distinction as applied to Renaissance and Baroque art anticipates strikingly Wölfflin's similar distinction into 'linear' and 'painterly'. See *Prin-*

ciples of Art History, Dover ed., n.d., p. 18f.

25. K. p. 562.

26. It is not clear whether this was the Tate version or the earlier one in the Verney collection.

27. J. Flaxman, *Lectures on Sculpture*, op. cit., *Lecture* I, p. 4.

28. Flaxman, op. cit., *Lecture II*, p. 35f. See also James Barry, who had also regarded the Cherubim of the Temple as Hebrew sculpture, *Lectures on Painting by the Royal Academicians*, R. N. Wornum ed., 1848, p. 58f.

29. See Blunt, *The Art of William Blake*, p. 18.

30. J. Carey and A. Fowler, *The Poems of John Milton*, 1968, p. 1153, citing also Josephus, *Antiquities*, I, VIII, p. 2.

31. Milton, *The Reason of Church Government*, 1641, p. 41.

32. K. p. 480.

33. *A Vision of the Last Judgement* (K. pp. 604–5).

34. *A Vision of the Last Judgement* (K. p. 605).

35. I *Kings*, vi, 23–8.

36. *Descriptive Catalogue* (K. p. 565).

37. K. p. 775.

38. *Descriptive Catalogue* (K. p. 571).

39. *Jerusalem*, pl. 16 (K. p. 638): 'All things acted on Earth are seen in the bright Sculptures of/Los's Halls, & every Age renews its powers from these Works/With every pathetic story possible to happen from Hate or/Wayward Love; & every sorrow & distress is carved here,/Every Affinity of Parents, Marriages & Friendships are here/In all their various combinations wrought with wondrous Art,/All that can happen to Man in his pilgrimage of seventy years:' See also S. A. Larrabee, *English Bards and Grecian Marbles*, 1943, Ch. v.

40. K. p. 571.

41. K. p. 579.

42. K. p. 569.

43. I am indebted here to a discussion of the Plowman with Mr Andrew Wilton.

44. A painting in similar format in illustration of Spenser's *Faerie Queene*, (Petworth House), although probably painted *c.* 1825–6 was almost certainly intended as a companion to the *Canterbury Pilgrims* tempera. See *Blake News-*

letter, Winter, 1974–5, Vol. 8, no. 3, pp. 56–87.

45. K. p. 578. For Blake's relationship with comparative mythologists see R. Todd 'William Blake and the eighteenth-century mythologists' in *Tracks in the Snow*, 1946, and E, G. Hungerford, *Shores of Darkness*, 1941.

46. *Descriptive Catalogue* (K. p. 579).

47. See, for example, as a prototype for the figure of Pitt a standing Buddha from Mathura, B. Rowland, *The Art and Architecture of India*, Pelican History of Art, 1959, pl. 80.

48. See Blunt, *The Art of William Blake*, p. 38.

49. K. p. 583.

50. Blunt, *The Art of William Blake*, p. 38.

51. See M. Whinney, *Sculpture in Britain*, op. cit., pl. 153A.

52. Flaxman, *Lectures on Sculpture*, op. cit., Lecture II, p. 52.

53. *Examiner*, 17 September 1809 (*Records*, pp. 215–8).

54. Letter from George Cumberland to to his son G. Cumberland jr., 13 November 1809 (*Records*, p. 219).

55. For a full account of Crabb Robinson's literary connections see H. Marquardt, *Henry Crabb Robinson und seine deutschen Freunde*, 1964.

56. Reprinted in German and with English translation in *Records*, pp. 432–54.

57. *Records*, p. 452.

19. Apocalypse and Last Judgement

1. K. p. 566.

2. *La Peinture Romantique Anglaise*, exhib. cat. Petit Palais, Paris, 1972, no. 326. A study was exhibited at the Royal Academy in 1807. See also M. D. Paley, *Energy and Imagination*, op. cit., p. 176f. for the most extensive treatment of the problem of the Pitt and Nelson paintings.

3. Blunt, *The Art of William Blake*, p. 96f.

4. For another suggestion, see Erdman, *Prophet*, pp. 446–54.

5. See E. Wind, 'The Revolution of History Painting', in *J. W. I.* II, 1938, pp. 116, 127.

6. K. p. 566.

7. *The Whore of Babylon*, 1809 (British Museum), is the only one to be dated.

8. *Fitzwilliam cat.* no. 23.

9. Blake may have actually had in mind the Colossus of Rhodes, described by Pliny as a sun-god (see Flaxman, *Lectures*, op. cit., p. 272), and depicted in an engraving by Heemskerk (Hollstein, no. 361); in which case it would have been for him a Greek reminiscence of an 'Original', presumably of the Angel of Revelation.

10. *Tate cat.* nos 41 and 40 respectively.

11. J. T. Smith, *Records*, p. 467.

12. These are the *Description of A Vision of the Last Judgment* written for Ozias Humphry in January–February 1808 and known in three drafts (K. pp. 442–4), and *A Vision of the Last Judgment*, which was originally compiled from extracts in the *Notebook* and given its title by D. G. Rossetti (K. pp. 604–15).

13. *Hamburg cat.* no. 111.

14. *Hamburg cat.* no. 110.

15. See A. O. Lovejoy, 'Milton and the Paradox of the Fortunate Fall' in C. A. Patrides ed., *Milton's Epic Poetry*, 1967, pp. 55–73.

16. *Records*, pp. 188–9.

17. A. S. Roe, 'A Drawing of the Last Judgment', *Huntington Library Quarterly*, XXI, pp. 37–55

18. K. p. 604.

19. K. p. 617.

20. *Separate Plates*, no. 26.

21. K. p. 613.

22. Fuseli continued to use the word in a pejorative sense, and he praised Blake for avoiding 'Gothic superstition' in the introduction to the Blair's *Grave* engravings.

23. *Records*, p. 235.

24. K. p. 582.

25. J. T. Smith, *Records*, p. 467.

26. Gilchrist, Vol. II, p. 231, no. 199.

27. See *Fitzwilliam cat.* no. 33 for an extended discussion of the painting.

28. *Bibliography*, no. 375.

29. *Hamburg cat.*, no. 113.

30. Martin Butlin has suggested that a damaged and over-painted *Holy Family* from the Crewe Coll. may also have belonged to this series.

20. *Milton* and *Jerusalem*

1. Keynes and Wolf, p. 101.

2. Keynes and Wolf, p. 111, and Erdman, *Poetry and Prose*, p. 730.

3. Erdman in *Poetry and Prose* gives a date of 1797–1807? (pp. 737–9).

4. *Descriptive Catalogue* (K. p. 578).

5. K. p. 263.

6. Keynes and Wolf, p. 102.

7. The numbering here follows Keynes and Wolf, pp. 98–100.

8. In copies C and D there is an additional plate of text with a design of four females amongst Druidic stones (Keynes and Wolf, pl. a). See Keynes and Wolf, pp. 100–1, for a description of the six additional plates.

9. Pl. 17 (K. p. 500).

10. I Kings vi and *Milton*, pl. 19 (K. p. 500).

11. Pl. 17 (K. p. 501).

12. Pl. 20 (K. p. 505).

13. K. p. 797.

14. *Four Zoas* (K. p. 354).

15. *Illuminated Blake*. There included as pl. 47.

16. See D. V. Erdman, 'The suppressed and Altered Passages in Blake's *Jerusalem, Studies in Bibliography*, XVII, 1964.

17. *Records*, p. 187.

18. Erdman, *Poetry and Prose*, p. 730. There is a coloured copy (copy D) in the Mellon Coll. and a coloured copy of the first chapter (copy B) in an English private coll. (see *Hamburg cat.*, nos 67–91); Keynes and Wolf list a number of coloured proof pages.

19. Pl. 74 (K. p. 715).

20. Pl. 89 (K. p. 735).

21. Pl. 91 (K. p. 738).

22. See p. 81.

23. See Keynes, *Blake Studies*, op. cit., 'New lines from *Jerusalem*', pp. 115–21.

24. See, for example, *Ezekiel*, iii, 16–17. 'And it came to pass at the end of seven days, that the word of the Lord came unto me, saying, Son of man, I have made thee a watchman unto the house of Israel: therefore hear the word at my mouth, and give them warning from me.'

25. Pl. I (K. p. 620).

26. K. p. 442.

27. See, for example, the frontispiece to

Lavater's *Aphorisms* designed by Fuseli and engraved by Blake, 1788 (*Bibliography*, no. 389A).

28. The figures are so identified in a unique proof of the plate in the Keynes Coll. (see catalogue of Graham Robertson Coll., no. 137).

29. *Hamburg cat.*, no. 93. The extra figure is identified by Morton Paley as 'Hand'.

30. *Separate Plates*, no. II.

31. See D. Bindman in *Essays for Sir Geoffrey Keynes*, op. cit., p. 44.

32. For an account of alterations to this plate see Deirdre Toomey, 'The States of Plate 25 of *Jerusalem*', *Blake Newsletter*, Vol. 6, no. 2, Fall 1972, p. 46; and for a coloured proof of the design see *Hamburg cat.*, no. 94.

33. *Tate cat.*, no. 29.

34. G. L. Keynes, ed., *William Blake: Drawings*, 1971, no. 35.

35. Erdman, *Illuminated Blake*, 399 and another, pulled at a later stage, was recently acquired by the Morgan Library.

36. *Jerusalem*, pl. 28 (K. p. 652).

37. Pl. 50 (K. p. 681).

38. For a different interpretation see Erdman, *Illuminated Blake*, p. 310.

39. Erdman sees the figure at the top as Albion leaning in the arms of 'Los-Jesus'; *Illuminated Blake*, p. 312.

40. Pl. 41 (p. 37), K. p. 669.

41. Erdman identifies the recumbent figure as Albion.

42. K. p. 624.

43. K. p. 744.

44. Keynes, *Pencil Drawings*, no. 56.

45. See also Erdman, *Illuminated Blake*, p. 360.

46. Erdman, *Illuminated Blake*, p. 290.

47. This figure can be identified as a fish by comparison with the humanized fishes in Blake's illustrations to *Ode on the Death of a Favourite Cat* in the *Illustrations to Gray*, see Keynes ed., op. cit., design no. 10.

48. Ovid, *Metamorphoses*, Book XII, 72ff.

49. Could Blake have been making an etymological association between Severn, Sabrina and Swan?

50. K. p. 636.

51. Todd, *Tracks in the Snow*, op. cit., pp. 37–8.

52. For a different view see Erdman, *Illuminated Blake*, p. 292.

53. K. p. 645.

54. Erdman, *Illuminated Blake*, p. 378.

55. For identifications of these figures see Erdman, *Illuminated Blake*, p. 379.

56. See p. 84.

21. *Comus* and *Paradise Lost*

1. Letter to Butts, 6 July 1803 (K. p. 824).

2. K. p. 810. For a recent account of the Rev. Joseph Thomas see L. Parris, 'William Blake's Mr Thomas', *Times Literary Supplement*, 5 December 1968, p. 1390.

3. *Huntington cat.*, p. 32f.

4. In September 1805 (*Records*, p. 166).

5. See ill. 2 of the *Paradise Regained* series. *Fitzwilliam cat.* no. 34B.

6. See ill. IV of the Huntington Library *Paradise Lost* series (see p. 190 of the present book).

7. *Boston cat.* (unnumbered).

8. *Huntington cat.*, no. 154. There is in the Fogg Museum a small watercolour of *Satan watching the endearments of Adam and Eve*, dated 1806.

9. For a clarification of the distribution of the *Paradise Lost* watercolours see M. Butlin, 'A "Minute Particular" particularised: Blake's second set of illustrations to *Paradise Lost*', *Blake Newsletter*, Fall 1972, Vol. 6, no. 2, p. 44.

10. For a useful anthology of Miltonic designs see M. R. Pointon, *Milton and English Art*, 1970.

11. See M. Peckham, 'Blake, Milton and Edward Burney', *Princeton University Library Chronicle*, XI (1950), pp. 107–26.

12. See D. Bindman, 'Hogarth's Satan, Sin and Death and its influence'. *Burl. Mag.*, March, 1970.

13. In *Life of Milton*. See R. D. Havens, op. cit., p. 40.

14. M. Pointon, op. cit., p. 174f.

15. *Hamburg cat.*, no. 160.

16. *Milton Gallery* catalogue nos 13–16 (*Schiff, Füsslis Milton-Galerie*, op. cit., pp. 146–7.)

17. Irwin, op. cit., p. 162.

18. See Boydell edition of *Milton's Works*, 1795.

19. E. Burke, *Sublime and Picturesque*, op. cit., p. 31.

20. See R. Schmutzler, *Art Nouveau*, 1964.
21. Fuseli was much exercised by the problem of the identity of Eve's creator and in his own version for the *Milton Gallery* (Schiff, p. 897) he left the creator deliberately ambiguous. In a letter to Roscoe of 14 August 1795 he wrote of the Creator in the background: 'for believers, let it be the Son, the Visible Agent of his father; for others it is merely a superior Being entrusted with creation, and looking up for approbation of this work to the inspiring power above.' (*Fuseli*, exhib. cat. Tate Gallery, 1975, pp. 88–9).
22. *Paradise Lost*, III, 375–7, 384–7.
23. *Paradise Lost*, XII, 413–17, 429–33.
24. *Fitzwilliam cat.* no. 37.
25. See Blake's remark to Crabb Robinson in a conversation of 17 December 1825: 'I saw Milton in Imagination And he told me to beware of being misled by his Paradise Lost. In particular he wished me to show the falsehood of his doctrine that the pleasures of sex arose from the fall—The fall could not produce any pleasure.' (*Records*, p. 317).
26. See, for example, Hayman's engraving, where Adam is engaged actively in discourse with Raphael while Eve is in the distance. See also the Westall and Hamilton engravings.
27. See Blake's engraved edition of Young's *Night Thoughts*, 1797, p. 72.
28. *Paradise Lost*, IX, 782–4, 892–4.
29. See p. 119.

22. Illustrations to Milton's Minor Poems

1. *Hamburg cat.*, no. 146.
2. *Huntington cat.* p. 26f.
3. See p. 121.
4. For the lark as the portent of the descent of Los see p. 175.
5. *On the Morning of Christ's Nativity*, 109–16.
6. Flaxman, *Lectures*, 1838 ed., p. 25.
7. *Fitzwilliam cat.* no. 34. Some of the watercolours are watermarked 1816.
8. *Fitzwilliam cat.*, p. 41, n. 1.
9. See A. van Sinderen, *Blake: The Mystic Genius*, 1949 (contains coloured reproductions of whole set).

10. K. pp. 617–19.
11. Hayley dates them to the Horton period, i.e. 1632–8. W. Hayley, ed., *The Poetical Works of Milton*, 1794, Vol. I, XXII.
12. J. Carey and A. Fowler, ed., *The Poems of John Milton*, 1968, p. 130.
13. M. Pointon, op. cit., pp. 36, 51–2.
14. Schiff, no. 907.
15. *Separate Plates* XIX. There are two proof impressions known (British Museum and Sir Geoffrey Keynes). The second state is inscribed 'Solomon says Vanity of Vanities all is Vanity & what can be foolisher than this.'
16. *Milton a Poem*, pl. 35 (K. p. 526).
17. Fuseli also painted this subject, for the *Milton Gallery* (Schiff, nos 909–10).
18. I can offer no explanation of the small figure running from Milton nor of the gowned figure (or could it be two figures embracing?) above to the left.
19. See J. Grant, 'A note on the first illustration', in *Visionary Forms Dramatic*, pp. xi–xiv.
20. Damon, *Dictionary*, p. 285.
21. See A. Blunt, 'Blake's "Ancient of Days",' *J. W. I.* Vol. II, 1938–9, pp. 59–60.
22. From a remark made to Crabb Robinson by Blake in 1825. See *Records*, p. 316.

23. The New Public

1. For Blake's first meeting with John Linnell in 1818 see *Records*, pp. 256–7.
2. See Keynes, *Blake Studies*, ch. IX, 'William Blake with Charles Lamb and his Circle'.
3. For Aders see G. Grigson, *Samuel Palmer: the Visionary Years*, 1947, and *Hamburg cat.*, Glossar.
4. Engraved by John Linnell, probably in 1824 (impression in F. A. Carey Coll.).
5. *Records*, pp. 309–10.
6. See Grigson, op. cit., p. 17 and n. 17. August Wilhelm Schlegel had breakfast with Flaxman on a visit to England in 1823. (E. J. Morley ed., *H. C. Robinson on Books and their writers*, 1938, Vol. I, p. 298.)
7. For the Aders coll. see G. Passavant, *Tour of a German Artist in England*, 1836, Vol. I, pp. 201–19, and for the

Boisserée Brothers, W. D. Robson-
Scott, *The Gothic Revival in Germany*,
1964, pp. 157–8 passim. There is also
an album compiled by Mrs Aders in the
Houghton Library, Harvard College,
which contains drawings by Blake's
German admirer, Jacob Götzenberger.
(See *Records*, p. 338 passim.)

8. *Records*, p. 276.

9. Most of these are now in the Fitz-
william Museum, cat. nos 5, 9, 13, 15.

10. For a definitive account of the 'Vision-
ary Heads' see M. Butlin, *The Blake-
Varley Sketchbook of 1819*, 1969.

11. Butlin, op. cit., p. 8.

12. *Tate cat.* no. 53, and G. L. Keynes,
'Blake's Visionary Heads and the Ghost
of a Flea', *Blake Studies*, XVII.

13. For a touching account of a meeting
in October 1824, see *Records*, p. 291.

14. *Records*, p. 310.

15. *Records*, p. 315.

16. *Records*, p. 258.

17. *Records*, pp. 312–18.

18. K. p. 776. There are two known im-
pressions, in the Keynes Coll. and a
private coll., Pittsburgh, U.S.A.

19. *On Homer's Poetry and on Virgil*, K.
p. 778.

20. *Records*, p. 283.

21. *Records*, p. 315.

22. *Records*, p. 318.

23. Bentley, *Bibliography*, no. 411.

24. *Records*, p. 271.

25. For the full quotation see *Records*, pp.
271–2.

26. See letter to John Linnell, 21 De-
cember 1828 (R. Lister, ed., *The
Letters of Samuel Palmer*, 1974, Vol. I,
pp. 49–50).

27. *Records*, p. 282.

28. *Records*, p. 311.

29. B. R. Haydon, *Autobiography and
Journals*, ed. M. Elwin, 1950, ch. VI.

30. *Records*, p. 283.

31. Haydon, op. cit., p. 81: 'The very day
after he came down with large can-
vasses, and without at all entering into
the principles of these divine things
hastily made compositions from Greek
history, putting in Theseus, the Ilissus,
and others of the figures, and restoring
defective parts.'

32. Grigson, op. cit., p. 12. 'Sedulous
efforts to render the marbles exactly,
even to their granulation, led me too

much aside from the study of organisa-
tion and structure.'

33. Letter to Linnell, October 1824
(*Records*, p. 290).

24. The Book of Job

1. For interpretative accounts of this
painting see G. L. Keynes, 'The Ar-
lington Court Picture', *Blake Studies*,
ch. XXV, and Kathleen Raine in
J. W. C. I., XX, 1957, pp. 318–37. See
also J. E. Grant, Robert Simmons and
Janet Warner in *Studies in Romanticism*,
Vol. 10, 1971, no. 1, p. 21.

2. Keynes, op. cit., p. 197f.

3. Reproduced in *Blake Studies*, pl. 50.

4. Letter to Gilchrist, 23 August 1855
(*Palmer Letters*, op. cit., p. 509). See
also Gilchrist, 1880 ed., Vol. II, p. 251,
no. 243.

5. The composition certainly owes some-
thing to Flaxman's reconstruction of
the pediment of the *Olympian Jupiter*
engraved by Blake for Rees, *Encyclo-
pedia*, 1816, *Sculpture*, pl. I and possibly
also to Poussin's *Kingdom of Flora*.

6. Miss Raine was the first to identify the
figure as *Ulysses*, and has argued that
the picture is based on Thomas Taylor's
translation of the *Caves of the Nymphs*
by the Neoplatonic scholar Porphyry
(third century A.D.) with additional
details from Homer and other sources
(*J. W. C. I.* 1957, op. cit.). I am aware
that most scholars do not accept the
Homeric origin of the subject (see
Mellor, op. cit., p. 256f.).

7. According to Keynes 'She points up
with her left hand to the spiritual
world above and down with her right
to the stream of generation and materi-
alism, the three figures forming to-
gether a clockwise circle, implying
perpetual death and rebirth.' *Blake
Studies*, op. cit., p. 203.

8. On a watercolour from the *Divine
Comedy* series (Roe 7) of the classical
universe (K. p. 785).

9. Preston, *Graham Robertson cat.* no. 24.

10. *Blake Studies*, op. cit., p. 204.

11. I am greatly indebted to Martin
Butlin for discussing the dating of the
Morgan set with me. Bo Lindberg sug-
gests 1807–10 in *William Blake's Illus-*

trations to the Book of Job, Abo Aka-
demi, 1973, pp. 19–20. In addition to
Lindberg's outstanding and exhaustive
book, J. Wicksteed, Blake's Vision of the
Book of Job, 1910 and 1924, is an im-
portant pioneering interpretation. A
complete collection of facsimiles of the
watercolours was published by the
Pierpont Morgan Library, ed. G. L.
Keynes and L. Binyon, 1935.

12. In my opinion the 'New Zealand set'
of watercolours is not by Blake himself.
For arguments in its favour see P.
Hofer ed., Illustrations of the Book of
Job, 1937, and the introduction to the
Pierpont Morgan facsimiles.

13. Keynes, Blake Studies, op. cit., p. 217

14. Records, p. 582.

15. Fitzwilliam cat. p. 39.

16. See letter from Linnell to Dilke, 27
September 1844. Quoted in Hofer ed.,
Illustrations to Job, op. cit., p. 8.

17. Hamburg cat., no. 204.

18. Lindberg, op. cit. (pp. 19–20) sug-
gests that a payment of £21 to Blake
from Butts of 1810 might account for
the Job watercolours.

19. Separate Plates, nos III and VIII.

20. Listed by Lindberg, op. cit., p. 10f.

21. Hollstein, nos 256–63.

22. 2 Corinthians, iii, 6; and 1 Corinth-
ians, ii, 14.

23. Cf. also the resemblance between
Adam and Jehovah in the colourprint
God judging Adam (Tate cat. no. 15).

24. Letter to Gilchrist, 23 August 1855
(Palmer Letters, op. cit., p. 508).

25. For the reception of the Job engravings
see Records, p. 327f.

26. Records, p. 397.

27. See p. 201.

28. Keynes, Studies, p. 235.

29. Records, p. 279. The Royal Academy
have regrettably in recent years been
selling off much of their share of
Cumberland's collection.

30. Records, p. 279.

31. Tate cat. no. 5.

32. Separate Plates, no. XVI.

33. Ariadne Florentina, Lectures, 1872
(Cook and Wedderburn, Vol. 22, p.
470).

34. Illustrations to Job, op. cit., p. 72.

35. Jerusalem, pl. 70 (K. pp. 708–9).

36. See p. 138.

37. Descriptive Catalogue (K. p. 565).

38. The germ of the idea of the pictorial
wall in Job's house seems to have come
from an engraving of 1779 after
Stothard, inscribed as by Blake in
pencil (British Museum 49–7–21–19 in
Balmanno Album).

39. Jerusalem, pl. 98 (K. p. 746).

25. The Last Works

1. Records, p. 291.

2. See Keynes, Blake Studies, ch. XXII, 'The
Pilgrim's Progress'. Also dating from
this period is the striking but damaged
tempera Madonna and Child (Mellon
Coll.) inscribed: 'Freso [sic]/1825/W.
Blake.' See Todd, William Blake The
Artist, p. 140.

3. See E. P. Thompson, The Making of
the English Working Classes, op. cit.,
pp. 31–5, for the importance of The
Pilgrim's Progress for radical thinkers
in Blake's time.

4. For Blake's engraving of The Man
sweeping the Interpreter's Parlour,
probably engraved about at this time,
see Separate Plates, no. XI.

5. Records, p. 295.

6. In the end only seven unfinished en-
gravings were produced and published
after Blake's death. See Bentley,
Bibliography, no. 331A.

7. Records, p. 316.

8. Records, p. 316.

9. Records, p. 313.

10. Blake also remarked to Crabb Robin-
son: 'Dante (tho' now with God) lived
and died an Atheist. He was the slave
of the world + time—But Dante +
Wordw: in spite of their Atheism were
inspired by the Holy Ghost.' (Records,
p. 325).

11. The references here are to A. S. Roe,
Blake's Illustrations to the Divine
Comedy, 1953, which discusses ex-
haustively each illustration. See also J.
Burke 'The Eidetic and the borrowed
image: an interpretation of Blake's
theory and practice of art', in Essays in
honour of Daryl Lindsay, 1964, for
the prototypes of some of Blake's most
striking Dantesque images.

12. In German and English depictions of
the story of Paolo and Francesca (Flax-

man, Koch etc.) the whirlwind itself is shown, but in French versions (Ingres, Delacroix, but not Girodet) the emphasis is upon the drama of their discovery.

13. *Tate cat.* no. 22.

14. A comparable fluidity and more translucent use of colour can be seen in a number of paintings in watercolour and tempera, all of which can be dated to the years 1825–6 and which are revised versions of earlier compositions. These include the two watercolours commissioned by Sir Thomas Lawrence: *The Wise and Foolish Virgins* (Philip Hofer Coll.), the *Dream of Queen Katherine* (Rosenwald Coll.) and the set of three tempera panels of *Count Ugolino in Prison* (Keynes Coll.),

The Body of Abel found by Adam and Eve and *Satan smiting Job with Sore Boils* (*Tate cat.* nos 54 and 55 respectively). According to Gilchrist, Vol. I, pp. 357–8. Lawrence paid Blake 15 guineas apiece for the two watercolours.

15. The sequence of four watercolours (Roe 86–9) was shown in the Hamburg Exhibition 1975 (see *Hamburg cat.* nos 213–16).

16. Roe, op. cit., pp. 169–70.

17. Written on design no. 7 (K. p. 785).

18. See *Europe, A Prophecy*, 1794.

19. See note 10.

20. *Records*, p. 317.

21. See P. Nanavutty, 'A Title Page in Blake's Illustrated Genesis Manuscript', *J. W. C. I.*, x, 1947, pp. 114–22.

Index of Blake's Works

Index of Persons